P.

CUSTOM EDITIONS

THE WESTERN WORLD

Volume I

Pearson
Custom
Publishing

Director of Database Publishing: Michael Payne
Sponsoring Editor: Natalie Danner
Development Editor: Katherine R. Gretz
Editorial Assistant: Samantha A. Goodman
Operations Manager: Eric M. Kenney
Marketing Manager: Nathan Wilbur
Production Editors: Mary Kaiser and Vikram Savkar
Cover Design: Renee Sartell

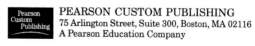
PEARSON CUSTOM PUBLISHING
75 Arlington Street, Suite 300, Boston, MA 02116
A Pearson Education Company

Acknowledgments

As anyone could well imagine, creating *Penguin Custom Editions: The Western World* was an enormous undertaking. Not only did the project involve compiling a collection of more than a thousand selections—all of which had to be identified, excerpted, introduced, categorized, copy edited, composed, proofread, and cleared for copyright, among other things—but as a new kind of publication, it raised a new and unpredictable set of challenges that demanded the creative skills of a dedicated team. The editors owe a sincere debt of gratitude to the scholars and professionals who worked with us to hone the original concept, to shape the materials as they emerged, and to transform idea into reality.

From the start, *Penguin Custom Editions* depended on the support of key people at Penguin Putnam, Inc. and at Penguin Books. In particular, Daniel T. Lundy's enthusiasm for the project buoyed us along, and John Schline's patience and perseverance remain much appreciated. Thanks also to Mary Sunden, Margaret Bluman, Andrew Rosenheim, and Florence Eichin.

The project benefited greatly from the advice of the many teachers who reviewed the original proposal and who, in the process, identified potential pitfalls and helped us to see how to avoid them: David A. Brewer, *The Ohio State University;* Denise Z. Davidson, *Georgia State University;* Barbara B. Diefendorf, *Boston University;* Daniel Gordon, *University of Massachusetts at Amherst;* Paul Halliday, *Union College;* Susan Hult, *Houston Community College, Central;* Ethan Knapp, *The Ohio State University;* Elizabeth A. Lehfeldt, *Cleveland State University;* Katharine J. Lualdi, *University of Southern Maine;* Christopher Martin, *Boston University;* Phillip C. Naylor, *Marquette University;* Catherine F. Patterson, *University of Houston;* John Paul Riquelme, *Boston University;* Barbara H. Rosenwein, *Loyola University of Chicago;* Charles J. Rzepka, *Boston University;* John Savage, *New York University;* and Daniel R. Schwarz, *Cornell University.*

As the manuscript neared completion, we had the good fortune to garner feedback from colleagues who helped us see what was working, what needed improvement, and how best to go about it. Many thanks to Feroz

Ahmad, *University of Massachusetts, Boston;* Joseph Aieta, *Babson College;* Kathleen Shine Cain, *Merrimack College;* Paul Doherty, *Boston College;* Paul Faler, *University of Massachusetts, Boston;* Julia Genster, *Tufts University;* Patricia A. Halpin, *Assumption College;* Robert Keohan, *Merrimack College;* Mary Kramer, *University of Massachusetts, Lowell;* Matthew Lenoe, *Assumption College;* Jennifer Morrison, *Regis College;* Janice Neuleib, *Illinois State University;* Shaun O'Connell, *University of Massachusetts, Boston;* Mark O'Connor, *Boston College;* Stuart Peterfreund, *Northeastern University;* Stephen Ruffus, *Salt Lake Community College;* Maurice Scharton, *Illinois State University;* Steven Scherwatzky, *Merrimack College;* Mary Shaner, *University of Massachusetts, Boston;* Louise Z. Smith, *University of Massachusetts, Boston;* Judith A. Stanford, *Rivier College;* Elizabeth Kowaleski Wallace, *Boston College;* James D. Wallace, *Boston College;* David Wick, *Gordon College;* and Alex Wilkes, *Northeastern University.*

Penguin Custom Editions simply would not have been possible without the talented people at Pearson Custom Publishing. Ellen Kuhl suggested the project to us and became its impresario extraordinaire throughout each step of the publishing process. Her ideas, hard work, and humor were key assets in bringing this work to fruition. Katherine Gretz invented the rules and held us to them; her creativity, her almost unbelievable organizational abilities, and her willingness to laugh at an endless stream of puns made it possible for us to finish what we started. Lydia Stuart Horton skillfully copy edited more than 15,000 pages of manuscript with a keen eye for detail and consistency. Among countless other things, Amy Hurd and Stephanie Tobin monitored the whereabouts of thousands upon thousands of files and pieces of paper without losing a single one; Mary Kaiser and Vikram Savkar wrestled all of that paper into finely crafted pages with the invaluable assistance of Melanie Aswell, her proofreading team, and Jim O'Malley at Stratford Publishing. Nathan Wilbur enthusiastically spread the news and Renee Sartell made it beautiful. Finally, a nod of grateful appreciation goes to Deborah Shaw, Francesca Marcantonio, Michael Payne, Pat Porter, Jay Schmidt, Eric Kenney, Lisa Cutler, Pat Boles, Don Kilburn, and to the many who contributed without our awareness. It has been a pleasure and we're looking forward to doing it again.

Mark Kishlansky
David Blackbourn
Virginia Brown
James Hankins

⟋ CONTENTS ⟍

PLATO

The Myth of Atlantis

Plato of Athens (c. 429–347 B.C.E.) stands with Aristotle as one of the two most important philosophers of Antiquity and as a major shaper of the Western intellectual history as a whole. Descended from a wealthy and aristocratic family, his intellectual outlook was decisively formed by his teacher, Socrates. Socrates' judicial murder at the hands of political opponents helped turn Plato into a critic of democracy and a supporter of aristocracy, in his special sense of the term, that is, rule by the wise and virtuous (or "philosopher-kings"). From Socrates, Plato learned a mode of inquiry that consisted of subjecting received opinions to systematic crossexamination ("dialectic"), as well as certain moral doctrines such as the view that the source of wrongdoing is ignorance, or that the gods' approval or disapproval does not render actions right or wrong. Plato attempted to put his political ideas into practice by serving as counselor to Dionysius II, tyrant of Syracuse, but the young ruler's sporadic enthusiasm for philosophy did not survive political reality, and the two men were finally estranged. Plato was more successful as the founder of a philosophical school, the Academy, established in a grove dedicated to the hero Academus outside Athens during the early fourth century B.C.E. The school continued for several centuries and was instrumental in preserving Plato's teachings and writings.

Plato's surviving writings are cast in dialogue form to force the reader to make up his or her own mind about the positions and arguments presented. Plato never appears, though students of the dialogues often assume, perhaps correctly, that his point of view is represented by Socrates. Modern scholarship largely agrees in dividing the dialogues into three broad groupings: early, middle, and late. Attempts to coordinate these groupings with known events in Plato's life or with the development of his thought, however, are more controversial.

The Critias *is a late, unfinished dialogue written about the same time as the* Timaeus, *and continues the latter's discussion of a mythic utopia called Atlantis set in the remote past. In the present selection from the* Critias, *the eponymous interlocutor describes an ideal city on the island of Atlantis. The*

*account is meant to serve as a mythical or quasi-historical counterpart to
more abstract discussions of the ideal state in* The Republic.

POSEIDON AND CLEITO, THEIR DESCENDANTS, THE NATURAL RESOURCES OF THE ISLAND

The story is a long one and it begins like this. We have already men-
tioned how the gods distributed the whole earth between them in larger
or smaller shares and then established shrines and sacrifices for them-
selves. Poseidon's share was the island of Atlantis and he settled the chil-
dren borne to him by a mortal woman in a particular district of it. At the
centre of the island,[1] near the sea, was a plain, said to be the most beauti-
ful and fertile of all plains, and near the middle of this plain about fifty
stades inland a hill of no great size. Here there lived one of the original
earth-born inhabitants called Evenor, with his wife Leucippe. They had
an only child, a daughter called Cleito. She was just of marriageable age
when her father and mother died, and Poseidon was attracted by her and
had intercourse with her, and fortified the hill where she lived by enclos-
ing it with concentric rings of sea and land. There were two rings of land
and three of sea, like cartwheels, with the island at their centre and equi-
distant from each other, making the place inaccessible to man (for there
were still no ships or sailing in those days). He equipped the central
island with godlike lavishness; he made two springs flow, one of hot and
one of cold water, and caused the earth to grow abundant produce of
every kind. He begot five pairs of male twins, brought them up, and
divided the island of Atlantis into ten parts which he distributed
between them. He allotted the elder of the eldest pair of twins his
mother's home district and the land surrounding it, the biggest and best
allocation, and made him King over the others; the others he made gov-
ernors, each of a populous and large territory. He gave them all names.
The eldest, the King, he gave a name from which the whole island and
surrounding ocean took their designation of 'Atlantic', deriving it from
Atlas the first King. His twin, to whom was allocated the furthest part
of the island towards the Pillars of Heracles and facing the district
now called Gadira, was called in Greek Eumelus but in his own lan-
guage Gadirus, which is presumably the origin of the present name. Of
the second pair he called one Ampheres and the other Euaemon. The
elder of the third pair was called Mneseus, the younger Autochthon, the
elder of the fourth Elasippus, the younger Mestor; the name given to

the elder of the fifth pair was Azaes, to the younger Diaprepes. They and their descendants for many generations governed their own territories and many other islands in the ocean and, as has already been said, also controlled the populations this side of the straits as far as Egypt and Tyrrhenia. Atlas had a long and distinguished line of descendants, eldest son succeeding eldest son and maintaining the succession unbroken for many generations; their wealth was greater than that possessed by any previous dynasty of kings or likely to be accumulated by any later, and both in the city and countryside they were provided with everything they could require. Because of the extent of their power they received many imports, but for most of their needs the island itself provided. It had mineral resources from which were mined both solid materials and metals,[2] including one metal which survives today only in name, but was then mined in quantities in a number of localities in the island, orichalc, in those days the most valuable metal except gold. There was a plentiful supply of timber for structural purposes, and every kind of animal domesticated and wild, among them numerous elephants.[3] For there was plenty of grazing for this largest and most voracious of beasts, as well as for all creatures whose habitat is marsh, swamp and river, mountain or plain. Besides all this, the earth bore freely all the aromatic substances it bears today, roots, herbs, bushes and gums exuded by flowers or fruit. There were cultivated crops, cereals which provide our staple diet, and pulse (to use its generic name) which we need in addition to feed us; there were the fruits of trees, hard to store but providing the drink and food and oil which give us pleasure and relaxation and which we serve after supper as a welcome refreshment to the weary when appetite is satisfied—all these were produced by that sacred island, then still beneath the sun, in wonderful quality and profusion.

THE CITY AND THE BUILDINGS

This then was the island's natural endowment, and the inhabitants proceeded to build temples, palaces, harbours and docks, and to organize the country as a whole in the following manner. Their first work was to bridge the rings of water round their mother's original home, so forming a road to and from their palace. This palace they proceeded to build at once in the place where the god and their ancestors had lived, and each successive king added to its beauties, doing his best to surpass his predecessors, until they had made a residence whose size and beauty were astonishing to see. They began by digging a canal three hundred feet wide, a hundred feet deep and fifty stades long from the sea to the outermost ring, thus

making it accessible from the sea like a harbour; and they made the entrance to it large enough to admit the largest ships. At the bridges they made channels through the rings of land which separated those of water, large enough to admit the passage of a single trireme, and roofed over to make an underground tunnel; for the rims of the rings were of some height above sea-level. The largest of the rings, to which there was access from the sea, was three stades in breadth and the ring of land within it the same. Of the second pair the ring of water was two stades in breadth, and the ring of land again equal to it, while the ring of water running immediately round the central island was a stade across. The diameter of the island on which the palace was situated was five stades. It and the rings and the bridges (which were a hundred feet broad) were enclosed by a stone wall all round, with towers and gates guarding the bridges on either side where they crossed the water. The stone for them, which was white, black and yellow, they cut out of the central island and the outer and inner rings of land, and in the process excavated pairs of hollow docks with roofs of rock. Some of their buildings were of a single colour, in others they mixed different coloured stone to divert the eye and afford them appropriate pleasure. And they covered the whole circuit of the outermost wall with a veneer of bronze, they fused tin over the inner wall and orichalc gleaming like fire over the wall of the acropolis itself.

The construction of the palace within the acropolis was as follows. In the centre was a shrine sacred to Poseidon and Cleito, surrounded by a golden wall through which entry was forbidden, as it was the place where the family of the ten kings was conceived and begotten; and there year by year seasonal offerings were made from the ten provinces to each one of them. There was a temple of Poseidon himself, a stade in length, three hundred feet wide and proportionate in height, though somewhat outlandish in appearance. The outside of it was covered all over with silver, except for the figures on the pediment which were covered with gold. Inside, the roof was ivory picked out with gold, silver and orichalc, and all the walls, pillars and floor were covered with orichalc. It contained gold statues of the god standing in a chariot drawn by six winged horses, so tall that his head touched the roof, and round him, riding on dolphins, a hundred Nereids (that being the accepted number of them at the time), as well as many other statues dedicated by private persons. Round the temple were statues of the original ten kings and their wives, and many others dedicated by kings and private persons belonging to the city and its dominions. There was an altar of a size and workmanship to match that of the building and a palace equally worthy of the greatness of the empire and the magnificence of its temples. The two springs, cold and

hot, provided an unlimited supply of water for appropriate purposes, remarkable for its agreeable quality and excellence; and this they made available by surrounding it with suitable buildings and plantations, leading some of it into basins in the open air and some of it into covered hot baths for winter use. Here separate accommodation was provided for royalty and for commoners, and, again, for women, for horses and for other beasts of burden, appropriately equipped in each case. The outflow they led into the grove of Poseidon, which (because of the goodness of the soil) was full of trees of marvellous beauty and height, and also channelled it to the outer ring-islands by aqueducts at the bridges. On each of these ring-islands they had built many temples for different gods, and many gardens and areas for exercise, some for men and some for horses. On the middle of the larger island in particular there was a special course for horse-racing; its width was a stade and its length that of a complete circuit of the island, which was reserved for it. Round it on both sides were barracks for the main body of the king's bodyguard. A more select body of the more trustworthy were stationed on the smaller island ring nearer the citadel, and the most trustworthy of all had quarters assigned to them in the citadel and were attached to the king's person.

Finally, there were dockyards full of triremes and their equipment, all in good shape.

So much then for the arrangement of the royal residence and its environs. Beyond the three outer harbours there was a wall, beginning at the sea and running right round in a circle, at a uniform distance of fifty stades from the largest ring and harbour and returning on itself at the mouth of the canal to the sea. This wall was densely built up all round with houses and the canal and large harbour were crowded with vast numbers of merchant ships from all quarters, from which rose a constant din of shouting and noise day and night.

THE REST OF THE ISLAND

I have given you a pretty complete account of what was told me about the city and its original buildings; I must now try to recall the nature and organization of the rest of the country. To begin with the region as a whole was said to be high above the level of the sea, from which it rose precipitously; the city was surrounded by a uniformly flat plain, which was in turn enclosed by mountains which came right down to the sea. This plain was rectangular in shape, measuring three thousand stades in length and at its midpoint two thousand stades in breadth from the coast. This whole area of the island faced south, and was sheltered from

the north winds. The mountains which surrounded it were celebrated as being more numerous, higher and more beautiful than any which exist today; and in them were numerous villages and a wealthy population, as well as rivers and lakes and meadows, which provided ample pasture for all kinds of domesticated and wild animals, and a plentiful variety of woodland to supply abundant timber for every kind of manufacture.

Over a long period of time the work of a number of kings had effected certain modifications in the natural features of the plain. It was naturally a long, regular rectangle; and any defects in its shape were corrected by means of a ditch dug round it. The depth and breadth and length of this may sound incredible for an artificial structure when compared with others of a similar kind, but I must give them as I heard them. The depth was a hundred feet, the width a stade, and the length, since it was dug right round the plain, was ten thousand stades.[4] The rivers which flowed down from the mountains emptied into it, and it made a complete circuit of the plain, running round to the city from both directions, and there discharging into the sea.[5] Channels about a hundred feet broad were cut from the ditch's landward limb straight across the plain, at a distance of a hundred stades from each other, till they ran into it on its seaward side. They cut cross channels between them and also to the city, and used the whole complex to float timber down from the mountains and transport seasonal produce by boat. They had two harvests a year, a winter one for which they relied on rainfall and a summer one for which the channels, fed by the rivers, provided irrigation.

MILITARY SERVICE

The distribution of man-power was as follows: each allotment of land was under obligation to furnish one leader of a military detachment. Each allotment was ten square stades in size and there were in all 60,000 allotments; there was an unlimited supply of men in the mountains and other parts of the country and they were assigned by district and village to the leaders of the allotments. The leader was bound to provide a sixth part of the equipment of a war chariot, up to a total complement of 10,000, with two horses and riders; and in addition a pair of horses without a chariot, a charioteer to drive them and a combatant with light shield[6] to ride with him, two hoplites, two archers and two slingers, three light-armed stone throwers and three javelin men, and four sailors as part of the complement of twelve hundred ships. Such were the military dispositions of the royal city; those of the other nine varied in detail and it would take too long to describe them.

POLITICAL AND LEGAL AUTHORITY

Their arrangements for the distribution of authority and office were the following. Each of the ten kings had absolute power, in his own region and city, over persons and in general over laws, and could punish or execute at will. But the distribution of power between them and their mutual relations were governed by the injunctions of Poseidon, enshrined in the law and engraved by the first kings on an orichalc pillar in the temple of Poseidon in the middle of the island. Here they assembled alternately every fifth and sixth year (thereby showing equal respect to both odd and even numbers), consulted on matters of mutual interest and inquired into and gave judgement on any wrong committed by any of them. And before any prospective judgement they exchanged mutual pledges in the following ceremony. There were in the temple of Poseidon bulls roaming at large. The ten kings, after praying to the god that they might secure a sacrifice that would please him, entered alone and started a hunt for a bull, using clubs and nooses but no metal weapon; and when they caught him they cut his throat over the top of the pillar so that the blood flowed over the inscription. And on the pillar there was engraved, in addition to the laws, an oath invoking awful curses on those who disobeyed it. When they had finished the ritual of sacrifice and were consecrating the limbs of the bull, they mixed a bowl of wine and dropped in a clot of blood for each of them, before cleansing the pillar and burning the rest of the blood. After this they drew wine from the bowl in golden cups, poured a libation over the fire and swore an oath to give judgement in accordance with the laws written on the pillar, to punish any past offences, never knowingly in future to transgress what was written, and finally neither to give nor obey orders unless they were in accordance with the laws of their father. Each one of them swore this oath on his own behalf and that of his descendants, and after drinking dedicated his cup to the god's temple. There followed an interval for supper and necessary business, and then when darkness fell and the sacrificial fire had died down they all put on the most splendid dark blue ceremonial robes and sat on the ground by the embers of the sacrificial fire, in the dark, all glimmer of fire in the sanctuary being extinguished. And thus they gave and submitted to judgement on any complaints of wrong made against them; and afterwards, when it was light, wrote the terms of the judgement on gold plates which they dedicated together with their robes as a record. And among many other special laws governing the privileges of the kings the most important were that they should never make war on each other, but come to each other's help if any of them were threatened with a dissolution of the power of the royal house in his state; in that case, they should

follow the custom of their predecessors and consult mutually about policy for war and other matters, recognizing the suzerainty of the house of Atlas. But the King of that house should have no authority to put any of his fellows to death without the consent of a majority of the ten.

DEGENERATION AND PUNISHMENT

This was the nature and extent of the power which existed then in those parts of the world and which god brought to attack our country. His reason, so the story goes, was this. For many generations, so long as the divine element in their nature survived, they obeyed the laws and loved the divine to which they were akin. They retained a certain greatness of mind, and treated the vagaries of fortune and one another with wisdom and forbearance, as they reckoned that qualities of character were far more important than their present prosperity. So they bore the burden of their wealth and possessions lightly, and did not let their high standard of living intoxicate them or make them lose their self-control, but saw soberly and clearly that all these things flourish only on a soil of common goodwill and individual character, and if pursued too eagerly and overvalued destroy themselves and morality with them. So long as these principles and their divine nature remained unimpaired the prosperity which we have described continued to grow.

But when the divine element in them became weakened by frequent admixture with mortal stock, and their human traits became predominant, they ceased to be able to carry their prosperity with moderation. To the perceptive eye the depth of their degeneration was clear enough, but to those whose judgement of true happiness is defective they seemed, in their pursuit of unbridled ambition and power, to be at the height of their fame and fortune. And the god of gods, Zeus, who reigns by law, and whose eye can see such things, when he perceived the wretched state of this admirable stock decided to punish them and reduce them to order by discipline.

He accordingly summoned all the gods to his own most glorious abode, which stands at the centre of the universe and looks out over the whole realm of change, and when they had assembled addressed them as follows: . . .

EXPLANATORY NOTES

1. i.e. midway along its greatest length.
2. The contrast is between solid materials like stone and marble and 'fusible' substances, i.e., in the main metals.

3. The first Greek author to mention the elephant is Herodotus in the fifth century (though the Greeks knew ivory long before that). Aristotle has quite a lot about the elephant in his *Historia Animalium*, but this is the only other mention of it before him.
4. Length 3,000, breadth 2,000 (see above): $5,000 \times 2 = 10,000$.
5. Through the canal running through the city.
6. In Homeric warfare the charioteer drove the combatant into battle, where he dismounted to fight.

HOMER

The Shield of Achilles

Homer's two epic poems, The Iliad *and* The Odyssey, *are the first works of European literature and the greatest of their kind, but nothing is known about their author. Homer probably lived in the eighth century B.C.E., in the eastern Greek world; Smyrna in Asia Minor and the island of Chios, among many others, claimed him. According to tradition, he was blind. In any case, the poems are the product of a long oral tradition that preserved the memory of events in the Bronze Age, four hundred years before the poems were composed. They incorporate many ancient elements and stories, but each is the coherent work of one author who carefully produced a unified epic that also reflects the life of his own time. Whether* The Iliad *and* The Odyssey *are both by the same poet has been argued for more than two thousand years, and the issue is unlikely ever to be resolved. If both are by Homer,* The Iliad *is probably a work of his youth and* The Odyssey *of his old age. But differences of style, treatment, and characterization are striking. There is also a possibility that the poems were altered before they assumed their final form in the sixth century B.C.E.*

This description of the shield of Achilles, a famous example of ekphrasis or vivid description, portrays life in the Greek cities and country of Homer's time.

First he began to make a huge and massive shield, decorating it all over. He put a triple rim round its edge, bright and gleaming, and hung a silver baldric from it. The body of the shield was made of five layers: and on its face he elaborated many designs in the cunning of his craft.

On it he made the earth, and sky, and sea, the weariless sun and the moon waxing full, and all the constellations that crown the heavens, Pleiades and Hyades, the mighty Orion and the Bear, which men also call by the name of Wain: she wheels round in the same place and watches for Orion, and is the only one not to bathe in Ocean.

"The Shield of Achilles," from Book 18 in *The Iliad*, by Homer, translated by Martin Hammond, copyright © 1987 by Martin Hammond, 307–310. Reprinted by permission of Penguin Books Ltd.

And on it he made two fine cities of mortal men. In one there were marriages and feasting, and they were escorting the brides from their houses through the streets under the light of burning torches, and the wedding-song rose loud. The young men were whirling in the dance, and among them reed-flutes and lyres kept up their music, while the women all stood at the doors of their houses and looked on admiring. The men had gathered in the market-place, where a quarrel was in progress, two men quarrelling over the blood-money for a man who had been killed: one claimed that he was making full compensation, and was showing it to the people, but the other refused to accept any payment: both were eager to take a decision from an arbitrator. The people were taking sides, and shouting their support for either man, while the heralds tried to keep them in check. And the elders sat on the polished stone seats in the sacred circle, taking the rod in their hands as they received it from the loud-voiced heralds: then each would stand forward with the rod, and give his judgment in turn. And two talents of gold lay on the ground in the middle of their circle, to be given to the one who spoke the straightest judgment.

The other city had two encamped armies surrounding it, their weapons glittering. There was debate among them, with support for either view, whether to storm the city and sack it, or to agree with the inhabitants a division of their property, taking half of all the possessions contained in the lovely town. But the defenders were not ready to yield, and had secretly armed for an ambush. Their dear wives and young children and the men overtaken by old age stood on the walls to defend them, while the others set out. They were led by Ares and Pallas Athene, both shown in gold, and dressed in golden clothing, huge and beautiful in their armour, and standing out, as gods will, clear above the rest: and the people with them were of smaller size. When they reached the place that suited their ambush, down by a river, where all the cattle came to water, they took up their position there covered in shining bronze. Then two scouts were posted at a distance from the main body, to wait for sight of the sheep and twist-horned cattle. Soon they appeared, and with them two herdsmen playing on their pipes, with no thought for danger. The men in ambush saw them coming and rushed out on them, then quickly surrounded the herds of cattle and fine flocks of white-woolled sheep, and killed the shepherds with them. But when the besiegers heard the great commotion among their cattle from where they sat in their assembly-place, they immediately mounted behind their high-stepping horses and went in pursuit and quickly overtook them. Then they formed for battle and fought it out by the banks of the river, casting at each other with

11

their bronze-tipped spears. And Strife and Confusion were in their company, and cruel Death—she gripped one man alive with a fresh wound on him, and another one unwounded, and was dragging a dead man by the feet through the shambles: the cloak on her shoulders was deep red with men's blood. The figures closed and fought like living men, and dragged away from each other the bodies of those who were killed.

And he made on it a field of soft fallow, rich ploughland, broad and triple-tilled. There were many ploughmen on it, wheeling their teams and driving this way and that. Whenever they had turned and reached the headland of the field, a man would come forward and put a cup of honey-sweet wine in their hands: then they would turn back down the furrows, pressing on through the deep fallow to reach the headland again. The field darkened behind them, and looked like earth that is ploughed, though it was made in gold. This was the marvel of his craftsmanship.

And he made on it a king's estate of choice land, where workers were reaping the corn with sharp sickles in their hands. The crop fell to the ground in handful after handful along the swathe, while binders tied the cut trusses into sheaves and twine. There were three sheaf-binders standing ready, and boys working behind the reapers kept them constantly supplied, gathering the cut corn and bringing it in armfuls to them. And among them the king holding his sceptre stood quietly by the swathe, with delight in his heart. To one side his heralds were preparing a feast under an oak, busy with a great ox they had slaughtered: and the women were pouring out an abundance of white barley for the workers' meal.

And he made on it a vineyard heavy with grapes, a beautiful thing made in gold: but the clusters on the vines were dark, and the rows of poles supporting them were silver: and all around the plot he set a ditch worked in blue enamel, and a fence of tin. A single path led in to the vineyard, and along it went the pickers at the time of the grape-harvest. Girls and young men, innocent-hearted, were carrying out the honey-sweet crop in woven baskets. In their midst a boy was playing a lovely tune on a clear-sounding lyre, and to it sweetly singing the Linos-song in his delicate voice: they followed him with singing and shouting, and danced behind him with their feet beating time to his music.

And he made on it a herd of straight-horned cattle. The cows were fashioned in gold and tin, and were mooing as they hurried from the farmyard to their pasture by a purling river, beside the beds of swaying reeds. Four herdsmen in gold walked along with the cattle, and there were nine quick-footed dogs accompanying them. But at the head of the cattle two fearsome lions had caught a bellowing bull, and he was dragged away roaring loud. The dogs and the young men went after him. The lions had

broken open the great ox's hide and were gulping its inwards and black blood. The herdsmen could only set their quick dogs at them and urge them on. The dogs would always turn back before biting the lions, but they stood close and barked at them, while keeping clear.

And the famous lame god made on it a great pasture-ground for white-woolled sheep in a beautiful valley, with steadings and covered huts and sheepfolds.

And the famous lame god elaborated a dancing-floor on it, like the dancing-floor which once Daidalos built in the broad space of Knosos for lovely-haired Ariadne. On it there were dancing young men and girls whose marriage would win many oxen, holding each other's hands at the wrist. The girls wore dresses of fine linen, and the men closely-woven tunics with a light sheen of olive oil: and the girls had beautiful garlands on their heads, and the men wore golden daggers hanging from belts of silver. At times they would run round on their skilful feet very lightly, as when a potter sits to a wheel that fits comfortably in his hands and tries it, to see if it will spin smoothly: and then they would form lines and run to meet each other. A large crowd stood round enjoying the sight of the lovely dance: and two acrobats among the performers led their dancing, whirling and tumbling at the centre.

And he made on it the mighty river of Ocean, running on the rim round the edge of the strong-built shield.

HOMER

In the Land of the Dead

Homer's two epic poems, The Iliad *and* The Odyssey, *are the first works of European literature and the greatest of their kind, but nothing is known about their author. Homer probably lived in the eighth century* B.C.E., *in the eastern Greek world; Smyrna in Asia Minor and the island of Chios, among many others, claimed him. According to tradition, he was blind. In any case, the poems are the product of a long oral tradition that preserved the memory of events in the Bronze Age, four hundred years before the poems were composed. They incorporate many ancient elements and stories, but each is the coherent work of one author who carefully produced a unified epic that also reflects the life of his own time. Whether* The Iliad *and* The Odyssey *are both by the same poet has been argued for more than two thousand years, and the issue is unlikely ever to be resolved. If both are by Homer,* The Iliad *is probably a work of his youth and* The Odyssey *of his old age. But differences of style, treatment, and characterization are striking. There is also a possibility that the poems were altered before they assumed their final form in the sixth century* B.C.E.

Odysseus here describes the Underworld, where he meets the Greek heroes Agamemnon, murdered by his own wife, and Achilles, who would rather be a slave on earth than king of the dead.

'In the end, holy Persephone drove off the women's ghosts. They scattered in all directions, and I was approached by the soul of Agamemnon, son of Atreus. He came in sorrow, and round about him were gathered the souls of all those who had met their doom and died with him in Aegisthus' palace. As soon as he had drunk the dark blood, he recognized me, uttered a loud cry and burst into tears, stretching his arms out in my direction in his eagerness to reach me. But this he could not do, for all the strength and vigour had gone for ever from those once supple limbs. Moved to compassion at the sight, I too gave way to tears and spoke to him with winged words:

"'Illustrious son of Atreus, Agamemnon, King of men, what mortal stroke of fate laid you low? Did Poseidon rouse fearful squalls and tempestuous winds and overwhelm your ships? Or did you fall to some hostile tribe on land as you were driving off their cattle and their flocks or fighting with them for their town and women?"

"'Royal son of Laertes, Odysseus of the nimble wits," he answered me at once, "Poseidon did not wreck my ships with fearful squalls and tempestuous winds, nor did I fall to any hostile tribe on land. It was Aegisthus who plotted my destruction and with my accursed wife put me to death. He invited me to the palace, he feasted me, and he killed me as a man fells an ox at its manger. That was my most pitiful end. And all around me my companions were cut down in ruthless succession, like white-tusked swine slaughtered in the mansion of some rich and powerful lord, for a wedding, or a banquet, or a sumptuous private feast. You, Odysseus, have witnessed the deaths of many men in single combat or in the thick of battle, but none with such horror as you would have felt had you seen us lying there by the wine-bowl and the laden tables in the hall, while the whole floor swam with our blood.

"'Yet the most pitiable thing of all was the cry I heard from Cassandra,[1] daughter of Priam, whom that treacherous schemer Clytaemnestra murdered at my side. I raised my hands, but then beat them on the ground, dying, thrust through by a sword. The bitch turned her face aside, and could not even bring herself, though I was on my way to Hades, to shut my eyes with her hands or to close my mouth. There is nothing more degraded or shameful than a woman who can contemplate and carry out deeds like the hideous crime of murdering the husband of her youth. I had certainly expected a joyful welcome from my children and my servants when I reached my home. But now, in the depth of her villainy, she has branded with infamy not herself alone but the whole of her sex, even the virtuous ones, for all time to come."

"'Alas!' I exclaimed. "All-seeing Zeus has indeed proved himself a relentless foe to the House of Atreus from the beginning, working his will through women's crooked ways. It was for Helen's sake that so many of us met our deaths, and it was Clytaemnestra who hatched the plot against her absent lord."

"'Yes," replied Agamemnon. "Never be too trustful even of your wife, nor show her all that is in your mind. Reveal a little of your plans to her, but keep the rest to yourself. Not that *your* wife, Odysseus will ever murder you. Icarius' daughter is far too loyal in her thoughts and feelings. The wise Penelope! She was a young woman when we said goodbye to her on our way to the war. She had a baby son at her breast.

And now, I suppose, he has begun to take his seat among the men. Fortunate young man! His loving father will come home and see him, and he will kiss his father. That is how things should be. Whereas that wife of mine refused me even the satisfaction of setting eyes on my son—she killed me before I could. And now I will give you a piece of advice; take it to heart. Do not sail openly into port when you reach your home-country. Make a secret approach. Women, I tell you, are no longer to be trusted. But can you give me the truth about my son? Have you and your friends heard of him as still alive, in Orchomenus possibly, or sandy Pylos, or maybe with Menelaus in the plains of Sparta? For my good Orestes has not yet died and come below."

'"Son of Atreus," I answered him, "why ask me that? I have no idea whether he is alive or dead. It does no good to utter empty words."

'So we stood there grieving, exchanging joyless words as the tears rolled down our cheeks. And now there came the soul of Peleus' son Achilles, of Patroclus, of the handsome Antilochus, and of Ajax, who in stature and in manly grace was second to none of the Danaans except the handsome son of Peleus. The soul of Achilles, the great runner, recognized me. "Favourite of Zeus, son of Laertes, Odysseus, master of stratagems," he said in mournful tones, "what next, dauntless man? What greater exploit can you plan to surpass your voyage here? How did you dare to come below to Hades' realm, where the dead live on as mindless disembodied ghosts?"

'"Achilles," I answered him, "son of Peleus, far the strongest of the Achaeans, I came to consult with Teiresias in the hope of finding out from him how I could reach rocky Ithaca. For I have not managed to come near Achaea yet, nor set foot on my own island, but have been dogged by misfortune. But you, Achilles, are the most fortunate man that ever was or will be! For in the old days when you were on Earth, we Argives honoured you as though you were a god; and now, down here, you have great power among the dead. Do not grieve at your death, Achilles."

'"And do not you make light of death, illustrious Odysseus," he replied, "I would rather work the soil as a serf on hire to some landless impoverished peasant than be King of all these lifeless dead. Come, give me news of that fine son of mine. Did he follow me to the war to play a leading part or not? And tell me anything you have heard of the noble Peleus. Does the Myrmidon nation still do him homage, or do they dishonour him in Hellas and Phthie because old age has made a cripple of him? For I am not up there in the sunlight to protect him as I once protected the Argives and laid the champions of the enemy low on the broad plains of Troy. If I could return for a single moment to my father's house

as I then was I would make those who forcibly rob him of his position of honour cringe before the might of my unconquerable hands."'

EXPLANATORY NOTE

1. Brought home by Agamemnon as a prize of war.

HOMER

Odysseus Fools the Cyclops

Homer's two epic poems, The Iliad *and* The Odyssey, *are the first works of European literature and the greatest of their kind, but nothing is known about their author. Homer probably lived in the eighth century* B.C.E., *in the eastern Greek world; Smyrna in Asia Minor and the island of Chios, among many others, claimed him. According to tradition, he was blind. In any case, the poems are the product of a long oral tradition that preserved the memory of events in the Bronze Age, four hundred years before the poems were composed. They incorporate many ancient elements and stories, but each is the coherent work of one author who carefully produced a unified epic that also reflects the life of his own time. Whether* The Iliad *and* The Odyssey *are both by the same poet has been argued for more than two thousand years, and the issue is unlikely ever to be resolved. If both are by Homer,* The Iliad *is probably a work of his youth and* The Odyssey *of his old age. But differences of style, treatment, and characterization are striking. There is also a possibility that the poems were altered before they assumed their final form in the sixth century* B.C.E.

Here, Odysseus describes how he tricked and blinded the savage one-eyed Cyclops, who has eaten his men.

'Evening came, and with it the Cyclops, shepherding his plump flocks, every one of which he herded into the broad cave, leaving none out in the walled yard, either because he suspected something or because a god had ordered him to. He lifted the great doorstone, set it in its place, and then sat down to milk his ewes and bleating goats, which he did methodically, giving each mother its young one in due course. When he had efficiently completed all these tasks, he once more snatched two of us and prepared his supper. Then with an olive-wood bowl of my dark wine in my hands, I went up to him and said: "Here, Cyclops, have some wine to wash down that meal of human flesh, and find out for yourself what kind of vintage was stored away in our ship's hold. I brought it for you

as an offering in the hope that you would take pity on me and help me on my homeward way. But your savagery is more than we can bear. Hard-hearted man, how can you expect ever to have a visitor again from the world of men? You have not behaved rightly."

'The Cyclops took the wine and drank it up. And the delicious drink gave him such exquisite pleasure that he asked me for another bowlful. "Give me more, please, and tell me your name, here and now—I would like to make you a gift that will please you. We Cyclopes have wine of our own made from the grapes that our rich soil and rains from Zeus produce. But this vintage of yours is a drop of the real nectar and ambrosia."

'So said the Cyclops, and I handed him another bowlful of the sparkling wine. Three times I filled it for him; and three times the fool drained the bowl to the dregs. At last, when the wine had fuddled his wits, I addressed him with soothing words.

'"Cyclops," I said, "you ask me my name. I'll tell it to you; and in return give me the gift you promised me. My name is Nobody. That is what I am called by my mother and father and by all my friends."

'The Cyclops answered me from his cruel heart. "Of all his company I will eat Nobody last, and the rest before him. That shall be your gift."

'He had hardly spoken before he toppled over and fell face upwards on the floor, where he lay with his great neck twisted to one side, and all-compelling sleep overpowered him. In his drunken stupor he vomited, and a stream of wine mixed with morsels of men's flesh poured from his throat. I went at once and thrust our pole deep under the ashes of the fire to make it hot, and meanwhile gave a word of encouragement to all my men, to make sure that no one would hang back through fear. When the fierce glow from the olive stake warned me that it was about to catch alight in the flames, green as it was, I withdrew it from the fire and my men gathered round. A god now inspired them with tremendous courage. Seizing the olive pole, they drove its sharpened end into the Cyclops' eye, while I used my weight from above to twist it home, like a man boring a ship's timber with a drill which his mates below him twirl with a strap they hold at either end, so that it spins continuously. In much the same way we handled our pole with its red-hot point and twisted it in his eye till the blood boiled up round the burning wood. The scorching heat singed his lids and brow all round, while his eyeball blazed and the very roots crackled in the flame. The Cyclops' eye hissed round the olive stake in the same way that an axe or adze hisses when a smith plunges it into cold water to quench and strengthen the iron. He gave a dreadful shriek, which echoed round the rocky walls, and we backed away from him in terror, while he pulled the stake from his eye,

streaming with blood. Then he hurled it away from him with frenzied hands and raised a great shout to the other Cyclopes who lived in neighbouring caves along the windy heights. Hearing his screams they came up from every quarter, and gathering outside the cave asked him what the matter was.

'"What on earth is wrong with you, Polyphemus? Why must you disturb the peaceful night and spoil our sleep with all this shouting? Is a robber driving off your sheep, or is somebody trying by treachery or violence to kill you?"

'Out of the cave came mighty Polyphemus' voice in reply: "O my friends, it's Nobody's treachery, not violence, that is doing me to death."

'"Well then," came the immediate reply, 'if you are alone and nobody is assaulting you, you must be sick and sickness comes from almighty Zeus and cannot be helped. All you can do is to pray to your father, the Lord Poseidon."

'And off they went, while I laughed to myself at the way in which my cunning *notion*[1] of a false name had taken them in. The Cyclops, still moaning in agonies of pain, groped about with his hands and pushed the rock away from the mouth of the cave. Then he sat himself down in the doorway and stretched out both arms in the hope of catching us in the act of slipping out among the sheep. What a fool he must have thought me! Meanwhile I was cudgelling my brains for the best possible course, trying to hit on some way of saving my friends as well as myself. I thought up plan after plan, scheme after scheme. It was a matter of life or death: we were in mortal peril.

'This was the scheme that eventually seemed best. The rams of the flock were of good stock, thick-fleeced, fine, big animals in their coats of black wool. These I quietly lashed together with the plaited willow twigs which the inhuman monster used for his bed. I took them in threes. The middle one was to carry one of my followers, with its fellows on either side to protect him. Each of my men thus had three rams to bear him. But for myself I chose a full-grown ram who was the pick of the whole flock. Seizing him by the back, I curled myself up under his shaggy belly and lay there upside down, with a firm grip on his wonderful fleece and with patience in my heart. In this way, with sighs and groans, we waited for the blessed Dawn.

'As soon as she arrived, fresh and rosy-fingered, the he-goats and the rams began to scramble out and make for the pastures, but the females, unmilked as they were and with udders full to bursting, stood bleating by the pens. Their master, though tortured and in terrible agony, passed his hands along the backs of all the animals as they stopped in front

of him; but the idiot never noticed that my men were tied under the chests of his own woolly rams. The last of the flock to come up to the doorway was the big ram, burdened by his own fleece and by me with my thoughts racing. As he felt him with his hands the great Polyphemus broke into speech:

"'Sweet ram," he said, "why are you the last of the flock to pass out of the cave like this? You have never before lagged behind the others, but always step so proudly out and are the first of them to crop the lush shoots of the grass, first to make your way to the flowing stream, and first to want to return to the fold when evening falls. Yet today you are the last of all. You must be grieved for your master's eye, blinded by a wicked man and his accursed friends, when he had robbed me of my wits with wine. Nobody was his name; and I swear that he has not yet saved his skin! Ah, if only you could feel as I do and find a voice to tell me where he's hiding from my fury! I'd hammer him and splash his brains all over the floor of the cave, and my heart would find some relief from the suffering which that nothing, that Nobody, has caused me!"

'So he let the ram pass through the entrance and when we had put a little distance between ourselves and the courtyard of the cave, I first let go my ram and then untied my men. Then, quickly, though with many a backward look, we drove our long-striding sheep and goats—a rich, fat flock—right down to the ship. My dear companions were overjoyed when they caught sight of us survivors, but broke into loud lamentations for the others. With nods and frowns I indicated silently that they should stop their weeping and hurry to bundle the fleecy sheep and goats on board and put to sea. So they went on board at once, took their places at the oars, and all together struck the white water with the blades.'

EXPLANATORY NOTE

1. The Greek for 'no one' is *me tis,* but run together as *metis* it means 'wily scheme, resourcefulness'. Odysseus laughs to himself because *metis* (no one/resourcefulness) has foiled the Cyclops. '*Notion*' is an attempt to get the pun.

HOMER

A Faithful Dog

————————

Homer's two epic poems, The Iliad *and* The Odyssey, *are the first works of European literature and the greatest of their kind, but nothing is known about their author. Homer probably lived in the eighth century* B.C.E., *in the eastern Greek world; Smyrna in Asia Minor and the island of Chios, among many others, claimed him. According to tradition, he was blind. In any case, the poems are the product of a long oral tradition that preserved the memory of events in the Bronze Age, four hundred years before the poems were composed. They incorporate many ancient elements and stories, but each is the coherent work of one author who carefully produced a unified epic that also reflects the life of his own time. Whether* The Iliad *and* The Odyssey *are both by the same poet has been argued for more than two thousand years, and the issue is unlikely ever to be resolved. If both are by Homer,* The Iliad *is probably a work of his youth and* The Odyssey *of his old age. But differences of style, treatment, and characterization are striking. There is also a possibility that the poems were altered before they assumed their final form in the sixth century* B.C.E.

This selection shows the homely side of Homer's epic, portraying the devotion of Odysseus's old hunting dog.

————————

As they stood talking, a dog lying there lifted his head and pricked up his ears. Argus was his name. Patient Odysseus himself had owned and bred him, though he had sailed for holy Ilium before he could reap the benefit. In years gone by the young huntsmen had often taken him out after wild goats, deer and hares. But now, in his owner's absence, he lay abandoned on the heaps of dung from the mules and cattle which lay in profusion at the gate, awaiting removal by Odysseus' servants as manure for his great estate. There, full of vermin, lay Argus the hound. But directly he became aware of Odysseus' presence, he wagged his tail and dropped his ears, though he lacked the strength now to come nearer to his master.

Odysseus turned his eyes away, and, making sure Eumaeus did not notice, brushed away a tear, and said:

'Eumaeus, it is extraordinary to see a hound like this lying in the dung. He's a beauty, though I cannot really tell whether his looks were matched by his speed or whether he was just one of those dogs whom their masters feed at table and keep for show.'

Then you, Eumaeus the swineherd, said in reply: 'This dog did have a master, but it's all too plain that he died abroad. If he was now what he was in the heyday of his looks and form, as Odysseus left him when he sailed for Troy, you'd be astonished at his speed and power. No game that he gave chase to could escape him in the deepest depth of the forest. He was a marvel too at picking up the scent. But now he's in a bad way; his master has died far away from home and the women are too thoughtless to look after him. Servants, when their masters are no longer there to order them about, have little will to do their duties as they should. All-seeing Zeus takes half the good out of a man on the day he becomes a slave.'

With this Eumaeus left him, and, entering the stately palace, passed straight into the hall where the haughty Suitors were assembled. As for Argus, the black hand of Death descended on him the moment he caught sight of Odysseus—after twenty years.

HERODOTUS

Thermopylae: Last Stand of the Spartans

Herodotus (c. 490–420 B.C.E.) was born in the Greek city of Halicarnassus in Asia Minor. He is called "the father of history" because he was the first in the western tradition to write a coherent account and explanation of past events. He lived in Athens for a time, then in 444 B.C.E. joined the new Athenian colony of Thurii in southern Italy, where he apparently spent the rest of his life. Herodotus traveled a great deal in Greece, Asia Minor, Egypt, Babylonia, and the Black Sea region. His personal observations and interviews add to the vividness of The Histories, *which describe and explain the wars between Greece and the Persian Empire in the context of all that was known of the world in his time. He wrote them in the 430s B.C.E.*

This selection presents what, for Herodotus, was the moment of greatest glory for the Greeks, when a force of 300 Spartans died fighting in a narrow pass to defend their country against the vast Persian army.

The Greeks at Thermopylae had their first warning of the death that was coming with the dawn from the seer Megistias, who read their doom in the victims of sacrifice; deserters, too, came in during the night with news of the Persian flank movement, and lastly, just as day was breaking, the look-out men came running from the hills. In council of war their opinions were divided, some urging that they must not abandon their post, others the opposite. The result was that the army split: some dispersed, contingents returning to their various cities, while others made ready to stand by Leonidas. It is said that Leonidas himself dismissed them, to spare their lives, but thought it unbecoming for the Spartans under his command to desert the post which they had originally come to guard.[1] I myself am inclined to think that he dismissed them when he realized that they had no heart for the fight and were unwilling to take their share of the danger; at the same time honour forbade that he himself should go. And indeed by remaining at his post he left great glory

behind him, and Sparta did not lose her prosperity, as might otherwise have happened; for right at the outset of the war the Spartans had been told by the Delphic oracle that either their city must be laid waste by the foreigner or a Spartan king be killed. . . .

I believe it was the thought of this oracle, combined with his wish to lay up for the Spartans a treasure of fame in which no other city should share, that made Leonidas dismiss those troops; I do not think that they deserted, or went off without orders, because of a difference of opinion. Moreover, I am strongly supported in this view by the case of the seer Megistias, who was with the army—an Acarnanian, said to be of the clan of Melampus—who foretold the coming doom from his inspection of the sacrificial victims. He quite plainly received orders from Leonidas to quit Thermopylae, to save him from sharing the army's fate. He refused to go, but he sent his only son, who was serving with the forces.

Thus it was that the confederate troops, by Leonidas' orders, abandoned their posts and left the pass, all except the Thespians and the Thebans who remained with the Spartans. The Thebans were detained by Leonidas as hostages very much against their will; but the Thespians of their own accord refused to desert Leonidas and his men, and stayed, and died with them. They were under the command of Demophilus the son of Diadromes.[2]

In the morning Xerxes poured a libation to the rising sun, and then waited until the time when the market-place is filled before he began to move forward. This was according to Ephialtes' instructions, for the way down from the ridge is much shorter and more direct than the long and circuitous ascent. As the Persian army advanced to the assault, the Greeks under Leonidas, knowing that they were going to their deaths, went out into the wider part of the pass much further than they had done before; in the previous days' fighting they had been holding the wall and making sorties from behind it into the narrow neck, but now they fought outside the narrows. Many of the barbarians fell; behind them the company commanders plied their whips indiscriminately, driving the men on. Many fell into the sea and were drowned, and still more were trampled to death by one another. No one could count the number of the dead. The Greeks, who knew that the enemy were on their way round by the mountain track and that death was inevitable, put forth all their strength and fought with fury and desperation. By this time most of their spears were broken, and they were killing Persians with their swords.

In the course of that fight Leonidas fell, having fought most gallantly, and many distinguished Spartans with him—their names I have learned,

as those of men who deserve to be remembered; indeed, I have learned the names of all the three hundred. Amongst the Persian dead, too, were many men of high distinction, including two brothers of Xerxes, Habrocomes and Hyperanthes, sons of Darius by Artanes' daughter Phratagune. Artanes, the son of Hystaspes and grandson of Arsames, was Darius' brother; as Phratagune was his only child, his giving her to Darius was equivalent to giving him his entire estate.

There was a bitter struggle over the body of Leonidas; four times the Greeks drove the enemy off, and at last by their valour rescued it.[3] So it went on, until the troops with Ephialtes were close at hand; and then, when the Greeks knew that they had come, the character of the fighting changed. They withdrew again into the narrow neck of the pass, behind the wall, and took up a position in a single compact body—all except the Thebans—on the little hill at the entrance to the pass, where the stone lion in memory of Leonidas stands today. Here they resisted to the last, with their swords, if they had them, and, if not, with their hands and teeth, until the Persians, coming on from the front over the ruins of the wall and closing in from behind, finally overwhelmed them with missile weapons.

Of all the Spartans and Thespians who fought so valiantly the most signal proof of courage was given by the Spartan Dieneces. It is said that before the battle he was told by a native of Trachis that, when the Persians shot their arrows, there were so many of them that they hid the sun. Dieneces, however, quite unmoved by the thought of the strength of the Persian army, merely remarked: 'This is pleasant news that the stranger from Trachis brings us: if the Persians hide the sun, we shall have our battle in the shade.' He is said to have left on record other sayings, too, of a similar kind, by which he will be remembered. After Dieneces the greatest distinction was won by two Spartan brothers, Alpheus and Maron, the sons of Orsiphantus; and of the Thespians the man to gain the highest glory was a certain Dithyrambus, the son of Harmatides.

The dead were buried where they fell, and with them the men who had been killed before those dismissed by Leonidas left the pass. Over them is this inscription, in honour of the whole force:

Four thousand here from Pelops' land
Against three million once did stand.[4]

The Spartans have a special epitaph; it runs:

Go tell the Spartans, you who read:
We took their orders, and here lie dead.

26

For the seer Megistias there is the following:

Here lies Megistias, who died
When the Mede passed Spercheius' tide.
A prophet; yet he scorned to save
Himself, but shared the Spartans' grave.

EXPLANATORY NOTES

1. On the Spartan prohibition against leaving their post see Demartus' words at ch. 104 [of the source material].
2. Plutarch, ... in one of the few places where he scores a hit against Herodotus, finds fault here for the treatment of the Thebans. Retaining people of doubtful loyalty in such a situation would have weakened Leonidas' position. Herodotus here has fallen for the anti-Theban propaganda that was rife in Athens before and during the Peloponnesian War. Diodorus (XI. 4. 7) says that the Thebans with Leonidas were members 'of the party', i.e. the one that was opposed to Persia. . . .
3. The struggle for the body of Leonidas has epic associations: see the struggle for the body of Patroclus at *Il.* XVII. 274–5.
4. Herodotus's troops from the Peloponnese number 3100 in his army list (ch. 202).

PLATO

Soul, the Prisoner of the Body

———————

Plato of Athens (c. 429–347 B.C.E.) stands with Aristotle as one of the two most important philosophers of Antiquity and as a major shaper of the Western intellectual history as a whole. Descended from a wealthy and aristocratic family, his intellectual outlook was decisively formed by his teacher, Socrates. Socrates' judicial murder at the hands of political opponents helped turn Plato into a critic of democracy and a supporter of aristocracy, in his special sense of the term, that is, rule by the wise and virtuous (or "philosopher-kings"). From Socrates Plato learned a mode of inquiry that consisted of subjecting received opinions to systematic cross-examination ("dialectic"), as well as certain moral doctrines, such as the view that the source of wrongdoing is ignorance, or that the gods' approval or disapproval does not render actions right or wrong. Plato attempted to put his political ideas into practice by serving as counselor to Dionysius II, tyrant of Syracuse, but the young ruler's sporadic enthusiasm for philosophy did not survive political reality, and the two men became estranged. Plato was more successful as the founder of a philosophical school, the Academy, established in a grove dedicated to the hero Academus outside Athens during the early fourth century B.C.E. The school continued for several centuries and was instrumental in preserving Plato's teachings and writings.

Plato's surviving writings are cast in dialogue form to force the reader to make up his or her own mind about the positions and arguments presented. Plato never appears, though students of the dialogues often assume, perhaps correctly, that his point of view is represented by Socrates. Modern scholarship largely agrees in dividing the dialogues into three broad groupings: early, middle, and late. Attempts to coordinate these groupings with known events in Plato's life or with the development of his thought, however, are more controversial.

The Phaedo, *a work of Plato's middle period, is an extended argument for the immortality of the soul, put into the mouth of Socrates, who is depicted in prison, awaiting execution. It is one of Plato's most successful interweavings of literary narrative and philosophical debate. In the present passage, Socrates describes the struggle of reason against the passions and*

appetites of the body, introducing his famous comparison of the body to a
prison for the soul. Only Philosophy can free the prisoner.

Reflections after the similarity argument concerning the fate of those
souls which have and which have not separated themselves from bodily
concerns.

'The truth is much more like this: if at its release the soul is pure and
does not drag along with it any trace of the body, because it has never
willingly associated with it in life; if it has shunned it and isolated itself
because that is what it always practises—I mean doing philosophy in the
right way and really getting used to facing death calmly: wouldn't you
call this "practising death"?'

'Most decidedly.'

'Very well; if this is its condition, then it departs to the place where
things are like itself—invisible, divine, immortal and wise; where, on its
arrival, happiness awaits it, and release from uncertainty and folly, from
fears and gnawing desires, and all other human evils; and where (as they
say of the initiates in the Mysteries) it really spends the rest of time with
divine beings. Shall we adopt this view, Cebes, or some other?'

'This one, by all means,' said Cebes.

'But, I suppose, if at the time of its release the soul is tainted and
impure, because it has always associated with the body and cared for it
and loved it, and has been so beguiled by the body and its passions and
pleasures that nothing seems real to it but those physical things which
can be touched and seen and eaten and drunk and used for sexual enjoy-
ment, making it accustomed to hate and fear and avoid what is invisible
and obscure to our eyes, but intelligible and comprehensible by philoso-
phy—if the soul is in this state, do you think that it will be released just
by itself, uncontaminated?'

'Not in the least,' he said.

'On the contrary, it will, I imagine, be permeated by the corporeal,
which fellowship and intercourse with the body will have ingrained in
its very nature through constant association and long practice.'

'Certainly.'

'And we must suppose, my dear fellow, that the corporeal is heavy,
oppressive, earthly and visible. So the soul which is tainted by its pres-
ence is weighed down and dragged back into the visible world, through
fear (as they say) of Hades or the invisible, and hovers about tombs and

29

graveyards. The shadowy apparitions which have actually been seen there are the ghosts of those souls which have not got clear away, but still retain some portion of the visible; which is why they can be seen.'

'That seems likely enough, Socrates.'

'Yes, it does, Cebes. Of course these are not the souls of the good, but of inferior people, and they are compelled to wander about these places as a punishment for their bad conduct in the past. They continue wandering until at last, through craving for the corporeal, which unceasingly pursues them, they are imprisoned once more in a body. And as you might expect, they are attached to the same sort of character or nature which they have developed during life.'

'What sort do you mean, Socrates?'

'Well, those who have cultivated gluttony or assault or drunkenness, instead of taking pains to avoid them, are likely to assume the form of donkeys and other perverse animals; don't you think so?'

'Yes, that is very likely.'

'And those who have deliberately preferred a life of injustice, suppression, and robbery with violence become wolves and hawks and kites; unless we can suggest any other more likely animals.'

'No, the ones which you mention are exactly right.'

'So it is easy to imagine into what sort of animals all the other kinds of soul will go, in accordance with their conduct during life.'

'Yes, certainly.'

'I suppose that the happiest people, and those who reach the best destination, are the ones who have cultivated the goodness of an ordinary citizen, so-called 'temperance' and 'justice', which is acquired by habit and practice, without the help of philosophy and reason.'

'How are these the happiest?'

'Because they will probably pass into some other kind of social and disciplined creature like bees, wasps and ants; or even back into the human race again, becoming decent citizens.'

'Very likely.'

'But no soul which has not practised philosophy, and is not absolutely pure when it leaves the body, may attain to the divine nature; that is only for the lover of learning. This is the reason, my dear Simmias and Cebes, why true philosophers abstain from all bodily desires and withstand them and do not yield to them. It is not because they are afraid of financial loss or poverty, like the average man who thinks of money first; nor because they shrink from dishonour and a bad reputation, like lovers of prestige and authority.'

'No, those would be unworthy motives, Socrates,' said Cebes.

'They would indeed,' he agreed. 'And so, Cebes, those who care about their souls and do not devote themselves to the body dissociate themselves firmly from these others and refuse to accompany them on their haphazard journey; they believe that it is wrong to oppose philosophy with her offer of liberation and purification, so they turn and follow her wherever she leads.'

'What do you mean, Socrates?'

'I will explain,' he said. 'Every seeker after wisdom knows that up to the time when philosophy takes it over his soul is a helpless prisoner, chained hand and foot in the body, compelled to view reality not directly but only through its prison bars, and wallowing in utter ignorance. And philosophy can see the ingenuity of the imprisonment, which is brought about by the prisoner's own active desire, which makes him first accessory to his own confinement. Well, philosophy takes over the soul in this condition and by gentle persuasion tries to set it free. She points out that observation by means of the eyes and ears and all the other senses abounds with deception, and she urges the soul to refrain from using them unless it is necessary to do so, and encourages it to collect and concentrate itself in isolation, trusting nothing but its own isolated judgement upon realities considered in isolation, and attributing no truth to any other thing which it views through another medium in some other thing; such objects, she knows, are sensible and visible but what she herself sees is intelligible and invisible. Now the soul of the true philosopher feels that it must not reject this opportunity for release, and so it abstains as far as possible from pleasures and desires and griefs, because it reflects that the result of giving way to pleasure, fear, pain, or desire is not as might be supposed the trivial misfortune of becoming ill or wasting money through self-indulgence, but the last and worst calamity of all, which the sufferer does not take into account.'

'What is that, Socrates?' asked Cebes.

'When anyone's soul feels a keen pleasure or pain it cannot help supposing that whatever causes the most violent emotion is the plainest and truest reality; which it is not. It is chiefly visible things that have this effect, isn't it?'

'Quite so.'

'Is it not on this sort of occasion that soul passes most completely into the bondage of body?'

'How is that?'

'Because every pleasure or pain has a sort of rivet with which it fastens the soul to the body and pins it down and makes it corporeal, accepting as true whatever the body certifies. The result of agreeing with the body

31

and finding pleasure in the same things is, I imagine, that it cannot help coming to share its character and its diet, so that it can never get clean away to the unseen world, but is always saturated with the body when it sets out, and so soon falls back again into another body, where it takes root and grows. Consequently it has no share of fellowship with the pure and uniform and divine.'

'Yes, that is perfectly true, Socrates,' said Cebes.

'It is for these reasons, Cebes, that true philosophers exhibit self-control and courage; not for the reasons that most people do. Or do you think it's for the same reasons?'

'No, certainly not.'

'No, indeed. A philosopher's soul will take the view which I have described. It will not first expect to be set free by philosophy, and then allow pleasure and pain to reduce it once more to bondage, thus condemning itself to an endless task, like Penelope, when she worked to undo her own weaving; no, this soul brings calm to the seas of desire by following Reason and abiding always in her company, and by contemplating the true and divine and unambiguous, and drawing inspiration from it; because such a soul believes that this is the right way to live while life endures, and that after death it reaches a place which is kindred and similar to its own nature, and there is rid for ever of human ills. After such a training, my dear Simmias and Cebes, the soul can have no grounds for fearing that on its separation from the body it will be blown away and scattered by the winds, and so disappear into thin air, and cease to exist altogether.'

PLATO

Cosmic Love

Plato of Athens (c. 429–347 B.C.E.) stands with Aristotle as one of the two most important philosophers of Antiquity and as a major shaper of the Western intellectual history as a whole. Descended from a wealthy and aristocratic family, his intellectual outlook was decisively formed by his teacher, Socrates. Socrates' judicial murder at the hands of political opponents helped turn Plato into a critic of democracy and a supporter of aristocracy, in his special sense of the term, that is, rule by the wise and virtuous (or "philosopher-kings"). From Socrates Plato learned a mode of inquiry that consisted of subjecting received opinions to systematic crossexamination ("dialectic"), as well as certain moral doctrines such as the view that the source of wrongdoing is ignorance, or that the gods' approval or disapproval does not render actions right or wrong. Plato attempted to put his political ideas into practice by serving as counselor to Dionysius II, tyrant of Syracuse, but the young ruler's sporadic enthusiasm for philosophy did not survive political reality, and the two men were finally estranged. Plato was more successful as the founder of a philosophical school, the Academy, established in a grove dedicated to the hero Academus outside Athens during the early fourth century B.C.E. The school continued for several centuries and was instrumental in preserving Plato's teachings and writings.

Plato's surviving writings are cast in dialogue form to force the reader to make up his or her own mind about the positions and arguments presented. Plato never appears, though students of the dialogues often assume, perhaps correctly, that his point of view is represented by Socrates. Modern scholarship largely agrees in dividing the dialogues into three broad groupings: early, middle, and late. Attempts to coordinate these groupings with known events in Plato's life or with the development of his thought, however, are more controversial.

In the Symposium, *a dialogue of his middle period, Plato presents a lively Greek dinner party where a series of speakers in turn offer their views on eros, meaning love or desire. They see love as a natural response to beauty, as a motive for social action, a means of ethical education, even as a cosmic force. In the present selection, Socrates relates how the*

prophetess Diotima of Mantinea once explained to him the cosmic genesis of love; the passage is a key source for later treatments of the metaphysical origins of erotic desire, or "Platonic love."

'"Even you, Socrates, could perhaps be initiated in the rites of love I've described so far. But the purpose of these rites, if they are performed correctly, is to reach the final vision of the mysteries; and I'm not sure you could manage this. But I'll tell you about them," she said, "and make every effort in doing so; try to follow, as far as you can.

'"The correct way", she said, "for someone to approach this business is to begin when he's young by being drawn towards beautiful bodies. At first, if his guide leads him correctly, he should love just one body and in that relationship produce beautiful discourses. Next he should realize that the beauty of any one body is closely related to that of another, and that, if he is to pursue beauty of form, it's very foolish not to regard the beauty of all bodies as one and the same. Once he's seen this, he'll become a lover of all beautiful bodies, and will relax his intense passion for just one body, despising this passion and regarding it as petty. After this, he should regard the beauty of minds as more valuable than that of the body, so that, if someone has goodness of mind even if he has little of the bloom of beauty, he will be content with him, and will love and care for him, and give birth to the kinds of discourse that help young men to become better. As a result, he will be forced to observe the beauty in practices and laws and to see that every type of beauty is closely related to every other, so that he will regard beauty of body as something petty. After practices, the guide must lead him towards forms of knowledge, so that he sees their beauty too. Looking now at beauty in general and not just at individual instances, he will no longer be slavishly attached to the beauty of a boy, or of any particular person at all, or of a specific practice. Instead of this low and small-minded slavery, he will be turned towards the great sea of beauty and gazing on it he'll give birth, through a boundless love of knowledge, to many beautiful and magnificent discourses and ideas. At last, when he has been developed and strengthened in this way, he catches sight of one special type of knowledge, whose object is the kind of beauty I shall now describe.

'"Now try", she said, "to concentrate as hard as you can. Anyone who has been educated this far in the ways of love, viewing beautiful things in the right order and way, will now reach the goal of love's ways. He will suddenly catch sight of something amazingly beautiful in its

nature; this, Socrates, is the ultimate objective of all the previous efforts. First, this beauty always *is*, and doesn't come into being or cease; it doesn't increase or diminish. Second, it's not beautiful in one respect but ugly in another, or beautiful at one time but not at another, or beautiful in relation to this but ugly in relation to that; nor beautiful here and ugly there because it is beautiful for some people but ugly for others. Nor will beauty appear to him in the form of a face or hands or any part of the body; or as a specific account or piece of knowledge; or as being anywhere in something else, for instance in a living creature or earth or heaven or anything else. It will appear as in itself and by itself, always single in form; all other beautiful things share its character, but do so in such a way that, when other things come to be or cease, it is not increased or decreased in any way nor does it undergo any change.

' "When someone goes up by these stages, through loving boys in the correct way, and begins to catch sight of that beauty, he has come close to reaching the goal. This is the right method of approaching the ways of love or being led by someone else: beginning from these beautiful things always to go up with the aim of reaching that beauty. Like someone using a staircase, he should go from one to two and from two to all beautiful bodies, and from beautiful bodies to beautiful practices, and from practices to beautiful forms of learning. From forms of learning, he should end up at that form of learning which is of nothing other than *that* beauty itself, so that he can complete the process of learning what beauty really is.

' "In that form of life, my dear Socrates," said the Mantinean stranger, "if in any, human life should be lived, gazing on beauty itself. If you ever saw that, it would seem to be on a different level from gold and clothes and beautiful boys and young men. At present you're so overwhelmed when you see these that you're ready, together with many others, to look at your boyfriends and be with them forever, if that was somehow possible, doing without food and drink and doing nothing but gazing at them and being with them. So what should we imagine it would be like", she said, "if someone could see beauty itself, absolute, pure, unmixed, not cluttered up with human flesh and colours and a great mass of mortal rubbish, but if he could catch sight of divine beauty itself, in its single form? Do you think", she said, "that would be a poor life for a human being, looking in that direction and gazing at that object with the right part of himself and sharing its company? Don't you realize," she said, "that it's only in that kind of life, when someone sees beauty with the part that can see it, that he'll be able to give birth not just to images of virtue (since it's not images he's in touch with), but to true virtue (since

it's true beauty he's in touch with). It's someone who's given birth to true virtue and brought it up who has the chance of becoming loved by the gods, and immortal—if any human being can be immortal."

'Well, Phaedrus and the rest of you, this is what Diotima said, and I was convinced. Because I was convinced, I try to convince others that, to acquire this possession, you couldn't easily find a better partner for human nature than Love. That's the basis for my claiming that every man should hold Love in respect, and I myself respect the ways of love and practise them with exceptional care. That's why I urge others to do the same, and on this and every other occasion I do all I can to praise the power and courage of Love.'

. . .

PLATO

Know Thyself

Plato of Athens (c. 429–347 B.C.E.) stands with Aristotle as one of the two most important philosophers of Antiquity and as a major shaper of the Western intellectual history as a whole. Descended from a wealthy and aristocratic family, his intellectual outlook was decisively formed by his teacher, Socrates. Socrates' judicial murder at the hands of political opponents helped turn Plato into a critic of democracy and a supporter of aristocracy, in his special sense of the term, that is, rule by the wise and virtuous (or "philosopher-kings"). From Socrates Plato learned a mode of inquiry that consisted of subjecting received opinions to systematic cross-examination ("dialectic"), as well as certain moral doctrines such as the view that the source of wrongdoing is ignorance, or that the gods' approval or disapproval does not render actions right or wrong. Plato attempted to put his political ideas into practice by serving as counselor to Dionysius II, tyrant of Syracuse, but the young ruler's sporadic enthusiasm for philosophy did not survive political reality, and the two men became estranged. Plato was more successful as the founder of a philosophical school, the Academy, established in a grove dedicated to the hero Academus outside Athens during the early fourth century B.C.E. The school continued for several centuries and was instrumental in preserving Plato's teachings and writings.

Plato's surviving writings are cast in dialogue form to force the reader to make up his or her own mind about the positions and arguments presented. Plato never appears, though students of the dialogues often assume, perhaps correctly, that his point of view is represented by Socrates. Modern scholarship largely agrees in dividing the dialogues into three broad groupings: early, middle, and late. Attempts to coordinate these groupings with known events in Plato's life or with the development of his thought, however, are more controversial.

The Apology, *a work of Plato's early period, is an idealized reconstruction of the speech given by Socrates in his own defense in the trial before the Athenian people that led eventually to his execution. In the present passage, Socrates describes how he began his philosophical mission in response to an*

utterance of the Delphic Oracle, and learns that he is the wisest of the Greeks because he is aware of his own ignorance.

———————

Here perhaps one of you might interrupt me and say, 'But what is it that you do, Socrates? How is it that you have been misrepresented like this? Surely all this talk and gossip about you would never have arisen if you had confined yourself to ordinary activities, but only if your behaviour was abnormal. Give us the explanation, if you do not want us to draw our own conclusions.' This seems to me to be a reasonable request, and I will try to explain to you what it is that has given me this false notoriety; so please give me your attention. Perhaps some of you will think that I am not being serious; but I assure you that I am going to tell you the whole truth.

I have gained this reputation, gentlemen, from nothing more or less than a kind of wisdom. What kind of wisdom do I mean? Human wisdom, I suppose. It seems that I really am wise in this limited sense. Presumably the geniuses whom I mentioned just now are wise in a wisdom that is more than human—I do not know how else to account for it, because I certainly do not have this knowledge, and anyone who says that I have is lying and just saying it to slander me. Now, gentlemen, please do not interrupt me even if I seem to make an extravagant claim; for what I am going to tell you is not a tale of my own; I am going to refer you to an unimpeachable authority. I shall call as witness to my wisdom (such as it is) the god at Delphi.

You know Chaerephon, I presume. He was a friend of mine from boyhood, and a good democrat who played his part with the rest of you in the recent expulsion and restoration. And you know what he was like; how enthusiastic he was over anything that he had once undertaken. Well, one day he actually went to Delphi and asked this question of the god—as I said before, gentlemen, please do not interrupt—what he asked was whether there was anyone wiser than myself. The Pythian priestess replied that there was no one. As Chaerephon is dead, the evidence for my statement will be supplied by his brother here.

Please consider my object in telling you this. I want to explain to you how the attack on my reputation first started. When I heard about the oracle's answer, I said to myself, 'What is the god saying, and what is his hidden meaning? I am only too conscious that I have no claim to wisdom, great or small; so what can he mean by asserting that I am the wisest man in the world? He cannot be telling a lie; that would not be right for him.'

After puzzling about it for some time, I set myself at last with considerable reluctance to check the truth of it in the following way. I went to interview a man with a high reputation for wisdom, because I felt that here if anywhere I should succeed in disproving the oracle and pointing out to my divine authority, 'You said that I was the wisest of men, but here is a man who is wiser than I am.'

Well, I gave a thorough examination to this person—I need not mention his name, but it was one of our politicians that I was studying when I had this experience—and in conversation with him I formed the impression that although in many people's opinion, and especially in his own, he appeared to be wise, in fact he was not. Then when I began to try to show him that he only thought he was wise and was not really so, my efforts were resented both by him and by many of the other people present. However, I reflected as I walked away: 'Well, I am certainly wiser than this man. It is only too likely that neither of us has any knowledge to boast of; but he thinks that he knows something which he does not know, whereas I am quite conscious of my ignorance. At any rate it seems that I am wiser than he is to this small extent, that I do not think that I know what I do not know.'

After this I went on to interview a man with an even greater reputation for wisdom, and I formed the same impression again; and here too I incurred the resentment of the man himself and a number of others.

From that time on I interviewed one person after another. I realized with distress and alarm that I was making myself unpopular, but I felt compelled to put the god's business first; since I was trying to find out the meaning of the oracle, I was bound to interview everyone who had a reputation for knowledge. And by Dog, gentlemen (for I must be frank with you), my honest impression was thus: it seemed to me, as I pursued my investigation at the god's command, that the people with the greatest reputations were almost entirely deficient, while others who were supposed to be their inferiors were much more noteworthy for their general good sense.

I want you to think of my adventures as a cycle of labours undertaken to establish the truth of the oracle once for all. After I had finished with the politicians I turned to the poets, dramatic, lyric, and all the rest, in the belief that here I should expose myself as a comparative ignoramus. I used to pick up what I thought were some of their most polished works and question them closely about the meaning of what they had written, in the hope of incidentally enlarging my own knowledge. Well, gentlemen, I hesitate to tell you the truth, but it must be told. It is hardly an exaggeration to say that any of the bystanders could have explained

those poems better than their actual authors. So I soon made up my mind about the poets too: I decided that it was not wisdom that enabled them to write their poetry, but a kind of instinct or inspiration, such as you find in seers and prophets who deliver all their sublime messages without knowing in the least what they mean. It seemed clear to me that the poets were in much the same case; and I also observed that the very fact that they were poets made them think that they had a perfect under-standing of all other subjects, of which they were totally ignorant. So I left that line of inquiry too with the same sense of advantage that I had felt in the case of the politicians.

Last of all I turned to the skilled craftsmen. I knew quite well that I had practically no understanding myself, and I was sure that I should find them full of impressive knowledge. In this I was not disappointed; they understood things which I did not, and to that extent they were wiser than I was. However, gentlemen, these professional experts seemed to share the same failing which I had noticed in the poets; I mean that on the strength of their technical proficiency they claimed a perfect understanding of every other subject, however important; and I felt that this error eclipsed their positive wisdom. So I made myself spokesman for the oracle, and asked myself whether I would rather be as I was— neither wise with their wisdom nor ignorant with their ignorance—or possess both qualities as they did. I replied through myself to the oracle that it was best for me to be as I was. . . .

The effect of these investigations of mine, gentlemen, has been to arouse against me a great deal of hostility, and hostility of a particularly bitter and persistent kind, which has resulted in various malicious sugges-tions, and in having that term 'wise' applied to me. This is due to the fact that whenever I succeed in disproving another person's claim to wisdom in a given subject, the bystanders assume that I know everything about that subject myself. But the truth of the matter, gentlemen, is likely to be this: that real wisdom is the property of the god, and this oracle is his way of telling us that human wisdom has little or no value. It seems to me that he is not referring literally to Socrates, but has merely taken my name as an example, as if he would say to us, 'The wisest of you men is he who has realized, like Socrates, that in respect of wisdom he is really worthless.'

That is why I still go about seeking and searching in obedience to the divine command, if I think that anyone is wise, whether citizen or stranger; and when I decide that he is not wise, I try to assist the god by proving that he is not. This occupation has kept me too busy to do much either in politics or in my own affairs; in fact, my service to God has reduced me to extreme poverty.

Furthermore the young men—those with wealthy fathers and plenty of leisure—have of their own accord attached themselves to me because they enjoy hearing other people cross-questioned. These often take me as their model, and go on to try to question other persons; whereupon, I suppose, they find an unlimited number of people who think that they know something, but really know little or nothing. Consequently their victims become annoyed, not with themselves but with me; and they complain that there is a pestilential busybody called Socrates who fills young people's heads with wrong ideas. If you ask them what he does, and what he teaches that has this effect, they have no answer, not knowing what to say; but as they do not want to admit their confusion, they fall back on the stock charges against any seeker after wisdom: that he teaches his pupils about things in the heavens and below the earth, and to disbelieve in gods, and to make the weaker argument defeat the stronger. They would be very loath, I fancy, to admit the truth: which is that they are being convicted of pretending to knowledge when they are entirely ignorant. They were so jealous, I suppose, for their own reputation, and also energetic and numerically strong, and spoke about me with such vigour and persuasiveness, that their harsh criticisms have for a long time now been monopolizing your ears.

PLATO

The Myth of Er

Plato of Athens (c. 429–347 B.C.E.) stands with Aristotle as one of the two most important philosophers of Antiquity and as a major shaper of the Western intellectual history as a whole. Descended from a wealthy and aristocratic family, his intellectual outlook was decisively formed by his teacher, Socrates. Socrates' judicial murder at the instance of political opponents helped turn Plato into a critic of democracy and a supporter of aristocracy, in his special sense of the term, that is, rule by the wise and virtuous (or "philosopher-kings"). From Socrates Plato learned a mode of inquiry that consisted of subjecting received opinions to systematic cross-examination ("dialectic"), as well as certain moral doctrines such as the view that the source of wrongdoing is ignorance, or that the gods' approval or disapproval does not render actions right or wrong. Plato attempted to put his political ideas into practice by serving as counselor to Dionysius II, tyrant of Syracuse, but the young ruler's sporadic enthusiasm for philosophy did not survive political reality, and the two men were finally estranged. Plato was more successful as the founder of a philosophical school, the Academy, which he established in a grove dedicated to the hero Academus outside Athens during the early fourth century B.C.E.; the school continued for several centuries and was instrumental in preserving Plato's teachings and writings. Plato's surviving writings are cast in dialogue form, to force the reader to make up his or her own mind about the positions and arguments presented. Plato himself never appears, though students of the dialogues often assume, perhaps correctly, that his point of view is represented by Socrates. Modern scholarship largely agrees in dividing the dialogues into three broad groupings: early, middle, and late. Attempts to coordinate these groupings with known events in Plato's life or with the development of his thought, however, are more controversial.

The Republic, Plato's most famous dialogue, is considered a work of Plato's mature, or middle period, where his ethical and political beliefs have struck root in more fundamental metaphysical and epistemological convictions. The major question animating the dialogue is the nature of justice. Plato's Socrates defends the view that justice consists in a harmony of soul stemming from a vision of transcendental Good, which in turn provides a standard for rational control of the passions and appetites, leading

to happiness. In this passage from Book X, Plato describes, in the form of a myth, the rewards and punishments of the just and unjust after death, and discusses the responsibility of individuals and the doctrine of the transmigration of souls.

The purpose of the whole argument has been to show that goodness is its own reward, irrespective of consequences. But, now that has been proved, we may add that in fact the good man is rewarded by society in this life.

'And now,' I said, 'I think our argument has fulfilled the conditions you laid down, and, in particular, has avoided mentioning the rewards and reputation which justice brings, as you complained Homer and Hesiod do. We have found that justice is itself the best thing for our true self[1] and that we should act justly whether or not we have Gyges' ring, and a cap of invisibility into the bargain.'

'That's perfectly true.'

'That being so, Glaucon,' I asked, 'can there be any objection if we go on and describe the rewards which justice and excellence of every kind bring at the hands of men and gods, in this life and the next?'

'No objection at all.'

'Then you must give up the concession I made in our argument.'

'What was that?'

'I agreed that the good man should have a reputation for wickedness and the wicked man for goodness; you said that, though it might in fact be impossible for either men or gods to be so deceived, yet you wanted the concession for the purposes of the argument so that we could judge between justice and injustice in themselves, without their consequences. Don't you remember?'

'I can hardly deny it,' he said.

'Then, now that judgement has been given,' I said, 'I want to ask that we should agree to restore Justice her good name with gods and men; she can then gather the rewards gained from appearances and give them to her possessor, just as we have seen her faithfully giving the benefits of the reality to those who really hold to her.'[2]

'That's a fair request.'

'Then will you first grant that neither the just nor the unjust man's character is hidden from the gods?'

'Yes.'

'If so, then, as we agreed at the beginning,[3] they will love one and hate the other.'

'That's true.'

'And the man they love may expect, may he not, all the blessings heaven can give him, except in so far as there is necessary punishment due to him for offences committed in a former life?'

'Yes.'

'So we must assume that, if the just man is poor or ill or suffering from any other apparent misfortune, it is for his ultimate good in this life or the next. For the gods will never neglect the man whose heart is set on justice and who is ready, by pursuing excellence, to become as like god as man is able.'

'If he is like them, they are not likely to neglect him.'

'On the other hand, we must suppose that the reverse of all this is true of the unjust man.'

'Most certainly.'

'These, therefore, are the rewards the just man receives from the gods.'

'I should certainly agree.'

'And what about men?' I asked. 'If the truth be told, isn't it this—that the clever rogue is rather like a runner who does well over the first half of the course, but then flags? He is very quick off the mark, but in the end is humiliated and runs off with his tail between his legs[4] without any prize. The real runner stays the course and carries off the prize in triumph. Isn't the same thing true in general of the just man? In any action, in dealings with others, or in life itself, isn't he the man who in the end gets both the rewards and the good name among his fellows?'

'Yes.'

'Then will you allow me to say about him all that you said about the unjust man? That is, that the just man, when he grows old, will, if he wishes, hold positions of authority in the state, marry whom he likes and marry his children to whom he likes, and so on, as you said of the unjust man. Conversely the unjust man will, in general, even if he gets away with it when he is young, be caught at the end of the course and humiliated; his old age will be miserable, he will be an object of contempt to citizen and foreigner alike, and will be whipped and suffer all those punishments you so rightly called brutal—torture and branding; there is no need for me to repeat them. Will you let me say all this?'

'Yes, you may fairly say it.'

The Good Man's rewards in the life after death. The responsibility of the individual and the doctrine of transmigration. This concluding section of the dialogue is cast in the form of a myth, as is Plato's habit when he

*wishes to convey religious or moral truths for which plain prose is inade-
quate. Much of the detail is borrowed from contemporary sources, proba-
bly Orphic.*

'These, then,' said I, 'are the prizes and rewards and gifts which the just
man receives from gods and men while he is still alive, over and above
those which justice herself brings him.'

'And very sure and splendid they are,' he replied.

'Yet they are nothing in number and magnitude when compared to
the things that await the just man and unjust man after death; you must
hear about these too, so that our discussion may pay in full what it owes
to both of them.'

'There are few things I would hear more gladly.'

'What I have to tell won't be like Odysseus' tale to Alcinous,'[5] I con-
tinued, 'but the story of a brave man, Er, son of Armenius, a native of
Pamphylia. He was killed in battle, and when the dead were taken up on
the tenth day the rest were already decomposing, but he was still quite
sound; he was taken home and was to be buried on the twelfth day, and
was lying on the funeral pyre, when he came to life again and told the
story of what he had seen in the other world. He said that when his soul
left his body it travelled in company with many others till they came to a
wonderfully strange place, where there were, close to each other, two
gaping chasms in the earth, and opposite and above them two other
chasms in the sky. Between the chasms sat Judges, who having delivered
judgment, ordered the just to take the right-hand road that led up
through the sky, and fastened the evidence for the judgment in front of
them, while they ordered the unjust, who also carried the evidence of all
that they had done behind them, to take the left-hand road that led
downwards. When Er came before them, they said that he was to be
messenger to men about the other world, and ordered him to listen to
and watch all that went on in that place. He then saw the souls, when
judgment had been passed on them, departing some by one of the heav-
enly and some by one of the earthly chasms; while by the other two
chasms some souls rose out of the earth, stained with the dust of travel,
and others descended from heaven, pure and clean. And the throng of
souls arriving seemed to have come from a long journey, and turned
aside gladly into the meadow and encamped there as for a festival;
acquaintances exchanged greetings, and those from earth and those from
heaven inquired each other's experiences. And those from earth told
theirs with sorrow and tears, as they recalled all they had suffered and
seen on their underground journey, which lasted a thousand years, while

the others told of the delights of heaven and of the wonderful beauty of what they had seen. It would take a long time to tell you the whole story, Glaucon, but the sum of it is this. For every wrong he has done to any-one a man must pay the penalty in turn, ten times for each, that is to say, once every hundred years, this being reckoned as the span of a man's life. He pays, therefore, tenfold retribution for each crime, and so for instance those who have been responsible for many deaths, by betraying state or army, or have cast others into slavery, or had a hand in any other crime, must pay tenfold in suffering for each offence. And correspond-ingly those who have done good and been just and god-fearing are rewarded in the same proportion. He told me too about infants who died as soon as they were born or who lived only a short time, but what he said is not worth recalling. And he described the even greater penal-ties and rewards of those who had honoured or dishonoured gods or parents or committed murder. For he said that he heard one soul ask another where Ardiaeus the Great was. (This Ardiaeus was the tyrant of a city in Pamphylia some thousand years before, who had killed his old father and elder brother and done many other wicked things, according to the story.) "He has not come, and he never will," was the reply. "For this was one of the terrible things we saw. We were near the mouth of the chasm and about to go up through it after all our sufferings when we suddenly saw him and others, most of them tyrants, though there were a few who had behaved very wickedly in private life, whom the mouth would not receive when they thought they were going to pass through; for whenever anyone incurably wicked like this, or anyone who had not paid the full penalty, tried to pass, it bellowed. There were some fierce and fiery-looking men standing by, who understood the sound, and thereupon seized some and led them away, while others like Ardiaeus they bound hand and foot and neck, flung them down and flayed them, and then impaled them on thorns by the roadside; and they told the passers-by the reason why this was done and said they were to be flung into Tartarus." And Er said that the fear that the voice would sound for them as they went up was the worst of all the many fears they experi-enced; and when they were allowed to pass in silence their joy was great.

'These, then, are the punishments and penalties and the correspon-ding rewards of the other world.'

The paragraph which follows gives, in brief and allusive form, a picture of the structure of the universe, in which the rings on the spindle-whorl are the orbits of the planets and the sphere of the fixed stars. A brief note on the details is given in Appendix II [of this source].

'After seven days spent in the meadow the souls had to set out again on the eighth and came in four days to a place from which they could see a shaft of light stretching from above straight through earth and heaven, like a pillar, closely resembling a rainbow, only brighter and clearer; this they reached after a further day's journey and saw there in the middle of the light stretching from the heaven the ends of the bonds of it;[6] for this light is the bond of heaven and holds its whole circumference together, like the swifter of a trireme. And from these ends hangs the spindle of Necessity, which causes all the orbits to revolve; its shaft and its hook are of adamant, and its whorl a mixture of adamant and other substances. And the whorl is made in the following way. Its shape is like the ones we know; but from the description Er gave me we must suppose it to consist of a large whorl hollowed out, with a second, smaller one fitting exactly into it, the second being hollowed out to hold a third, the third a fourth, and so on up to a total of eight, like a nest of bowls. For there were in all eight whorls, fitting one inside the other, with their rims showing as circles from above and forming the continuous surface of a single whorl round the shaft, which was driven straight through the middle of the eighth. The first and outermost whorl had the broadest rim; next broadest was the sixth, next the fourth, next the eighth, next the seventh, next the fifth, next the third, and last of all the second. And the rim of the largest and outermost was many-coloured, that of the seventh was the brightest, the eighth was illuminated by the seventh, from which it takes its colour, the second and fifth were similar to each other and yellower than the others, the third was the whitest, the fourth reddish and the sixth second in whiteness. The whole spindle revolved with a single motion, but within the movement of the whole the seven inner circles revolved slowly in the opposite direction to that of the whole, and of them the eighth moved fastest, and next fastest the seventh, sixth, and fifth, which moved at the same speed; third in speed was the fourth, moving as it appeared to them with a counter-revolution; fourth was the third, and fifth the second. And the whole spindle turns in the lap of Necessity. And on the top of each circle stands a siren, which is carried round with it and utters a note of constant pitch, and the eight notes together make up a single scale. And round about at equal distances sit three other figures, each on a throne, the three Fates, daughters of Necessity, Lachesis, Clotho, and Atropos; their robes are white and their heads garlanded, and they sing to the sirens' music, Lachesis of things past, Clotho of things present, Atropos of things to come. And Clotho from time to time takes hold of the outermost rim of the spindle and helps to turn it, and in the same way Atropos turns the inner rims with her left

hand, while Lachesis takes inner and outer rims with left and right hand alternately.

'On their arrival the souls had to go straight before Lachesis. And an Interpreter first marshalled them in order and then took from the lap of Lachesis a number of lots and patterns of life and, mounting on a high rostrum, proclaimed: "This is the word of Lachesis, maiden daughter of Necessity. Souls of a day, here you must begin another round of mortal life whose end is death. No Guardian Spirit will be allotted to you; you shall choose your own. And he on whom the lot falls first shall be the first to choose the life which then shall of necessity be his. Excellence knows no master; a man shall have more or less of her according to the value he sets on her. The fault lies not with God, but with the soul that makes the choice." With these words he threw the lots among them, and each picked up that which fell beside him, all except Er himself, who was forbidden to do so. And as each took up his lot he saw what number he had drawn. Then the Interpreter set before them on the ground the different patterns of life, far more in number than the souls who were to choose them. They were of every conceivable kind, animal and human. For there were tyrannies among them, some life-long, some falling in mid-career and ending in poverty, exile and beggary; there were lives of men famed for their good looks and strength and athletic prowess, or for their distinguished birth and family connections, there were lives of men with none of these claims to fame. And there was a similar choice of lives for women. There was no choice of quality of character since of necessity each soul must assume a character appropriate to its choice; but wealth and poverty, health and disease were all mixed in varying degrees in the lives to be chosen.

'Then comes the moment, my dear Glaucon, when everything is at stake. And that is why it should be our first care to abandon all other forms of knowledge, and seek and study that which will show us how to perceive and find the man who will give us the knowledge and ability to tell a good life from a bad one and always choose the better course so far as we can; we must reckon up all that we have said in this discussion of ours, weighing the arguments together and apart to find out how they affect the good life, and see what effects, good or ill, good looks have when accompanied by poverty or wealth or by different dispositions of character, and what again are the effects of the various blends of birth and rank, strength and weakness, cleverness and stupidity, and all other qualities inborn or acquired. If we take all this into account and remember how the soul is constituted, we can choose between the worse life and the better, calling the one that leads us to become more unjust the

worse, and the one that leads us to become more just the better. Everything else we can let go, for we have seen that this is the best choice both for living and dead. This belief we must retain with an iron grip when we enter the other world, so that we may be unmoved there by the temptation of wealth or other evils, and avoid falling into the life of a tyrant or other evil-doer and perpetrating unbearable evil and suffering worse, but may rather know how to choose the middle course, and avoid so far as we can, in this life and the next, the extremes on either hand. For this is the surest way to the highest human happiness.

'But to return. Er told us that the Interpreter then spoke as follows: "Even for the last comer, if he chooses wisely and lives strenuously, there is left a life with which he may be well content. Let him who chooses first look to his choice, and him who chooses last not despair." When he had spoken, the man with the first lot came forward and chose the greatest tyranny he could find. In his folly and greed he chose it without examining it fully, and so did not see that it was his fate to eat his children and suffer other horrors; when he examined it at leisure, he beat his breast and bewailed his choice, ignored the Interpreter's warning, and forgot that his misfortunes were his own fault, blaming fate and heaven and anything but himself. He was one of the souls who had come from heaven, having lived his previous life in a well-governed state, but having owed his goodness to habit and custom and not to philosophy; and indeed, broadly speaking, the majority of those who were caught in this way came from heaven without the discipline of suffering, while those who came from earth had suffered themselves and seen others suffer and were not so hasty in their choice. For this reason and because of the luck of the draw there was a general change of good for evil and evil for good. Yet it is true also that anyone who, during his earthly life, faithfully seeks wisdom and whose lot does not fall among the last may hope, if we may believe Er's tale, not only for happiness in this life but for a journey from this world to the next and back again that will not lie over the stony ground of the underworld but along the smooth road of heaven.

'And to see the souls choosing their lives was indeed a sight, Er said, a sight to move pity and laughter and wonder. For the most part they followed the habits of their former life. And so he saw the soul that had once been Orpheus[7] choose the life of a swan; it was unwilling to be born of a woman because it hated all women after its death at their hands. The soul of Thamyris[8] chose the life of a nightingale, and he saw a swan and other singing birds choose the life of a man. The twentieth soul to choose chose a lion's life; it was the soul of Ajax,[9] son of Telamon, which did not want to become a man, because it remembered the judgment of the arms. It was

followed by Agamemnon,[10] who also because of his sufferings hated humanity and chose to be an eagle. And Atalanta's[11] turn came somewhere about the middle, and when she saw the great honours of an athlete's life she could not resist them and chose it. After her he saw Epeius[12] son of Panopeus, taking on the role of a skilled craftswoman, and right among the last the buffoon Thersites[13] putting on the form of an ape. And it so happened that it fell to the soul of Odysseus to choose last of all. The memory of his former sufferings had cured him of all ambition and he looked round for a long time to find the uneventful life of an ordinary man; at last he found it lying neglected by the others, and when he saw it he chose it with joy and said that had his lot fallen first he would have made the same choice. And there were many other changes from beast to man and beast to beast, the unjust changing into wild animals and the just into tame in every kind of interchange.

'And when all the souls had made their choice they went before Lachesis in the order of their lots, and she allotted to each its chosen Guardian Spirit, to guide it through life and fulfil its choice. And the Guardian Spirit first led it to Clotho, thus ratifying beneath her hand and whirling spindle the lot it had chosen; and after saluting her he led it next to where Atropos spins, so making the threads of its destiny irreversible; and then, without turning back, each soul came before the throne of Necessity and passing before it waited till all the others had done the same, when they proceeded together to the plain of Lethe through a terrible and stifling heat; for the land was without trees or any vegetation.

'In the evening they encamped by the Forgetful River, whose water no pitcher can hold. And all were compelled to drink a certain measure of its water; and those who had no wisdom to save them drank more than the measure. And as each man drank he forgot everything. They then went to sleep and when midnight came there was an earthquake and thunder, and like shooting stars they were all swept suddenly up and away, this way and that, to their birth. Er himself was forbidden to drink, and could not tell by what manner of means he returned to his body; but suddenly he opened his eyes and it was dawn and he was lying on the pyre.

'And so, my dear Glaucon, his tale was preserved from perishing, and, if we remember it, may well preserve us in turn, and we shall cross the river of Lethe safely and shall not defile our souls. This at any rate is my advice, that we should believe the soul to be immortal, capable of enduring all evil and all good, and always keep our feet on the upward way and pursue justice with wisdom. So we shall be at peace with the gods and

with ourselves, both in our life here and when, like the victors in the games collecting their prizes, we receive our reward; and both in this life and in the thousand-year journey which I have described, all will be well with us.'

EXPLANATORY NOTES

1. Lit: 'the soul itself'.
2. I.e. She can reward the reputation for justice as well, as the argument has shown her reward the reality.
3. 352*ab*.
4. The Greek has 'with ears on shoulders', of which, as Shorey notes, the English idiom is the equivalent.
5. *Odyssey*, ix–xii, where Odysseus tells his adventures to Alcinous, king of Phaeacia. Proverbial of a long story. But there is also a play on words: Alcinoos means 'stout-hearted', 'brave', as Er was.
6. Probably of the heaven, but possibly of the light: the Greek is ambiguous.
7. Singer and religious teacher, torn in pieces by Maenads, women followers of Dionysus.
8. Another singer, blinded because he challenged the Muses.
9. After the death of Achilles the Greeks adjudged his arms to Odysseus, in preference to Ajax. Ajax committed suicide in disappointment.
10. Victor of Troy, murdered by his wife Clytemnestra on his return.
11. Arcadian princess and huntress. Her suitors had to race with her and were killed if defeated.
12. Maker of the Trojan horse.
13. From the *Iliad*.

PLATO

The Simile of the Cave

Plato of Athens (c. 429–347 B.C.E.) stands with Aristotle as one of the two most important philosophers of Antiquity and as a major shaper of the Western intellectual history as a whole. Descended from a wealthy and aristocratic family, his intellectual outlook was decisively formed by his teacher, Socrates. Socrates' judicial murder at the instance of political opponents helped turn Plato into a critic of democracy and a supporter of aristocracy, in his special sense of the term, that is, rule by the wise and virtuous (or "philosopher-kings"). From Socrates Plato learned a mode of inquiry that consisted of subjecting received opinions to systematic cross-examination ("dialectic"), as well as certain moral doctrines such as the view that the source of wrongdoing is ignorance, or that the gods' approval or disapproval does not render actions right or wrong. Plato attempted to put his political ideas into practice by serving as counselor to Dionysius II, tyrant of Syracuse, but the young ruler's sporadic enthusiasm for philosophy did not survive political reality, and the two men were finally estranged. Plato was more successful as the founder of a philosophical school, the Academy, which he established in a grove dedicated to the hero Academus outside Athens during the early fourth century B.C.E. The school continued for several centuries and was instrumental in preserving Plato's teachings and writings. Plato's surviving writings are cast in dialogue form, to force the reader to make up his or her own mind about the positions and arguments presented. Plato himself never appears, though students of the dialogues often assume, perhaps correctly, that his point of view is represented by Socrates. Modern scholarship largely agrees in dividing the dialogues into three broad groupings: early, middle, and late. Attempts to coordinate these groupings with known events in Plato's life or with the development of his thought, however, are more controversial.

The Republic, Plato's most famous dialogue, is considered a work of Plato's mature, or middle period, where his ethical and political beliefs have struck root in more fundamental metaphysical and epistemological convictions. The major question animating the dialogue is the nature of justice. Plato's Socrates defends the view that justice consists in a harmony of soul stemming from a vision of transcendental Good, which in turn

*provides a standard for rational control of the passions and appetites, lead-
ing to happiness. In this famous passage from Book VII, Plato illustrated
his metaphysics and epistemology using the famous simile of the Cave,
which shows the obstacles philosophers face in their search for truth, and
emphasizes the obligation philosophers are under to use their knowledge
for the good of the state.*

*This is a more graphic presentation of the truths presented in the analogy
of the Line; in particular, it tells us more about the two states of mind
called in the Line analogy Belief and Illusion. We are shown the ascent of
the mind from illusion to pure philosophy, and the difficulties which
accompany its progress. And the philosopher, when he has achieved the
supreme vision, is required to return to the cave and serve his fellows, his
very unwillingness to do so being his chief qualification.*

*As Cornford pointed out, the best way to understand the simile is to
replace 'the clumsier apparatus' of the cave by the cinema, though today
television is an even better comparison. It is the moral and intellectual
condition of the average man from which Plato starts; and though clearly
the ordinary man knows the difference between substance and shadow in
the physical world, the simile suggests that his moral and intellectual
opinions often bear as little relation to the truth as the average film or tel-
evision programme does to real life.*

'I want you to go on to picture the enlightenment or ignorance of our
human condition somewhat as follows. Imagine an underground cham-
ber like a cave, with a long entrance open to the daylight and as wide as
the cave. In this chamber are men who have been prisoners there since
they were children, their legs and necks being so fastened that they can
only look straight ahead of them and cannot turn their heads. Some way
off, behind and higher up, a fire is burning, and between the fire and the
prisoners and above them runs a road, in front of which a curtain-wall
has been built, like the screen at puppet shows between the operators
and their audience, above which they show their puppets.'

'I see.'

'Imagine further that there are men carrying all sorts of gear along
behind the curtain-wall, projecting above it and including figures of men
and animals made of wood and stone and all sorts of other materials, and
that some of these men, as you would expect, are talking and some not.'

'An odd picture and an odd sort of prisoner.'

'They are drawn from life,'[1] I replied. 'For, tell me, do you think our prisoners could see anything of themselves or their fellows except the shadows thrown by the fire on the wall of the cave opposite them?'

'How could they see anything else if they were prevented from moving their heads all their lives?'

'And would they see anything more of the objects carried along the road?'

'Of course not.'

'Then if they were able to talk to each other, would they not assume that the shadows they saw were the real things?'

'Inevitably.'

'And if the wall of their prison opposite them reflected sound, don't you think that they would suppose, whenever one of the passers-by on the road spoke, that the voice belonged to the shadow passing before them?'

'They would be bound to think so.'

'And so in every way they would believe that the shadows of the objects we mentioned were the whole truth.'[2]

'Yes, inevitably.'

'Then think what would naturally happen to them if they were released from their bonds and cured of their delusions. Suppose one of them were let loose, and suddenly compelled to stand up and turn his head and look and walk towards the fire; all these actions would be painful and he would be too dazzled to see properly the objects of which he used to see the shadows. What do you think he would say if he was told that what he used to see was so much empty nonsense and that he was now nearer reality and seeing more correctly, because he was turned towards objects that were more real, and if on top of that he were compelled to say what each of the passing objects was when it was pointed out to him? Don't you think he would be at a loss, and think that what he used to see was far truer[3] than the objects now being pointed out to him?'

'Yes, far truer.'

'And if he were made to look directly at the light of the fire, it would hurt his eyes and he would turn back and retreat to the things which he could see properly, which he would think really clearer than the things being shown him.'

'Yes.'

'And if,' I went on, 'he were forcibly dragged up the steep and rugged ascent and not let go till he had been dragged out into the sunlight, the process would be a painful one, to which he would much object, and when he emerged into the light his eyes would be so dazzled by the glare

of it that he wouldn't be able to see a single one of the things he was now told were real.'[4]

'Certainly not at first,' he agreed.

'Because, of course, he would need to grow accustomed to the light before he could see things in the upper world outside the cave. First he would find it easiest to look at shadows, next at the reflections of men and other objects in water, and later on at the objects themselves. After that he would find it easier to observe the heavenly bodies and the sky itself at night, and to look at the light of the moon and stars rather than at the sun and its light by day.'

'Of course.'

'The thing he would be able to do last would be to look directly at the sun itself, and gaze at it without using reflections in water or any other medium, but as it is in itself.'

'That must come last.'

'Later on he would come to the conclusion that it is the sun that produces the changing seasons and years and controls everything in the visible world, and is in a sense responsible for everything that he and his fellow-prisoners used to see.'

'That is the conclusion which he would obviously reach.'

'And when he thought of his first home and what passed for wisdom there, and of his fellow-prisoners, don't you think he would congratulate himself on his good fortune and be sorry for them?'

'Very much so.'

'There was probably a certain amount of honour and glory to be won among the prisoners, and prizes for keensightedness for those best able to remember the order of sequence among the passing shadows and so be best able to divine their future appearances. Will our released prisoner hanker after these prizes or envy this power or honour? Won't he be more likely to feel, as Homer says, that he would far rather be "a serf in the house of some landless man",[5] or indeed anything else in the world, than hold the opinions and live the life that they do?'

'Yes,' he replied, 'he would prefer anything to a life like theirs.'

'Then what do you think would happen,' I asked, 'if he went back to sit in his old seat in the cave? Wouldn't his eyes be blinded by the darkness, because he had come in suddenly out of the sunlight?'

'Certainly.'

'And if he had to discriminate between the shadows, in competition with the other prisoners, while he was still blinded and before his eyes got used to the darkness—a process that would take some time—wouldn't he be likely to make a fool of himself? And they would say that his visit

to the upper world had ruined his sight, and that the ascent was not worth even attempting. And if anyone tried to release them and lead them up, they would kill him if they could lay hands on him.'

'They certainly would.'

'Now, my dear Glaucon,' I went on, 'this simile must be connected throughout with what preceded it.[6] The realm revealed by sight corresponds to the prison, and the light of the fire in the prison to the power of the sun. And you won't go wrong if you connect the ascent into the upper world and the sight of the objects there with the upward progress of the mind into the intelligible region. That at any rate is my interpretation, which is what you are anxious to hear; the truth of the matter is, after all, known only to god. But in my opinion, for what it is worth, the final thing to be perceived in the intelligible region, and perceived only with difficulty, is the form of the good; once seen, it is inferred to be responsible for whatever is right and valuable in anything, producing in the visible region light and the source of light, and being in the intelligible region itself controlling source of truth and intelligence. And anyone who is going to act rationally either in public or private life must have sight of it.'

'I agree,' he said, 'so far as I am able to understand you.'

'Then you will perhaps also agree with me that it won't be surprising if those who get so far are unwilling to involve themselves in human affairs, and if their minds long to remain in the realm above. That's what we should expect if our simile holds good again.'

'Yes, that's to be expected.'

'Nor will you think it strange that anyone who descends from contemplation of the divine to human life and its ills should blunder and make a fool of himself, if, while still blinded and unaccustomed to the surrounding darkness, he's forcibly put on trial in the law-courts or elsewhere about the shadows of justice or the figures[7] of which they are shadows, and made to dispute about the notions of them held by men who have never seen justice itself.'

'There's nothing strange in that.'

'But anyone with any sense,' I said, 'will remember that the eyes may be unsighted in two ways, by a transition either from light to darkness or from darkness to light, and will recognize that the same thing applies to the mind. So when he sees a mind confused and unable to see clearly he will not laugh without thinking, but will ask himself whether it has come from a clearer world and is confused by the unaccustomed darkness, or whether it is dazzled by the stronger light of the clearer world to which it has escaped from its previous ignorance. The first condition of life is a reason for congratulation, the second for sympathy, though if one wants

to laugh at it one can do so with less absurdity than at the mind that has descended from the daylight of the upper world.'

'You put it very reasonably.'

'If this is true,' I continued, 'we must reject the conception of education professed by those who say that they can put into the mind knowledge that was not there before—rather as if they could put sight into blind eyes.'

'It is a claim that is certainly made,' he said.

'But our argument indicates that the capacity for knowledge is innate in each man's mind, and that the organ by which he learns is like an eye which cannot be turned from darkness to light unless the whole body is turned; in the same way the mind as a whole must be turned away from the world of change until its eye can bear to look straight at reality, and at the brightest of all realities which is what we call the good. Isn't that so?'

'Yes.'

'Then this turning around of the mind itself might be made a subject of professional skill,[8] which would effect the conversion as easily and effectively as possible. It would not be concerned to implant sight, but to ensure that someone who had it already was not either turned in the wrong direction or looking the wrong way.'

'That may well be so.'

'The rest, therefore, of what are commonly called excellences[9] of the mind perhaps resemble those of the body, in that they are not in fact innate, but are implanted by subsequent training and practice; but knowledge, it seems, must surely have a diviner quality, something which never loses its power, but whose effects are useful and salutary or again useless and harmful according to the direction in which it is turned. Have you never noticed how shrewd is the glance of the type of men commonly called bad but clever? They have small minds, but their sight is sharp and piercing enough in matters that concern them; it's not that their sight is weak, but that they are forced to serve evil, so that the keener their sight the more effective that evil is.'

'That's true.'

'But suppose,' I said, 'that such natures were cut loose, when they were still children, from all the dead weights natural to this world of change and fastened on them by sensual indulgences like gluttony, which twist their minds' vision to lower things, and suppose that when so freed they were turned towards the truth, then this same part of these same individuals would have as keen a vision of truth as it has of the objects on which it is at present turned.'

'Very likely.'

'And is it not also likely, and indeed a necessary consequence of what we have said, that society will never be properly governed either by the uneducated, who have no knowledge of the truth, or by those who are allowed to spend all their lives in purely intellectual pursuits? The uneducated have no single aim in life to which all their actions, public and private, are to be directed; the intellectuals will take no practical action of their own accord, fancying themselves to be out of this world in some kind of earthly paradise.'

'True.'

'Then our job as lawgivers is to compel the best minds to attain what we have called the highest form of knowledge, and to ascend to the vision of the good as we have described, and when they have achieved this and see well enough, prevent them behaving as they are now allowed to.'

'What do you mean by that?'

'Remaining in the upper world, and refusing to return again to the prisoners in the cave below and share their labours and rewards, whether trivial or serious.'

'But surely,' he protested, 'that will not be fair. We shall be compelling them to live a poorer life than they might live.'

'The object of our legislation,' I reminded him again, 'is not the special welfare of any particular class in our society, but of the society as a whole;[10] and it uses persuasion or compulsion to unite all citizens and make them share together the benefits which each individually can confer on the community; and its purpose in fostering this attitude is not to leave everyone to please himself, but to make each man a link in the unity of the whole.'

'You are right; I had forgotten,' he said.

'You see, then, Glaucon,' I went on, 'we shan't be unfair to our philosophers, but shall be quite fair in what we say when we compel them to have some care and responsibility for others. We shall tell them that philosophers born in other states can reasonably refuse to take part in the hard work of politics; for society produces them quite involuntarily and unintentionally, and it is only just that anything that grows up on its own should feel it has nothing to repay for an upbringing which it owes to no one. "But," we shall say, "we have bred you both for your own sake and that of the whole community to act as leaders and king-bees in a hive; you are better and more fully educated than the rest and better qualified to combine the practice of philosophy and politics. You must therefore each descend in turn and live with your fellows in the cave and get used to seeing in the dark; once you get used to it you will see a thousand times better than they do and will distinguish the various shadows, and know what they are

shadows of, because you have seen the truth about things admirable and just and good. And so our state and yours will be really awake, and not merely dreaming like most societies today, with their shadow battles and their struggles for political power, which they treat as some great prize. The truth is quite different: the state whose prospective rulers come to their duties with least enthusiasm is bound to have the best and most tranquil government, and the state whose rulers are eager to rule the worst."[11]

'I quite agree.'

'Then will our pupils, when they hear what we say, dissent and refuse to take their share of the hard work of government, even though spending the greater part of their time together in the pure air above?'

'They cannot refuse, for we are making a just demand of just men. But of course, unlike present rulers, they will approach the business of government as an unavoidable necessity.'

'Yes, of course,' I agreed. 'The truth is that if you want a well-governed state to be possible, you must find for your future rulers some way of life they like better than government; for only then will you have government by the truly rich, those, that is, whose riches consist not of gold, but of the true happiness of a good and rational life. If you get, in public affairs, men whose life is impoverished and destitute of personal satisfactions, but who hope to snatch some compensation for their own inadequacy from a political career, there can never be good government. They start fighting for power, and the consequent internal and domestic conflicts ruin both them and society.'

'True indeed.'

'Is there any life except that of true philosophy which looks down on positions of political power?'

'None whatever.'

'But what we need is that the only men to get power should be men who do not love it, otherwise we shall have rivals' quarrels.'

'That is certain.'

'Who else, then, will you compel to undertake the responsibilities of Guardians of our state, if it is not to be those who know most about the principles of good government and who have other rewards and a better life than the politician's?'

'There is no one else.'

EXPLANATORY NOTES

1. Lit: 'like us'. How 'like' has been a matter of controversy. Plato can hardly have meant that the ordinary man cannot distinguish between shadows and

real things. But he does seem to be saying, with a touch of caricature (we must not take him too solemnly), that the ordinary man is often very uncritical in his beliefs, which are little more than a 'careless acceptance of appearances' (Crombie).

2. Lit: 'regard nothing else as true but the shadows'. The Greek word *alēthēs* (true) carries an implication of genuineness, and some translators render it here as 'real'.

3. Or 'more real'.

4. Or 'true', 'genuine'.

5. *Odyssey*, xi, 489.

6. I.e. the similes of the Sun and the Line. The detailed relations between the three similes have been much disputed, as has the meaning of the word here translated 'connected'. Some interpret it to mean a detailed correspondence ('every feature ... is meant to fit'—Cornford), others to mean, more loosely, 'attached' or 'linked to'. That Plato intended some degree of 'connection' between the three similes cannot be in doubt in view of the sentences which follow. But we should remember that they are similes, not scientific descriptions, and it would be a mistake to try to find too much detailed precision. Plato has just spoken of the prisoners getting their hands' on their returned fellow and killing him. How could they do that if fettered as described at the opening of the simile? But Socrates was executed, so of course they must.

This translation assumes the following main correspondences:

Tied prisoner in the cave	Illusion
Freed prisoner in the cave	Belief
Looking at shadows and reflections in the world outside the cave and the ascent thereto	Reason
Looking at real things in the world outside the cave	Intelligence
Looking at the sun	Vision of the form of the good.

7. Cf. 514*b–c.*

8. *Technē.*

9. *Aretē.*

10. Cf. 420*b* and 466*a.*

11. Socrates takes up here a point made to Thrasymachus at 347*b.*

ANONYMOUS

The Hippocratic Oath

*The collection of medical works that goes under the name "Hippocratic
writings" consists of some sixty treatises dealing with subjects such as
pathology, diagnosis and prognosis, the preservation of health, treatment of
diseases, physiology, and medical ethics. Mainly dating from the period 430
to 330 B.C.E., these treatises exhibit a wide variety of styles, differing in
genre from the textbook to the practical manual to collections of fragments
and miscellaneous material. In most cases it is impossible to establish their
authorship (all the works are anonymous), and indeed the corpus reflects
conflicting approaches and viewpoints. This indicates that the works are not
attributable to a single author and can be associated only loosely with the
name of Hippocrates, who was probably born around 460 B.C.E. in the
island of Cos and became known as the most famous doctor of classical
Antiquity.*

*Problems with the works' authorship were, however, no obstacle to
their influence. Through them, Hippocrates came to be seen as the origina-
tor, for example, of the physiological theory of the interaction between the
four primary opposites (hot, cold, dry, and wet) and the primary simple ele-
ments (earth, air, fire and water). Indeed, in many cases he was seen as the
founder of the art of medicine itself. At times Hippocrates' influence was
overshadowed by that of Galen (second century C.E.), but when the latter's
star began to wane in the sixteenth century, the reputation of Hippocrates
continued and even grew. In particular, Hippocrates was admired both for
the preciseness of his clinical observations and for his emphasis on a proper
ethical relationship between doctor and patient. The Hippocratic writings
not only shed light on the early development of medicine, but discuss issues
of medical ethics that are still relevant today. These qualities make this
body of texts of continuing interest, even after all the modern advances in
the field of medicine.*

*To understand the Hippocratic writings it is necessary to keep in mind
the context in which they were composed. There was no system, in the
ancient world, for the licensing of doctors, nor did doctors have a monopoly
on the treatment of the sick. Indeed, doctors faced competition from
herbalists, sellers of charms and drugs, midwives, magicians, and plain*

quacks. Furthermore, given that there was no knowledge of the micro-organic causes of disease, medicine was as much a matter of speculation and hit-and-miss experience as of scientific knowledge. All of this helps explain the attempts to emphasize the scientific character of the discipline and the caution physicians exercised to prevent their art from being brought into disrepute. It must be said that, even though the medical theories of the time were wrong on many points, they were at least supported by a general theory of how the human body works and by a sincere desire to help patients, or at least to avoid making their conditions worse.

The present selection reports the so-called "Hippocratic Oath," taken even today in the United States (in modified form) by medical doctors entering the profession. Although scholars are not agreed as to who exactly took this oath in the ancient world and whether or not its rules were representative of ancient doctors' ideals in general, the document points to a developing professional sense among certain physicians and to a dedication to a common set of ethical principles. As will be seen, euthanasia and abortion were issues in that time as well, and doctors were well aware that their professional status gave them the opportunity to abuse their position and mishandle their patients.

THE OATH

I swear by Apollo the healer, by Aesculapius, by Health and all the powers of healing, and call to witness all the gods and goddesses that I may keep this Oath and Promise to the best of my ability and judgement.

I will pay the same respect to my master in the Science as to my parents and share my life with him and pay all my debts to him. I will regard his sons as my brothers and teach them the Science, if they desire to learn it, without fee or contract. I will hand on precepts, lectures and all other learning to my sons, to those of my master and to those pupils duly apprenticed and sworn, and to none other.

I will use my power to help the sick to the best of my ability and judgement; I will abstain from harming or wronging any man by it.

I will not give a fatal draught to anyone if I am asked, nor will I suggest any such thing. Neither will I give a woman means to procure an abortion.

I will be chaste and religious in my life and in my practice.

I will not cut, even for the stone, but I will leave such procedures to the practitioners of that craft.

Whenever I go into a house, I will go to help the sick and never with the intention of doing harm or injury. I will not abuse my position to

indulge in sexual contacts with the bodies of women or of men, whether they be freemen or slaves.

Whatever I see or hear, professionally or privately, which ought not to be divulged, I will keep secret and tell no one.

If, therefore, I observe this Oath and do not violate it, may I prosper both in my life and in my profession, earning good repute among all men for all time. If I transgress and forswear this Oath, may my lot be otherwise.

THUCYDIDES

Pericles' Funeral Oration

Thucydides' incomplete History of the Peloponnesian War *(431–404 B.C.E.), the greatest work of history surviving from the ancient world, depicts a mighty struggle between a federation of democratic city-states led by Athens and a federation of oligarchies headed by Sparta. Little is known of the author's life. He was an Athenian of the upper classes, born sometime between 460 and 455 B.C.E., who served as a general of the Athenian forces in 424 B.C.E., and was a devoted follower of the great Athenian politician Pericles. Thucydides tells his readers that he began to write his history soon after the beginning of the Peloponnesian war, so that it has much of the character of an eyewitness account, but internal evidence shows that he must have continued to revise his work down to the end of his life, around 400 B.C.E.*

After an introductory book, the work divides into four sections: an account of the Ten Years War (431–421 B.C.E., Books 2 to 5.24), the interwar period (421–415 B.C.E., Book 5.25–116), the Sicilian Expedition (415–413 B.C.E., Books 6 and 7), and the so-called Decelian War (413–411 B.C.E., Book 8). These twenty years, in Thucydides' telling, describe an arc of political and moral decline for Athens, ending with her disastrous defeat in Sicily and the temporary triumph of oligarchic forces inside Athens herself. Such a story would seem to offer numerous opportunities for moralistic comment and patriotic bluster, but Thucydides resisted these temptations. His passion was constrained by a determination to be as truthful as possible, with a view to contributing to the scientific study of man. He was less interested in assigning blame than in understanding the workings of power and human nature. Such an understanding, he believed, was the true purpose of history, and its achievement in Thucydides' great book was the basis of his claim that his work would be "a possession for all time." The most famous passage in Thucydides' history is the funeral oration in Book 2 that he put in the mouth of Pericles, who describes movingly the ideals of Athenian democracy.

"Pericles' Funeral Oration," from Book 2 of *Thucydides: History of the Peloponnesian War,* translated by Rex Warner, translation copyright © 1954 by Rex Warner, 143–151. Reprinted by permission of Penguin Books Ltd.

PERICLES' FUNERAL ORATION

In the same winter the Athenians, following their annual custom, gave a public funeral for those who had been the first to die in the war. These funerals are held in the following way: two days before the ceremony the bones of the fallen are brought and put in a tent which has been erected, and people make whatever offerings they wish to their own dead. Then there is a funeral procession in which coffins of cypress wood are carried on wagons. There is one coffin for each tribe, which contains the bones of members of that tribe. One empty bier is decorated and carried in the procession: this is for the missing, whose bodies could not be recovered. Everyone who wishes to, both citizens and foreigners, can join in the procession, and the women who are related to the dead are there to make their laments at the tomb. The bones are laid in the public burial-place, which is in the most beautiful quarter outside the city walls. Here the Athenians always bury those who have fallen in war. The only exception is those who died at Marathon, who, because their achievement was considered absolutely outstanding, were buried on the battlefield itself.

When the bones have been laid in the earth, a man chosen by the city for his intellectual gifts and for his general reputation makes an appropriate speech in praise of the dead, and after the speech all depart. This is the procedure at these burials, and all through the war, when the time came to do so, the Athenians followed this ancient custom. Now, at the burial of those who were the first to fall in the war Pericles, the son of Xanthippus, was chosen to make the speech. When the moment arrived, he came forward from the tomb and, standing on a high platform, so that he might be heard by as many people as possible in the crowd, he spoke as follows:

'Many of those who have spoken here in the past have praised the institution of this speech at the close of our ceremony. It seemed to them a mark of honour to our soldiers who have fallen in war that a speech should be made over them. I do not agree. These men have shown themselves valiant in action, and it would be enough, I think, for their glories to be proclaimed in action, as you have just seen it done at this funeral organized by the state. Our belief in the courage and manliness of so many should not be hazarded on the goodness or badness of one man's speech. Then it is not easy to speak with a proper sense of balance, when a man's listeners find it difficult to believe in the truth of what one is saying. The man who knows the facts and loves the dead may well think that an oration tells less than what he knows and what he would like to hear: others who do not know so much may feel envy for the dead, and

think the orator over-praises them, when he speaks of exploits that are beyond their own capacities. Praise of other people is tolerable only up to a certain point, the point where one still believes that one could do oneself some of the things one is hearing about. Once you get beyond this point, you will find people becoming jealous and incredulous. However, the fact is that this institution was set up and approved by our fore-fathers, and it is my duty to follow the tradition and do my best to meet the wishes and the expectations of every one of you.

'I shall begin by speaking about our ancestors, since it is only right and proper on such an occasion to pay them the honour of recalling what they did. In this land of ours there have always been the same people living from generation to generation up till now, and they, by their courage and their virtues, have handed it on to us, a free country. They certainly deserve our praise. Even more so do our fathers deserve it. For to the inheritance they had received they added all the empire we have now, and it was not without blood and toil that they handed it down to us of the present generation. And then we ourselves, assembled here today, who are mostly in the prime of life, have, in most directions, added to the power of our empire and have organized our State in such a way that it is perfectly well able to look after itself both in peace and in war.

'I have no wish to make a long speech on subjects familiar to you all: so I shall say nothing about the warlike deeds by which we acquired our power or the battles in which we or our fathers gallantly resisted our enemies, Greek or foreign. What I want to do is, in the first place, to discuss the spirit in which we faced our trials and also our constitution and the way of life which has made us great. After that I shall speak in praise of the dead, believing that this kind of speech is not inappropriate to the present occasion, and that this whole assembly, of citizens and foreigners, may listen to it with advantage.

'Let me say that our system of government does not copy the institutions of our neighbours. It is more the case of our being a model to others, than of our imitating anyone else. Our constitution is called a democracy because power is in the hands not of a minority but of the whole people. When it is a question of settling private disputes, everyone is equal before the law; when it is a question of putting one person before another in positions of public responsibility, what counts is not membership of a particular class, but the actual ability which the man possesses. No one, so long as he has it in him to be of service to the state, is kept in political obscurity because of poverty. And, just as our political life is free and open, so is our day-to-day life in our relations with each

other. We do not get into a state with our next-door neighbour if he enjoys himself in his own way, nor do we give him the kind of black looks which, though they do no real harm, still do hurt people's feelings. We are free and tolerant in our private lives; but in public affairs we keep to the law. This is because it commands our deep respect.

'We give our obedience to those whom we put in positions of authority, and we obey the laws themselves, especially those which are for the protection of the oppressed, and those unwritten laws which it is an acknowledged shame to break.

'And here is another point. When our work is over, we are in a position to enjoy all kinds of recreation for our spirits. There are various kinds of contests and sacrifices regularly throughout the year; in our own homes we find a beauty and a good taste which delight us every day and which drive away our cares. Then the greatness of our city brings it about that all the good things from all over the world flow in to us, so that to us it seems just as natural to enjoy foreign goods as our own local products.

'Then there is a great difference between us and our opponents, in our attitude towards military security. Here are some examples: Our city is open to the world, and we have no periodical deportations in order to prevent people observing or finding out secrets which might be of military advantage to the enemy. This is because we rely, not on secret weapons, but on our own real courage and loyalty. There is a difference, too, in our educational systems. The Spartans, from their earliest boyhood, are submitted to the most laborious training in courage; we pass our lives without all these restrictions, and yet are just as ready to face the same dangers as they are. Here is a proof of this: When the Spartans invade our land, they do not come by themselves, but bring all their allies with them; whereas we, when we launch an attack abroad, do the job by ourselves, and, though fighting on foreign soil, do not often fail to defeat opponents who are fighting for their own hearths and homes. As a matter of fact none of our enemies has ever yet been confronted with our total strength, because we have to divide our attention between our navy and the many missions on which our troops are sent on land. Yet, if our enemies engage a detachment of our forces and defeat it, they give themselves credit for having thrown back our entire army; or, if they lose, they claim that they were beaten by us in full strength. There are certain advantages, I think, in our way of meeting danger voluntarily, with an easy mind, instead of with a laborious training, with natural rather than with state-induced courage. We do not have to spend our time practising to meet sufferings which are still in the future; and when

they are actually upon us we show ourselves just as brave as these others who are always in strict training. This is one point in which, I think, our city deserves to be admired. There are also others:

'Our love of what is beautiful does not lead to extravagance; our love of the things of the mind does not make us soft. We regard wealth as something to be properly used, rather than as something to boast about. As for poverty, no one need be ashamed to admit it: the real shame is in not taking practical measures to escape from it. Here each individual is interested not only in his own affairs but in the affairs of the state as well: even those who are mostly occupied with their own business are extremely well-informed on general politics—this is a peculiarity of ours: we do not say that a man who takes no interest in politics is a man who minds his own business; we say that he has no business here at all. We Athenians, in our own persons, take our decisions on policy or submit them to proper discussions: for we do not think that there is an incompatibility between words and deeds; the worst thing is to rush into action before the consequences have been properly debated. And this is another point where we differ from other people. We are capable at the same time of taking risks and of estimating them beforehand. Others are brave out of ignorance; and, when they stop to think, they begin to fear. But the man who can most truly be accounted brave is he who best knows the meaning of what is sweet in life and of what is terrible, and then goes out undeterred to meet what is to come.

'Again, in questions of general good feeling there is a great contrast between us and most other people. We make friends by doing good to others, not by receiving good from them. This makes our friendship all the more reliable, since we want to keep alive the gratitude of those who are in our debt by showing continued goodwill to them: whereas the feelings of one who owes us something lack the same enthusiasm, since he knows that, when he repays our kindness, it will be more like paying back a debt than giving something spontaneously. We are unique in this. When we do kindnesses to others, we do not do them out of any calculations of profit or loss: we do them without afterthought, relying on our free liberality. Taking everything together then, I declare that our city is an education to Greece, and I declare that in my opinion each single one of our citizens, in all the manifold aspects of life, is able to show himself the rightful lord and owner of his own person, and do this, moreover, with exceptional grace and exceptional versatility. And to show that this is no empty boasting for the present occasion, but real tangible fact, you have only to consider the power which our city possesses and which has been won by those very qualities which I have mentioned. Athens, alone

of the states we know, comes to her testing time in a greatness that surpasses what was imagined of her. In her case, and in her case alone, no invading enemy is ashamed at being defeated, and no subject can complain of being governed by people unfit for their responsibilities. Mighty indeed are the marks and monuments of our empire which we have left. Future ages will wonder at us, as the present age wonders at us now. We do not need the praises of a Homer, or of anyone else whose words may delight us for the moment, but whose estimation of facts will fall short of what is really true. For our adventurous spirit has forced an entry into every sea and into every land; and everywhere we have left behind us everlasting memorials of good done to our friends or suffering inflicted on our enemies.

'This, then, is the kind of city for which these men, who could not bear the thought of losing her, nobly fought and nobly died. It is only natural that every one of us who survive them should be willing to undergo hardships in her service. And it was for this reason that I have spoken at such length about our city, because I wanted to make it clear that for us there is more at stake than there is for others who lack our advantages; also I wanted my words of praise for the dead to be set in the bright light of evidence. And now the most important of these words has been spoken. I have sung the praises of our city; but it was the courage and gallantry of these men, and of people like them, which made her splendid. Nor would you find it true in the case of many of the Greeks, as it is true of them, that no words can do more than justice to their deeds.

'To me it seems that the consummation which has overtaken these men shows us the meaning of manliness in its first revelation and in its final proof. Some of them, no doubt, had their faults; but what we ought to remember first is their gallant conduct against the enemy in defence of their native land. They have blotted out evil with good, and done more service to the commonwealth than they ever did harm in their private lives. No one of these men weakened because he wanted to go on enjoying his wealth: no one put off the awful day in the hope that he might live to escape his poverty and grow rich. More to be desired than such things, they chose to check the enemy's pride. This, to them, was a risk most glorious, and they accepted it, willing to strike down the enemy and relinquish everything else. As for success or failure, they left that in the doubtful hands of Hope, and when the reality of battle was before their faces, they put their trust in their own selves. In the fighting, they thought it more honourable to stand their ground and suffer death than to give in and save their lives. So they fled from the reproaches of men,

abiding with life and limb the brunt of battle; and, in a small moment of time, the climax of their lives, a culmination of glory, not of fear, were swept away from us.

'So and such they were, these men worthy of their city. We who remain behind may hope to be spared their fate, but must resolve to keep the same daring spirit against the foe. It is not simply a question of estimating the advantages in theory. I could tell you a long story (and you know it as well as I do) about what is to be gained by beating the enemy back. What I would prefer is that you should fix your eyes every day on the greatness of Athens as she really is, and should fall in love with her. When you realize her greatness, then reflect that what made her great was men with a spirit of adventure, men who knew their duty, men who were ashamed to fall below a certain standard. If they ever failed in an enterprise, they made up their minds that at any rate the city should not find their courage lacking to her, and they gave to her the best contribution that they could. They gave her their lives, to her and to all of us, and for their own selves they won praises that never grow old, the most splendid of sepulchres—not the sepulchre in which their bodies are laid, but where their glory remains eternal in men's minds, always there on the right occasion to stir others to speech or to action. For famous men have the whole earth as their memorial: it is not only the inscriptions on their graves in their own country that mark them out; no, in foreign lands also, not in any visible form but in people's hearts, their memory abides and grows. It is for you to try to be like them. Make up your minds that happiness depends on being free, and freedom depends on being courageous. Let there be no relaxation in face of the perils of the war. The people who have most excuse for despising death are not the wretched and unfortunate, who have no hope of doing well for themselves, but those who run the risk of a complete reversal in their lives, and who would feel the difference most intensely, if things went wrong for them. Any intelligent man would find a humiliation caused by his own slackness more painful to bear than death, when death comes to him unperceived, in battle, and in the confidence of his patriotism.

'For these reasons I shall not commiserate with those parents of the dead, who are present here. Instead I shall try to comfort them. They are well aware that they have grown up in a world where there are many changes and chances. But this is good fortune—for men to end their lives with honour, as these have done, and for you honourably to lament them: their life was set to a measure where death and happiness went hand in hand. I know that it is difficult to convince you of this. When you see other people happy you will often be reminded of what used to

make you happy too. One does not feel sad at not having some good thing which is outside one's experience: real grief is felt at the loss of something which one is used to. All the same, those of you who are of the right age must bear up and take comfort in the thought of having more children. In your own homes these new children will prevent you from brooding over those who are no more, and they will be a help to the city, too, both in filling the empty places, and in assuring her security. For it is impossible for a man to put forward fair and honest views about our affairs if he has not, like everyone else, children whose lives may be at stake. As for those of you who are now too old to have children, I would ask you to count as gain the greater part of your life, in which you have been happy, and remember that what remains is not long, and let your hearts be lifted up at the thought of the fair fame of the dead. One's sense of honour is the only thing that does not grow old, and the last pleasure, when one is worn out with age, is not, as the poet said, making money, but having the respect of one's fellow men.

'As for those of you here who are sons or brothers of the dead, I can see a hard struggle in front of you. Everyone always speaks well of the dead, and, even if you rise to the greatest heights of heroism, it will be a hard thing for you to get the reputation of having come near, let alone equalled, their standard. When one is alive, one is always liable to the jealousy of one's competitors, but when one is out of the way, the honour one receives is sincere and unchallenged.

'Perhaps I should say a word or two on the duties of women to those among you who are now widowed. I can say all I have to say in a short word of advice. Your great glory is not to be inferior to what God has made you, and the greatest glory of a woman is to be least talked about by men, whether they are praising you or criticizing you. I have now, as the law demanded, said what I had to say. For the time being our offerings to the dead have been made, and for the future their children will be supported at the public expense by the city, until they come of age. This is the crown and prize which she offers, both to the dead and to their children, for the ordeals which they have faced. Where the rewards of valour are the greatest, there you will find also the best and bravest spirits among the people. And now, when you have mourned for your dear ones, you must depart.'

THUCYDIDES

Pericles' Last Speech

Thucydides' incomplete History of the Peloponnesian War *(431–404 B.C.E.), the greatest work of history surviving from the ancient world, depicts a mighty struggle between a federation of democratic city-states led by Athens and a federation of oligarchies headed by Sparta. Little is known of the author's life. He was an Athenian of the upper classes, born sometime between 460 and 455 B.C.E., who served as a general of the Athenian forces in 424 B.C.E., and was a devoted follower of the great Athenian politician Pericles. Thucydides tells his readers that he began to write his history soon after the beginning of the Peloponnesian war, so that it has much of the character of an eyewitness account, but internal evidence shows that he must have continued to revise his work down to the end of his life, around 400 B.C.E.*

After an introductory book, the work divides into four sections: an account of the Ten Years War (431–421 B.C.E., Books 2 to 5.24), the interwar period (421–415 B.C.E., Book 5.25–116), the Sicilian Expedition (415–413 B.C.E., Books 6 and 7), and the so-called Decelian War (413–411 B.C.E., Book 8). These twenty years, in Thucydides' telling, describe an arc of political and moral decline for Athens, ending with her disastrous defeat in Sicily and the temporary triumph of oligarchic forces inside Athens herself. Such a story would seem to offer numerous opportunities for moralistic comment and patriotic bluster, but Thucydides resisted these temptations. His passion was constrained by a determination to be as truthful as possible, with a view to contributing to the scientific study of man. He was less interested in assigning blame than in understanding the workings of power and human nature. Such an understanding, he believed, was the true purpose of history, and its achievement in Thucydides' great book was the basis of his claim that his work would be "a possession for all time."

In this famous passage from Book 2, Thucydides imaginatively reconstructed Pericles' last speech, in which the leader defends himself for a disastrous military decision, and tells the Athenians that their empire is like a tyranny which they must hold or be destroyed by the hatred of their subject

"Pericles' Last Speech," from Book 2 of *Thucydides: History of the Peloponnesian War,* translated by Rex Warner, translation copyright © 1954 by Rex Warner, 158–164. Reprinted by permission of Penguin Books Ltd.

*cities and rivals. Thucydides then summed up Pericles' career, suggesting
provocatively that Athens while under his sway was not really a democracy
at all.*

———————

After the second invasion of the Peloponnesians there had been a change
in the spirit of the Athenians. Their land had been twice devastated, and
they had to contend with the war and the plague at the same time. Now
they began to blame Pericles for having persuaded them to go to war and
to hold him responsible for all the misfortunes which had overtaken them;
they became eager to make peace with Sparta and actually sent ambassa-
dors there, who failed to achieve anything. They were then in a state of
utter hopelessness, and all their angry feelings turned against Pericles.

Pericles himself saw well enough how bitterly they felt at the situa-
tion in which they found themselves; he saw, in fact, that they were
behaving exactly as he had expected that they would. He therefore, since
he was still general, summoned an assembly with the aim of putting fresh
courage into them and of guiding their embittered spirits so as to leave
them in a calmer and more confident frame of mind. Coming before
them, he made the following speech:

'I expected this outbreak of anger on your part against me, since I
understand the reasons for it; and I have called an assembly with this
object in view, to remind you of your previous resolutions and to put
forward my own case against you, if we find that there is anything
unreasonable in your anger against me and in your giving way to your
misfortunes. My own opinion is that when the whole state is on the right
course it is a better thing for each separate individual than when private
interests are satisfied but the state as a whole is going downhill. However
well off a man may be in his private life, he will still be involved in the
general ruin if his country is destroyed; whereas, so long as the state
itself is secure, individuals have a much greater chance of recovering
from their private misfortunes. Therefore, since a state can support indi-
viduals in their suffering, but no one person by himself can bear the load
that rests upon the state, is it not right for us all to rally to her defence? Is
it not wrong to act as you are doing now? For you have been so dis-
mayed by disaster in your homes that you are losing your grip on the
common safety; you are attacking me for having spoken in favour of war
and yourselves for having voted for it.

'So far as I am concerned, if you are angry with me you are angry with
one who has, I think, at least as much ability as anyone else to see what

ought to be done and to explain what he sees, one who loves his city and one who is above being influenced by money. A man who has the knowledge but lacks the power clearly to express it is no better off than if he never had any ideas at all. A man who has both these qualities, but lacks patriotism, could scarcely speak for his own people as he should. And even if he is patriotic as well, but not able to resist a bribe, then this one fault will expose everything to the risk of being bought and sold. So that if at the time when you took my advice and went to war you considered that my record with regard to these qualities was even slightly better than that of others, then now surely it is quite unreasonable for me to be accused of having done wrong.

'If one has a free choice and can live undisturbed, it is sheer folly to go to war. But suppose the choice was forced upon one—submission and immediate slavery or danger with the hope of survival: then I prefer the man who stands up to danger rather than the one who runs away from it. As for me, I am the same as I was, and do not alter; it is you who have changed. What has happened is this: you took my advice when you were still untouched by misfortune, and repented of your action when things went badly with you; it is because your own resolution is weak that my policy appears to you to be mistaken. It is a policy which entails suffering, and each one of you already knows what this suffering is; but its ultimate benefits are still far away and not yet clear for all to see. So, now that a great and sudden disaster has fallen on you, you have weakened in carrying out to the end the resolves which you made. When things happen suddenly, unexpectedly, and against all calculation, it takes the heart out of a man; and this certainly has happened to you, with the plague coming on top of everything else. Yet you must remember that you are citizens of a great city and that you were brought up in a way of life suited to her greatness; you must therefore be willing to face the greatest disaster and be determined never to sacrifice the glory that is yours. We all look with distaste on people who arrogantly pretend to a reputation to which they are not entitled; but equally to be condemned are those who, through lack of moral fibre, fail to live up to the reputation which is theirs already. Each of you, therefore, must try to stifle his own particular sorrow as he joins with the rest in working for the safety of us all.

'And if you think that our war-time sufferings may grow greater and greater and still not bring us any nearer to victory, you ought to be satisfied with the arguments which I have often used on other occasions to show that there is no good reason for such fears. But there is this point also which I shall mention. In thinking of the greatness of your empire there is one advantage you have which, I think, you have never yet taken

into consideration, nor have I mentioned it in my previous speeches. Indeed, since it sounds almost like boasting, I should not be making use of this argument now if it were not for the fact that I see that you are suffering from an unreasonable feeling of discouragement. Now, what you think is that your empire consists simply of your allies: but I have something else to tell you. The whole world before our eyes can be divided into two parts, the land and the sea, each of which is valuable and useful to man. Of the whole of one of these parts you are in control—not only of the area at present in your power, but elsewhere too, if you want to go further. With your navy as it is today there is no power on earth—not the King of Persia nor any people under the sun—which can stop you from sailing where you wish. This power of yours is something in an altogether different category from all the advantages of houses or of cultivated land. You may think that when you lose them you have suffered a great loss, but in fact you should not take things so hardly; you should weigh them in the balance with the real source of your power and see that, in comparison, they are no more to be valued than gardens and other elegances that go with wealth. Remember, too, that freedom, if we preserve our freedom by our own efforts, will easily restore us to our old position; but to submit to the will of others means to lose even what we still have. You must not fall below the standard of your fathers, who not only won an empire by their own toil and sweat, without receiving it from others, but went on to keep it safe so that they could hand it down to you. And, by the way, it is more of a disgrace to be robbed of what one has than to fail in some new undertaking. Not courage alone, therefore, but an actual sense of your superiority should animate you as you go forward against the enemy. Confidence, out of a mixture of ignorance and good luck, can be felt even by cowards; but this sense of superiority comes only to those who, like us, have real reasons for knowing that they are better placed than their opponents. And when the chances on both sides are equal, it is intelligence that confirms courage—the intelligence that makes one able to look down on one's opponent, and which proceeds not by hoping for the best (a method only valuable in desperate situations), but by estimating what the facts are, and thus obtaining a clearer vision of what to expect.

'Then it is right and proper for you to support the imperial dignity of Athens. This is something in which you all take pride, and you cannot continue to enjoy the privileges unless you also shoulder the burdens of empire. And do not imagine that what we are fighting for is simply the question of freedom or slavery: there is also involved the loss of our empire and the dangers arising from the hatred which we have incurred

in administering it. Nor is it any longer possible for you to give up this empire, though there may be some people who in a mood of sudden panic and in a spirit of political apathy actually think that this would be a fine and noble thing to do. Your empire is now like a tyranny: it may have been wrong to take it; it is certainly dangerous to let it go. And the kind of people who talk of doing so and persuade others to adopt their point of view would very soon bring a state to ruin, and would still do so even if they lived by themselves in isolation. For those who are politically apathetic can only survive if they are supported by people who are capable of taking action. They are quite valueless in a city which controls an empire, though they would be safe slaves in a city that was controlled by others.

'But you should not be led astray by such citizens as these; nor should you be angry with me, you who came to the same conclusion as I did about the necessity for making war. Certainly the enemy have invaded our country and done as one might have expected they would do, once you refused to give in to them; and then the plague, something which we did not expect, fell upon us. In fact out of everything else this has been the only case of something happening which we did not anticipate. And I know that it is very largely because of this that I have become unpopular, quite unfairly, unless you are also going to put down to my credit every piece of unexpected good fortune that comes your way. But it is right to endure with resignation what the gods send, and to face one's enemies with courage. This was the old Athenian way: do not let any act of yours prevent it from still being so. Remember, too, that the reason why Athens has the greatest name in all the world is because she has never given in to adversity, but has spent more life and labour in warfare than any other state, thus winning the greatest power that has ever existed in history, such a power that will be remembered for ever by posterity, even if now (since all things are born to decay) there should come a time when we were forced to yield: yet still it will be remembered that of all Hellenic powers we held the widest sway over the Hellenes, that we stood firm in the greatest wars against their combined forces and against individual states, that we lived in a city which had been perfectly equipped in every direction and which was the greatest in Hellas.

'No doubt all this will be disparaged by people who are politically apathetic; but those who, like us, prefer a life of action will try to imitate us, and, if they fail to secure what we have secured, they will envy us. All who have taken it upon themselves to rule over others have incurred hatred and unpopularity for a time; but if one has a great aim to pursue, this burden of envy must be accepted, and it is wise to accept it. Hatred

does not last for long; but the brilliance of the present is the glory of the future stored up for ever in the memory of man. It is for you to safeguard that future glory and to do nothing now that is dishonourable. Now, therefore, is the time to show your energy and to achieve both these objects. Do not send embassies to Sparta: do not give the impression that you are bowed down under your present sufferings! To face calamity with a mind as unclouded as may be, and quickly to react against it—that, in a city and in an individual, is real strength.'

In this way Pericles attempted to stop the Athenians from being angry with him and to guide their thoughts in a direction away from their immediate sufferings. So far as public policy was concerned, they accepted his arguments, sending no more embassies to Sparta and show-ing an increased energy in carrying on the war; yet as private individuals they still felt the weight of their misfortunes. The mass of the people had had little enough to start with and had now been deprived of even that; the richer classes had lost their fine estates with their rich and well-equipped houses in the country, and, which was the worst thing of all, they were at war instead of living in peace. In fact, the general ill feeling against Pericles persisted, and was not satisfied until they had condemned him to pay a fine. Not long afterwards, however, as is the way with crowds, they re-elected him to the generalship and put all their affairs into his hands. By that time people felt their own private sufferings rather less acutely and, so far as the general needs of the state were concerned, they regarded Pericles as the best man they had. Indeed, during the whole period of peace-time when Pericles was at the head of affairs the state was wisely led and firmly guarded, and it was under him that Athens was at her greatest. And when the war broke out, here, too, he appears to have accurately estimated what the power of Athens was. He survived the out-break of war by two years and six months, and after his death his fore-sight with regard to the war became even more evident. For Pericles had said that Athens would be victorious if she bided her time and took care of her navy, if she avoided trying to add to the empire during the course of the war, and if she did nothing to risk the safety of the city itself. But his successors did the exact opposite, and in other matters which appar-ently had no connection with the war private ambition and private profit led to policies which were bad both for the Athenians themselves and for their allies. Such policies, when successful, only brought credit and advantage to individuals, and when they failed, the whole war potential of the state was impaired. The reason for this was that Pericles, because of his position, his intelligence, and his known integrity, could respect the liberty of the people and at the same time hold them in check. It was he

who led them, rather than they who led him, and, since he never sought power from any wrong motive, he was under no necessity of flattering them: in fact he was so highly respected that he was able to speak angrily to them and to contradict them. Certainly when he saw that they were going too far in a mood of over-confidence, he would bring back to them a sense of their dangers; and when they were discouraged for no good reason he would restore their confidence. So, in what was nominally a democracy, power was really in the hands of the first citizen. But his successors, who were more on a level with each other and each of whom aimed at occupying the first place, adopted methods of demagogy which resulted in their losing control over the actual conduct of affairs. Such a policy, in a great city with an empire to govern, naturally led to a number of mistakes, amongst which was the Sicilian expedition, though in this case the mistake was not so much an error of judgement with regard to the opposition to be expected as a failure on the part of those who were at home to give proper support to their forces overseas.[1] Because they were so busy with their own personal intrigues for securing the leadership of the people, they allowed this expedition to lose its impetus, and by quarrelling among themselves began to bring confusion into the policy of the state. And yet, after losing most of their fleet and all the other forces in Sicily, with revolutions already breaking out in Athens, they none the less held out for eight years against their original enemies, who were now reinforced by the Sicilians, against their own allies, most of which had revolted, and against Cyrus, son of the King of Persia, who later joined the other side and provided the Peloponnesians with money for their fleet. And in the end it was only because they had destroyed themselves by their own internal strife that finally they were forced to surrender. So overwhelmingly great were the resources which Pericles had in mind at the time when he prophesied an easy victory for Athens over the Peloponnesians alone.

EXPLANATORY NOTE

1. This explanation of the failure of the Sicilian expedition is not borne out by the narrative in Books VI–VII.

ARRIAN

Cutting the Gordian Knot

Flavius Arrianus (c. 90–160 C.E.) descended from an aristocratic Greek family of Nicomedia in Asia Minor, and was a Roman citizen. He studied with the Stoic philosopher Epictetus and became a friend of the emperor Hadrian (who ruled 117–138 C.E.). Arrian rose high in imperial service, gaining the consulate around 129 C.E. and governing the eastern province of Cappadocia in 131–137 C.E. During that time, he drove off an invasion of the nomadic Alans who had attacked Armenia. Soon after, he retired to Athens, where he also achieved high office but devoted himself primarily to writing. In addition to The Campaigns of Alexander, *Arrian wrote on India and the Black Sea, hunting and the art of war.*

In this selection, Arrian illustrates Alexander's ingenuity and boldness in cutting the Gordian knot, an action that has become proverbial.

To return to Alexander at Gordium. Upon reaching this place he was irresistibly impelled to visit the palace of Gordius and his son Midas high up on the acropolis, in order to inspect the famous Wagon of Gordius and the Knot with which its yoke was fixed. There was a story about this wagon, widely believed in the neighbourhood. Gordius (so went the tale) lived in Phrygia in the ancient days; he was poor and had but two yoke of oxen and a small plot of land to till. With one pair of oxen he ploughed, with the other he drove his wagon. One day when he was ploughing an eagle perched on the yoke of his plough and stayed there until the oxen were loosed and the day's work done. Gordius was troubled, and went to the seers of Telmissus to consult them about what this sign from heaven might mean—for the people of Telmissus were skilled in interpreting God's mysteries, and their women and children as well as their men inherited the gift of divination. Near a village belonging to these people he fell in with a girl who was drawing water; he told her of the eagle, and she in reply, being herself sprung from a line of seers, advised him to return to the place where he had seen the sign and

offer sacrifice to Zeus the King. Gordius urged her to go with him and show him the form the sacrifice should take, and he performed it as she directed, and afterwards married her, and they had a son whose name was Midas.

Now when Midas had grown to be a fine and handsome man there was trouble and strife among the Phrygians, and an oracle told them that a wagon would bring them a king, who would put an end to their quarrels. While they were still debating what to do about these things, Midas with his father and mother drove up in the wagon and came to a stop at their place of meeting. Taking this to be the fulfilment of the oracle, the Phrygians decided that here was the man whom the god had foretold that a wagon would bring. So they put Midas on the throne, and he made an end of their trouble and strife and laid up his father's wagon on the acropolis as a thank-offering to Zeus the King for sending the eagle.

There was also another traditional belief about the wagon: according to this, the man who undid the knot which fixed its yoke was destined to be the lord of Asia.[1] The cord was made from the bark of the cornel tree, and so cunningly was the knot tied that no one could see where it began or where it ended. For Alexander, then, how to undo it was indeed a puzzle, though he was none the less unwilling to leave it as it was, as his failure might possibly lead to public disturbances. Accounts of what followed differ: some say that Alexander cut the knot with a stroke of his sword and exclaimed, 'I have undone it!', but Aristobulus thinks that he took out the pin—a sort of wooden peg which was driven right through the shaft of the wagon and held the knot together—and thus pulled the yoke away from the shaft. I do not myself presume to dogmatize on this subject. In any case, when he and his attendants left the place where the wagon stood, the general feeling was that the oracle about the untying of the knot had been fulfilled.

EXPLANATORY NOTE

1. In Alexander's day this meant the Persian Empire.

ARRIAN

Alexander Conquers the Indians

Flavius Arrianus (c. 90–160 C.E.) descended from an aristocratic Greek family of Nicomedia in Asia Minor, and was a Roman citizen. He studied with the Stoic philosopher Epictetus and became a friend of the emperor Hadrian (who ruled 117–138 C.E.). Arrian rose high in imperial service, gaining the consulate around 129 C.E. and governing the eastern province of Cappadocia in 131–137 C.E. During that time, he drove off an invasion of the nomadic Alans who had attacked Armenia. Soon after, he retired to Athens, where he also achieved high office but devoted himself primarily to writing. In addition to The Campaigns of Alexander, *Arrian wrote on India and the Black Sea, hunting and the art of war.*

This passage describes one of Alexander's greatest military exploits, his defeat of the Indian army strengthened by elephants, an animal the Greeks had never faced.

The Indians who did succeed in getting away reported to Porus that Alexander had crossed the river in force and that his son had been killed in the action. Porus was faced with a difficult choice, for the troops under Craterus, who had been left behind in Alexander's original position opposite the main Indian army, could now be seen making their way over the river. Swiftly he made up his mind; he determined to move in force against Alexander, and to fight it out with the King of Macedon himself and the flower of his men. Then, leaving behind a small force with a few elephants to spread alarm among Craterus' cavalry as they attempted to land on the river-bank, he marched to meet Alexander with all his cavalry, 4,000 strong, all of his 300 chariots, 200 elephants, and the picked contingents of his infantry, numbering some 30,000 men.[1]

Much of the ground was deep in soft mud, so he continued his advance till he found a spot where the sandy soil offered a surface sufficiently firm and level for cavalry manœuvre, and there made his dispositions. In the van he stationed his elephants at intervals of about 100 feet,

on a broad front, to form a screen for the whole body of the infantry and to spread terror among the cavalry of Alexander. He did not expect that any enemy unit would venture to force a way through the gaps in the line of elephants, either on foot or on horseback; terror would make the horses uncontrollable, and infantry units would be even less likely to make the attempt, as they would be met and checked by his own heavy infantry and then destroyed by the elephants turning upon them and trampling them down. Behind the elephants were the foot-soldiers, though not on a front of equal extent: the various units, forming a second line, were so disposed as to fill the intervals in the line of elephants. There was infantry on both wings as well, outflanking the elephants, and, finally, on both flanks of the infantry were the mounted units, each with a screen of war-chariots.

Noting that the enemy was making his dispositions for battle, Alexander checked the advance of his cavalry to allow the infantry to come up with him. Regiment by regiment they made contact, moving swiftly, until the whole force was again united. Alexander had no intention of making the fresh enemy troops a present of his own breathless and exhausted men, so he paused before advancing to the attack. Meanwhile, he kept his cavalry manœuvring up and down the line, while the infantry units were allowed to rest until they were once more in good heart for battle.

Observation of the Indian dispositions decided him against attempting an assault upon their centre, where the heavy infantry was massed in the intervals of the protecting screen of elephants, and his reluctance to take this course was based precisely upon Porus' own calculations; relying, instead, on his superiority in cavalry, he moved the major portion of his mounted troops towards the enemy's left wing, to make his assault in that sector. Coenus was sent over to the Indians' right with Demetrius' regiment and his own, his orders being that when the enemy moved their cavalry across to their left to counter the massed formations of the Macedonian mounted squadrons, he should hang on to their rear. The heavy infantry was put in charge of Seleucus, Antigenes, and Tauron, with orders not to engage until it was evident that the Indians, both horse and foot, had been thrown into confusion by the Macedonian cavalry.

Once the opposing armies were within range, Alexander launched his mounted archers, 1,000 strong, against the enemy's left wing, hoping to shake it by the hail of their arrows and the weight of their charge, and immediately afterwards himself advanced with the Companions against the Indian left, intent upon making his assault while they were still reeling

under the attack of the mounted archers and before their cavalry could change formation from column into mass.

The Indians meanwhile withdrew all the cavalry from other sections of their line, and moved it across to meet and counter Alexander's movement towards their flank, and it was not long before Coenus' men could be seen following, according to orders, close in their rear. The Indians were thereupon compelled to split their force into two; the larger section, containing the best troops, continued to proceed against Alexander, while the remainder wheeled about in order to deal with Coenus. This, of course, was disastrous not only to the effectiveness of the Indians' dispositions, but to their whole plan of battle. Alexander saw his chance; precisely at the moment when the enemy cavalry were changing direction, he attacked. The Indians did not even wait to receive his charge, but fell back in confusion upon the elephants, their impregnable fortress—or so they hoped. The elephant-drivers forced their beasts to meet the opposing cavalry, while the Macedonian infantry, in its turn, advanced against them, shooting down the drivers, and pouring in a hail of missiles from every side upon the elephants themselves. It was an odd bit of work—quite unlike any previous battle; the monster elephants plunged this way and that among the lines of infantry, dealing destruction in the solid mass of the Macedonian phalanx, while the Indian horsemen, seeing the infantry at one another's throats, wheeled to the assault of the Macedonian cavalry. Once again, however, the strength and experience of Alexander's mounted troops were too much for them, and they were forced back a second time on the elephants.

During the action all the Macedonian cavalry units had, by the exigencies of the fighting rather than deliberate orders, concentrated into a single body; and now its successive charges upon this sector or that inflicted heavy losses on the enemy. By this time the elephants were boxed up, with no room to manœuvre, by troops all round them, and as they blundered about, wheeling and shoving this way and that, they trampled to death as many of their friends as of their enemies. The result was that the Indian cavalry, jammed in around the elephants and with no more space to manœuvre than they had, suffered severely; most of the elephant-drivers had been shot; many of the animals had themselves been wounded, while others, riderless and bewildered, ceased altogether to play their expected part, and, maddened by pain and fear, set indiscriminately upon friend and foe, thrusting, trampling, and spreading death before them. The Macedonians could deal with these maddened creatures comfortably enough; having room to manœuvre, they were able to use their judgement, giving ground when they charged, and going

for them with their javelins when they turned and lumbered back, whereas the unfortunate Indians, jammed up close among them as they attempted to get away, found them a more dangerous enemy even than the Macedonians.

In time the elephants tired and their charges grew feebler; they began to back away, slowly, like ships going astern, and with nothing worse than trumpetings. Taking his chance, Alexander surrounded the lot of them—elephants, horsemen, and all—and then signalled his infantry to lock shields and move up in a solid mass. Most of the Indian cavalry was cut down in the ensuing action; their infantry, too, hard pressed by the Macedonians, suffered terrible losses. The survivors, finding a gap in Alexander's ring of cavalry, all turned and fled. Craterus and the other officers who had been left on the bank of the river began to cross as soon as they saw Alexander's triumphant success, and their fresh troops, taking over the pursuit from Alexander's weary men, inflicted upon the vanquished Indians further losses no less severe.

Nearly 20,000 of the Indian infantry were killed in this battle, and about 3,000 of their cavalry. All their war-chariots were destroyed. Among the dead were two sons of Porus, Spitaces the local Indian governor, all the officers in command of the elephants and chariots, and all the cavalry officers and other commanders of high rank. The surviving elephants were captured.

EXPLANATORY NOTE

1. Curtius (8.13.6) agrees with Arrian's figures for infantry and chariots, but has 85 elephants. He does not mention cavalry; but see last note. Diodorus (17.87.2) gives 50,000 infantry, 3,000 cavalry, over 1,000 chariots, and 130 elephants; Plutarch (*Alexander* 62.1) 20,000 infantry and 2,000 cavalry.

ARISTOTLE

The Political Animal

———————

Aristotle (384–322 B.C.E.) ranks among the greatest philosophers of classical Antiquity, and is arguably the most influential thinker in the western tradition. Although large parts of his philosophical system were no longer accepted after the seventeenth century, many of his writings (especially on ethics, politics, and psychology) continue to arouse interest today. Born at Stageira in Macedonia (and thus often called the Stagirite), at the age of seventeen Aristotle went to study in Athens, where he became a student of Plato and a member of the Platonic Academy until his master's death in 347 B.C.E. After an unsuccessful bid to lead the Academy, Aristotle spent several years teaching and doing research in Asia Minor, then became tutor to Alexander the Great, the son of King Philip of Macedonia. After Alexander's accession to the throne, Aristotle returned to Athens, where he stayed from around 334 B.C.E. until shortly before his death. There he established his own school and research center, the Lyceum, in competition with the Platonic Academy. This is symbolic of the divergences between Aristotle's and Plato's thought on a number of key philosophical issues.

Among the more significant differences between Plato and Aristotle are the Stagirite's rejection of the theory of ideas and his attempt to construct a systematic philosophy embracing not only moral philosophy, but also logic, natural philosophy, and metaphysics. Furthermore, the style of the works is significantly different. Many of Aristotle's works have been lost, so it is not possible to speak of his total production authoritatively; most of the surviving works are either lecture notes or systematic treatises not designed for a broad public, and in some cases the history of these texts' transmission has done them a real disservice. The result is a rather dry, "scientific" style dictated by the systematic scope of the works and their procedure by proof and argumentation, although this is often enlivened by Aristotle's polemical stance toward other thinkers. The lecture notes often suffer from extreme conciseness and editorial interventions; these can make for slow reading and have given rise to a rich commentary literature. However, most readers agree that the works more than repay the effort involved in studying them.

The Politics, written probably during Aristotle's second sojourn in Athens, is a powerful work of political theory and analysis that continues to challenge readers today. Apparently delivered originally as lectures to Aristotle's students, the work discusses fundamental points of political theory (what is the purpose of the state? who can be rightfully called a citizen?); studies and critiques the various kinds of constitutions, theoretical and real; and concludes with a description of Aristotle's ideal state. As in his Ethics, Aristotle was strongly moved by teleological considerations: In his discussion of the relative merits of the various constitutions, for example, he frequently reminded his readers of the need to ask what the purpose of government was in the first place. Throughout, he emphasized the importance of justice and virtue in politics. In the present selection from Book I, Aristotle began by describing the state as an association "formed with a view to some good purpose," and observed that the various members of the state had different functions. He then demonstrated that the state had a natural origin, founded on the fact that man was by nature a social and political animal who was drawn to participate in various associations (families, villages, states). However, unlike associations formed by other animals, human associations were based on common views of what was good and evil. Also, they implicitly recognized that the state was prior to the individual.

Ii

1252a1 Observation tells us that every state is an association, and that every association is formed with a view to some good purpose. I say 'good', because in all their actions all men do in fact aim at what they think good. Clearly then, as all associations aim at some good, that association which is the most sovereign among them all and embraces all others will aim highest, i.e. at the most sovereign of all goods. This is the association which we call the state, the association which is 'political'.[1]
. . .

Iii

The Two 'Pairs'

1252a24 We shall, I think, in this as in other subjects, get the best view of the matter if we look at the natural growth of things from the beginning. The first point is that those which are incapable of existing without each other must be united as a pair. For example, (a) the union of male and female is essential for reproduction, and this is not a matter of *choice*, but

is due to the *natural* urge, which exists in the other animals too and in plants, to propagate one's kind.[2] Equally essential is (b) the combination of the natural ruler and ruled, for the purpose of preservation. For the element that can use its intelligence to look ahead is by nature ruler and by nature master, while that which has the bodily strength to do the actual work is by nature a slave, one of those who are ruled. Thus there is a common interest uniting master and slave.

Formation of the Household

1252a34 Nature, then, has distinguished between female and slave: she recognizes different functions and lavishly provides different tools, not an all-purpose tool like the Delphic knife;[3] for every instrument will be made best if it serves not many purposes but one. But non-Greeks assign to female and slave exactly the same status. This is because they have nothing which is by nature fitted to rule; their association[4] consists of a male slave and a female slave.[5] So, as the poets say, 'It is proper that Greeks should rule non-Greeks',[6] the implication being that non-Greek and slave are by nature identical.

1252b9 Thus it was out of the association formed by men with these two, women and slaves, that a household was first formed; and the poet Hesiod was right when he wrote, 'Get first a house and a wife and an ox to draw the plough.'[7] (The ox is the poor man's slave.) This association of persons, established according to nature for the satisfaction of daily needs, is the household, the members of which Charondas calls 'bread-fellows', and Epimenides the Cretan 'stable-companions'.[8]

Formation of the Village

1252b15 The next stage is the village, the first association of a number of houses for the satisfaction of something *more* than daily needs. It comes into being through the processes of nature in the fullest sense, as off-shoots[9] of a household are set up by sons and grandsons. The members of such a village are therefore called by some 'homogalactic'.[10] This is why states were at first ruled by kings, as are foreign nations to this day: they were formed from constituents which were themselves under kingly rule. For every household is ruled by its senior member, as by a king, and the offshoots too, because of their blood relationship, are ruled in the same way. This kind of rule is mentioned in Homer:[11] 'Each man has power of law[12] over children and wives.' He is referring to scattered settlements, which were common in primitive times. For this reason the gods too are said to be governed by a king—namely because men themselves were originally ruled by kings and some are so still. Just as men

imagine gods in human shape, so they imagine their way of life to be like that of men.

Formation of the State

1252b27 The final association, formed of several villages, is the state. For all practical purposes the process is now complete; self-sufficiency[13] has been reached, and while the state came about as a means of securing life itself, it continues in being to secure the *good* life. Therefore every state exists by nature, as the earlier associations too were natural. This association is the end of those others, and nature is itself an end; for whatever is the end-product of the coming into existence of any object, that is what we call its nature—of a man, for instance, or a horse or a household. Moreover the aim and the end is perfection; and self-sufficiency is both end and perfection.[14]

The State and the Individual

1253a1 It follows that the state belongs to the class of objects which exist by nature, and that man is by nature a political animal.[15] Any one who by his nature and not simply by ill-luck has no state is either too bad or too good, either subhuman or superhuman—he is like the war-mad man condemned in Homer's words[16] as 'having no family, no law,[17] no home'; for he who is such[18] by nature is mad on war: he is a non-cooperator like an isolated piece in a game of draughts.

1253a7 But obviously man is a political animal in a sense in which a bee is not, or any other gregarious animal.[19] Nature, as we say, does nothing without some purpose; and she has endowed man alone among the animals with the power of speech. Speech is something different from voice, which is possessed by other animals also and used by them to express pain or pleasure; for their nature does indeed enable them not only to feel[20] pleasure and pain but to communicate these feelings to each other. Speech, on the other hand serves to indicate what is useful and what is harmful, and so also what is just and what is unjust. For the real difference between man and other animals is that humans alone have perception[21] of good and evil, just and unjust, etc. It is the sharing of a common view in *these* matters that makes a household and a state.

1253a18 Furthermore, the state has a natural priority over the household and over any individual among us. For the whole must be prior to the part. Separate hand or foot from the whole body, and they will no longer be hand or foot except in name, as one might speak of a 'hand' or 'foot' sculptured in stone. That will be the condition of the spoilt[22] hand, which no longer has the capacity and the function which define it. So,

though we may say they have the same names, we cannot say that they are, in that condition,[23] the same things. It is clear then that the state is both natural and prior to the individual. For if an individual is not fully self-sufficient after separation, he will stand in the same relationship to the whole as the parts in the other case do.[24] Whatever is incapable of participating in the association which we call the state, a dumb animal for example, and equally whatever is perfectly self-sufficient and has no need to (e.g. a god), is not a part of the state at all.

1253a29 Among all men, then, there is a natural impulse towards this kind of association; and the first man to construct a state deserves credit for conferring very great benefits. For as man is the best of all animals when he has reached his full development, so he is worst of all when divorced from law and justice. Injustice armed is hardest to deal with; and though man is born with weapons which he can use in the service of practical wisdom and virtue, it is all too easy for him to use them for the opposite purposes. Hence man without virtue is the most savage, the most unrighteous, and the worst in regard to sexual licence and gluttony. The virtue of justice is a feature of a state; for justice is the arrangement of the political association,[25] and a sense of justice decides what is just.[26]

EXPLANATORY NOTES

1. *Hē koinonia politikē:* 'the association that takes the form of a *polis* (state)'.
2. Male and female are 'incapable of existing without each other' not as individuals but as members of a species, over a period of many generations. Note the contrast between instinctive *nature (phusis) and rational and purposive choice (prohairesis)*; on the latter, see *Nicomachean Ethics* III ii.
3. Evidently a knife capable of more than one mode of cutting, and not perfectly adapted to any one of them.
4. I.e. of marriage.
5. Somewhat confusingly, Aristotle uses 'slave' both in a literal and in a metaphorical sense. In non-Greek societies a woman and a slave are 'in the same position' in that their *de facto* rulers (husband and master respectively) have not the wisdom and the rationality nature demands in a natural ruler: authority is exercised by persons who are in point of fitness for rule *no better than* slaves. The 'slave' husband makes a 'slave' of his *wife*.
6. Euripides, *Iphigeneia in Aulis* 1400.
7. *Works and Days* 405.
8. Charondas was a lawgiver of Catana, in Sicily, probably of the sixth century: Aristotle refers to him several times. Epimenides was a Cretan seer and wonder-worker of about 600.
9. *Apoikia:* 'settlement', 'colony', 'extension'.

10. I.e. 'sucklings of the same milk'.
11. *Odyssey* IX, 114–5.
12. *Themisteuei*, 'lays down *themis*' ('ordinance', 'customary law', a term in early Greek social and legal thought).
13. *Autarkeia*, 'political and/or economic independence'. Aristotle's use of the word here is however somewhat wider than this, and embraces opportunities to live the 'good' life according to the human virtues.
14. Aristotle makes succinct use of his teleological technicalities: the 'aim' ('that-for-the-sake-of-which', *to hou heneka*) is the 'final cause', the 'end' or purpose towards which a process of development is directed and in which it culminates.
15. *Politikon zōon*, 'who lives whose nature is to live, in a *polis* (state)'; cf. *Nicomachean Ethics,* I vii *ad fin.*
16. *Iliad* IX, 63.
17. *Athemistos:* see n. 12.
18. I.e. without a state. It is such a person's *pugnacity* that Aristotle seems to regard as marking him out as in some sense non-human; cf. *Nicomachean Ethics* 1177b9.
19. A slightly comic sentence; but obviously it is the notion of the state as an *association* that Aristotle has in mind. On this sentence see R. G. Mulgan, 'Aristotle's doctrine that man is a political animal', *Hermes,* 102 (1974), pp. 438–45, and cf. Aristotle, *History of Animals* 487b33–488a13.
20. *Aisthesis.*
21. Literally 'destroyed', 'ruined' (by the dismemberment apparently envisaged in the preceding sentence).
22. Of not having a function and a capacity.
23. E.g. limbs (individuals : state :: limbs : body).
24. *Politikēs koinōnias taxis*, 'the framework or organization of the association that takes the form of a polis (state)'.
25. In this paragraph *dikaiosunē*, the 'virtue' or 'sense' of justice, seems to be distinguished from *dikē*, 'justice', the concrete expression or embodiment of that virtue or sense in a legal and administrative system. 'What is just' (*dikaion*) evidently means particular and individual just relationships arrived at or (in courts) reestablished by the application of *dikaiosunē* through the medium of the system of justice, or just system, *dikē*.

ARISTOTLE

Analyzing the Epic

*Aristotle (384–322 B.C.E.), the son of a doctor, was born in northern Greece.
At the age of seventeen, he entered Plato's Academy in Athens and stayed
there until Plato died in 347 B.C.E. Then, after a short period in Asia Minor,
he accepted the invitation of King Philip of Macedon to become the tutor of
his son Alexander. He stayed in Macedonia from 343 to 335 B.C.E., then
returned to Athens where he founded his own school, the Lyceum. He built
up a great library and carried on intensive research there. After Alexan-
der's death in 323 B.C.E., Aristotle left Athens and died the following year.*

*Aristotle was one of the most learned men of all time. He wrote on a
vast range of subjects, from zoology and meteorology, to politics, rhetoric,
and poetics. His philosophical works had a profound influence in Antiquity
and the Middle Ages. Curiously, none of his works survive in their original
form, but only in the notes taken by students. The following selection shows
Aristotle's analytical method in defining and understanding the epic, which
he compares with tragedy.*

EPIC

Tragedy and imitation in action has been adequately covered in what has
already been said. As for the art of imitation in narrative verse, it is clear
that the plots ought (as in tragedy) to be constructed dramatically; that
is, they should be concerned with a unified action, whole and complete,
possessing a beginning, middle parts and an end, so that (like a living
organism) the unified whole can effect its characteristic pleasure. They
should not be organized in the same way as histories, in which one has to
describe not a single action, but a single period of time, i.e. all the events
that occurred during that period involving one or more people, each
of which has an arbitrary relation to the others. The naval engagement
at Salamis, and the battle against the Carthaginians in Sicily occurred

simultaneously without in any way tending towards the same end;[1] in exactly the same way one thing may follow another in succession over a period of time without their producing a single result. But perhaps the majority of poets compose in this way.

So (as we have already said) Homer's brilliance is evident in this respect as well, in comparison with other poets. He did not even try to treat the war as a whole, although it does have a beginning and an end. Had he done so, the plot would have been excessively large and difficult to take in at one view—or, if it had been moderate in magnitude, it would have been over-complicated in its variety. Instead, he has taken one part and used many others as episodes (e.g. the catalogue of ships,[2] and other episodes which he uses to diversify his composition). The other poets write about a single person, a single period of time, or a single action of many parts—e.g. the poet of the *Cypria* and the *Little Iliad*.[3] This means that only one tragedy can be made out of the *Iliad* and *Odyssey*, or at most two, but many out of the *Cypria* and the *Little Iliad* (more than eight, e.g. *Adjudication of Arms, Philoctetes, Neoptolemus, Eurypylus, Beggary, Spartan Women, Sack of Troy, Putting to Sea;* also *Sinon* and *Trojan Women*). . . .

Epic must also have the same kinds as tragedy; it is either simple or complex, or based on character or on suffering.[4] The component parts, except for lyric poetry and spectacle, are also the same; it too needs reversals, recognitions and sufferings, and the reasoning and diction should be of high quality. Homer was the first to use all of these elements in a completely satisfactory way. Each of his two poems has a different structure; the *Iliad* is simple and based on suffering, the *Odyssey* is complex (recognition pervades it) and based on character. In addition, he excels everyone in diction and reasoning. . . .

Epic is differentiated in the length of its plot-structure and in its verse-form. The stated definition of length is adequate; one must be able to take in the beginning and the end in one view. This would be the case if the structures were shorter than those of the ancient epics, and matched the number of tragedies presented at one sitting.[5] Epic has an important distinctive resource for extending its length. In tragedy it is not possible to imitate many parts of the action being carried on simultaneously, but only the one on stage involving the actors. But in epic, because it is narrative, it is possible to treat many parts being carried on simultaneously; and these (provided that they are germane) make the poem more impressive. So epic has this advantage in achieving grandeur, variety of interest for the hearer and diversity of episodes; similarity quickly palls, and may cause tragedies to fail.

As for the verse-form, experience has proved the appropriateness of the heroic verse. If one were to compose a narrative imitation in some other verse-form, or a combination of them, it would seem unsuitable. Heroic verse is the most stately and grandiose form of verse; this is why it is particularly receptive to non-standard words and metaphors (for narrative imitation departs further from the norm than other kinds). Iambic verse and the trochaic tetrameter express movement (the latter having a dance-like quality, and the former being suited to action). It would be still more peculiar if one mixed them, as Chaeremon did.[6] For this reason no one has composed a long structure in any verse-form other than the heroic; as we have said, nature itself teaches people to choose what is appropriate to it.

EXPLANATORY NOTES

1. The victories over the Persians at Salamis and over the Carthaginians at Himera in Sicily were said to have happened on the same day (Herodotus, *Histories* 7.166). For the contrast between poetry and history cf. chapter 9 (51a38–b7).
2. *Iliad*, 2.484–779; the catalogue relates to the beginning of the war rather than its tenth year, in which the *Iliad* is set.
3. The *Cypria* recounted the antecedents of the Trojan War; the *Little Iliad* took up the story from the end of the *Iliad*.
4. Cf. 55b32–56a3 and n. 83.
5. That is, three tragedies, amounting to 4,000–5,000 lines; by contrast, the *Iliad* is over 15,000 lines long and the *Odyssey* over 12,000.
6. Cf. 47b21f. (n. 5).

PLAUTUS

Marry a Poor Wife

Titus Maccius Plautus (c. 254–184 B.C.E.), the comic poet who wrote the earliest surviving works of Roman literature, was born in the hill country of Umbria in central Italy. Beyond that, almost nothing is known of his life. Stories, probably made up on the basis of his name ("Maccius" is a typical clown's name and "plautus" means "flat-footed") and works, claim that he was variously a stagehand, an actor, a miller's assistant, and a merchant; he may even have been originally a slave. In any case, he wrote at least twenty-one plays that were enormously popular. Plautus based his comedies on Greek originals—most of them are set in Greece—but like Shakespeare (who knew and admired these plays), he adapted them to a Roman setting. He portrayed characters and situations typical of his own time and place, and was especially adept at presenting the lives and characters of slaves, who usually are the most talented and interesting of his characters. His plays are in verse and have choruses designed to be sung. They contain much satire on contemporary Roman life.

In the present selection from the Aulularia (The Pot of Gold), *an old bachelor explains why it is best to marry a wife who doesn't bring a dowry.*

EUCLIO: Thank goodness he's gone. Oh ye gods, it's asking for trouble for a poor man to have any dealings with a rich man. Here's this Megadorus landing me in all sorts of trouble, pretending to send me these cooks as a compliment, when all he really wants is to give them a chance of stealing *this*. And as if that wasn't enough, even the old woman's pet rooster very nearly ruined me, when he went scratching around near the very place where this pot was buried. That got me riled, naturally; so I upped with a stick and knocked his head off—a thief caught in the act. I wouldn't be surprised if the cooks had offered him a reward for finding something. Anyway I nipped that little scheme in the bud. And that started the cock-fighting! . . .

Hullo, here comes my future son-in-law, back from town. Now what? I can't very well go by without speaking to him.

[*But* MEGADORUS *is in the mind for a long soliloquy;* EUCLIO *stands aside and listens, fascinated.*]

MEGADORUS: I have been telling all my friends about my marriage prospects. Everybody speaks highly of the girl. 'Well done,' they say, 'an excellent idea.' I quite agree. Indeed I think it would be an excellent thing if more rich men married poor men's daughters, without dowries. It would make for harmony in the community, and there would be much less friction in the home. The wives would learn obedience, and the husbands wouldn't have to spend so much money. The mass of the people would welcome such a reform; the only opposition would come from the greedy minority, whose avarice and cupidity are beyond the power of law or leather to restrain. If you ask me then 'Whom are the rich heiresses to marry, if the poor are to be so privileged?' I say let them marry as they please, but not with dowry for company. On those terms, they'll perhaps improve their morals, and bring good characters with them instead of the dowries which they now contribute to the home. Under my law, I'd warrant that mules, which now cost more than horses, would become cheaper than Gallic geldings.

EUCLIO: It's really a pleasure to hear him sticking up for thrift.

MEGADORUS: No, I never want to hear a wife say 'I brought you more in dowry than your whole property was worth, so I have a right to expect you to give me purple and gold, mules, servants, stablemen, footmen, page-boys, and carriages to ride in.'

EUCLIO: He knows wives all right, doesn't he? I'd like to see him made censor of women's morals.

MEGADORUS: Nowadays, wherever you look, you see more vehicles outside the town houses than you ever see when you're on holiday in the country. And that's nothing to what you have to put up with when the creditors are at the door. Here come the cloth-fuller, the embroiderer, the goldsmith, the wool-weaver; the designers of fringes, makers of underwear, inventors of veils, dyers in purple and saffron, sleeve-stitchers, linen-weavers, perfumiers; shoe-makers and slipper-makers, sandal-fitters and leather-stainers, all waiting to be paid; repairers, corset-makers, girdle-experts. And when these have been got rid of—in come another three hundred with their bills; the hall full of needlewomen, cabinet-makers, bag-makers ... Is that the lot? No; more dyers, more ... any damned pest with a pocket to fill.

EUCLIO: I'd interrupt him, only I don't want to stop his discoursing on the ways of women. I'll let him go on.

MEGADORUS: And when all these tradesmen in trash have been satisfied, here comes a poor soldier, asking for his pay. Oh dear, the banker must be consulted, the accounts looked into; the soldier meanwhile standing there hungry, waiting for his money. When the figures have been totted up with the banker, it turns out ... These are only a few of the plaguey and iniquitous extravagances that follow from large dowries. A wife without a dowry is under her husband's thumb; with one, she can condemn him to misery and bankruptcy ...

CICERO

The Value of Literature

Marcus Tullius Cicero (106–43 B.C.E.), the greatest of Rome's public speakers as well as a leading philosopher and writer, also had an active political career. Although he was born in the country and was not an aristocrat, he became a successful lawyer and started to establish a reputation in his twenties. After studying philosophy in Greece, he returned to Rome and entered public life, serving in a series of high offices at the youngest permissible age. His attacks on a corrupt governor of Sicily in 70 B.C.E. brought him considerable fame. During his term as consul (chief magistrate) in 63 B.C.E., he suppressed an attempted revolution, gaining both popularity and a hostility that led to his exile from Rome for four years. Thereafter, though he remained a public figure, he was increasingly sidelined as generals like Pompey and Caesar seized power. He used these years to publish a great variety of works, including fifty-eight of his speeches, numerous treatises on philosophy and rhetoric, and hundreds of letters. He returned to the political stage in 44 B.C.E. when he launched a series of attacks on Marc Antony, who in response had him executed the following year.

The present selection, from a speech in defense of the Greek poet Archias, shows Cicero's humanistic side by stressing the importance and pleasure of literature for a busy official like himself.

You will no doubt be asking me, Gratius, why I feel such an affection for this man. The answer is that he provides my mind with refreshment after this din of the courts; he soothes my ears to rest when they are wearied by angry disputes. How could I find material, do you suppose, for the speeches I make every day on such a variety of subjects, unless I steeped my mind in learning? How could I endure the constant strains if I could not distract myself from them by this means? Yes, I confess I am devoted to the study of literature. If people have buried themselves in books, if they have used nothing they have read for the benefit of their fellowmen, if they have never displayed the fruits of such reading before the

public eye, well, let them by all means be ashamed of the occupation. But why, gentlemen, should I feel any shame? Seeing that not once throughout all these years have I allowed myself to be prevented from helping any man in the hour of his need because I wanted a rest, or because I was eager to pursue my own pleasures, or even because I needed a sleep!

I cannot therefore, I submit, be justly rebuked or censured if the time which others spend in advancing their own personal affairs, taking holidays and attending Games, indulging in pleasures of various kinds or even enjoying mental relaxation and bodily recreation, the time they spend on protracted parties and gambling and playing ball, proves in my case to have been taken up with returning over and over again to these literary pursuits. And I have all the more right to engage in such studies because they improve my capacity as a speaker; and this, for what it is worth, has unfailingly remained at the disposal of my friends whenever prosecutions have placed them in danger. Even if some may regard my ability as nothing very great, at least I realize the source from which the best part of it has come. For unless I had convinced myself from my earliest years, on the basis of lessons derived from all I had read, that nothing in life is really worth having except moral decency and reputable behaviour, and that for their sake all physical tortures and all perils of death and banishment must be held of little account, I should never have been able to speak up for the safety of you all in so many arduous clashes, or to endure these attacks which dissolute rogues launch against me every day. The whole of literature, philosophy and history is full of examples which teach this lesson—but which would have been plunged in utter darkness if the written word had not been available to illuminate them. Just think of the number of vividly drawn pictures of valiant men of the past that Greek and Latin writers have preserved for our benefit: not for mere inspection only, but for imitation as well. Throughout my public activities I have never ceased to keep these great figures before my eyes, and have modelled myself heart and soul on the contemplation of their excellence.

It might be objected that those great men, whose noble deeds have been handed down in the literary record, were not themselves by any means thoroughly well versed in the learning which I praise so highly. Certainly, it would be difficult to make a categorical assertion that they were. Nevertheless, I am quite clear what my answer to such a point should be. I agree that there have been many people whose exceptional inborn qualities, expressed in almost godlike endowments of mind and character without the support of any cultural qualifications at all, have enabled them by their own unaided endeavours to reach the heights of

self-management and moral excellence. Indeed, I would go further, and express the view that the number of virtuous and admirable men produced by character without learning exceeds those who are the products of learning without character. Nevertheless I do also maintain that, when noble and elevated natural gifts are supplemented and shaped by the influence of theoretical knowledge, the result is then something truly remarkable and unique. Such a personality could be seen by our fathers in the superhuman figure of the younger Scipio Africanus. Such, too, were those paragons of moderation and self-control Gaius Laelius and Lucius Furius;[1] such was the courageous and venerable Marcus Cato, the most erudite man of his day. They would certainly never have spent their time on literary studies if these had not helped them to understand what a better life could be, and how to bring that ideal into effect for themselves.

And yet let us leave aside for a moment any practical advantage that literary studies may bring. For even if their aim were pure enjoyment and nothing else, you would still, I am sure, feel obliged to agree that no other activity of the mind could possibly have such a broadening and enlightening effect. For there is no other occupation upon earth which is so appropriate to every time and every age and every place. Reading stimulates the young and diverts the old, increases one's satisfaction when things are going well, and when they are going badly provides refuge and solace. It is a delight in the home; it can be fitted in with public life; throughout the night, on journeys, in the country, it is a companion which never lets me down.

EXPLANATORY NOTE

1. C. Laelius (Minor) Sapiens and L. Furius Philus were prominent members of the circle of Scipio Aemilianus (Africanus junior).

HORACE

How to Write Poetry

Quintus Horatius Flaccus (65–8 B.C.E.), known in English as Horace, was ancient Rome's greatest lyric poet, a writer of great originality and versatility. He supposedly came from a poor family, but was educated in Rome and Athens and rose to be commander of a legion under Caesar's assassin Brutus. He returned to Italy to find his family lands confiscated by the victorious party of Octavian, so he determined to make a living by writing. He got a job with the government, met Virgil, and attracted the patronage of the wealthy Maecenas, the emperor's closest adviser. He was given a farm in the country south of Rome and devoted himself to poetry. He began with the Epodes, *humorous verses in the Greek tradition, then turned to a Roman genre with the* Satires. *These generally good-natured and somewhat philosophical poems on such themes as greed, ambition, gluttony, and sex were published in 30 B.C.E. His next achievement, the* Odes *of 23 B.C.E., gave him unquestioned recognition as Rome's greatest lyric poet; he was never surpassed. The* Epistles, *written during the next decade, are discourses full of good advice cast in the form of letters. A final volume of* Odes *appeared in 17 B.C.E.*

Horace's works were enormously popular and influential, especially in the seventeenth and eighteenth centuries. Many of his phrases became part of the English poetic vocabulary. In one of his last works, the Art of Poetry, *Horace gives advice on appropriate themes and subjects for tragic and other verse.*

Suppose a painter decided to set a human head
on a horse's neck, and to cover the body with coloured feathers,
combining limbs so that the top of a lovely woman
came to a horrid end in the tail of an inky fish—
when invited to view the piece, my friends, could you stifle your
[laughter?
Well, dear Pisos, I hope you'll agree that a book containing
fantastic ideas, like those conceived by delirious patients,

where top and bottom never combine to form a whole,
is exactly like that picture.
 'Painters and poets alike
have always enjoyed the right to take what risks they please.' 10
I know; I grant that freedom and claim the same in return,
but not to the point of allowing wild to couple with tame,
or showing a snake and a bird, or a lamb and tiger, as partners.

Often you'll find a serious work of large pretensions
with here and there a purple patch that is sewn on
to give a vivid and striking effect—lines describing
Diana's grove and altar, or a stream which winds and hurries
along its beauteous vale, or the river Rhine, or a rainbow.
But here they are out of place. Perhaps you can draw a cypress;
what good is that, if the subject you've been engaged to paint 20
is a shipwrecked sailor swimming for his life? The job began
as a wine-jar; why as the wheel revolves does it end as a jug?
So make what you like, provided the thing is a unified whole.

Poets in the main (I'm speaking to a father and his excellent sons)
are baffled by the outer form of what's right. I strive to be brief,
and become obscure; I try for smoothness, and instantly lose
muscle and spirit; to aim at grandeur invites inflation;
excessive caution or fear of the wind induces grovelling.
The man who brings in marvels to vary a simple theme
is painting a dolphin among the trees, a boar in the billows. 30
Avoiding a fault will lead to error if art is missing.

Any smith in the area round Aemilius' school
will render nails in bronze and imitate wavy hair;
the final effect eludes him because he doesn't know how
to shape a whole. If I wanted to do a piece of sculpture,
I'd no more copy him than I'd welcome a broken nose,
when my jet black eyes and jet black hair had won admiration.

You writers must pick a subject that suits your powers,
giving lengthy thought to what your shoulders are built for
and what they aren't. If your choice of theme is within your scope, 40
you won't have to seek for fluent speech or lucid arrangement.
Arrangement's virtue and value reside, if I'm not mistaken,
in this: to say right now what has to be said right now,
postponing and leaving out a great deal for the present.

The writer pledged to produce a poem must also be subtle
and careful in linking words, preferring this to that.
When a skilful collocation renews a familiar word,

that is distinguished writing. If novel terms are demanded
to introduce obscure material, then you will have the
chance to invent words which the apron-wearing Cethegi 50
never heard; such a right will be given, if it's not abused.
New and freshly created words are also acceptable
when channelled from Greek, provided the trickle is small. For why
should Romans refuse to Virgil and Varius what they've allowed
to Caecilius and Plautus? And why should they grumble if I succeed
in bringing a little in, when the diction of Ennius and Cato
showered wealth on our fathers' language and gave us unheard of
names for things? We have always enjoyed and always will
the right to produce terms which are marked with the current stamp.
Just as the woods change their leaves as year follows year 60
(the earliest fall, *and others spring up to take their place*) 60a
so the old generation of words passes away,
and the newly arrived bloom and flourish like human children.
We and our works are owed to death, whether our navy
is screened from the northern gales by Neptune welcomed ashore—
a royal feat—or a barren swamp which knew the oar
feeds neighbouring cities and feels the weight of the plough,
or a river which used to damage the crops has altered its course
and learned a better way. Man's structures will crumble;
so how can the glory and charm of speech remain for ever?
Many a word long dead will be born again, and others 70
which now enjoy prestige will fade, if Usage requires it.
She controls the laws and rules and standards of language.

The feats of kings and captains and the grim battles they fought—
the proper metre for such achievements was shown by Homer.
The couplet of longer and shorter lines provided a framework,
first for lament, then for acknowledging a prayer's fulfilment.
Scholars, however, dispute the name of the first poet
to compose small elegiacs; the case is still undecided.
Madness handed Archilochus her own missile—the iambus.
The foot was found to fit the sock and the stately buskin, 80
because it conveyed the give and take of dialogue; also
it drowned the noise of the pit and was naturally suited to action.
The lyre received from the Muse the right to celebrate gods
and their sons, victorious boxers, horses first in the race,
the ache of a lover's heart, and uninhibited drinking.
If, through lack of knowledge, or talent, I fail to observe
the established genres and styles, then why am I hailed as a poet?
And why, from misplaced shyness, do I shrink from learning the
 [trade?
A comic subject will not be presented in tragic metres.

Likewise Thyestes' banquet is far too grand a tale 90
for verse of an everyday kind which is more akin to the sock.
Everything has its appropriate place, and it ought to stay there.
Sometimes, however, even Comedy raises her voice,
as angry Chremes storms along in orotund phrases;
and sometimes a tragic actor grieves in ordinary language—
Peleus and Telephus (one an exile, the other a beggar)
both abandon their bombast and words of a foot and a half
when they hope to touch the listener's heart with their sad appeals.

Correctness is not enough in a poem; it must be attractive,
leading the listener's emotions in whatever way it wishes. 100
When a person smiles, people's faces smile in return;
when he weeps, they show concern. Before you can move me to
 [tears,
you must grieve yourself. Only then will your woes distress me,
Peleus or Telephus. If what you say is out of character,
I'll either doze or laugh. Sad words are required
by a sorrowful face; threats come from one that is angry,
jokes from one that is jolly, serious words from the solemn.
Nature adjusts our inner feelings to every variety
of fortune, giving us joy, goading us on to anger,
making us sink to the ground under a load of suffering. 110
Then, with the tongue as her medium, she utters the heart's emotions.
If what a speaker says is out of tune with his state,
the Roman audience, box and pit, will bellow with laughter.
A lot depends on whether the speaker is a god or a hero,
a ripe old man, or one who is still in the flush and flower
of youth, a lady of high degree, or a bustling nurse,
a roaming merchant, or one who tills a flourishing plot,
a Colchian or an Assyrian, a native of Thebes or Argos.

Writers, follow tradition, or at least avoid anomalies
when you're inventing. If you portray the dishonoured Achilles, 120
see that he's tireless, quick to anger, implacable, fierce;
have him repudiate laws, and decide all issues by fighting.
Make Medea wild and intractable, Ino tearful,
Ixion treacherous, Io a roamer, Orestes gloomy.
If you are staging something untried and taking the risk
of forming a new character, let it remain to the end
as it was when introduced, and keep it true to itself.

It's hard to express general things in specific ways.
You'd be well advised to spin your plays from the song of Troy
rather than introduce what no one has said or thought of. 130
If you want to acquire some private ground in the public domain,

don't continue to circle the broad and common track,
or try to render word for word like a loyal translator;
don't follow your model into a pen from which
diffidence or the laws of the genre prevent escape;
and don't begin in the style of the ancient cyclic poet:
'Of Priam's fate I sing and a war that's famed in story.'
What can emerge in keeping with such a cavernous promise?
The mountains will labour and bring to birth a comical mouse.
How much better the poet who builds nothing at random: 140
'Tell, O Muse, of the man who after Troy had fallen
saw the cities of many people and their ways of life.'
His aim is not to have smoke after a flash, but light
emerging from smoke, and thus revealing his splendid marvels:
the cannibal king Antíphates, the Cyclops, Scylla, Charybdis.
He doesn't start Diomédes' return from when Meleager
died, nor the Trojan war from the egg containing Helen.
He always presses on to the outcome and hurries the reader
into the middle of things as though they were quite familiar.
He ignores whatever he thinks cannot be burnished bright; 150
he invents at will, he mingles fact and fiction, but always
so that the middle squares with the start, and the end with the middle.

Consider now what I, and the public too, require,
if you want people to stay in their seats till the curtain falls
and then respond with warmth when the soloist calls for applause:
you must observe the behaviour that goes with every age-group,
taking account of how dispositions change with the years.
The child who has learnt to repeat words and to plant his steps
firmly is keen to play with his friends; he loses his temper
easily and then recovers it, changing from hour to hour. 160
The lad who has left his tutor but has not acquired a beard
enjoys horses and hounds and the grass of the sunny park.
Easily shaped for the worse, he is rude to would-be advisers,
reluctant to make any practical plans, free with his money;
quixotic and passionate, he soon discards what he set his heart on.
Manhood brings its own mentality, interests change;
now he looks for wealth and connections, strives for position,
and is wary of doing anything which may be hard to alter.
An old man is surrounded by a host of troubles: he amasses
money but leaves it untouched, for he's too nervous to use it; 170
poor devil, his whole approach to life is cold and timid;
he puts things off, is faint in hope, and shrinks from the future.
Morose and a grumbler, he is always praising the years gone by
when he was a boy, scolding and blaming 'the youth of today'.
The years bring many blessings as they come to meet us; receding,

they take many away. To avoid the mistake of assigning
an old man's lines to a lad, or a boy's to a man, you should always
stick to the traits that naturally go with a given age.

An action is shown occurring on stage or else is reported.
Things received through the ear stir the emotions more faintly 180
than those which are seen by the eye (a reliable witness) and hence
conveyed direct to the watcher. But don't present on the stage events which
ought to take place within. Much of what happenes
should be kept from view and then retailed by vivid description.
The audience must not see Medea slaying her children,
or the diabolical Atreus cooking human flesh,
or Procne sprouting wings or Cadmus becoming a snake.
I disbelieve such exhibitions and find them abhorrent.
No play should be longer or shorter than five acts,
if it hopes to stage a revival 'in response to public demand'. 190
Don't let a god intervene unless the dénouement requires
such a solution; nor should a fourth character speak.
The chorus should take the role of an actor, discharging its duty
with all its energy; and don't let it sing between the acts
anything not germane and tightly joined to the plot.
It ought to side with the good and give them friendly advice,
control the furious, encourage those who are filled with fear.
It ought to praise the simple meal which is not protracted,
healthy justice and laws, and peace with her open gates.
It ought to preserve secrets, and pray and beseech the gods 200
that good fortune may leave the proud and return to the wretched.
The pipe (which was not, as now, ringed with brass and a rival
of the trumpet, but rather slender and simple with not many openings)
was once enough to guide and assist the chorus and fill
with its breath the rows of seats which weren't too densely packed.
The crowd was, naturally, easy to count because it was small,
and the folk brought with them honest hearts, decent and modest.
When, thanks to their victories, the people widened their country,
extending the walls around their city and flouting the ban
which used to restrain daytime drinking on public occasions, 210
a greater degree of licence appeared in tunes and tempo.
(What taste was likely from an ignorant crowd on holiday,
a mixture of country and town, riff-raff and well-to-do?)
Vulgar finery and movements augmented the ancient art,
as the piper trailed his robe and minced across the stage.
The musical range of the sober lyre was also enlarged,
while a cascading style brought in a novel delivery,
and the thought, which shrewdly purveyed moral advice and also
predicted the future, came to resemble the Delphic oracles.

The man who competed in tragic verse for a worthless he-goat 220
later presented as well the naked rustic satyrs.
Rough, though without any loss of dignity, he turned to joking;
for the crowd which, after the rites, was in a drunken holiday mood
had to be kept in their seats by something new and attractive.
However, to make a success of your clownish cheeky satyrs
and achieve a proper transition from heavy to light, make sure
that no god or hero who is brought on to the stage
shall, after just being seen in regal purple and gold,
take his language down to the plane of a dingy cottage,
or in trying to keep aloft grasp at cloudy nothings. 230
Tragedy thinks it beneath her to spout frivolous verse;
and so, like a lady obliged to dance on a public holiday,
she'll be a little reluctant to join the boisterous satyrs.
If *I* ever write a satyr drama, my Pisos, I shan't
confine my choice to plain and familiar nouns and verbs;
nor shall I strive so hard to avoid the tone of tragedy
that it might as well be the voice of Davus or brazen Pythias,
who has just obtained a talent by wiping Simo's eye,
as of Silenus—guardian and servant of the god in his care.
I'll aim at a new blend of familiar ingredients; and people 240
will think it's easy—but will waste a lot of sweat and effort
if they try to copy it. Such is the power of linkage and joinery,
such the lustre that is given forth by commonplace words.
Fauns from the forest, in my opinion, ought to be careful
not to go in for the dandy's over-emotional verses,
or to fire off volleys of filthy, disgraceful jokes,
as if they came from the street corner or the city square.
Knights—free-born and men of property—take offence
and don't greet with approval all that's enjoyed by the buyer
of roasted nuts and chick-peas, or give it a winner's garland. 250

A long syllable after a short is named Iambus.
Being a quick foot, he ordered iambic verses
to be called 'trimeters', in spite of the fact that six beats
occurred in a pure iambic line. At a time in the past,
so as to reach the ear with a bit more weight and slowness,
he was kind and obliging enough to adopt the stately spondees
and share the family inheritance—though never going so far
in friendship as to relinquish the second or fourth position.
Iambus rarely appears in Accius' 'noble' trimeters,
and his all too frequent absence from th1e lines that Ennius trundles 260
onto the stage leaves them open to the damaging charge
of hasty and slapdash work or else of professional ignorance.

It isn't every critic who detects unmusical pieces;
so Roman poets have enjoyed quite excessive indulgence.
Shall *I* therefore break out, and ignore the laws of writing?
Or assume my faults will be seen by all, and huddle securely
within the permitted range? Then I've avoided blame;
I haven't earned any praise. My Roman friends, I urge you:
get hold of your Greek models, and study them day and night.
. . .

LIVY

Romulus and Remus

Titus Livius (c. 59 B.C.E.–17 C.E.) was born in Padua in northern Italy, but spent much of his life in Rome, where he studied philosophy and oratory and attracted the attention of the emperor Augustus. He never held public office, but seems to have devoted most of his life to writing his enormous history of Rome, from its foundation down to 9 B.C.E. Of the original 142 books, 35 survive complete. He narrated history chronologically, and usually uncritically, but his work is notable for his vivid reconstruction of past events and people. In dealing with the earliest history, when Rome was ruled by kings (753–509 B.C.E.), Livy relied heavily on myth and oral tradition, using his material more as a source for moral examples and lessons— illustrations of ancient virtue—than as a true historical account.

The present selection recounts the mythical foundation of Rome by Romulus and Remus, who were miraculously suckled by a wolf.

Proca, the next king, had two sons, Numitor and Amulius, to the elder of whom, Numitor, he left the hereditary realm of the Silvian family; that, at least, was his intention, but respect for seniority was flouted, the father's will ignored and Amulius drove out his brother and seized the throne. One act of violence led to another; he proceeded to murder his brother's male children, and made his niece, Rhea Silvia, a Vestal, ostensibly to do her honour, but actually by condemning her to perpetual virginity to preclude the possibility of issue.

But (I must believe) it was already written in the book of fate that this great city of ours should arise, and the first steps be taken to the founding of the mightiest empire the world has known—next to God's. The Vestal Virgin was raped and gave birth to twin boys. Mars, she declared, was their father—perhaps she believed it, perhaps she was merely hoping by the pretence to palliate her guilt. Whatever the truth of the matter, neither gods nor men could save her or her babes from the savage hands

of the king. The mother was bound and flung into prison; the boys, by the king's order, were condemned to be drowned in the river. Destiny, however, intervened; the Tiber had overflowed its banks; because of the flooded ground it was impossible to get to the actual river, and the men entrusted to do the deed thought that the flood-water, sluggish though it was, would serve their purpose. Accordingly they made shift to carry out the king's orders by leaving the infants on the edge of the first flood-water they came to, at the spot where now stands the Ruminal fig-tree— said to have once been known as the fig-tree of Romulus. In those days the country thereabouts was all wild and uncultivated, and the story goes that when the basket in which the infants had been exposed was left high and dry by the receding water, a she-wolf, coming down from the neighbouring hills to quench her thirst, heard the children crying and made her way to where they were. She offered them her teats to suck and treated them with such gentleness that Faustulus, the king's herdsman, found her licking them with her tongue. Faustulus took them to his hut and gave them to his wife Larentia to nurse. Some think that the origin of this fable was the fact that Larentia was a common whore and was called Wolf by the shepherds.

Such then, was the birth and upbringing of the twins. By the time they were grown boys, they employed themselves actively on the farm and with the flocks and began to go hunting in the woods; their strength grew with their resolution, until not content only with the chase they took to attacking robbers and sharing their stolen goods with their friends the shepherds. Other young fellows joined them, and they and the shepherds would fleet the time together, now in serious talk, now in jollity. . . .

Now Faustulus had suspected all along that the boys he was bringing up were of royal blood. He knew that two infants had been exposed by the king's orders, and the rescue of his own two fitted perfectly in point of time. Hitherto, however, he had been unwilling to declare what he knew, until either a suitable opportunity occurred or circumstances compelled him. Now the truth could no longer be concealed, so in his alarm he told Romulus the whole story; Numitor, too, when he had Remus in custody and was told that the brothers were twins, was set thinking about his grandsons; the young men's age and character, so different from the lowly born, confirmed his suspicions; and further inquiries led him to the same conclusion, until he was on the point of acknowledging Remus. The net was closing in, and Romulus acted. He was not strong enough for open hostilities, so he instructed a number of the herdsmen to meet at the king's house by different routes at a

preordained time; this was done, and with the help of Remus, at the head of another body of men, the king was surprised and killed. Before the first blows were struck, Numitor gave it out that an enemy had broken into the town and attacked the palace; he then drew off all the men of military age to garrison the inner fortress, and, as soon as he saw Romulus and Remus, their purpose accomplished, coming to congratulate him, he summoned a meeting of the people and laid the facts before it: Amulius's crime against himself, the birth of his grandsons, and the circumstances attending it, how they were brought up and ultimately recognized, and, finally, the murder of the king for which he himself assumed responsibility. The two brothers marched through the crowd at the head of their men and saluted their grandfather as king, and by a shout of unanimous consent his royal title was confirmed.

Romulus and Remus, after the control of Alba had passed to Numitor in the way I have described, were suddenly seized by an urge to found a new settlement on the spot where they had been left to drown as infants and had been subsequently brought up. There was, in point of fact, already an excess of population at Alba, what with the Albans themselves, the Latins, and the addition of the herdsmen: enough, indeed, to justify the hope that Alba and Lavinium would one day be small places compared with the proposed new settlement. Unhappily the brothers' plans for the future were marred by the same source which had divided their grandfather and Amulius—jealousy and ambition. A disgraceful quarrel arose from a matter in itself trivial. As the brothers were twins and all question of seniority was thereby precluded, they determined to ask the tutelary gods of the countryside to declare by augury which of them should govern the new town once it was founded, and give his name to it. For this purpose Romulus took the Palatine hill and Remus the Aventine as their respective stations from which to observe the auspices. Remus, the story goes, was the first to receive a sign—six vultures; and no sooner was this made known to the people than double the number of birds appeared to Romulus. The followers of each promptly saluted their master as king, one side basing its claim upon priority, the other upon number. Angry words ensued, followed all too soon by blows, and in the course of the affray Remus was killed. There is another story, a commoner one, according to which Remus, by way of jeering at his brother, jumped over the half-built walls of the new settlement, whereupon Romulus killed him in a fit of rage, adding the threat, 'So perish whoever else shall overleap my battlements.'

This, then, was how Romulus obtained the sole power. The newly built city was called by its founder's name.

OVID

Where to Find Women

Publius Ovidius Naso, or Ovid, (43 B.C.E.–17 C.E.) was, during his time, Rome's most famous literary figure, a master of love poetry and versified mythology. His lighthearted, cynical attitude toward love and women, combined with the elegance of his verses, brought him tremendous fame. None of this had been planned by Ovid's father, who was determined that his son should follow a career of public service. A native of Sulmona in the mountains of central Italy, Ovid studied rhetoric in Rome, visited Athens, and served in the minor offices that normally led to a career. The publication of his brilliant love poems, The Amores, *though, showed that he was determined to devote his life to writing. He was able to follow this course thanks to the patronage of a rich lawyer, Messalla Corvinus, who was a good friend of the emperor Augustus. Through Messalla, Ovid met the other poets who were creating a flourishing literary epoch, and he made many important connections. His most notorious work,* The Art of Love, *in which he gave practical advice for seducers and seemed to scoff at traditional morality, was an instant hit when it appeared around 1 B.C.E. A burst of activity followed with the* Metamorphoses, *an ingenious success in putting classical Roman myths into verse; and the* Fasti, *a verse presentation of the legends associated with the Roman calendar. Ovid was Rome's leading poet when, in 8 C.E., he was suddenly expelled from Rome to take up permanent exile at Tomis on the Black Sea, by the personal order of the emperor. The causes are still a mystery: The "immorality" of* The Art of Love *was a pretext, but the poet seems somehow to have been involved in a scandal or conspiracy that effected the emperor directly. He spent the rest of his writing career pleading in verse for a forgiveness that never came.*

Ovid's clear and genial poetry has always been popular, especially from the Middle Ages through the eighteenth century, and has left its mark on most European literature of that time. This selection from The Art of Love *reveals the Ovid who prudes detested: lively, witty, charming, and giving advice on the best places for meeting and seducing women.*

While you are fancy-free still, and can drive at leisure,
 Pick a girl, tell her, 'You're the one I love.
And only you.' But this search means using your eyes: a mistress
 Won't drop out of the sky at your feet.
A hunter's skilled where to spread his nets for the stag, senses 45
 In which glen the wild boar lurks.
A fowler's familiar with copses, an expert angler
 Knows the richest shoaling-grounds for fish.
You too, so keen to establish some long-term relationship,
 Must learn, first, where girl is to be found. 50
Your search need not take you—believe me—on an overseas voyage:
 A short enough trek will bring you to your goal.
True, Perseus fetched home Andromeda from the coloured Indies,
 While Phrygian Paris abducted Helen in Greece,
But Rome can boast of so many and such dazzling beauties 55
 You'd swear the whole world's talent was gathered here.
The girls of your city outnumber Gargara's wheatsheaves,
 Methymna's grape-clusters, all
Birds on the bough, stars in the sky, fish in the ocean:
 Venus indeed still haunts 60
Her son Aeneas' foundation. If you like budding adolescents
 Any number of (guaranteed) maidens are here to delight
Your roving eye. You prefer young women? They'll charm you
 By the thousand, you won't know which to choose.
And if you happen to fancy a more mature, experienced 65
 Age-group, believe me, *they* show up in droves.

Here's what to do. When the sun's on the back of Hercules'
 Lion, stroll down some shady colonnade,
Pompey's, say, or Octavia's (for her dead son Marcellus:
 Extravagant marble facings, R.I.P.), 70
Or Livia's, with its gallery of genuine Old Masters,
 Or the Danaids' Portico (note
The artwork: Danaus' daughters plotting mischief for their cousins,
 Father attitudinizing with drawn sword).
Don't miss the shrine of Adonis, mourned by Venus, 75
 Or the synagogue—Syrian Jews
Worship there each Sabbath—or the linen-clad heifer-goddess's
 Memphian temple: Io makes many a maid what *she*
Was to Jove. The very courts are hunting-grounds for passion;
 Amid lawyers' rebuttals love will often be found. 80
Here, where under Venus' marble temple the Appian
 Fountain pulses its jets high in the air,
Your jurisconsult's entrapped by Love's beguilements—
 Counsel to others, he cannot advise himself.

Here, all too often, words fail the most eloquent pleader, 85
 And a new sort of case comes on—his own. He must
Defend *himself* for a change, while Venus in her nearby
 Temple snickers at this reversal of roles.

But the theatre's curving tiers should form your favourite
 Hunting-ground: here you are sure to find 90
The richest returns, be your wish for lover or playmate,
 A one-night stand or a permanent affair.
As ants hurry to and fro in column, mandibles
 Clutching grains of wheat
(Their regular diet), as bees haunt fragrant pastures 95
 And meadows, hovering over the thyme,
Flitting from flower to flower, so our fashionable ladies
 Swarm to the games in such crowds, I often can't
Decide which I like. As spectators they come, come to be inspected:
 Chaste modesty doesn't stand a chance. 100
Such incidents at the games go back to Romulus—
 Men without women, Sabine rape.
No marble theatre then, no awnings, no perfumed saffron
 To spray the stage red:
The Palatine woods supplied a leafy backdrop (nature's 105
 Scenery, untouched by art),
While the tiers of seats were plain turf, and spectators shaded
 Their shaggy heads with leaves.
Urgently brooding in silence, the men kept glancing
 About them, each marking his choice 110
Among the girls. To the skirl of Etruscan flutes' rough triple
 Rhythm, the dancers stamped
And turned. Amid cheers (applause then lacked discrimination)
 The king gave the sign for which
They'd so eagerly watched. Project Rape was on. Up they sprang then 115
 With a lusty roar, laid hot hands on the girls.
As timorous doves flee eagles, as a lambkin
 Runs when it sees the hated wolf,
So this wild charge of men left the girls all panic-stricken,
 Not one had the same colour in her cheeks as before— 120
The same nightmare for all, though terror's features varied:
 Some tore their hair, some just froze
Where they sat; some, dismayed, kept silence, others vainly
 Yelled for Mamma; some wailed; some gaped;
Some fled, some just stood there. So they were carried off as 125
 Marriage-bed plunder; even so, many contrived
To make panic look fetching. Any girl who resisted her pursuer
 Too vigorously would find herself picked up

And borne off regardless. 'Why spoil those pretty eyes with weeping?'
 She'd hear, 'I'll be all to you 130
That your Dad ever was to your Mum.' (You alone found the proper
 Bounty for soldiers, Romulus: give me that,
And I'll join up myself!) Ever since that day, by hallowed custom,
 Our theatres have always held dangers for pretty girls.

OVID

Caesar Becomes a God

Publius Ovidius Naso, or Ovid, (43 B.C.E.–17 C.E.) was, during his time, Rome's most famous literary figure, a master of love poetry and versified mythology. His lighthearted, cynical attitude toward love and women, combined with the elegance of his verses, brought him tremendous fame. None of this had been planned by Ovid's father, who was determined that his son should follow a career of public service. A native of Sulmona in the mountains of central Italy, Ovid studied rhetoric in Rome, visited Athens, and served in the minor offices that normally led to a career. The publication of his brilliant love poems, The Amores, *though, showed that he was determined to devote his life to writing. He was able to follow this course thanks to the patronage of a rich lawyer, Messalla Corvinus, who was a good friend of the emperor Augustus. Through Messalla, Ovid met the other poets who were creating a flourishing literary epoch, and he made many important connections. His most notorious work,* The Art of Love, *in which he gave practical advice for seducers and seemed to scoff at traditional morality, was an instant hit when it appeared around 1 B.C.E. A burst of activity followed with the* Metamorphoses, *an ingenious success in putting classical Roman myths into verse; and the* Fasti, *a verse presentation of the legends associated with the Roman calendar. Ovid was Rome's leading poet when, in 8 C.E., he was suddenly expelled from Rome to take up permanent exile at Tomis on the Black Sea, by the personal order of the emperor. The causes are still a mystery: The "immorality" of* The Art of Love *was a pretext, but the poet seems somehow to have been involved in a scandal or conspiracy that effected the emperor directly. He spent the rest of his writing career pleading in verse for a forgiveness that never came.*

Ovid's clear and genial poetry has always been popular, especially from the Middle Ages through the eighteenth century, and it left its mark on most European literature of that time. This concluding story of the Metamorphoses *stresses the glory of Augustus and the divinity of his adoptive father, Julius Caesar.*

... Caesar is a god in a city that is his own. He excelled in peace and war, but it was not so much the wars he brought to a triumphal conclusion, or his achievements at home, or his majesty swiftly won, but rather his own offspring that caused him to become a new star, a fiery-tailed comet. Among Caesar's exploits, no achievement was greater than this, that he was the father of such a son. He conquered the sea-girt Britons, and sailed a victorious fleet through the seven channels of the papyrus-bearing Nile, he brought the rebellious Numidians under the sway of the Roman people, and Juba too, from the land of the Cinyps, and Pontus that proudly boasts of Mithridates. He earned many triumphs, and celebrated not a few: yet surely none would count this more glorious than to have been the father of one so great. Since Caesar's son became the guardian of the world, the gods have shown abundant favour to the human race. Therefore, so that his descendant might come of more than mortal stock, Caesar had to be made a god.

When the golden goddess who was Aeneas' mother saw this, when she saw too that an armed conspiracy was being formed, and grim death planned for Rome's high priest, she grew pale, and went about crying to every god she met: 'See, what an elaborate plot is being hatched against me, what a treacherous attack is being made on the only one of Trojan Julus' descendants left to me! Shall I always be singled out, to be harassed by anxiety all too well-founded, I who was wounded by the spear of Calydonian Diomede, overwhelmed by Troy's failure to defend her walls, who saw my son driven to wander far, tossed about upon the sea, visiting the abodes of the silent shades, fighting with Turnus or rather, if I am to speak truth, with Juno? Why recall now the sufferings of my family in the past? My present fear does not allow me to remember previous misfortunes. Look there, do you see those guilty weapons being sharpened? Keep them away, I pray you, prevent this wicked deed! Do not let Vesta's flames be extinguished by the blood of her priest!'

It was in vain that Venus anxiously voiced these complaints all over the sky, trying to stir the sympathies of the gods. They could not break the iron decrees of the ancient sisters. However, they gave unmistakable warnings of the grief that was to come. Tales are told of how arms clashed amid black thunderclouds, and terrifying trumpets and battle-horns were heard in the sky, foretelling the guilty deed. The face of the sun, too, was gloomy, and shed a pallid light upon the troubled earth. Firebrands were often seen, blazing among the stars, and drops of blood fell with the rain. The day-star was dark, with spots of rusty black upon its disc, and the chariot of the moon was spattered with blood. In a thousand places the Stygian screech-owl gave its ominous warnings, in a

116

thousand places ivory statues wept, and chants and threatening words are said to have been heard, in the sacred groves. No victim could gain a favourable response; when the entrails were examined, the head of the liver was found to be severed, and the liver itself indicated that civil strife was at hand. In the forum and around the houses and the temples of the gods, dogs howled by night, and the silent shades of the departed roamed abroad, while earthquakes shook the city.

Yet the warnings sent by the gods could not defeat the conspiracy, or stop fate's destined plan. Drawn swords were carried into the sacred building—for of all the places in the city, none but the senate-house sufficed for the foul deed of murder. Then Venus beat her breast, with both hands, and tried to hide Aeneas' descendant in that cloud which had previously cloaked Paris, when he was snatched away from his enemy, the son of Atreus, the cloud in which Aeneas had escaped the sword of Diomede. But the father of heaven reproached her: 'Are you trying, all by yourself, my daughter, to alter the course of fate, that none can combat? You may go yourself into the house of the three sisters, and there you will see the records of destiny, massive tablets of bronze and solid iron, which have no fear of thunderings in the sky, or of the wrathful lightning, safe and eternal though the heavens fall. You will find there the fate of your descendant engraved in everlasting adamant. I have read it myself, and noted it: now I shall repeat it to you, that you may no longer be ignorant of the future.

'This man for whom you are distressed, my Venus, has finished his allotted span, and completed the number of years he was fated to spend on earth. But he will enter heaven as a god, and be worshipped on earth in temples: for you will bring this about, you and his son who, inheriting his name, will bear alone the burden set upon his shoulders. Yet, in his heroic quest for vengeance for his murdered father, he will have us on his side in war. The walls of Mutina, besieged by an army under his auspices, will be defeated, and will sue for peace. Pharsalia will feel his power, Macedonian Philippi will be soaked in blood a second time. The great name of Pompey will be vanquished on the Sicilian seas, and the Egyptian consort of a Roman general, trusting in that marriage bond to her cost, will be brought low. Her threats to make my Capitol the slave of her Canopus will prove an empty boast. Why should I go through the tale of barbarian lands and races, lying on the shores of ocean, in the east and in the west? All habitable lands on earth will be his, and even the sea will be his slave.

'When the blessing of peace has been bestowed upon the earth, he will turn his attention to the rights of the citizens, and will pass laws,

eminently just. By his own example he will direct the people's ways and, looking forward to the future and his remote descendants, will require the son of his hallowed wife to adopt his name, and with it his responsibilities. Only when he is ripe in years, and has lived as long as Nestor of Pylos, will he ascend to our heavenly home, and the stars that are his kin. Meanwhile, snatch up Caesar's soul from his murdered body, and transform it into a star, so that Julius deified may ever look from his lofty seat upon the forum and my Capitol.'

Scarcely had Jupiter finished speaking when gentle Venus stood in the midst of the senate-house, though none could see her, and snatched away from the body of her Caesar the soul that had been newly released. She did not allow it to be dispersed into the air, but bore it up to the stars in heaven. As she carried it, she felt it kindle and catch fire. Released from her bosom, it flew up high beyond the moon and, its fiery tail leaving a wide track behind, flashed forth as a star. Julius the god, looking down upon the good deeds of his son, admits that they are greater than his own, and glories in being surpassed. Though Augustus forbids his own actions to be rated above those of his father, yet the talk of men, free and unrestricted by any edicts, prefers him against his will, and in this alone opposes his commands. Thus did great Atreus yield to Agamemnon's claim to fame, so Theseus was greater than Aegeus, Achilles than Peleus. Lastly, to cite a family as great as Caesar's own, so is his father Saturn less than Jove.

Jupiter controls the palaces of heaven, and the kingdoms of the three-fold universe. The earth is under Augustus' sway. Each is a father and a ruler. I pray you, gods who accompanied Aeneas, to whom fire and sword gave way, gods of our own land, and you, Romulus, founder of our city, Mars, the father of unconquered Romulus, and Vesta too, worshipped among Caesar's household gods, and with her you, O Phoebus, who have your home with us, and Jupiter on high, who dwell on the Tarpeian citadel, and all the rest whom it is right and proper for a poet to invoke: may that day be slow to come, postponed beyond our generation, on which Augustus, leaving the world he rules, will make his way to heaven and there grant the prayers which he is no longer present to receive.

TACITUS

Nero and the Burning of Rome

Cornelius Tacitus (c. 56–120 C.E.), whose mastery of language and powers of analysis make him one of the greatest historians of Antiquity, had a distinguished civil career. He reached high office in his thirties, became consul in 97 C.E., and governor of one of Rome's richest provinces, Asia (Western Turkey), in 112 C.E. He was well educated in rhetoric and developed tremendous skill as a public speaker, which he put to use as he turned to writing history in the last decades of his life.

Tacitus's major works, The Annals *and* The Histories, *covered the early Empire from the death of Augustus in 14 C.E. to that of Domitian in 96 C.E. He wrote in equal detail about politics, individuals, and military and foreign affairs, to provide a comprehensive history. Most of the* Annals, *but only the first books of the* Histories, *have survived. They reflect Tacitus's hatred of despotism in their damning portrayals of such emperors as Tiberius and Nero, and their minions. His sarcastic, epigrammatic style spares no one in the ruling classes, whom he considers an enemy of freedom and decency. The present selection describes the great fire that destroyed most of Rome in 64 C.E., together with its rebuilding along modern and more sanitary lines by Nero, who placed the blame for the disaster on the obscure but unpopular sect of the Christians.*

Disaster followed. Whether it was accidental or caused by a criminal act on the part of the emperor is uncertain—both versions have supporters. Now started the most terrible and destructive fire which Rome had ever experienced. It began in the Circus, where it adjoins the Palatine and Caelian hills. Breaking out in shops selling inflammable goods, and fanned by the wind, the conflagration instantly grew and swept the whole length of the Circus. There were no walled mansions or temples, or any other obstructions, which could arrest it. First, the fire swept violently over the level spaces. Then it climbed the hills—but returned to ravage the lower ground again. It outstripped every counter-measure.

The ancient city's narrow winding streets and irregular blocks encouraged its progress.

Terrified, shrieking women, helpless old and young, people intent on their own safety, people unselfishly supporting invalids or waiting for them, fugitives and lingerers alike—all heightened the confusion. When people looked back, menacing flames sprang up before them or outflanked them. When they escaped to a neighbouring quarter, the fire followed—even districts believed remote proved to be involved. Finally, with no idea where or what to flee, they crowded on to the country roads, or lay in the fields. Some who had lost everything—even their food for the day—could have escaped, but preferred to die. So did others, who had failed to rescue their loved ones. Nobody dared fight the flames. Attempts to do so were prevented by menacing gangs. Torches, too, were openly thrown in, by men crying that they acted under orders. Perhaps they had received orders. Or they may just have wanted to plunder unhampered.

Nero was at Antium. He only returned to the city when the fire was approaching the mansion he had built to link the Gardens of Maecenas to the Palestine. The flames could not be prevented from overwhelming the whole of the Palatine, including his palace. Nevertheless, for the relief of the homeless, fugitive masses he threw open the Field of Mars, including Agrippa's public buildings, and even his own Gardens. Nero also constructed emergency accommodation for the destitute multitude. Food was brought from Ostia and neighbouring towns, and the price of corn was cut to less than ¼ sesterce a pound. Yet these measures, for all their popular character, earned no gratitude. For a rumour had spread that, while the city was burning, Nero had gone on his private stage and, comparing modern calamities with ancient, had sung of the destruction of Troy.

By the sixth day enormous demolitions had confronted the raging flames with bare ground and open sky, and the fire was finally stamped out at the foot of the Esquiline Hill. But before panic had subsided, or hope revived, flames broke out again in the more open regions of the city. Here there were fewer casualties; but the destruction of temples and pleasure arcades was even worse. This new conflagration caused additional ill-feeling because it started on Tigellinus' estate[1] in the Aemilian district. For people believed that Nero was ambitious to found a new city to be called after himself.

Of Rome's fourteen districts only four remained intact. Three were levelled to the ground. The other seven were reduced to a few scorched and mangled ruins. To count the mansions, blocks, and temples

destroyed would be difficult. They included shrines of remote antiquity, such as Servius Tullius' temple of the Moon, the Great Altar and holy place dedicated by Evander to Hercules, the temple vowed by Romulus to Jupiter the Stayer, Numa's sacred residence, and Vesta's shrine containing Rome's household gods. Among the losses, too, were the precious spoils of countless victories, Greek artistic masterpieces, and authentic records of old Roman genius. All the splendour of the rebuilt city did not prevent the older generation from remembering these irreplaceable objects. It was noted that the fire had started on July 19th, the day on which the Senonian Gauls had captured and burnt the city. Others elaborately calculated that the two fires were separated by the same number of years, months, and days.[2]

But Nero profited by his country's ruin to build a new palace. Its wonders were not so much customary and commonplace luxuries like gold and jewels, but lawns and lakes and faked rusticity—woods here, open spaces and views there. With their cunning, impudent artificialities, Nero's architects and engineers, Severus and Celer, did not balk at effects which Nature herself had ruled out as impossible. . . .

In parts of Rome unfilled by Nero's palace, construction was not—as after the burning by the Gauls—without plan or demarcation. Streetfronts were of regulated alignment, streets were broad, and houses built round courtyards. Their height was restricted, and their frontages protected by colonnades. Nero undertook to erect these at his own expense, and also to clear debris from building-sites before transferring them to their owners. He announced bonuses, in proportion for rank and resources, for the completion of houses and blocks before a given date. Rubbish was to be dumped in the Ostian marshes by corn-ships returning down the Tiber.

A fixed proportion of every building had to be massive, untimbered stone from Gabii or Alba (these stones being fireproof). Furthermore, guards were to ensure a more abundant and extensive public watersupply, hitherto diminished by irregular private enterprise. Householders were obliged to keep fire-fighting apparatus in an accessible place; and semi-detached houses were forbidden—they must have their own walls. These measures were welcomed for their practicality, and they beautified the new city. Some, however, believed that the old town's configuration had been healthier, since its narrow streets and high houses had provided protection against the burning sun, whereas now the shadowless open spaces radiated a fiercer heat. . . .

But neither human resources, nor imperial munificence, nor appeasement of the gods, eliminated sinister suspicions that the fire had been

instigated. To suppress this rumour, Nero fabricated scapegoats—and punished with every refinement the notoriously depraved Christians (as they were popularly called). Their originator, Christ, had been executed in Tiberius' reign by the governor of Judaea, Pontius Pilatus.[3] But in spite of this temporary setback the deadly superstition had broken out afresh, not only in Judaea (where the mischief had started) but even in Rome. All degraded and shameful practices collect and flourish in the capital.

First, Nero had self-acknowledged Christians arrested. Then, on their information, large numbers of others were condemned—not so much for incendiarism as for their anti-social tendencies.[4] Their deaths were made farcical. Dressed in wild animals' skins, they were torn to pieces by dogs, or crucified, or made into torches to be ignited after dark as substitutes for daylight. Nero provided his Gardens for the spectacle, and exhibited displays in the Circus, at which he mingled with the crowd—or stood in a chariot, dressed as a charioteer. Despite their guilt as Christians, and the ruthless punishment it deserved, the victims were pitied. For it was felt that they were being sacrificed to one man's brutality rather than to the national interest.[5]

EXPLANATORY NOTES

1. Its site is uncertain.
2. 418 years, 418 months, and 418 days had passed since the traditional date of the burning of Rome by the Gauls (390 B.C.).
3. This is the only mention in pagan Latin of Pontius Pilate's action.
4. But this phrase *(odio humani generis)* may instead mean 'because the human race detested them'.
5. Tacitus seems to hesitate (as often) between two versions. Were the Christians persecuted as incendiaries or as Christians? Our other sources know nothing of the former charge. Probably they were persecuted as an illegal association potentially guilty of violence or subversiveness (i.e. treason), but although the attack created a sinister precedent its main purpose at the time was merely to distract attention from rumours against Nero by finding a suitable scapegoat. Christian beliefs are unlikely to have been attacked as such. It has often been disputed whether Nero's government regarded the Christians as a sect of the Jews (whose Roman community had been penalized by Tiberius and Claudius, but may now have obtained protection through the influence of Poppaea). The martyrdoms of St Peter and St Paul are attributed to this or later persecutions of Nero. In the later Roman empire the Christian writer Tertullian attacked Tacitus for this passage (and for his slanders on the Jews in the *Histories*).

SUETONIUS

The Life of Augustus

Suetonius (c. 70–c. 130 C.E.), the greatest of Roman biographers, had a distinguished career as an imperial secretary. His access to state records and other documentary evidence makes him one of the most important sources for the history of Rome's first eleven emperors. Of equestrian (knightly) origin, Suetonius was a friend of the younger Pliny, who furthered his protégé's career in the civil service as well as his reputation as an author. After serving in several capacities—as librarian, archivist, cultural adviser, and secretary—under the emperors Trajan and Hadrian, Suetonius was dismissed in 122 C.E. for improper behavior at court, after which he disappears from public view. In addition to The Twelve Caesars, *Suetonius wrote a biographical compendium of eminent Roman authors (*On Illustrious Men*), as well as treatises on technical topics such as clothing, festivals, time-keeping, and grammar. Except for a few fragments of* Illustrious Men, *none of the latter works have survived. The date of his death is uncertain.*

The Twelve Caesars *is Suetonius's most famous and enduring work. It treats the lives of the Caesars from Julius to Domitian, including fascinating and sometimes scandalous details considered unworthy of serious history by most ancient authors. But Suetonius intended to write not history but biography, as evidenced by the thematic rather than chronological arrangement of the lives. He wrote candidly and directly about his Caesars, avoiding overt moral judgments by presenting several sides of a story, or by a bald recitation of the factual evidence as he found it. His masterful use of documentary sources and the anecdotal character sketch exerted a powerful influence on the development of biography as a genre in the West. The life of Augustus, excerpted in this selection, is the longest and perhaps the most important biography in the work, since it affords glimpses of the emperor's life and character not otherwise available from the extant historical record.*

61. This completes my account of Augustus' civil and military career, and of how he governed the Empire, in all parts of the world, in peace and war. Now follows a description of his private life, his character, and his domestic fortunes, from his youth until the last day of his life.

At the age of twenty, while Consul for the first time, Augustus lost his mother; and at the age of fifty-four, his sister Octavia. He had been a devoted son and brother while they lived, and conferred the highest posthumous honours on them at their deaths.

62. As a young man he was betrothed to the daughter of Publius Servilius Isauricus, but on his reconciliation with Mark Antony, after their first disagreement, the troops insisted that they should become closely allied by marriage; so, although Antony's step-daughter Claudia—borne by his wife Fulvia to Publius Clodius—was only just of marriageable age, Augustus married her; however, he quarrelled with Fulvia and divorced Claudia before the union had been consummated. Soon afterwards he married Scribonia, both of whose previous husbands had been ex-consuls, and by one of whom she had a child. Augustus divorced her, too, 'because,' as he wrote, 'I could not bear the way she nagged at me'—and immediately took Livia Drusilla away from her husband, Tiberius Nero, though she was pregnant at the time. Livia remained the one woman whom he truly loved until his death.

. . .

65. His satisfaction with the success of this family and its training was, however, suddenly dashed by Fortune. He came to the conclusion that the Elder and the Younger Julia had both been indulging in every sort of vice; and banished them. When Gaius then died in Lycia, and Lucius eighteen months later at Massilia, Augustus publicly adopted his remaining grandchild, Agrippa Postumus and, at the same time, his step-son Tiberius; a special bill to legalize this act was passed in the Forum.[1] Yet he soon disinherited Postumus, whose behaviour had lately been vulgar and brutal, and packed him off to Surrentum.

When members of his family died Augustus bore his loss with far more resignation than when they disgraced themselves. The deaths of Gaius and Lucius did not break his spirit; but after discovering his daughter Julia's adulteries, he refused to see visitors for some time. He wrote a letter about her case to the Senate, staying at home while a quaestor read it to them. He even considered her execution; at any rate, hearing that one Phoebe, a freedwoman in Julia's confidence, had hanged herself, he cried: 'I should have preferred to be Phoebe's father!' Julia was forbidden to drink wine or enjoy any other luxury during her exile; and denied all male company, whether free or servile, except by Augustus's

special permission and after he had been given full particulars of the applicant's age, height, complexion, and of any distinguishing marks on his body—such as moles or scars. He kept Julia for five years on a prison island before moving her to the mainland, where she received somewhat milder treatment. Yet nothing would persuade him to forgive his daughter; and when the Roman people interceded several times on her behalf, earnestly pleading for her recall, he stormed at a popular assembly: 'If you ever bring up this matter again, may the gods curse you with daughters and wives like mine!' While in exile Julia the Younger gave birth to a child, which Augustus refused to allow to be acknowledged or reared. Because Agrippa Postumus' conduct, so far from improving, grew daily more irresponsible, he was transferred to an island, and held their under military surveillance. Augustus then asked the Senate to pass a decree making Postumus' banishment permanent; but whenever his name, or that of either Julia, came up in conversation he would sigh deeply, and sometimes quote a line from the *Iliad*:

'Ah, never to have married, and childless to have died!'

referring to them as 'my three boils' or 'my three running sores'.

66. Though slow in making friends, once Augustus took to a man, he showed great constancy and not only rewarded him as his qualities deserved, but even condoned his minor shortcomings. . . .
. . .

68. As a young man Augustus was accused of various improprieties. For instance, Sextus Pompey jeered at his effeminacy; Mark Antony alleged that Julius Caesar made him submit to unnatural relations as the price of adoption; Antony's brother Lucius added that, after sacrificing his virtue to Caesar, Augustus had sold his favours to Aulus Hirtius in Spain, for 3,000 gold pieces, and that he used to soften the hair on his legs by singeing them with red-hot walnut shells. One day at the Theatre an actor came on the stage representing a eunuch priest of Cybele, the Mother of the Gods; and, as he played his timbrel, another actor exclaimed:

'Look, how this invert's finger beats the drum!'

Since the Latin phrase could also mean: 'Look how this invert's finger *sways the world!*' the audience took the line for a hint at Augustus and broke into enthusiastic applause.

69. Not even his friends could deny that he often committed adultery, though of course they said, in justification, that he did so for reasons of state, not simple passion—he wanted to discover what his enemies were

at by getting intimate with their wives or daughters. Mark Antony accused him not only of indecent haste in marrying Livia, but of hauling an ex-consul's wife from her husband's dining-room into the bedroom—before his eyes, too! He brought the woman back, says Antony, blushing to the ears and with her hair in disorder. Antony also writes that Scribonia was divorced for having said a little too much when a rival got her claws into Augustus; and that his friends used to behave like Toranius, the slave-dealer, in arranging his pleasures for him—they would strip mothers of families, or grown girls, of their clothes and inspect them as though they were up for sale. . . .

. . .

71. Augustus easily disproved the accusation (or slander, if you like) of prostituting his body to men, by the decent normality of his sex-life, then and later; and that of having over-luxurious tastes by his conduct at the capture of Alexandria, where the only loot he took from the Palace of the Ptolemies was a single agate cup—he melted down all the golden dinner services. However, the charge of being a womanizer stuck, and as an elderly man he is said to have still harboured a passion for deflowering girls—who were collected for him from every quarter, even by his wife! Augustus did not mind being called a gambler; he diced openly, in his old age too, simply because he enjoyed the game—not only in December, when the licence of the Saturnalia justified it, but on other holidays, as well, and actually on working days. . . .

. . .

76. In this character sketch I need not omit his eating habits. He was frugal and, as a rule, preferred the food of the common people, especially the coarser sort of bread, small fishes, fresh hand-pressed cheese, and green figs of the second crop; and would not wait for dinner, if he felt hungry, but ate anywhere. . . .

77. Augustus was also a habitually abstemious drinker. During the siege of Mutina, according to Cornelius Nepos, he never took more than three drinks of wine-and-water at dinner. In later life his limit was a pint; if he ever exceeded this he would deliberately vomit. Raetian was his favourite, but he seldom touched wine between meals; instead, he would moisten his throat with a morsel of bread dunked in cold water; or a slice of cucumber or the heart of a young lettuce; or a sour apple either fresh or dried.

78. After lunch he used to rest for a while without removing clothes or shoes; one hand shading his eyes, his feet uncovered. When dinner was over he would retire to a couch in his study, where he worked late until all the outstanding business of the day had been cleared off; or most

of it. Then he went to bed and slept seven hours at the outside, with three or four breaks of wakefulness. If he found it hard to fall asleep again on such occasions, as frequently happened, he sent for readers or story-tellers; and on dropping off would not wake until the sun was up. He could not bear lying sleepless in the dark with no one by his side; and if he had to officiate at some official or religious ceremony that involved early rising—which he also loathed—would spend the previous night at a friend's house as near the appointed place as possible. Even so, he often needed more sleep than he got, and would doze off during his litter journeys through the city if anything delayed his progress and the bearers set the litter down.

79. Augustus was remarkably handsome and of very graceful gait even as an old man; but negligent of his personal appearance. He cared so little about his hair that, to save time, he would have two or three barbers working hurriedly on it together, and meanwhile read or write something, whether they were giving him a haircut or a shave. He always wore so serene an expression, whether talking or in repose, that a Gallic chief once confessed to his compatriots: 'When granted an audience with the Emperor during his passage across the Alps I would have carried out my plan of hurling him over a cliff had not the sight of that tranquil face softened my heart; so I desisted.'

Augustus' eyes were clear and bright, and he liked to believe that they shone with a sort of divine radiance: it gave him profound pleasure if anyone at whom he glanced keenly dropped his head as though dazzled by looking into the sun. In old age, however, his left eye had only partial vision. His teeth were small, few, and decayed; his hair, yellowish and rather curly; his eyebrows met above the nose; he had ears of moderate size, a nose projecting a little at the top and then bending slightly inward, and a complexion intermediate between dark and fair. Julius Marathus, Augustus' freedman and recorder, makes his height 5 feet 7 inches; but this is an exaggeration, although, with body and limbs so beautifully proportioned, one did not realize how small a man he was, unless someone tall stood close to him.

. . .

83. As soon as the Civil Wars were over Augustus discontinued his riding and fencing exercises on the Campus Martius and used, instead, to play catch with two companions, or hand-ball with several. But soon he was content to go riding, or take walks, muffled in a cloak or blanket, that ended with a sprint and some jumping. Sometimes he went fishing as a relaxation; sometimes he played at dice, marbles, or nuts in the company of little boys, and was always on the lookout for ones with pretty

faces and cheerful chatter, especially Syrians and Moors—he loathed people who were dwarfish or in any way deformed, regarding them as freaks of nature and bringers of bad luck.

84. Even in his boyhood Augustus had studied rhetoric with great eagerness and industry, and during the Mutina campaign, busy though he was, is said to have read, written, and declaimed daily. From that time onwards he carefully drafted every address intended for delivery to the Senate, the popular Assembly, or the troops; though gifted with quite a talent for extempore speech. What is more, he avoided the embarrassment of forgetting his words, or the drudgery of memorizing them, by always reading from a manuscript. All important statements made to individuals, and even to his wife Livia, were first committed to notebooks and then repeated aloud; he was haunted by a fear of saying either too much or too little if he spoke off-hand. His articulation of words, constantly practised under an elocution teacher, was pleasant and rather unusual; but sometimes, when his voice proved inadequate for addressing a large crowd, he called a herald.

85. Augustus wrote numerous prose works on a variety of subjects, some of which he read aloud to a group of his closer friends as though in a lecture-hall: the *Reply to Brutus' Eulogy of Cato*, for instance. In this case, however, he tired just before the end—being then already an old man—and handed the last roll to Tiberius, who finished it for him. Among his other works were *An Encouragement to the Study of Philosophy* and thirteen books of *My Autobiography*, which took the story only up to the time of the Cantabrian War. He made occasional attempts at verse composition; including *Sicily*, a short poem in hexameters, and an equally short collection of *Epigrams*, most of them composed at the Baths. Both these books survive; but growing dissatisfied with the style of his tragedy, *Ajax*, which he had begun in great excitement, he destroyed it. When friends asked: 'Well, what has Ajax been doing lately?' he answered: 'Ajax has fallen on my sponge.'

. . .

89. He had ambitions to be as proficient in Greek as in Latin, and did very well at it. His tutor was Apollodorus of Pergamum, who accompanied him to Apollonia, though a very old man, and taught him elocution. Afterwards Augustus spent some time with Areus the philosopher, and his sons Dionysius and Nicanor, who broadened his general education; but never learned to speak Greek with real fluency, and never ventured on any Greek literary composition. Indeed, if he ever had occasion to use the language he would write down whatever it might be in Latin and get someone to make a translation. Yet nobody could describe him as

ignorant of Greek poetry, because he greatly enjoyed the Old Comedy, and often put plays of that period on the stage. His chief interest in the literature of both languages was the discovery of moral precepts, with suitable anecdotes attached, capable of public or private application; and he would transcribe passages of this sort for the attention of his generals or provincial governors, whenever he thought it necessary. . . .

. . .

100. Augustus died in the same room as his father Octavius. That was 19 August, A.D. 14, at about 3 p.m., the Consuls of the year being Sextus Pompeius and Sextus Appuleius. In thirty-five days' time he would have attained the age of seventy-six. Senators from the neighbouring municipalities and veteran colonies bore the body, in stages, all the way from Nola to Bovillae—but at night, owing to the hot weather—laying it during the daytime in the town hall or principal temple of every halting place. From Bovillae, a party of Roman knights carried it to the vestibule of his house at Rome.

The senators vied with one another in proposing posthumous honours for Augustus. Among the motions introduced were the following: that his funeral procession should pass through the Triumphal Gate preceded by the image of Victory from the Senate House, and that boys and girls of the nobility should sing his dirge; that on the day of his cremation iron rings should be worn instead of gold ones; that his ashes should be gathered by priests of the leading Colleges; that the name of the month 'August' should be transferred to September, because Augustus had been born in September but had died in the month now called August; and that the whole period between his birth and death should be officially entered in the Calendar as 'the Augustan Age'.

EXPLANATORY NOTE

1. i.e., a *lex curiata*, passed by the *comitia curiata*.

SENECA

Should a Philosopher Withdraw from the World?

One of the most influential writers of Antiquity, Lucius Annaeus Seneca (4 B.C.E.–65 C.E.) was born in Cordoba (Spain), spent part of his youth in Egypt, then settled in Rome where he studied law and pursued a political career. He obtained the office of quaestor and was a successful speaker in the Senate, but his rise was a cause for jealousy and he was twice (in 37 and 41 C.E., by successive emperors) condemned to death. His punishment was in each case commuted to exile, and he spent eight years on the island of Corsica, dedicating himself to literature and philosophy. In 49 C.E. he was recalled to Rome and made praetor. He was also entrusted with tutoring a twelve-year-old child who was later to become Emperor Nero. Upon Nero's accession to the throne in 54 C.E., Seneca became, together with an army officer named Burrus, the power behind the throne. For a period of eight years, the two men managed to direct imperial policy and redirect the emperor's baser instincts. This period was remembered by historians as one of the best in imperial government. But Nero became increasingly independent of his tutors, and Seneca's enemies whispered to the emperor that the philosopher had become corrupt, and his popularity a danger to the throne. In 62 C.E., Seneca thought it wise to retire from public life; but the discovery of a plot against the emperor, in which Seneca was implicated, spelled the philosopher's end, and he was forced to commit suicide.

Though an adherent of Stoicism (an austere philosophy that emphasized the pursuit of virtue, a modest lifestyle, and immunity to pain, grief, fear of death, and superstition), Seneca sought to humanize its more forbidding aspects and make the Stoic ideal seem attractive and attainable to a larger circle. He stressed the universal brotherhood of man and expressed, for the time, remarkable views on the natural equality of man. Furthermore, his writings have a religious flavor that proved appealing to Christians as well as to pagans. Although Seneca penned works in a variety of genres, including political speeches, dialogues, poems, letters, and treatises, his surviving oeuvre consists mainly of tragedies in verse and philosophical writings in prose. The latter took the form of letters, essays, and treatises, and includes

titles such as The Happy Life, The Shortness of Life, Providence, Anger, *and* Clemency. *These works are known not only for their philosophical insight, but for their style, which combines brevity, conversational ease, and wit in a way that contrasts sharply with the fulsome style of Seneca's predecessor* Cicero.

Seneca's 124 Letters, *directed to Lucilius Junior, a civil servant from Pompeii who had some interest in literature and philosophy, are mostly essays on moral topics, as is indicated by the Latin title* Epistulae morales. *It is not clear whether these letters were actually sent, or whether Seneca simply decided to use the letter form as a convenient vehicle for his ethical considerations. However, it is certain that the letters, whose style is highly polished, were meant for publication, and that Seneca worked on them especially during the last three years of his life. Full of pithy sentences as well as references to life in contemporary Rome, they offer a supple vehicle to communicate Seneca's chief philosophical concerns. The present selection, taken from letter VII, is an inquiry into how the philosopher should relate to those around him. In the first letter, Seneca described some gladiatorial combats and the crowd's thirst for the blood of the combatants. He recommended that, to avoid being influenced by such base instincts, a philosopher should as much as possible retire within himself, without however avoiding more intimate relationships.*

LETTER VII

YOU ask me to say what you should consider it particularly important to avoid. My answer is this: a mass crowd. It is something to which you cannot entrust yourself yet without risk. I at any rate am ready to confess my own frailty in this respect. I never come back home with quite the same moral character I went out with; something or other becomes unsettled where I had achieved internal peace, some one or other of the things I had put to flight reappears on the scene. We who are recovering from a prolonged spiritual sickness are in the same condition as invalids who have been affected to such an extent by prolonged indisposition that they cannot once be taken out of doors without ill effects. Associating with people in large numbers is actually harmful: there is not one of them that will not make some vice or other attractive to us, or leave us carrying the imprint of it or bedaubed all unawares with it. And inevitably enough, the larger the size of the crowd we mingle with, the greater the danger. But nothing is as ruinous to the character as sitting away one's time at a show—for it is then, through the medium of entertainment, that vices creep into one with more than usual ease. What do

you take me to mean? That I go home more selfish, more self-seeking and more self-indulgent? Yes, and what is more, a person crueller and less humane through having been in contact with human beings. I happened to go to one of these shows at the time of the lunch-hour interlude, expecting there to be some light and witty entertainment then, some respite for the purpose of affording people's eyes a rest from human blood. Far from it. All the earlier contests were charity in comparison. The nonsense is dispensed with now: what we have now is murder pure and simple. The combatants have nothing to protect them; their whole bodies are exposed to the blows; every thrust they launch gets home. A great many spectators prefer this to the ordinary matches and even to the special, popular demand ones. And quite naturally. There are no helmets and no shields repelling the weapons. What is the point of armour? Or of skill? All that sort of thing just makes the death slower in coming. In the morning men are thrown to the lions and the bears: but it is the spectators they are thrown to in the lunch hour. The spectators insist that each on killing his man shall be thrown against another to be killed in his turn; and the eventual victor is reserved by them for some other form of butchery; the only exit for the contestants is death. Fire and steel keep the slaughter going. And all this happens while the arena is virtually empty.

'But he was a highway robber, he killed a man.' And what of it? Granted that as a murderer he deserved this punishment, what have you done, you wretched fellow, to deserve to watch it? 'Kill him! Flog him! Burn him! Why does he run at the other man's weapon in such a cowardly way? Why isn't he less half-hearted about killing? Why isn't he a bit more enthusiastic about dying? Whip him forward to get his wounds! Make them each offer the other a bare breast and trade blow for blow on them.' And when there is an interval in the show: 'Let's have some throats cut in the meantime, so that there's something happening!' Come now, I say, surely you people realize—if you realize nothing else—that bad examples have a way of recoiling on those who set them? Give thanks to the immortal gods that the men to whom you are giving a lesson in cruelty are not in a position to profit from it.

When a mind is impressionable and has none too firm a hold on what is right, it must be rescued from the crowd: it is so easy for it to go over to the majority. A Socrates, a Cato or a Laelius might have been shaken in his principles by a multitude of people different from himself: such is the measure of the inability of any of us, even as we perfect our personality's adjustment, to withstand the onset of vices when they come with such a mighty following. A single example of extravagance or greed does

a lot of harm—an intimate who leads a pampered life gradually makes one soft and flabby; a wealthy neighbour provokes cravings in one; a companion with a malicious nature tends to rub off some of his rust even on someone of an innocent and open-hearted nature—what then do you imagine the effect on a person's character is when the assault comes from the world at large? You must inevitably either hate or imitate the world. But the right thing is to shun both courses: you should neither become like the bad because they are many, nor be an enemy of the many because they are unlike you. Retire into yourself as much as you can. Associate with people who are likely to improve you. Welcome those whom you are capable of improving. The process is a mutual one: men learn as they teach. And there is no reason why any pride in advertising your talents abroad should lure you forward into the public eye, inducing you to give readings of your works or deliver lectures. I should be glad to see you doing that if what you had to offer them was suitable for the crowd I have been talking about: but the fact is, not one of them is really capable of understanding you. You might perhaps come across one here and there, but even they would need to be trained and developed by you to a point where they could grasp your teaching. 'For whose benefit, then, did I learn it all?' If it was for your own benefit that you learnt it you have no call to fear that your trouble may have been wasted.

Just to make sure that I have not been learning solely for my own benefit today, let me share with you three fine quotations I have come across, each concerned with something like the same idea—one of them is by way of payment of the usual debt so far as this letter is concerned, and the other two you are to regard as an advance on account. 'To me,' says Democritus, 'a single man is a crowd, and a crowd is a single man.' Equally good is the answer given by the person, whoever it was (his identity is uncertain), who when asked what was the object of all the trouble he took over a piece of craftsmanship when it would never reach more than a few people, replied: 'A few is enough for me; so is one; and so is none.' The third is a nice expression used by Epicurus in a letter to one of his colleagues. 'I am writing this,' he says, 'not for the eyes of the many, but for yours alone: for each of us is audience enough for the other.' Lay these up in your heart, my dear Lucilius, that you may scorn the pleasure that comes from the majority's approval. The many speak highly of you, but have you really any grounds for satisfaction with yourself if you are the kind of person the many understand? Your merits should not be outward facing.

JUVENAL

Sex-Crazed Women

─────────

Little is known of the life of Juvenal (Decimus Junius Juvenalis, c. 35–140 C.E.), the most powerful of the Roman satirists and a model for many writers in the Renaissance and later. He came from a small town near Rome, evidently of a landowning family, and studied rhetoric in Rome. The emperor Domitian apparently sent him into exile for some insulting verses he had written, and confiscated his property. Juvenal passed though a period of real poverty that provoked the resentment and indignation evident in his verses. He later had some success and continued writing most of his life. His Satires *present a harsh and sarcastic view of life in Rome, with its rich patrons, servile clients, liars, cheats, thieves, and degenerates. He was particularly virulent against the women of his time, who he believed had left all their ancestral virtues far behind.*

This selection from the sixth Satire, *which denounces women, portrays a senator's wife who pursues a gladiator, and an empress who prostitutes herself.*

─────────

When that senator's wife, Eppia, eloped with her fancy swordsman
to Pharos and Nile and the Alexandrian stews,
Egypt itself cried out at Rome's monstrous morals.
Husband, family, sister, the bitch forsook them all, 85
country and tearful children, as well as—this *will* surprise you—
the public games, and her favourite matinée idol.
Luxury-reared, cradled by Daddy in swansdown,
brought up to frills and flounces, Eppia nevertheless
made as light of the sea as she did of her reputation— 90
not that our pampered ladies set any great store by *that*.
Boldly she faced the Tuscan waves, the booming
Ionian swell, heart steadfast, despite the constant
chop and change of the sea. When a woman faces danger
in a good cause, then chill terror ices her heart, 95
her knees turn to water, she can scarcely stand upright;

but wicked audacity breeds its own fortitude.
To go aboard ship at a husband's bidding is torture:
then bilge-water sickens, then the sky wheels dizzily round.
But a wife going off with her lover suffers no qualms. The one 100
pukes on her husband, the other eats with the sailors,
takes a turn around the deck, enjoys hauling on rough sheets.
What was the youthful charm that so fired Eppia? What
was it hooked her? What did she see in him that was worth
being mocked as a fighter's moll? For her poppet, her Sergius 105
was no chicken, forty at least, with one dud arm that held promise
of early retirement. Deformities marred his features—
a helmet-scar, a great wen on his nose, an unpleasant
discharge from one constantly weeping eye. What of it?
He was a gladiator. That makes anyone an Adonis; 110
that was what she chose over children, country, sister,
and husband: steel's what they crave. Yet this same Sergius,
once pensioned, would soon have begun to seem—a Veiento.
 Do such private scandals, do Eppia's deeds, appal you?
Then consider the Gods' rivals, hear what Claudius 115
had to put up with. The minute she heard him snoring
his wife—that whore-empress—who dared to prefer the mattress
of a stews to her couch in the Palace, called for her hooded
night-cloak and hastened forth, with a single attendant.
Then, her black hair hidden under an ash-blonde wig, 120
she'd make straight for her brothel, with its stale, warm coverlets,
and her empty reserved cell. Here, naked, with gilded
nipples, she plied her trade, under the name of 'The Wolf-Girl',
parading the belly that once housed a prince of the blood.[1]
She would greet each client sweetly, demand cash payment, 125
and absorb all their battering—without ever getting up.
Too soon the brothel-keeper dismissed his girls:
she stayed right till the end, always the last to go,
then trailed away sadly, still | with burning, rigid vulva,
exhausted by men, yet a long way from satisfied, 130
cheeks grimed with lamp-smoke, filthy, carrying home
to her Imperial couch the stink of the whorehouse.
What point in mentioning spells, or aphrodisiac potions,
or that lethal brew given to stepsons? Sexual compulsion
drives women to worse crimes: they err through excess of lust. 135

EXPLANATORY NOTE

1. The 'prince of blood' was Britannicus, Messalina's son by Claudius. The boy's stepmother, Agrippina, persuaded Claudius to adopt her own son Lucius Domitius (Nero), who thus succeeded to the throne after Claudius' death by poisoning in A.D. 54. Britannicus himself was also murdered a year later, presumably as a potential rival to Nero. See lines 615–26.

PETRONIUS

An Extravagant Banquet

———————

The Satyricon *is usually attributed to Titus (or Caius) Petronius, who rose to prominence in the court of the emperor Nero. Famed for his debauchery and love of luxury, he supposedly slept all day, caroused all night, and was extremely outspoken. Yet his tenure as governor of a province and then of the highest office, the consulate, was marked by ability and distinction. When he returned to Rome, he gained the nickname "Arbiter of Elegance," in recognition of his extreme talent for arranging affairs of the court, where luxury was the highest goal. He fell victim to intrigue, and followed the emperor's orders to commit suicide, which he did in his distinctive manner, by dining well, then composing a memoir of all Nero's debaucheries.*

His Satyricon *is the first novel of contemporary life in the western tradition. It survives only as a fragment that traces the adventures of a couple of low-life types in Italy; the most brilliant section portrays the character and extravagance of an enormously rich ex-slave, Trimalchio. The present selection describes Trimalchio's banquet and the unimaginable dishes he serves.*

———————

Finally we took our places. Boys from Alexandria poured iced water over our hands. Others followed them and attended to our feet, removing any hangnails with great skill. But they were not quiet even during this troublesome operation: they sang away at their work. I wanted to find out if the whole staff were singers, so I asked for a drink. In a flash a boy was there, singing in a shrill voice while he attended to me—and anyone else who was asked for something did the same. It was more like a musical comedy than a respectable dinner party.

Some extremely elegant hors d'oeuvres were served at this point—by now everyone had taken his place with the exception of Trimalchio, for whom, strangely enough, the place at the top was reserved. The dishes for the first course included an ass of Corinthian bronze with two panniers, white olives on one side and black on the other. Over the ass were two pieces of plate, with Trimalchio's name and the weight of the silver

inscribed on the rims. There were some small iron frames shaped like bridges supporting dormice sprinkled with honey and poppy seed. There were steaming hot sausages too, on a silver gridiron with damsons and pomegranate seeds underneath.

We were in the middle of these elegant dishes when Trimalchio himself was carried in to the sound of music and set down on a pile of tightly stuffed cushions. The sight of him drew an astonished laugh from the guests.[1] His cropped head stuck out from a scarlet coat; his neck was well muffled up and he had put round it a napkin with a broad purple stripe and tassels dangling here and there. On the little finger of his left hand he wore a heavy gilt ring and a smaller one on the last joint of the next finger. This I thought was solid gold, but actually it was studded with little iron stars. And to show off even more of his jewellery, he had his right arm bare and set off by a gold armlet and an ivory circlet fastened with a gleaming metal plate.

After picking his teeth with a silver toothpick, he began: 'My friends, I wasn't keen to come into the dining-room yet. But if I stayed away any more, I would have kept you back, so I've deprived myself of all my little pleasures for you. However, you'll allow me to finish my game.'

A boy was at his heels with a board of terebinth wood with glass squares, and I noticed the very last word in luxury—instead of white and black pieces he had gold and silver coins.[2] While he was swearing away like a trooper over his game and we were still on the hors d'oeuvres, a tray was brought in with a basket on it. There sat a wooden hen, its wings spread round it the way hens are when they are broody. Two slaves hurried up and as the orchestra played a tune they began searching through the straw and dug out peahens' eggs, which they distributed to the guests.

Trimalchio turned to look at this little scene and said: 'My friends, I gave orders for that bird to sit on some peahens' eggs. I hope to goodness they are not starting to hatch. However, let's try them and see if they are still soft.'

We took up our spoons (weighing at least half a pound each) and cracked the eggs, which were made of rich pastry. To tell the truth, I nearly threw away my share, as the chicken seemed already formed. But I heard a guest who was an old hand say: 'There should be something good here.' So I searched the shell with my fingers and found the plumpest little figpecker, all covered with yolk and seasoned with pepper.

At this point Trimalchio became tired of his game and demanded that all the previous dishes be brought to him. He gave permission in a loud voice for any of us to have another glass of mead if we wanted it. Suddenly there was a crash from the orchestra and a troop of waiters—still

singing—snatched away the hors d'oeuvres. However in the confusion one of the side-dishes happened to fall and a slave picked it up from the floor. Trimalchio noticed this, had the boy's ears boxed and told him to throw it down again. A cleaner came in with a broom and began to sweep up the silver plate along with the rest of the rubbish. Two long-haired Ethiopians followed him, carrying small skin bags like those used by the men who scatter the sand in the amphitheatre, and they poured wine over our hands—no one ever offered us water.

Our host was complimented on these elegant arrangements. 'Mars loves a fair fight,' he replied. 'That is why I gave orders for each guest to have his own table. At the same time these smelly slaves won't crowd so.'

Carefully sealed wine bottles were immediately brought, their necks labelled:

FALERNIAN

CONSUL OPIMIUS

ONE HUNDRED YEARS OLD[3]

While we were examining the labels, Trimalchio clapped his hands and said with a sigh:

'Wine has a longer life than us poor folks. So let's wet our whistles. Wine is life. I'm giving you real Opimian. I didn't put out such good stuff yesterday, though the company was much better class.'

Naturally we drank and missed no opportunity of admiring his elegant hospitality. In the middle of this a slave brought in a silver skeleton,[4] put together in such a way that its joints and backbone could be pulled out and twisted in all directions. After he had flung it about on the table once or twice, its flexible joints falling into various postures, Trimalchio recited:

'O woe, woe, man is only a dot:
Hell drags us off and that is the lot;
So let us live a little space,
At least while we can feed our face.'

After our applause the next course was brought in. Actually it was not as grand as we expected, but it was so novel that everyone stared. It was a deep circular tray with the twelve signs of the Zodiac arranged round the edge. Over each of them the chef had placed some appropriate dainty suggested by the subject.[5] Over Aries the Ram, chickpeas; over Taurus the Bull, a beefsteak; over the Heavenly Twins, testicles and kidneys; over Cancer the Crab, a garland; over Leo the Lion, an African fig;

over Virgo the Virgin, a young sow's udder; over Libra the Scales, a balance with a cheesecake in one pan and a pastry in the other; over Scorpio, a sea scorpion; over Sagittarius the Archer, a sea bream with eyespots; over Capricorn, a lobster; over Aquarius the Water-Carrier, a goose; over Pisces the Fishes, two mullets. In the centre was a piece of grassy turf bearing a honeycomb. A young Egyptian slave carried around bread in a silver oven . . . and in a sickening voice he mangled a song from the show *The Asafoetida Man*.

As we started rather reluctantly on this inferior fare, Trimalchio said: 'Let's eat, if you don't mind. This is the sauce of all order.' As he spoke, four dancers hurtled forward in time to the music and removed the upper part of the great dish, revealing underneath plump fowls, sows' udders, and a hare with wings fixed to his middle to look like Pegasus. We also noticed four figures of Marsyas with little skin bottles, which let a peppery fish-sauce go running over some fish, which seemed to be swimming in a little channel. We all joined in the servants' applause and amid some laughter we helped ourselves to these quite exquisite things.

Trimalchio was every bit as happy as we were with this sort of trick: 'Carve 'er!' he cried. Up came the man with the carving knife and, with his hands moving in time to the orchestra, he sliced up the victuals like a charioteer battling to the sound of organ music. And still Trimalchio went on saying insistently: 'Carve 'er, Carver!'

I suspected this repetition was connected with some witticism, and I went so far as to ask the man on my left what it meant. He had watched this sort of game quite often and said:

'You see the fellow doing the carving—he's called Carver. So whenever he says "Carver!" he's calling out his name and his orders.'

EXPLANATORY NOTES

1. Trimalchio's appearance is rightly laughed at by the guests. The close crop is a sign of the slave or ex-slave; the napkin ostentatiously displays the broad purple stripe which was worn by the senatorial order on their togas; gold rings are the specific privilege of Roman knights, so Trimalchio wears a gilt ring and a gold ring studded with iron—thus sailing as close to the wind as he dares.

2. Probably the game called *latrunculi*—a game something between draughts and chess, although sometimes dice played a part in it. The object was to put an opponent's piece between two of one's own and so capture him. There is at least one Egyptian picture of a solo game, although normally it was played between two people.

3. This label has given commentators a lot of trouble. Opimius was consul in 121 B.C., but although this vintage produced long-lived wines (some bottles, almost undrinkable, surviving to the middle of the first century A.D., according to the elder Pliny), we cannot, therefore, date the time of this episode to 21 B.C. The point is that Trimalchio is trying to impress his guests with the age and quality of his wine, but no vintner puts a label like this on a bottle unless he is trying to cheat a customer. Trimalchio does not know his dates—all he knows is that Opimian was the best (like Napoleon brandy). He is either lying or he has been cheated.

4. The skeleton is a frequent motif in fresco or mosaic on dining-room walls or house floors. Its purpose is to admonish the diners to eat, drink, and be merry, for tomorrow we die.

5. Each of the foods placed over the signs of the Zodiac is either a sort of rebus, e.g. over Aries, *cicer arietinum* (chickpeas), or has some appropriate connection with the sign in question, e.g. the goose is connected with rain and is placed over the rainy constellation of the Water-carrier. The rebuses will not always come through in translation, so I have substituted where necessary a reasonable English equivalent.

PLOTINUS

The True Source of Beauty

Plotinus (205–269 C.E.), the last great philosopher of Antiquity, was born in Egypt and wrote in Greek, though his name is Roman. At the age of twenty-eight he turned to philosophy and studied under Ammonius Saccas in Alexandria. After eleven years of study he joined a military expedition of Emperor Gordian III, hoping to learn more about the philosophy of the Persians. After the defeat of the Roman army Plotinus returned to Rome and became a teacher of philosophy. In Rome he was the guru of a circle of disciples, including a number of influential men and women as well as professional philosophers such as his biographer and editor, Porphyry.

Modern scholars since the nineteenth century have labelled Plotinus's philosophy "Neoplatonism," to distinguish it from what they take to be the historical teachings of Plato, but Plotinus saw himself as an authentic interpreter of Plato's writings, raising and solving difficulties in Plato's works. Plotinus's thought is preserved in some fifty-four essays, arranged by Porphyry into six groups of nine essays (and therefore called the Enneads, *from* ennea, *the number nine). Plotinus's essays cover the entire range of ancient philosophy save politics, and reflect the discussions held in his seminars with his pupils. Though not a systematic philosopher, his writings form a complete body of philosophical thought in which mystical experience and ascetic teachings are blended with and interpreted in light of doctrines from Plato, Aristotle, and other Greek philosophers.*

On Beauty (Ennead I.6) is Plotinus's earliest and best-known treatise. Based broadly on Diotima's speech in the Symposium *and on the myth of the chariot in the* Phaedrus, *it seeks the source of beauty not in harmonies found in material objects but in the realms of thought and of ultimate goodness upon which the material world itself depends.*

SIXTH TRACTATE

BEAUTY [1]

SUMMARY

One of Plotinus' earliest treatises, and perhaps his best-known, it is a good statement (together with the later Ennead V. 8) *of his aesthetics. Based broadly on Diotima's speech in the* Symposium *and on the myth of the* Phaedrus, *it seeks the source of physical beauty in the intelligible, and the source of that in the Good itself.*

1. Beauty addresses itself chiefly to sight; but there is a beauty for the hearing too, as in certain combinations of words and in all kinds of music, for melodies and cadences are beautiful; and minds that lift themselves above the realm of sense to a higher order are aware of beauty in the conduct of life, in actions, in character, in the pursuits of the intellect; and there is the beauty of the virtues. What loftier beauty there may be, yet, our argument will bring to light.

What, then, is it that gives comeliness to material forms and draws the ear to the sweetness perceived in sounds, and what is the secret of the beauty there is in all that derives from Soul?

Is there some One Principle from which all take their grace, or is there a beauty peculiar to the embodied and another for the bodiless? Finally, one or many, what would such a Principle be?

Consider that some things, material shapes for instance, are gracious not by anything inherent but by something communicated, while others are lovely of themselves, as, for example, Virtue.

The same bodies appear sometimes beautiful, sometimes not; so that there is a good deal between being body and being beautiful.

What, then, is this something that shows itself in certain material forms? This is the natural beginning of our inquiry.

What is it that attracts the eyes of those to whom a beautiful object is presented, and calls them, lures them, towards it, and fills them with joy at the sight? If we possess ourselves of this, we have at once a standpoint[1] for the wider survey.

Almost everyone[2] declares that the symmetry of parts towards each other and towards a whole, with, besides, a certain charm of colour, constitutes the beauty recognized by the eye, that in visible things, as indeed in all else, universally, the beautiful thing is essentially symmetrical, patterned.

But think what this means.

Only a compound can be beautiful, never anything devoid of parts; and only a whole; the several parts will have beauty, not in themselves, but only as working together to give a comely total. Yet beauty in an aggregate demands beauty in details: it cannot be constructed out of ugliness; its law must run throughout.

All the loveliness of colour and even the light of the sun, being devoid of parts and so not beautiful by symmetry, must be ruled out of the realm of beauty. And how comes gold to be a beautiful thing? And lightning by night, and the stars, why are these so fair?

In sounds also the simple must be proscribed, though often in a whole noble composition each several tone is delicious in itself.

Again since the one face, constant in symmetry, appears sometimes fair and sometimes not, can we doubt that beauty is something more than symmetry, that symmetry itself owes its beauty to a remoter principle?

Turn to what is attractive in methods of life or in the expression of thought; are we to call in symmetry here? What symmetry is to be found in noble conduct, or excellent laws, in any form of mental pursuit?

What symmetry can there be in points of abstract thought?

The symmetry of being accordant with each other? But there may be accordance or entire identity where there is nothing but ugliness: the proposition that honesty is merely a generous artlessness[3] chimes in the most perfect harmony with the proposition that morality means weakness of will; the accordance is complete.

Then again, all the virtues are a beauty of the Soul, a beauty authentic beyond any of these others; but how does symmetry enter here? The Soul, it is true, is not a simple unity, but still its virtue cannot have the symmetry of size or of number: what standard of measurement could preside over the compromise or the coalescence of the Soul's faculties or purposes?

Finally, how by this theory would there be beauty in the Intellectual-Principle, essentially the solitary?

2. Let us, then, go back to the source, and indicate at once the Principle that bestows beauty on material things.

Undoubtedly this Principle exists; it is something that is perceived at the first glance, something which the Soul names as from an ancient knowledge and, recognizing, welcomes it, enters into unison with it.

But let the Soul fall in with the Ugly and at once it shrinks within itself, denies the thing, turns away from it, not accordant, resenting it.

Our interpretation is that the Soul—by the very truth of its nature, by its affiliation to the noblest Existents in the hierarchy of Being—when it sees anything of that kin, or any trace of that kinship, thrills with an immediate delight, takes its own to itself, and thus stirs anew to the sense of its nature and of all its affinity.

But, is there any such likeness between the loveliness of this world and the splendours in the Supreme? Such a likeness in the particulars would make the two orders alike: but what is there in common between beauty here and beauty There?

We hold that all the loveliness of this world comes by communion in Ideal-Form.

All shapelessness whose kind admits of pattern and form, as long as it remains outside of Reason and Idea, is ugly by that very isolation from the Divine-Thought. And this is the Absolute Ugly: an ugly thing is something that has not been entirely mastered by pattern, that is by Reason, the Matter not yielding at all points and in all respects to Ideal-Form.

But where the Ideal-Form has entered, it has grouped and co-ordinated what from a diversity of parts was to become a unity: it has rallied confusion into cooperation: it has made the sum one harmonious coherence: for the Idea is a unity and what it moulds must come to unity as far as multiplicity may.

And on what has thus been compacted to unity, Beauty enthrones itself, giving itself to the parts as to the sum: when it lights on some natural unity, a thing of like parts, then it gives itself to that whole. Thus, for an illustration, there is the beauty, conferred by craftsmanship, of all a house with all its parts, and the beauty which some natural quality may give to a single stone.

This, then, is how the material thing becomes beautiful—by communicating in the thought (Reason, Logos) that flows from the Divine.

3. And the Soul includes a faculty peculiarly addressed to Beauty—one incomparably sure in the appreciation of its own, when Soul entire is enlisted to support its judgement.

Or perhaps the Soul itself acts immediately, affirming the Beautiful where it finds something accordant with the Ideal-Form within itself, using this Idea as a canon of accuracy in its decision.

But what accordance is there between the material and that which antedates all Matter?

On what principle does the architect, when he finds the house standing before him correspondent with his inner ideal of a house, pronounce it beautiful? Is it not that the house before him, the stones apart, is the

inner idea stamped upon the mass of exterior matter, the indivisible exhibited in diversity?

So with the perceptive faculty: discerning in certain objects the Ideal-Form which has bound and controlled shapeless matter, opposed in nature to Idea, seeing further stamped upon the common shapes some shape excellent above the common, it gathers into unity what still remains fragmentary, catches it up and carries it within, no longer a thing of parts, and presents it to the Ideal-Principle as something concordant and congenial, a natural friend: the joy here is like that of a good man who discerns in a youth the early signs of a virtue consonant with the achieved perfection within his own soul.

The beauty of colour is also the outcome of a unification: it derives from shape, from the conquest of the darkness inherent in Matter by the pouring-in of light, the unembodied, which is a Rational-Principle and an Ideal-Form.

Hence it is that Fire itself is splendid beyond all material bodies, holding the rank of Ideal-Principle to the other elements, making ever upwards, the subtlest, and sprightliest of all bodies, as very near to the unembodied;[4] itself alone admitting no other, all the others penetrated by it: for they take warmth but this is never cold; it has colour primally; they receive the Form of colour from it: hence the splendour of its light, the splendour that belongs to the Idea. And all that has resisted and is but uncertainly held by its light remains outside of beauty, as not having absorbed the plenitude of the Form of colour.

And harmonies unheard in sound create the harmonies we hear and wake the Soul to the consciousness of beauty, showing it the one essence in another kind: for the measures of our sensible music are not arbitrary but are determined by the Principle whose labour is to dominate Matter and bring pattern into being.

Thus far of the beauties of the realm of sense, images and shadow-pictures, fugitives that have entered into Matter—to adorn, and to ravish, where they are seen.

4. But there are earlier and loftier beauties than these. In the sense-bound life we are no longer granted to know them, but the Soul, taking no help from the organs, sees and proclaims them. To the vision of these we must mount, leaving sense to its own low place.

As it is not for those to speak of the graceful forms of the material world who have never seen them or known their grace—men born blind, let us suppose—in the same way those must be silent upon the beauty of noble conduct and of learning and all that order who have never cared

for such things, nor may those tell of the splendour of virtue who have never known the face of Justice and of Moral-Wisdom beautiful beyond the beauty of Evening and of Dawn.[5]

Such vision is for those only who see with the Soul's sight—and at the vision, they will rejoice, and awe will fall upon them and a trouble deeper than all the rest could ever stir, for now they are moving in the realm of Truth.

This is the spirit that Beauty must ever induce, wonderment and a delicious trouble, longing and love and a trembling that is all delight. For the unseen all this may be felt as for the seen; and this the Souls feel for it, every Soul in some degree, but those the more deeply that are the more truly apt to this higher love—just as all take delight in the beauty of the body but all are not stung as sharply, and those only that feel the keener wound are known as Lovers.

5. These Lovers, then, lovers of the beauty outside of sense, must be made to declare themselves.

What do you feel in presence of the grace you discern in actions, in manners, in sound morality, in all the works and fruits of virtue, in the beauty of Souls?[6] When you see that you yourselves are beautiful within, what do you feel? What is this Dionysiac exultation that thrills through your being, this straining upwards of all your soul, this longing to break away from the body and lie sunken within the veritable self?

These are no other than the emotions of Souls under the spell of love.

But what is it that awakens all this passion? No shape, no colour, no grandeur of mass: all is for a Soul, something whose beauty rests upon no colour, for the moral wisdom the Soul enshrines and all the other hueless splendour of the virtues. It is that you find in yourself, or admire in another, loftiness of spirit; righteousness of life; disciplined purity; courage of the majestic face; gravity, modesty that goes fearless and tranquil and passionless; and, shining down upon all, the light of godlike Intellection.

All these noble qualities are to be reverenced and loved, no doubt, but what entitles them to be called beautiful?

They exist: they manifest themselves to us: anyone that sees them must admit that they have reality of Being; and is not Real-Being really beautiful?

But we have not yet shown by what property in them they have wrought the Soul to loveliness: what is this grace, this splendour as of Light, resting upon all the virtues?

Let us take the contrary, the ugliness of the Soul, and set that against its beauty: to understand, at once, what this ugliness is and how it comes to appear in the Soul will certainly open our way before us.

Let us then suppose an ugly Soul, dissolute, unrighteous: teeming with all the lusts; torn by internal discord; beset by the fears of its cowardice and the envies of its pettiness; thinking, in the little thought it has, only of the perishable and the base; perverse in all its impulses; the friend of unclean pleasures; living the life of abandonment to bodily sensation and delighting in its deformity.

What must we think but that all this shame is something that has gathered about the Soul, some foreign bane outraging it, soiling it, so that, encumbered with all manner of turpitude, it has no longer a clean activity or a clean sensation, but commands only a life smouldering dully under the crust of evil; that, sunk in manifold death, it no longer sees what a Soul should see, may no longer rest in its own being, dragged ever as it is towards the outer, the lower, the dark?

An unclean thing, I dare to say; flickering hither and thither at the call of objects of sense, deeply infected with the taint of body, occupied always in Matter, and absorbing Matter into itself; in its commerce with the Ignoble it has trafficked away for an alien nature its own essential Idea.

If a man has been immersed in filth or daubed with mud, his native comeliness disappears and all that is seen is the foul stuff besmearing him: his ugly condition is due to alien matter that has encrusted him, and if he is to win back his grace it must be his business to scour and purify himself and make himself what he was.

So, we may justly say, a Soul becomes ugly—by something foisted up on it, by sinking itself into the alien, by a fall, a descent into body, into Matter. The dishonour of the Soul is in its ceasing to be clean and apart. Gold is degraded when it is mixed with earthy particles; if these be worked out, the gold is left and is beautiful, isolated from all that is foreign, gold with gold alone. And so the Soul; let it be but cleared of the desires that come by its too intimate converse with the body, emancipated from all the passions, purged of all that embodiment has thrust upon it, withdrawn, a solitary, to itself again—in that moment the ugliness that came only from the alien is stripped away.

6. For, as the ancient teaching was,[7] moral-discipline and courage and every virtue, not even excepting Wisdom itself, all is purification.[8]

Hence the Mysteries with good reason adumbrate the immersion of the unpurified in filth, even in the Nether-World, since the unclean

loves filth for its very filthiness, and swine foul of body find their joy in foulness.

What else is Sophrosyny, rightly so-called, but to take no part in the pleasures of the body, to break away from them as unclean and unworthy of the clean? So too, Courage is but being fearless of the death which is but the parting of the Soul from the body, an event which no one can dread whose delight is to be his unmingled self. And Magnanimity is but disregard for the lure of things here. And Wisdom is but the Act of the Intellectual-Principle withdrawn from the lower places and leading the Soul to the Above.

The Soul thus cleansed is all Idea and Reason, wholly free of body, intellective, entirely of that divine order from which the wellspring of Beauty rises and all the race of Beauty.

Hence the Soul heightened to the Intellectual-Principle is beautiful to all its power. For Intellection and all that proceeds from Intellection are the Soul's beauty, a graciousness native to it and not foreign, for only with these is it truly Soul. And it is just to say that in the Soul's becoming a good and beautiful thing is its becoming like to God, for from the Divine comes all the Beauty and all the Good in beings.

We may even say that Beauty *is* the Authentic-Existents and Ugliness is the Principle contrary to Existence: and the Ugly is also the primal evil; therefore its contrary is at once good and beautiful, or is Good and Beauty: and hence the one method will discover to us the Beauty-Good and the Ugliness-Evil.

And Beauty, this Beauty which is also The Good, must be posed as The First: directly deriving from this First is the Intellectual-Principle which is preeminently the manifestation of Beauty; through the Intellectual-Principle Soul is beautiful. The beauty in things of a lower order—actions and pursuits for instance—comes by operation of the shaping Soul which is also the author of the beauty found in the world of sense. For the Soul, a divine thing, a fragment as it were of the Primal Beauty, makes beautiful to the fullness of their capacity all things whatsoever that it grasps and moulds.

7. Therefore we must ascend again towards the Good, the desired of every Soul. Anyone that has seen This, knows what I intend when I say that it is beautiful. Even the desire of it is to be desired as a Good. To attain it is for those that will take the upward path, who will set all their forces towards it, who will divest themselves of all that we have put on in our descent: so, to those that approach the Holy Celebrations of the Mysteries, there are appointed purifications and the laying aside of the

garments worn before, and the entry in nakedness—until, passing, on the upward way, all that is other than the God, each in the solitude of himself shall behold that solitary-dwelling Existence, the Apart, the Unmingled, the Pure,[9] that from Which all things depend, for Which all look and live and act and know, the Source of Life and of Intellection and of Being.

And one that shall know this vision—with what passion of love shall he not be seized, with what pang of desire, what longing to be molten into one with This, what wondering delight! If he that has never seen this Being must hunger for It as for all his welfare, he that has known must love and reverence It as the very Beauty; he will be flooded with awe and gladness, stricken by a salutary terror; he loves with a veritable love, with sharp desire; all other loves than this he must despise, and disdain, all that once seemed fair.

This, indeed, is the mood even of those who, having witnessed the manifestation of Gods or Supernals, can never again feel the old delight in the comeliness of material forms: what then are we to think of one that contemplates Absolute Beauty in Its essential integrity, no accumulation of flesh and matter, no dweller on earth or in the heavens—so perfect Its purity—far above all such things in that they are non-essential, composite, not primal but descending from This?

Beholding this Being—the Choragus of all Existence, the Self-Intent that ever gives forth and never takes—resting, rapt, in the vision and possession of so lofty a loveliness, growing to Its likeness, what Beauty can the Soul yet lack? For This, the Beauty supreme, the absolute, and the primal, fashions Its lovers to Beauty and makes them also worthy of love.

And for This, the sternest and the uttermost combat is set before the Souls;[10] all our labour is for This, lest we be left without part in this noblest vision, which to attain is to be blessed in the blessful sight, which to fail of is to fail utterly.

For not he that has failed of the joy that is in colour or in visible forms, not he that has failed of power or of honours or of kingdom has failed, but only he that has failed of only This, for Whose winning he should renounce kingdoms and command over earth and ocean and sky, if only, spurning the world of sense from beneath his feet, and straining to This, he may see.

8. But what must we do? How lies the path? How come to vision of the inaccessible Beauty, dwelling as if in consecrated precincts, apart from the common ways where all may see, even the profane?

He that has the strength, let him arise and withdraw into himself, foregoing all that is known by the eyes, turning away for ever from the

material beauty that once made his joy. When he perceives those shapes of grace that show in body, let him not pursue: he must know them for copies, vestiges, shadows, and hasten away towards That they tell of. For if anyone follow what is like a beautiful shape playing over water—is there not a myth telling in symbol of such a dupe, how he sank into the depths of the current and was swept away to nothingness?[11] So too, one that is held by material beauty and will not break free shall be precipitated, not in body but in Soul, down to the dark depths loathed of the Intellective-Being, where, blind even in the Lower-World, he shall have commerce only with shadows, there as here.

'Let us flee then to the beloved Fatherland':[12] this is the soundest counsel. But what is this flight? How are we to gain the open sea? For Odysseus is surely a parable to us when he commands the flight from the sorceries of Circe or Calypso—not content to linger for all the pleasure offered to his eyes and all the delight of sense filling his days.

The Fatherland to us is There whence we have come, and There is The Father.

What then is our course, what the manner of our flight? This is not a journey for the feet; the feet bring us only from land to land; nor need you think of coach or ship to carry you away; all this order of things you must set aside and refuse to see: you must close the eyes and call instead upon another vision which is to be waked within you, a vision, the birthright of all, which few turn to use.

9. And this inner vision, what is its operation?
Newly awakened it is all too feeble to bear the ultimate splendour. Therefore the Soul must be trained—to the habit of remarking, first, all noble pursuits, then the works of beauty produced not by the labour of the arts but by the virtue of men known for their goodness: lastly, you must search the souls of those that have shaped these beautiful forms.

But how are you to see into a virtuous Soul and know its loveliness?

Withdraw into yourself and look. And if you do not find yourself beautiful yet, act as does the creator of a statue that is to be made beautiful: he cuts away here, he smoothes there, he makes this line lighter, this other purer, until a lovely face has grown upon his work. So do you also: cut away all that is excessive, straighten all that is crooked, bring light to all that is overcast, labour to make all one glow of beauty and never cease chiselling your statue,[13] until there shall shine out on you from it the godlike splendour of virtue, until you shall see the perfect goodness surely established in the stainless shrine.[14]

151

When you know that you have become this perfect work, when you are self-gathered in the purity of your being, nothing now remaining that can shatter that inner unity, nothing from without clinging to the authentic man, when you find yourself wholly true to your essential nature, wholly that only veritable Light which is not measured by space, not narrowed to any circumscribed form nor again diffused as a thing void of term, but ever unmeasurable as something greater than all measure and more than all quantity—when you perceive that you have grown to this, you are now become very vision: now call up all your confidence, strike forward yet a step—you need a guide no longer—strain, and see.

This is the only eye that sees the mighty Beauty. If the eye that adventures the vision be dimmed by vice, impure, or weak, and unable in its cowardly blenching to see the uttermost brightness, then it sees nothing even though another point to what lies plain to sight before it. To any vision must be brought an eye adapted to what is to be seen, and having some likeness to it. Never did eye see the sun unless it had first become sunlike,[15] and never can the Soul have vision of the First Beauty unless itself be beautiful.

Therefore, first let each become godlike and each beautiful who cares to see God and Beauty. So, mounting, the Soul will come first to the Intellectual-Principle and survey all the beautiful Ideas in the Supreme and will avow that this is Beauty, that the Ideas are Beauty. For by their efficacy comes all Beauty else, by the offspring and essence of the Intellectual-Being. What is beyond the Intellectual-Principle we affirm to be the nature of Good radiating Beauty before it. So that, treating the Intellectual-Cosmos as one, the first is the Beautiful: if we make distinction there, the Realm of Ideas[16] constitutes the Beauty of the Intellectual Sphere; and The Good, which lies beyond, is the Fountain at once and Principle of Beauty: the Primal Good and the Primal Beauty have the one dwelling-place and, thus, always, Beauty's seat is There.

EXPLANATORY NOTES

1. A reference to *Symp.* 211c3. Diotima's speech in the *Symposium* lies at the back of much of this tractate, as does the central myth of the *Phaedrus*.
2. This is in fact a Stoic definition of beauty (*SVF* III 279, 472), but neither Plato nor Aristotle would have dissented from it.
3. A reference to the opinions of Thrasymachus in *Rep.* I 348C.
4. This remarkable statement may be an adaptation to Platonic principles of the Stoic exaltation of 'pure' fire to the position of a creative element in the universe.

5. Actually a quotation from the lost *Melanippe* of Euripides (Fr. 486 Nauck), already applied to Justice by Aristotle at *Eth. Nic.* V 3, 1129b28–29.

6. Cf. *Symp.* 210BC.

7. Actually a reference to *Phaed.* 69c, where Plato refers to 'those who established the mysteries'.

8. Cf. the discussion of the 'purificatory' level of virtue in *Enn.* I. 2, 3ff.

9. Cf. *Symp.* 211e1.

10. A reference to *Phaedr.* 247b5–6.

11. A reference to the myth of Narcissus, drowning through falling in love with his own reflection in a pool, but here allegorized, interestingly, as the soul falling in love with its reflection in Matter.

12. A reference to *Iliad* 2. 140, with which Plotinus connects the homeward strivings of Odysseus (cf. *Od.* 9.29ff. and 10. 483–4), testimony to the allegorizing of the travels and homecoming of Odysseus as a sort of Pilgrim's Progress. The Fatherland for Plotinus is, of course, the intelligible world.

13. Cf. *Phaedr.* 252d7.

14. Cf. *Phaedr.* 254b7.

15. A reference to the Sun Simile of *Rep.* VI 508–9, but probably also to the culmination of the Allegory of the Cave at the beginning of Book VII, where the eyes finally become accustomed to the sunlight.

16. Cf. *Rep.* VII 517b5.

JOSEPHUS

Religious Parties in Roman Judea

Flavius Josephus (c. 37–100 C.E.), originally called Joseph ben Mathias, was an aristocratic Jewish priest of the school of the Pharisees. Though a staunch defender of Jewish religion and culture, a visit to Rome in 64 C.E. convinced him that the Roman Empire was destined for success. He thereafter became notably pro-Roman and tried to control the excesses of the extreme Jewish nationalists. Because of his prominence, he was put in command of Galilee during the Jewish revolt (66–72 C.E.), but was captured in 67 C.E. He survived because he predicted that the general Vespasian would become emperor, as eventually happened. During the remainder of the war, he accompanied Titus, Vespasian's son, then returned with him to Rome, where he became a Roman citizen and enjoyed considerable influence. He devoted the rest of his life to writing a detailed and dramatic account of the Jewish revolt as well as a more general history of the Jews.

The present selection forms part of the background for the revolt by explaining the nature of the rival schools of thought in Judea on the eve of the Roman occupation of 6 C.E.

Among the Jews there are three schools of thought, whose adherents are called Pharisees, Sadducees, and Essenes respectively. The Essenes profess a severer discipline: they are Jews by birth and are peculiarly attached to each other. They eschew pleasure-seeking as a vice and regard temperance and mastery of the passions as virtue. Scorning wedlock, they select other men's children while still pliable and teachable, and fashion them after their own pattern—not that they wish to do away with marriage as a means of continuing the race, but they are afraid of the promiscuity of women and convinced that none of the sex remains faithful to one man. Contemptuous of wealth, they are communists to perfection, and none of them will be found to be better off than the rest: their rule is that novices admitted to the sect must surrender their property to the order, so that among them all neither humiliating poverty nor excessive wealth

is ever seen, but each man's possessions go into the pool and as with brothers their entire property belongs to them all. Oil they regard as polluting, and if a man is unintentionally smeared with it he scrubs himself clean; for they think it desirable to keep the skin dry and always to wear white. Men to supervise the community's affairs are elected by show of hands, chosen for their tasks by universal suffrage.

They possess no one city but everywhere have large colonies.[1] When adherents arrive from elsewhere, all local resources are put at their disposal as if they were their own, and men they have never seen before entertain them like old friends. And so when they travel they carry no baggage at all, but only weapons to keep off bandits. In every town one of the order is appointed specially to look after strangers and issue clothing and provisions. In dress and personal appearance they are like children in the care of a stern tutor. Neither garments nor shoes are changed till they are dropping to pieces or worn out with age. Among themselves nothing is bought or sold: everyone gives what he has to anybody in need and receives from him in return something he himself can use; and even without giving anything in return they are free to share the possessions of anyone they choose.

They show devotion to the Deity in a way all their own. Before the sun rises they do not utter a word on secular affairs, but offer to Him some traditional prayers as if beseeching Him to appear.[2] After this their supervisors send every man to the craft he understands best, and they work assiduously till an hour before noon, when they again meet in one place and donning linen loincloths wash all over with cold water. After this purification they assemble in a building of their own which no one outside their community is allowed to enter; they then go into the refectory in a state of ritual cleanliness as if it was a holy temple and sit down in silence. Then the baker gives them their loaves in turn, and the cook sets before each man one plateful of one kind of food. The priest says grace before meat: to taste the food before this prayer is forbidden. After breakfast he offers a second prayer; for at beginning and end they give thanks to God as the Giver of life. Then removing their garments as sacred they go back to their work till evening. Returning once more they take supper in the same way, seating their guests beside them if any have arrived. Neither shouting nor disorder ever desecrates the house: in conversation each gives way to his neighbour in turn. To people outside the silence within seems like some dread mystery; it is the natural result of their unfailing sobriety and the restriction of their food and drink to a simple sufficiency.

In general they take no action without orders from the supervisors, but two things are left entirely to them—personal aid, and charity; they

may of their own accord help any deserving person in need or supply the penniless with food. But gifts to their own kinsfolk require official sanction. Showing indignation only when justified, they keep their tempers under control; they champion good faith and serve the cause of peace. Every word they speak is more binding than an oath; swearing they reject as something worse than perjury, for they say a man is already condemned if he cannot be believed without God being named. They are wonderfully devoted to the work of ancient writers, choosing mostly books that can help soul and body; from them in their anxiety to cure disease they learn all about medicinal roots and the properties of stones.[3]

Persons desirous of joining the sect are not immediately admitted. For a whole year a candidate is excluded but is required to observe the same rule of life as the members, receiving from them a hatchet,[4] the loin-cloth mentioned above, and white garments. When he has given proof of his temperance during this period, he is associated more closely with the rule and permitted to share the purer waters of sanctification, though not yet admitted to the communal life. He has demonstrated his strength of purpose, but for two more years his character is tested, and if he is then seen to be worthy, he is accepted into the society. But before touching the communal food he must swear terrible oaths, first that he will revere the Godhead, and secondly that he will deal justly with men, will injure no one either of his own accord or at another's bidding, will always hate the wicked and co-operate with the good, and will keep faith at all times and with all men—especially with rulers, since all power is conferred by God. If he himself receives power, he will never abuse his authority and never by dress or additional ornament outshine those under him; he will always love truth and seek to convict liars, will keep his hands from stealing and his soul innocent of unholy gain, and will never hide anything from members of the sect or reveal any of their secrets to others, even if brought by violence to the point of death. He further swears to impart their teaching to no man otherwise than as he himself received it, to take no part in armed robbery, and to preserve the books of the sect and in the same way the names of the angels. Such are the oaths by which they make sure of their converts.

Men convicted of major offences are expelled from the order, and the outcast often comes to a most miserable end; for bound as he is by oaths and customs, he cannot share the diet of non-members, so is forced to eat grass till his starved body wastes away and he dies. Charity compels them to take many offenders back when at their last gasp, since they feel that men tortured to the point of death have paid a sufficient penalty for their offences. In trying cases they are most careful and quite impartial,

and the verdict is given by a jury of not less than a hundred: when they reach a decision there is no appeal. What they reverence most after God is the Lawgiver,[5] and blasphemy against him is a capital offence. Obedience to older men and to the majority is a matter of principle: if ten sit down together one will not speak against the wish of the nine.

They are careful not to spit into the middle of other people or to the right, and they abstain from seventh-day work more rigidly than any other Jews; for not only do they prepare their meals the previous day so as to avoid lighting a fire on the Sabbath, but they do not venture to remove any utensil or to go and ease themselves. On other days they dig a hole a foot deep with their trenching-tool (for such is the hatchet they give to the novices) and draping their cloak round them so as not to affront the rays of the god, they squat over it; then they put the excavated soil back in the hole. On these occasions they choose the more secluded spots; and though emptying the bowels is quite natural, they are taught to wash after it, as if it defiled them.

They are divided into four grades, according to the stage they have reached in their preparation[6]; and so far are the juniors inferior to the seniors that if they touch them the persons touched must wash as though contaminated by an alien. They are long-lived, most of them passing the century, owing to the simplicity of their daily life, I suppose, and the regular routine. They despise danger and conquer pain by sheer will-power: death, if it comes with honour, they value more than life without end. Their spirit was tested to the utmost by the war with the Romans, who racked and twisted, burnt and broke them, subjecting them to every torture yet invented in order to make them blaspheme the Lawgiver or eat some forbidden food, but could not make them do either, or ever once fawn on their tormentors or shed a tear. Smiling in their agony and gently mocking those who tortured them, they resigned their souls in the joyous certainty that they would receive them back.[7]

It is indeed their unshakable conviction that bodies are corruptible and the material composing them impermanent, whereas souls remain immortal for ever. Coming forth from the most rarefied ether they are trapped in the prison-house of the body as if drawn down by one of nature's spells; but once freed from the bonds of the flesh, as if released after years of slavery, they rejoice and soar aloft. Teaching the same doctrine as the sons of Greece, they declare that for the good souls there waits a home beyond the ocean, a place troubled by neither rain nor snow nor heat, but refreshed by the zephyr that blows ever gentle from the ocean. Bad souls they consign to a darksome, stormy abyss, full of punishments that know no end. I think the Greeks had the same notion

when they assigned to their brave men, whom they call heroes or demigods, the Islands of the Blest,[8] and to the souls of the wicked the place of the impious in Hades, where according to their stories certain people undergo punishment—Sisyphus and Tantalus, Ixion and Tityus,[9] and the like. They tell these tales firstly because they believe souls to be immortal, and secondly in the hope of encouraging virtue and discouraging vice, since the good become better in their lifetime through the hope of a reward after death, and the propensities of the bad are restrained by the fear that, even if they are not caught in this life, after their dissolution they will undergo eternal punishment. This then is the religious teaching of the Essenes about the soul, providing an inescapable inducement to those who have once tasted their wisdom.

Some of them claim to foretell the future, after a lifelong study of sacred literature, purifications of different kinds, and the aphorisms of prophets; rarely if ever do their predictions prove wrong.

There is a second order of Essenes, which agrees with the other in its way of life, customs, and rules, and differs only in its views on marriage. They think that the biggest thing in life—the continuance of the race—is forfeited by men who do not marry, and further, if everyone followed their example mankind would rapidly disappear. However, they put their brides on probation for three years, and do not marry them till the regularity of their periods proves them capable of child-bearing.[10] When conception has taken place intercourse ceases—proof that the object of the marriage was not pleasure but the begetting of children. When women bathe they wear a dress just as the men wear a loincloth. Such are the customs of the order.

Of the two schools named first, the Pharisees are held to be the most authoritative exponents of the Law and count as the leading sect.[11] They ascribe everything to Fate or to God: the decision whether or not to do right rests mainly with men, but in every action Fate takes some part. Every soul is imperishable, but only the souls of good men pass into other bodies,[12] the souls of bad men being subjected to eternal punishment. The Sadducees,[13] the second order, deny Fate altogether and hold that God is incapable of either committing sin or seeing it; they say that men are free to choose between good and evil, and each individual must decide which he will follow. The permanence of the soul, punishments in Hades, and rewards they deny utterly. Again, Pharisees are friendly to one another and seek to promote concord with the general public, but Sadducees, even towards each other, show a more disagreeable spirit, and in their relations with men like themselves they are as harsh as they might be to foreigners.

This is all I wish to say about the Jewish schools of thought.

EXPLANATORY NOTES

1. Almost certainly Qumran was one (Appendix E [of *The Jewish War*]).
2. Or 'offer prayers to it (the sun) as if beseeching it to rise', rather surprisingly implying sun-worship. But cf. their extraordinary respect for 'the rays of the god' (paragraph 7).
3. Probably for use as charms or amulets.
4. Its use is given in paragraph 7.
5. Moses.
6. The lowest three are presumably the novices passing through the three years of probation (above).
7. Josephus' account of the war of 66–70 contains no reference to Roman attacks on the Essenes, or indeed to the Essenes themselves except for the rather surprising appointment of one of them as a military commander (p. 180).
8. Hesiod, *Works and Days* 169 ff.; Pindar, *Olymp.* 2, 77 ff.
9. Notorious sinners who suffered picturesque punishments to fit their crimes.
10. The Greek here makes little sense. This suggestion of a possible meaning is based on the Latin translation of Josephus ascribed to the fourth-century writer Rufinus.
11. They stood for strict adherence to the law of Moses in every particular. The Pharisaic scholars and teachers, the rabbis, by discussion and interpretation of the basic law produced a vast quantity of traditional, oral law to supplement it and regulate every aspect of daily life.
12. cf. [later in *The Jewish War*], p. 219, where again acceptance of the doctrine of the transmigration of souls (i.e. the reincarnation of the dead for further lives on earth) held by the Greek philosophers Pythagoras and Plato is attributed to the Pharisees.
13. The Sadducees were the wealthy aristocracy from whom the high priests were drawn.

GREGORY THE GREAT

A Miracle Worker

———

Gregory the Great (540–604 C.E.) is one of the great Christian popes and theologians of late Antiquity and is a Doctor of the Roman Catholic Church. He came from an influential family, received an excellent education, and obtained high public office, but he turned away from a worldly career to live as a monk in Rome. Soon, however, the pope called on him to serve as the papal representative in Constantinople. After five years as a diplomat, Gregory returned to the contemplative life, but not for long: In 590, he was elected pope, much against his will. During his papacy he improved monastic discipline, enforced clerical celibacy, sent missionaries to convert England, expanded the influence of the Western church, and prevented the Lombards from destroying Rome. He was an ardent promoter of Benedictine monasticism. After his death he was declared a saint by popular acclaim. His best-known work, the Dialogues *(c. 593), containing stories about early Latin saints, is an important source for the life of St. Benedict of Nursia, the father of Western monasticism. Gregory's life of Benedict was a model for later Latin hagiography.*

Gregory's life of Benedict recounts the deeds and miracles attributed to this holy man who, having studied in Rome, resolved to abandon worldly pleasures and take up a life of solitude and celibacy.

———

8 At about this time some shepherds also found Benedict concealed in his cave. When they saw him through the bramble bushes, clothed in animal skins, they thought he was some wild beast, but when they came to know God's servant, many of them were transformed and their bestial mentality changed into the grace of devoutness. As a result Benedict's name became known to all throughout the neighbouring areas and it happened that from that time onwards he began to be visited by large numbers of people who brought him food for his body and from his lips took back the food of life in their hearts.

II One day, while he was alone, the tempter came to him. A little bird, commonly known as a blackbird, began to flutter around his head, coming up close to his face in such an insistent manner that the holy man could have caught it in his hand if he had wanted to. Instead he made the sign of the cross and the bird flew away. However, when it had gone, it was followed by a feeling of carnal temptation stronger than any the holy man had ever experienced. For the evil spirit presented to his mind's eye a woman whom he had seen some time earlier, and the sight of her set the soul of God's servant on fire, making it burn so violently that his heart could hardly contain the flame of passion. Benedict almost decided to abandon the wilderness, overcome by sensual pleasure.

2 Suddenly he was touched by heavenly grace and came to himself once more. Seeing some dense bushes with nettles and brambles growing near by, he took off his clothes and threw himself naked into those sharp thorns and stinging nettles. Rolling around in them for a long time, he emerged with sores and scratches all over his body. These wounds to his skin allowed him to remove the mental wound from his body by turning the pleasure to pain. The external pain served as a beneficial punishment for he thereby managed to extinguish the fire burning sinfully within him; and so by transforming the fire he gained a victory over sin.

3 From that time onwards, as he himself later told his disciples, he managed to control the temptation of sexual pleasure so completely that he never experienced it in the slightest. Afterwards, many people began to abandon the world and to hasten to learn from him, for now that he was free from the vice of sexual temptation, it was right that he should become a teacher of virtue. That is why Moses orders that Levites should enter service from the age of twenty-five but from their fiftieth year they should become guardians of the vessels.

4 PETER: I now have some understanding of this text but I would still like you to explain it more fully.

GREGORY: It is obvious, Peter, that when one is young the temptation of the flesh is at its strongest, but from one's fiftieth year the body's heat begins to cool. The sacred vessels are the minds of the faithful: that is why it is necessary for the chosen ones, while they are still victims of temptation, to be subordinate, to serve and tire themselves out in works of obedience; but after the heat of temptation has receded and the mind attains the peace of age, they are the guardians of the vessels for they then are made the teachers of souls.

5 PETER: Yes, I agree with what you say. But now that you have revealed the secrets of this particular text, I beg you to continue with the account you started on of the life of this just man.

III GREGORY: As temptation receded then, the man of God produced a more abundant harvest of virtues, now that he had, as it were, pulled out the weeds from the cultivated soil. As word of his exemplary life spread, his name became increasingly famous.

2 Near by there stood a monastery where the abbot of the community had died. The whole community came to the venerable Benedict and begged him, with earnest entreaties, to become their abbot. For a long time he refused and put them off, predicting that his way of life would not suit the brothers, but at last he had to yield to their entreaties and gave his consent.

3 In that monastery Benedict preserved the life according to a rule, allowing no one, by unlawful behaviour, to turn aside to right or left from the path of the monastic life, as they had done previously. As a result the brothers of whom he was in charge became insanely angry and began to accuse each other for having asked this man to be their abbot, since their deviant behaviour clashed with his standard of rectitude. When they saw that under his leadership unlawful things were no longer lawful, they were aggrieved at having to abandon their habits, for they found it hard that their minds, which were set in their ways, should be forced to think new things (for the life of the virtuous is always a burden to the wicked). As a result they tried to devise a means of killing him.

4 Having decided upon a plan, they put poison into his wine. When the glass vessel containing that deadly drink was offered to their abbot as he reclined at table so that he might bless it in accordance with monastic custom, Benedict stretched out his hand and made the sign of the cross: the goblet broke as soon as this sign was made, even though it was not within his reach. It shattered as if he had thrown a stone at this vessel of death instead of making the sign of the cross. The man of God understood at once that it had contained a deadly drink because it could not bear the sign of life. He got up immediately and with a calm expression and without any agitation he called the brothers together and addressed them, saying, 'May God almighty have pity on you, my brothers. Why do you wish to do this to me? Did I not say to you at the beginning that your ways and mine were incompatible? Go and seek an abbot for yourselves who suits your ways, because after this you definitely cannot have me.'

5 Then he returned to the place of his beloved solitude and lived with himself, alone in the sight of Him who watches from on high.

PETER: I am not really clear what is meant by the phrase 'he lived with himself'.

GREGORY: The way of life of those monks who had united to conspire against him was so completely different from his own that if the holy

man had wished to force them to remain under his rule for a long time and against their will, he might perhaps have exceeded his strength and lost his peace and turned his mind's eye away from the light of contemplation. Each day, exhausted by their refusal to be corrected, he would have neglected his own affairs and might perhaps have abandoned himself without finding them. For whenever we are taken outside ourselves by becoming excessively preoccupied, we remain ourselves but we are no longer with ourselves because we utterly fail to see ourselves as we wander all over the place.

6 Would we say that someone was with himself if he were to go away to a distant country where he spent part of the inheritance he had received and then had to hire himself out to one of the citizens, feeding the man's pigs and watching them munch acorns while he went hungry? When he then begins to think of the good things he has lost, it is about him that Scripture says, *Returning to himself, he said, How many workers there are in my father's house who have plenty of bread!* If he were with himself, how could he return to himself?

7 I would therefore say that this venerable man lived with himself because he always kept watch over himself, always seeing himself in the Creator's eyes, constantly examining himself and not allowing his mind's eye to stray outside himself.

8 PETER: Then how about what is written concerning the apostle Peter when he had been led out of prison by the angel? *When he returned to himself, he said, Now I know for sure that the Lord sent his angel to snatch me from the hand of Herod and from every expectation of the Jewish people.*

9 GREGORY: There are two ways, Peter, in which we are carried outside ourselves: either we fall beneath ourselves by some lapse of thought, or we are raised above ourselves by the grace of contemplation. So the man who fed the pigs fell beneath himself because his mind wandered and because of his filthiness, but he whom the angel released and whose mind was caught up into a state of ecstasy, was outside himself, certainly, but above himself. Both of them returned to themselves, the former when he came back to his senses from the error of his deed, the latter, when from the heights of contemplation he returned to his former, normal state of mind. And so the venerable Benedict lived with himself in solitude, in so far as he kept himself within the walls of his thought, but whenever the ardour of contemplation swept him up on high, he undoubtedly left himself beneath himself.

10 PETER: What you say is clear. But please answer this: was he right to abandon the brothers once he had taken charge of them?

GREGORY: In my opinion, Peter, bad men who have ganged up together ought to be endured with patience if there are some good men among them who can be helped. But when the fruit from good men is completely lacking, effort on behalf of the bad is sometimes wasted, especially if there exist sufficient opportunities for bringing better fruit to God. Who should the holy man have remained to protect, when he saw that they had all united to persecute him?

11 We should also mention what often happens in the mind of those who are perfect: when they see that their efforts are fruitless, they move elsewhere to find more fruitful work. This is the reason why that outstanding preacher who longed to be released and to be with Christ, for whom to live was Christ and to die was profit, only sought painful struggles for himself but also inspired others to endure similar things, after suffering persecution at Damascus, got hold of a basket and a rope so that he could escape and arranged for himself to be let down secretly. Would we say that Paul feared death when he claims to be eager for it for the sake of Jesus' love? No, but when he saw that his hard work was bearing less fruit, he saved himself for more fruitful work elsewhere. God's fearless fighter refused to be imprisoned and went in search of battle in the open.

12 It was the same with the venerable Benedict: if you listen carefully, you will soon realize that in abandoning those who could not be taught and by remaining alive himself he was able to bring many others back to life from spiritual death.

PETER: Clear reason and the fitting evidence you have adduced prove that what you say is true. But I ask you to stop digressing and get back to your account of this great abbot's life.

13 GREGORY: As the holy man increased in virtues and miracles in this wilderness, he inspired many people to gather there to serve the almighty God—so many, in fact, that he built twelve monasteries there with the help of Jesus Christ, the almighty Lord. To each of these monasteries he assigned groups of twelve monks, as well as one abbot for each group. He did however keep a few monks with him, thinking that they would still benefit from his personal instruction.

14 At that time religious men from Roman noble families began to join him, too, and entrust their sons to him so that he might raise them for the almighty Lord. Euthicius and the patrician Tertullus also handed over their offspring, Maurus and Placidus, on whom their hopes of good fortune rested. Of these two, Maurus was slightly older, and as he was growing into a young man of fine character, he began to act as his master's assistant, while Placidus was still only child.

IV In one of these monasteries that he had built all around that area was a monk who could not stand still to pray. As soon as the brothers had bent down to start praying, this man would go outside and engage in worldly and ephemeral activities, letting his thoughts wander. After being repeatedly told off by his abbot, he was taken to the man of God, who also rebuked him in strong terms for his foolishness. Returning to the monastery he could only just manage to hold fast to the admonition of the man of God for two days: on the third day he reverted to his usual practice and began to wander around when it was time for prayer.

2 The abbot of his monastery, whom Benedict had appointed, reported this to the servant of God who said, 'I will come and correct him myself.' So the man of God came to this monastery, and while the brothers were devoting themselves to prayer at the regular time, he saw that after the psalm-singing this monk who could not remain at prayer was being pulled outside by a little black boy tugging at the fringe of his garment. Then Benedict whispered to the abbot of the monastery, who was called Pompeianus, and to Maurus, God's servant, 'Can you not see who is pulling this monk outside?' When they answered, 'No,' he said to them, 'Let us pray that you too might see whom this monk is following.' After praying for two days, the monk Maurus saw him, but Pompeianus, the abbot of the monastery, was unable to see him.

3 And so the next day, after the prayers were finished, the man of God went out of the chapel and found the monk standing outside. Benedict struck the man with his staff for being so spiritually blind and from that day on, the man no longer fell victim to the little black boy's persuasiveness. Instead, he was able to remain still during prayer: it was as if the old enemy had been beaten and no longer dared to try and control his thoughts.

ST. AUGUSTINE OF HIPPO

Augustine Describes His Conversion

St. Augustine of Hippo (354–430 C.E.) was the greatest theologian produced by the Western Church in Antiquity, and remains a leading authority of the Roman Catholic Church to the present day. Born in Thagaste in North Africa to a pagan father and a Christian mother, Augustine was educated in classical literature and rhetoric, eventually becoming a professor of rhetoric in Milan. After his conversion to Christianity he moved back to Africa where he organized a religious community, was ordained a priest, and in 396 C.E., was chosen bishop of Hippo, where he remained until the end of his life. He died in August of 430 C.E., as the Vandal tribes were besieging Hippo.

Augustine's Confessions *(397–398 C.E.) numbers among the great autobiographies in Western literature. It contains the story of Augustine's spiritual journey and his eventual conversion to Catholic Christianity, which Augustine tries to explain in terms of the operation of divine grace on his will and intellect. In the present selection, the most famous part of* The Confessions, *Augustine describes his inner struggle to see the truth and to overcome his worldly attachments.*

12

I probed the hidden depths of my soul and wrung its pitiful secrets from it, and when I mustered them all before the eyes of my heart, a great storm broke within me, bringing with it a great deluge of tears. I stood up and left Alypius so that I might weep and cry to my heart's content, for it occurred to me that tears were best shed in solitude. I moved away far enough to avoid being embarrassed even by his presence. He must have realized what my feelings were, for I suppose I had said something and he had known from the sound of my voice that I was ready to burst into tears. So I stood up and left him where we had been sitting, utterly bewildered. Somehow I flung myself down beneath a fig tree and gave way to the tears which now streamed from my eyes, the sacrifice that is acceptable to you.[1] I had much to say to you, my God, not in these very

words but in this strain: *Lord, will you never be content?*[2] *Must we always taste your vengeance? Forget the long record of our sins.*[3] For I felt that I was still the captive of my sins, and in my misery I kept crying 'How long shall I go on saying "tomorrow, tomorrow"? Why now not? Why not make an end of my ugly sins at this moment?'

I was asking myself these questions, weeping all the while with the most bitter sorrow in my heart, when all at once I heard the sing-song voice of a child in a nearby house. Whether it was the voice of a boy or a girl I cannot say, but again and again it repeated the refrain 'Take it and read, take it and read'. At this I looked up, thinking hard whether there was any kind of game in which children used to chant words like these, but I could not remember ever hearing them before. I stemmed my flood of tears and stood up, telling myself that this could only be a divine command to open my book of Scripture and read the first passage on which my eyes should fall. For I had heard the story of Antony, and I remembered how he had happened to go into a church while the Gospel was being read and had taken it as a counsel addressed to himself when he heard the words *Go home and sell all that belongs to you. Give it to the poor, and so the treasure you have shall be in heaven; then come back and follow me.*[4] By this divine pronouncement he had at once been converted to you.

So I hurried back to the place where Alypius was sitting, for when I stood up to move away I had put down the book containing Paul's Epistles. I seized it and opened it, and in silence I read the first passage on which my eyes fell: *Not in revelling and drunkenness, not in lust and wantonness, not in quarrels and rivalries. Rather, arm yourselves with the Lord Jesus Christ; spend no more thought on nature and nature's appetites.*[5] I had no wish to read more and no need to do so. For in an instant, as I came to the end of the sentence, it was as though the light of confidence flooded into my heart and all the darkness of doubt was dispelled.

I marked the place with my finger or by some other sign and closed the book. My looks now were quite calm as I told Alypius what had happened to me. He too told me what he had been feeling, which of course I did not know. He asked to see what I had read. I showed it to him and he read on beyond the text which I had read. I did not know what followed, but it was this: *Find room among you for a man of over-delicate conscience.*[6] Alypius applied this to himself and told me so. This admonition was enough to give him strength, and without suffering the distress of hesitation he made his resolution and took this good purpose to himself. And it very well suited his moral character, which had long been far, far better than my own.

Then we went in and told my mother, who was overjoyed. And when we went on to describe how it had all happened, she was jubilant with triumph and glorified you, *who are powerful enough, and more than powerful enough, to carry out your purpose beyond all our hopes and dreams.*[7] For she saw that you had granted her far more than she used to ask in her tearful prayers and plaintive lamentations. You converted me to yourself, so that I no longer desired a wife or placed any hope in this world but stood firmly upon the rule of faith, where you had shown me to her in a dream so many years before. And you *turned her sadness into rejoicing,*[8] into joy far fuller than her dearest wish, far sweeter and more chaste than any she had hoped to find in children begotten of my flesh.

EXPLANATORY NOTES

1. See Ps. 50: 19 (51: 17).
2. Ps. 6: 4 (6: 3).
3. Ps. 78: 5, 8 (79: 5, 8).
4. Matt. 19: 21.
5. Rom. 13: 13, 14. Saint Augustine does not quote the whole passage, which begins '*Let us pass our time honourably, as by the light of day, not in revelling and drunkenness,*' etc.
6. Rom. 14: 1.
7. Eph. 3: 20.
8. Ps. 29: 12 (30: 11).

ST. AUGUSTINE OF HIPPO

The Two Cities

———————

St. Augustine of Hippo (354–430 C.E.) was the greatest theologian produced by the Western Church in Antiquity, and remains a leading authority of the Roman Catholic Church to the present day. The story of his spiritual journey and eventual conversion to Catholic Christianity, told in The Confessions *(397–398 C.E.), remains among the great autobiographies in Western literature. Born in Thagaste in North Africa to a pagan father and a Christian mother, Augustine was educated in classical literature and rhetoric, eventually becoming a professor of rhetoric in Milan. After his conversion he moved back to Africa where he organized a religious community, was ordained a priest, and in 396 C.E. was chosen bishop of Hippo, where he remained until the end of his life. He died in August of 430 C.E., as the Vandal tribes were besieging Hippo.*

The City of God, a gigantic work in twenty-two books, was composed between 413 and 426 C.E., just a few decades after Christianity had become the official religion of the Roman Empire. The work was written as a defense of Christianity against pagan critics who argued that the triumph of the Christian faith had led to disaster for the Roman Empire; specifically, that Rome's neglect of her old gods had brought about the sack of Rome by the Goths in 410 C.E. Augustine in response argues that human society, "the city of man," is by its very nature doomed to destruction, and that the goal of the one true God is to save from the human race a chosen remnant, "a city of God," which, united by love of Him, will enjoy eternal bliss in the next life.

———————

BOOK XIV
28. THE CHARACTER OF THE TWO CITIES

We see then that the two cities were created by two kinds of love: the earthly city was created by self-love reaching the point of contempt for God, the Heavenly City by the love of God carried as far as contempt of self. In fact, the earthly city glories in itself, the Heavenly City glories in the Lord.[1] The former looks for glory from men, the latter finds its highest glory in God, the witness of a good conscience. The earthly lifts up its head in its own glory, the Heavenly City says to its God: 'My glory; you lift up my head.'[2] In the former, the lust for domination lords it over its princes as over the nations it subjugates; in the other both those put in authority and those subject to them serve one another in love, the rulers by their counsel, the subjects by obedience. The one city loves its own strength shown in its powerful leaders; the other says to its God, 'I will love you, my Lord, my strength.'[3]

Consequently, in the earthly city its wise men who live by men's standards have pursued the goods of the body or of their own mind, or of both. Or those of them who were able to know God 'did not honour him as God, nor did they give thanks to him, but they dwindled into futility in their thoughts, and their senseless heart was darkened: in asserting their wisdom'—that is, exalting themselves in their wisdom, under the domination of pride—'they became foolish, and changed the glory of the imperishable God into an image representing a perishable man, or birds or beasts or reptiles'—for in the adoration of idols of this kind they were either leaders or followers of the general public—'and they worshipped and served created things instead of the Creator, who is blessed for ever.'[4] In the Heavenly City, on the other hand, man's only wisdom is the devotion which rightly worships the true God, and looks for its reward in the fellowship of the saints, not only holy men but also holy angels, 'so that God may be all in all'.[5]

BOOK XV
1. THE TWO LINES OF DESCENT OF THE HUMAN RACE, ADVANCING FROM THE START TOWARDS DIFFERENT ENDS

Concerning the happiness of paradise and paradise itself, and concerning the life there of the first human beings and their sin, with its punishment, many opinions have been held by different people, many notions have been expressed in speech, or committed to writing. I myself have had a good deal to say on those subjects in previous books,[6] basing my

statements on holy Scripture; what I said there was either what I found stated in Scripture or what I could infer from scriptural statements, always keeping in conformity with the authority of the Bible. A more searching discussion of the subject would produce a great number and a great variety of arguments which would require for their deployment a greater number of volumes than the present work demands and my time permits. The time at my disposal does not allow me to linger on all the questions that may be raised by men with time on their hands and with a curiosity for finer points—the kind of people who are more ready to ask questions than capable of understanding the answers.

All the same, I think that I have already discharged my obligation to the important and knotty problems about the beginning of the world, and of the soul, and of the human race itself. I classify the human race into two branches: the one consists of those who live by human standards, the other of those who live according to God's will. I also call these two classes the two cities, speaking allegorically. By two cities I mean two societies of human beings, one of which is predestined to reign with God for all eternity, the other doomed to undergo eternal punishment with the Devil. But this is their final destiny, and I shall have to speak of that later on.[7] At present, since I have said enough about the origins of these societies, whether in the angels, whose number is unknown to us, or in the two first human beings, it seems to me that I should undertake to describe their development from the time when that first pair began to produce offspring up to the time when mankind will cease to reproduce itself. For the development of these two societies which form my subject lasts throughout this whole stretch of time, or era, in which the dying yield place to the newly-born who succeed them.

Now Cain was the first son born to those two parents of mankind, and he belonged to the city of man; the later son, Abel, belonged to the City of God.[8] It is our own experience that in the individual man, to use the words of the Apostle, 'it is not the spiritual element which comes first, but the animal; and afterwards comes the spiritual',[9] and so it is that everyone, since he takes his origin from a condemned stock, is inevitably evil and carnal to begin with, by derivation from Adam; but if he is reborn into Christ, and makes progress, he will afterwards be good and spiritual. The same holds true of the whole human race. When those two cities started on their course through the succession of birth and death, the first to be born was a citizen of this world, and later appeared one who was a pilgrim and stranger in the world, belonging as he did to the City of God. He was predestined by grace, and chosen by grace, by grace a pilgrim below, and by grace a citizen above. As far as he himself

is concerned he has his origin from the same lump which was con-
demned, as a whole lump, at the beginning. But God like a potter (the
analogy introduced by the Apostle is not impertinent but very pertinent)
made 'out of the same lump one vessel destined for honour, and another
for dishonour'.[10] But the first one made was the vessel for dishonour,
and afterwards came the vessel for honour. For in the individual man, as
I have said, the base condition comes first, and we have to start with that;
but we are not bound to stop at that, and later comes the noble state
towards which we may make progress, and in which we may abide,
when we have arrived at it. Hence it is not the case that every bad man
will become good, but no one will be good who was not bad originally.
Yet the sooner a man changes for the better the more quickly will he
secure for himself the title belonging to his attainment and will hide his
earlier appellation under the later name.

Scripture tells us that Cain founded a city,[11] whereas Abel, as a pil-
grim, did not found one. For the City of the saints is up above, although
it produces citizens here below, and in their persons the City is on pil-
grimage until the time of its kingdom comes. At that time it will assem-
ble all those citizens as they rise again in their bodies; and then they will
be given the promised kingdom, where with their Prince, 'the king of
ages',[12] they will reign, world without end.

. . . .

47. WERE THERE ANY CITIZENS OF THE HEAVENLY CITY OUTSIDE THE RACE OF ISRAEL BEFORE THE CHRISTIAN ERA?

For the same reason, if it has come, or if it ever came, to our knowledge
that any foreigner (I mean by that someone not born of the race of Israel,
and not given a place by that people in the canon of holy Scripture) has
written any prophecy about Christ, he can be quoted by us by way of
surplus. It is not that we should stand in need of his support, if such a
one failed to appear; but there is nothing far-fetched in the belief that
among other peoples besides the Jews there existed men to whom this
mystery was revealed, and who were compelled to go on to proclaim
what they knew. It may be that they shared in the same gracious gift of
God; or perhaps they did not, but were taught by evil angels; for those
spirits, as we know, acknowledged Christ in his presence,[13] when the
Jews did not recognize him. And I do not imagine that the Jews dare to
maintain that no one has ever belonged to God apart from the Israelites,
from the time when the line of Israel began, on the rejection of his elder

brother. Now it is a fact that there was no other people to bear the distinctive title of the people of God; for all that, the Jews cannot deny that in other nations also there have been some men who belonged not by earthly but by heavenly fellowship to the company of the true Israelites, the citizens of the country that is above. In fact, if the Jews deny this, they are very easily proved wrong by the example of Job, that holy and amazing man. He was neither a native of Israel nor a proselyte (that is, a newly admitted member of the people of Israel). He traced his descent from the race of Edom; he was born in Edom; he died there. And such is the praise accorded him in inspired utterances that no man of his period is put on the same level as far as righteousness and devotion are concerned. And although we do not find his date in the *Chronicle*[14] we gather from the book of Job (which the Israelites received into their authoritative canon on its own merits) that he belonged to the time of the third generation after Israel.

I have no doubt that it was the design of God's providence that from this one instance we should know that there could also be those among other nations who lived by God's standards and were pleasing to God, as belonging to the spiritual Jerusalem. But it must not be believed that this was granted to anyone unless he had received a divine revelation of 'the one mediator between God and men, the man Christ Jesus'[15] whose future coming in a material body was fore-announced to the saints of antiquity, just as his coming has been announced to us as something achieved, so that one and the same faith may lead to God, through him, all who are predestined for the City of God, which is God's house and God's temple. Nevertheless, all the prophecies which are produced from non-Jewish sources concerning the grace of God through Jesus Christ may be supposed to be Christian fabrications. That is why there is no surer way of refuting the 'foreigners' of whatever breed, in an argument on this subject, nothing more effective to bring them over to our side, if they are really intelligent, than to produce the inspired predictions about Christ in the texts of the Jewish Scriptures. For the expulsion of the Jews from their own home, and their dispersal throughout the world with a view to this testimony has resulted in the increase of the Church of Christ in every quarter of the globe.

48. HAGGAI'S PROPHECY OF THE FUTURE GLORY OF GOD'S HOUSE FINDS FULFILMENT IN THE CHURCH OF CHRIST

This House of God is of greater glory than was that former house built of wood and precious stones and other costly materials and metals. Thus the

prophecy of Haggai[16] was not fulfilled in the restoration of that earlier temple, for at no time after the restoration can it be shown to have had as great a glory as the temple had in Solomon's time. The truth is rather that the diminished glory of that house is demonstrated first in the cessation of prophecy, and then by great disasters of the nation itself down to the final destruction at the hands of the Romans, as witnessed by the record of events given above.[17] In contrast, this house of ours, which belongs to the new covenant, has assuredly a greater glory in that its stones are of more worth; for they are 'living stones',[18] and the building is constructed of these men who believe and who have themselves been created anew. And yet this new house was symbolized in the restoration of that temple, just because the very renewing of the temple symbolizes in a prophetic message the second covenant, the 'new covenant', as it is called. Thus, when God said, through the mouth of the prophet just mentioned, 'And I shall grant peace in that place',[19] the word 'place' is symbolic, and by it we are to understand the person whom it symbolizes. And so the re-building 'in that place' stands for the Church which was destined to be built by Christ; and the only acceptable meaning of the saying, 'I shall grant peace in this place' is, 'I shall grant peace in the place which this place symbolizes.'

The fact is that all things with symbolic meaning are seen as in some way acting the part of the things they symbolize; for instance, the Apostle says, 'That rock *was* Christ'[20] because the rock in question undoubtedly symbolized Christ. And so the glory of this house, the new covenant, is greater than the glory of the former house, the old covenant, and it will be seen to be even greater when it is dedicated. For then 'will come the one who is longed for by all nations',[21] as the Hebrew reads. Now his first coming was not yet longed for by all nations, for they did not know of him whom they were destined to long for, in whom they had not yet believed. Then too, in the version of the seventy translators (and their rendering is also prophetic), 'will come the chosen of the Lord from all nations'. For then, in truth, none but the elect will come, and it is of them that the Apostle says, 'Just as he has chosen us in him before the foundation of the world.'[22] Then, we may be sure, the master builder himself, who said, 'Many are called, but few are chosen',[23] is going to show us a house, built not of those who were called but came in such a way that they were thrown out of the feast,[24] but of those who have been chosen. And that house will thereafter dread no downfall, whereas at the present time when churches are made up of those, among the rest, who will be separated out as by a winnowing from on the threshing floor; and so the glory of this house is not shown in the splendour which will

be seen, when all who make up the house are those who will be there for ever.

49. THE MIXTURE OF ELECT AND REPROBATE IN THE CHURCH

In this wicked world, and in these evil times, the Church through her present humiliation is preparing for future exaltation. She is being trained by the stings of fear, the tortures of sorrow, the distresses of hardship, and the dangers of temptation; and she rejoices only in expectation, when her joy is wholesome. In this situation, many reprobates are mingled in the Church with the good, and both sorts are collected as it were in the dragnet of the gospel;[25] and in this world, as in a sea, both kinds swim without separation, enclosed in nets until the shore is reached. There the evil are to be divided from the good; and among the good, as it were in his temple, 'God will be all in all.'[26] In fact, we men recognize the fulfilment of the words of the speaker in the psalm, who said, 'I have made an announcement and said: "They are multiplied beyond counting."'[27] This has now been happening, ever since Christ spoke first through the mouth of John, his forerunner, and then by his own mouth, and said, 'Repent; for the kingdom of heaven has drawn near.'

Christ chose disciples, whom he also called 'apostles'. They were men of humble birth, without position, without education, so that if there was any greatness in them or in their doings that greatness would be Christ himself present in them and acting in them. He had one among their number whom, though evil, he used for good, both to fulfil his destiny of suffering and to present to his Church a pattern of forbearance with wicked men. After sowing the seed of the holy gospel, as far as it belonged to him to sow it through his bodily presence, he suffered, he died, he rose again, showing by his suffering what we ought to undergo for the cause of truth, by his resurrection what we ought to hope for in eternity, to say nothing of the deep mystery by which his blood was shed for the remission of sins. Then he spent forty days on earth in the company of his disciples, and in their sight ascended into heaven. Ten days after that he sent the Holy Spirit he had promised; and the greatest and most unmistakable sign of the Spirit's coming to those who believed was that every one of them spoke in the languages of all nations; thus signifying that the unity of the Catholic Church would exist among all nations and would thus speak in all languages.

. . . .

175

17. THE ORIGIN OF PEACE BETWEEN THE HEAVENLY SOCIETY AND THE EARTHLY CITY, AND OF DISCORD BETWEEN THEM

But a household of human beings whose life is not based on faith is in pursuit of an earthly peace based on the things belonging to this temporal life, and on its advantages, whereas a household of human beings whose life is based on faith looks forward to the blessings which are promised as eternal in the future, making use of earthly and temporal things like a pilgrim in a foreign land, who does not let himself be taken in by them or distracted from his course towards God, but rather treats them as supports which help him more easily to bear the burdens of 'the corruptible body which weighs heavy on the soul';[28] they must on no account be allowed to increase the load. Thus both kinds of men and both kinds of households alike make use of the things essential for this mortal life; but each has its own very different end in making use of them. So also the earthly city, whose life is not based on faith, aims at an earthly peace, and it limits the harmonious agreement of citizens concerning the giving and obeying of orders to the establishment of a kind of compromise between human wills about the things relevant to mortal life. In contrast, the Heavenly City—or rather that part of it which is on pilgrimage in this condition of mortality, and which lives on the basis of faith—must needs make use of this peace also, until this mortal state, for which this kind of peace is essential, passes away. And therefore, it leads what we may call a life of captivity in this earthly city as in a foreign land, although it has already received the promise of redemption, and the gift of the Spirit as a kind of pledge of it; and yet it does not hesitate to obey the laws of the earthly city by which those things which are designed for the support of this mortal life are regulated; and the purpose of this obedience is that, since this mortal condition is shared by both cities, a harmony may be preserved between them in things that are relevant to this condition.

But this earthly city has had some philosophers belonging to it whose theories are rejected by the teaching inspired by God. Either led astray by their own speculation or deluded by demons, these thinkers reached the belief that there are many gods who must be won over to serve human ends, and also that they have, as it were, different departments with different responsibilities attached. Thus the body is the department of one god, the mind that of another; and within the body itself, one god is in charge of the head, another of the neck and so on with each of the separate members. Similarly, within the mind, one is responsible for

natural ability, another for learning, another for anger, another for lust; and in the accessories of life there are separate gods over the departments of flocks, grain, wine, oil, forests, coinage, navigation, war and victory, marriage, birth, fertility, and so on.[29] The Heavenly City, in contrast, knows only one God as the object of worship, and decrees, with faithful devotion, that he only is to be served with that service which the Greeks call *latreia,* which is due to God alone. And the result of this difference has been that the Heavenly City could not have laws of religion common with the earthly city, and in defence of her religious laws she was bound to dissent from those who thought differently and to prove a burdensome nuisance to them. Thus she had to endure their anger and hatred, and the assaults of persecution; until at length that City shattered the morale of her adversaries by the terror inspired by her numbers, and by the help she continually received from God.

While this Heavenly City, therefore, is on pilgrimage in this world, she calls out citizens from all nations and so collects a society of aliens, speaking all languages. She takes no account of any difference in customs, laws, and institutions, by which earthly peace is achieved and preserved—not that she annuls or abolishes any of those, rather, she maintains them and follows them (for whatever divergences there are among the diverse nations, those institutions have one single aim— earthly peace), provided that no hindrance is presented thereby to the religion which teaches that the one supreme and true God is to be worshipped. Thus even the Heavenly City in her pilgrimage here on earth makes use of the earthly peace and defends and seeks the compromise between human wills in respect of the provisions relevant to the mortal nature of man, so far as may be permitted without detriment to true religion and piety. In fact, that City relates the earthly peace to the heavenly peace, which is so truly peaceful that it should be regarded as the only peace deserving the name, at least in respect of the rational creation; for this peace is the perfectly ordered and completely harmonious fellowship in the enjoyment of God, and of each other in God. When we arrive at that state of peace, there will be no longer a life that ends in death, but a life that is life in sure and sober truth; there will be no animal body to 'weigh down the soul' in its process of corruption; there will be a spiritual body with no cravings, a body subdued in every part to the will. This peace the Heavenly City possesses in faith while on its pilgrimage, and it lives a life of righteousness, based on this faith,[30] having the attainment of that peace in view in every good action it performs in relation to God, and in relation to a neighbour, since the life of a city is inevitably a social life.

. . . .

30. THE ETERNAL FELICITY OF THE
CITY OF GOD IN ITS PERPETUAL SABBATH

How great will be that felicity, where there will be no evil, where no good will be withheld, where there will be leisure for the praises of God, who will be all in all![31] What other occupation could there be, in a state where there will be no inactivity of idleness, and yet no toil constrained by want? I can think of none. And this is the picture suggested to my mind by the sacred canticle, when I read or hear the words, 'Blessed are those who dwell in your house; they will praise you for ever and ever!'[32]

All the limbs and organs of the body, no longer subject to decay, the parts which we now see assigned to various essential functions, will then be freed from all such constraint, since full, secure, certain and eternal felicity will have displaced necessity; and all those parts will contribute to the praise of God. For even those elements in the bodily harmony of which I have already spoken, the harmonies which, in our present state, are hidden, will then be hidden no longer. Dispersed internally and externally throughout the whole body, and combined with other great and marvellous things that will then be revealed, they will kindle our rational minds to the praise of the great Artist by the delight afforded by a beauty that satisfies the reason.

I am not rash enough to attempt to describe what the movements of such bodies will be in that life, for it is quite beyond my power of imagination. However, everything there will be lovely in its form, and lovely in motion and in rest, for anything that is not lovely will be excluded. And we may be sure that where the spirit wills there the body will straightway be; and the spirit will never will anything but what is to bring new beauty to the spirit and the body.

There will be true glory, where no one will be praised in error or in flattery; there will be true honour, where it is denied to none who is worthy, and bestowed on none who is unworthy. And honour will not be courted by any unworthy claimant, for none but the worthy can gain admission there. There will be true peace, where none will suffer attack from within himself nor from any foe outside.

The reward of virtue will be God himself, who gave the virtue, together with the promise of himself, the best and greatest of all possible promises. For what did he mean when he said, in the words of the prophet, 'I shall be their God, and they will be my people'?[33] Did he not mean, 'I shall be the source of their satisfaction; I shall be everything that men can honourably desire: life, health, food, wealth, glory, honour, peace and every blessing'? For that is also the correct interpretation of

the Apostle's words, 'so that God may be all in all'.[34] He will be the goal of all our longings; and we shall see him for ever; we shall love him without satiety; we shall praise him without wearying. This will be the duty, the delight, the activity of all, shared by all who share the life of eternity.

But what will be the grades of honour and glory here, appropriate to degrees of merit? Who is capable of imagining them, not to speak of describing them? But there will be such distinctions; of that there can be no doubt. And here also that blessed City will find in itself a great blessing, in that no inferior will feel envy of his superior, any more than the other angels are envious of the archangels. No one will wish to be what it has not been granted him to be; and yet he will be bound in the closest bond of peaceful harmony with one to whom it has been granted; just as in the body the finger does not wish to be the eye, since both members are included in the harmonious organization of the whole body. And so although one will have a gift inferior to another, he will have also the compensatory gift of contentment with what he has.

Now the fact that they will be unable to delight in sin does not entail that they will have no free will. In fact, the will will be the freer in that it is freed from a delight in sin and immovably fixed in a delight in not sinning. The first freedom of will, given to man when he was created upright at the beginning, was an ability not to sin, combined with the possibility of sinning. But this last freedom will be more potent, for it will bring the impossibility of sinning; yet this also will be the result of God's gift, not of some inherent quality of nature. For to be a partaker of God is not the same thing as to be God; the inability to sin belongs to God's nature, while he who partakes of God's nature receives the impossibility of sinning as a gift from God. Moreover, the stages of the divine gift had to be preserved. Free will was given first, with the ability not to sin; and the last gift was the inability to sin. The first freedom was designed for acquiring merit; the last was concerned with the reception of a reward. But because human nature sinned when it had the power to sin it is set free by a more abundant gift of grace so that it may be brought to that condition of liberty in which it is incapable of sin.

For the first immortality, which Adam lost by sinning, was the ability to avoid death; the final immortality will be the inability to die and in the same way, the first free will is the ability to avoid sin. For as man cannot lose the will to happiness, so he will not be able to lose the will to piety and justice. By sinning we lose our hold on piety and happiness; and yet in losing our happiness we do not lose the will to happiness. Certainly God himself cannot sin; are we therefore to say that God has no free will?

In the Heavenly City then, there will be freedom of will. It will be one and the same freedom in all, and indivisible in the separate individuals. It will be freed from all evil and filled with all good, enjoying unfailingly the delight of eternal joys, forgetting all offences, forgetting all punishments. Yet it will not forget its own liberation, nor be ungrateful to its liberator. It will remember even its past evils as far as intellectual knowledge is concerned; but it will utterly forget them as far as sense experience is concerned. For the highly trained physician is acquainted with almost all diseases, as far as they can be known in theory, while he is ignorant of most of them in respect of personal experience, since he has not suffered from them.

Thus, knowledge of evil is of two kinds: one in which it is accessible to apprehension by the mind, the other in which it is a matter of direct experience. Similarly, vices are known in one way through the teaching of the wise, and in another way in the evil life of the fools. There are two corresponding ways of forgetting evil. The learned scholar's way of forgetting is different from that of one who has experienced suffering. The scholar forgets by neglecting his studies; the sufferer, by escaping from his misery. The saints will have no sensible recollection of past evils; theirs will be the second kind of forgetfulness by which they will be set free from them all, and they will be completely erased from their feelings.

Yet such is the power of knowledge—and it will be very great in the saints—that it will prevent not only their own past misery but also the eternal misery of the damned from disappearing from memory. Otherwise, if they were to lose the knowledge of their past misery how will they, as the psalm says, 'sing the mercies of the Lord for all eternity'?[35] Nothing will give more joy to that City than this song to the glory of the grace of Christ by whose blood we have been set free. There that precept will find fulfilment: 'Be still, and know that I am God.'[36] That will truly be the greatest of Sabbaths; a Sabbath that has no evening, the Sabbath that the Lord approved at the beginning of creation, where it says, 'God rested on the seventh day from all his works, which he had been doing; and *God blessed the seventh day* and made it holy, because on that day he rested from all his works, which God had begun to do.'[37]

We ourselves shall become that seventh day, when we have been replenished and restored by his blessing and sanctification. There we shall have leisure to be still, and we shall see that he is God, whereas we wished to be that ourselves when we fell away from him, after listening to the Seducer saying, 'You will be like gods.' Then we abandoned the true God, by whose creative help we should have become gods, but by participating in him, not by deserting him. For what have we done without him? We

have 'fallen away in his anger'.[38] But now restored by him and perfected by his greater grace we shall be still and at leisure for eternity, seeing that he is God, and being filled by him when he will be all in all.[39]

For all our good works, when they are understood as being his works, not ours, are then reckoned to us for the attainment of that Sabbath rest. If we ascribe them to ourselves they will be 'servile work', and it is said that, on the Sabbath, 'You shall do no servile work.'[40] Hence the message by the mouth of the prophet Ezekiel: 'I gave them my Sabbaths as a sign between me and them; so that they might know that I am the Lord, and that I sanctify them.'[41] This we shall then know perfectly, when we are perfectly at rest, and in stillness see perfectly that he is God.

Now if the epochs of history are reckoned as 'days', following the apparent temporal scheme of Scripture, this Sabbath period will emerge more clearly as the seventh of those epochs. The first 'day' is the first period, from Adam to the Flood; the second from the Flood to Abraham. Those correspond not by equality in the passage of time, but in respect of the number of generations, for there are found to be ten generations in each of those periods.

From that time, in the scheme of the evangelist Matthew, there are three epochs, which take us down to the coming of Christ; one from Abraham to David, a second from David to the Exile in Babylon, and the third extending to the coming of Christ in the flesh. Thus we have a total of five periods. We are now in the sixth epoch, but that cannot be measured by the number of generations, because it is said, 'It is not for you to know the dates: the Father has decided those by his own authority.'[42] After this present age God will rest, as it were, on the seventh day, and he will cause us, who are the seventh day, to find our rest in him.

However, it would be a long task to go on to discuss each of those epochs in detail. The important thing is that the seventh will be our Sabbath, whose end will not be an evening, but the Lord's Day, an eighth day, as it were, which is to last for ever, a day consecrated by the resurrection of Christ, foreshadowing the eternal rest not only of the spirit but of the body also. There we shall be still and see; we shall see and we shall love; we shall love and we shall praise. Behold what will be, in the end, without end! For what is our end but to reach that kingdom which has no end?

And now, as I think, I have discharged my debt, with the completion, by God's help, of this huge work. It may be too much for some, too little for others. Of both these groups I ask forgiveness. But of those for whom it is enough I make this request: that they do not thank me, but join with me in rendering thanks to God. Amen. Amen.

EXPLANATORY NOTES

1. 2 Cor. 10, 17.
2. Ps. 3, 3.
3. Ps. 18, 1.
4. Rom. 1, 21ff.
5. 1 Cor. 15, 28.
6. Especially Bk xiv.
7. In Bks xix–xxii.
8. cf. Gen. 4, 1f.
9. 1 Cor. 5, 46.
10. Rom. 9, 21.
11. cf. Gen. 4, 17.
12. cf. 1 Tim. 1, 17.
13. cf. Matt. 8, 29; Mark 1, 24; Luke 4, 34.
14. The *Chronicle* of Eusebius-Jerome; cf. ch. 31.
15. 1 Tim. 2, 5.
16. cf. Hagg. 2, 7.
17. In ch. 45.
18. 1 Pet. 2, 5.
19. Hagg. 2, 9.
20. 1 Cor. 10, 4.
21. Hagg. 2, 7.
22. Eph. 1, 4.
23. Matt. 22, 14.
24. cf. Matt. 22, 11ff.
25. cf. Matt. 13, 47ff.
26. 1 Cor. 15, 28.
27. Ps. 40, 5.
28. Wisd. 9, 15.
29. cf. Bks iv, vi, vii.
30. cf Hab. 2, 4; Rom. 1, 17 etc.
31. 1 Cor. 15, 28.
32. Ps. 84, 5.
33. Lev. 26, 12.
34. 1 Cor. 15, 28.
35. Ps. 89, 2.
36. Ps. 46, 11.
37. Gen. 2, 2f.
38. Ps. 90 (lxx).
39. 1 Cor. 15, 28.
40. Deut. 5, 14.
41. Ezek. 20, 12.
42. Acts 1, 7.

BOETHIUS

Wheel of Fortune

Anicius Manlius Torquatus Severinus Boethius (c. 480–524) was the scion of a Christian senatorial family that first came to prominence in Rome during the Constantinian Age. Boethius enjoyed a distinguished career as public servant and as a friend and adviser to the Gothic king Theoderic. Theoderic ruled Italy in the early sixth century in the name of the Roman empire, and under his patronage Boethius rose to hold the title of consul in 510. But Boethius's deepest commitment was to the study of philosophy. He had had a philosophical education in his youth and dedicated his mature years to a great project, never completed, to translate into Latin the complete works of Plato and Aristotle. His own philosophical outlook was deeply colored by Platonism and Augustinianism. His work is a striking example of the fusion between Christian and classical culture that was characteristic of late Antiquity.

Around 524 Boethius became implicated, for reasons that remain unclear, in a court conspiracy and he fell from favor. He was imprisoned in a tower in Pavia, tortured, and finally put to death by bludgeoning. While in prison Boethius wrote what is by far his most famous work, The Consolation of Philosophy, *which became the most widely read philosophical work of the Middle Ages. It was translated into Anglo-Saxon by King Alfred and into Dutch, French, German, and Italian in the later Middle Ages; it inspired important philosophers and literary figures such as Thomas Aquinas, Dante, Chaucer, and Lorenzo de'Medici. The main themes of the book are the nature of true happiness, the justification of God's goodness despite the apparent existence of evil, and the reconciliation of human free will with Divine Providence. In the present selection Boethius gave a famous description of Fortune and her wheel.*

I

After this she fell silent for a while and the very forbearance of her silence made me turn my attention to her. At this she began to speak again.

'If I have fully diagnosed the cause and nature of your condition, you are wasting away in pining and longing for your former good fortune. It is the loss of this which, as your imagination works upon you, has so corrupted your mind. I know the many disguises of that monster, Fortune, and the extent to which she seduces with friendship the very people she is striving to cheat, until she overwhelms them with unbearable grief at the suddenness of her desertion. If you can recall to mind her character, her methods, and the kind of favour she proffers, you will see that in her you did not have and did not lose anything of value. But I am sure it will require no hard work on my part to bring all this back to your memory. It used to be your way whenever she came near with her flattery to attack her with manly arguments and hound her with pronouncements taken from the oracle of my shrine. However, no sudden change of circumstances ever occurs without some upheaval in the mind; and this is why you, too, have deserted for a while your usual calm.

'It is time, then, for you to take a little mild and pleasant nourishment which by being absorbed into your body will prepare the way for something stronger. Let us bring to bear the persuasive powers of sweet-tongued rhetoric, powers which soon go astray from the true path unless they follow my instructions. And let us have as well Music, the maidservant of my house, to sing us melodies of varying mood.

'What is it then O mortal man, that has thrown you down into the slough of grief and despondency? You must have seen something strange and unexpected. But you are wrong if you think Fortune has changed towards you. Change is her normal behaviour, her true nature. In the very act of changing she has preserved her own particular kind of constancy towards you. She was exactly the same when she was flattering you and luring you on with enticements of a false kind of happiness. You have discovered the changing faces of the random goddess. To others she still veils herself, but to you she has revealed herself to the full. If you are satisfied with her ways, you must accept them and not complain. But if you shudder to think of her unreliability, you must turn away and have nothing more to do with her dangerous games. She has caused you untold sorrow when she ought to have been a source of peace. For she has left you, she in whose constancy no man can ever trust. Do you really hold dear that kind of happiness which is destined to pass away? Do you really value the presence of Fortune when you cannot trust her to stay and when her departure will plunge you in sorrow? And if it is impossible to keep her at will and if her flight exposes men to ruin, what else is such a fleeting thing except a warning of coming disaster? It will never be sufficient just to notice what is under one's nose: prudence

calculates what the outcome of things will be. Either way Fortune's very mutability deprives her threats of their terror and her enticements of their allure. And last of all, once you have bowed your neck beneath her yoke, you ought to bear with equanimity whatever happens on Fortune's playground. If after freely choosing her as the mistress to rule your life you want to draw up a law to control her coming and going, you will be acting without any justification and your very impatience will only worsen a lot which you cannot alter. Commit your boat to the winds and you must sail whichever way they blow, not just where you want. If you were a farmer who entrusts his seed to the fields, you would balance the bad years against the good. So now you have committed yourself to the rule of Fortune, you must acquiesce in her ways. If you are trying to stop her wheel from turning,[1] you are of all men the most obtuse. For if it once begins to stop, it will no longer be the wheel of chance.

> 'With domineering hand she moves the turning wheel,
> Like currents in a treacherous bay swept to and fro:
> Her ruthless will has just deposed once fearful kings
> While trustless still, from low she lifts a conquered head;
> No cries of misery she hears, no tears she heeds,
> But steely hearted laughs at groans her deeds have wrung.
> Such is the game she plays, and so she tests her strength;
> Of mighty power she makes parade when one short hour
> Sees happiness from utter desolation grow.'

II

'I would like to continue our discussion a while by using Fortune's own arguments, and I would like you to consider whether her demands are just. "Why do you burden me each day, mortal man," she asks, "with your querulous accusations? What harm have I done you? What possessions of yours have I stolen? Choose any judge you like and sue me for possession of wealth and rank, and if you can show that any part of these belongs by right to any mortal man, I will willingly concede that what you are seeking to regain really did belong to you. When nature brought you forth from your mother's womb I received you naked and devoid of everything and fed you from my own resources. I was inclined to favour you, and I brought you up—and this is what makes you lose patience with me—with a measure of indulgence, surrounding you with all the splendour and affluence at my command. Now I have decided to withdraw my hand. You have been receiving a favour as one who has had the

185

use of another's possessions, and you have no right to complain as if what you have lost was fully your own. You have no cause to begin groaning at me: I have done you no violence. Wealth, honours and the like are all under my jurisdiction. They are my servants and know their mistress. When I come, they come with me, and when I go, they leave as well. I can say with confidence that if the things whose loss you are bemoaning were really yours, you could never have lost them. Surely I am not the only one to be denied the exercise of my rights? The heavens are allowed to bring forth the bright daylight and lay it to rest in the darkness of night: the year is allowed alternately to deck the face of the earth with fruit and flowers and to disfigure it with cloud and cold. The sea is allowed either to be calm and inviting or to rage with storm-driven breakers. Shall man's insatiable greed bind me to a constancy which is alien to my ways? Inconstancy is my very essence; it is the game I never cease to play as I turn my wheel in its every changing circle, filled with joy as I bring the top to the bottom and the bottom to the top. Yes, rise up on my wheel if you like, but don't count it an injury when by the same token you begin to fall, as the rules of the game will require. You must surely have been aware of my ways. You must have heard of Croesus, king of Lydia, who was once able to terrorize his enemy Cyrus, only to be reduced to misery and be condemned to be burnt alive: only a shower of rain saved him.[2] And you must have heard of Aemilius Paulus and how he wept tears of pity at all the disasters that had overwhelmed his prisoner, Perses, the last king of Macedonia.[3] Isn't this what tragedy commemorates with its tears and tumult—the overthrow of happy realms by the random strokes of Fortune? When you were a little boy you must have heard Homer's story of the two jars standing in God's house, the one full of evil and the other of good.[4] Now, you have had more than your share of the good, but have I completely deserted you? Indeed, my very mutability gives you just cause to hope for better things. So you should not wear yourself out by setting your heart on living according to a law of your own in a world that is shared by everyone.

> ' "If Plenty from her well-stocked horn
> With generous hand should distribute
> As many gifts as grains of sand
> The sea churns up when strong winds blow,
> Or stars that shine on starlit nights,
> The human race would still repeat
> Its querulous complaints.
> Though God should gratify their prayers
> With open-handed gifts of gold

And furbish greed with pride of rank,
All that God gave would seem as naught.
Rapacious greed soon swallows all
And opens other gaping mouths;
No reins will serve to hold in check
The headlong course of appetite
Once such largess has fanned the flames
 Of lust to have and hold:
No man is rich who shakes and groans
 Convinced that he needs more." '

EXPLANATORY NOTES

1. Though not original—the wheel of Fortune was a favourite expression of Cicero for instance—this is one of the most striking images in the *Consolation* and is the source of the many medieval allusions to Fortune and her wheel: cf. *Romance of the Rose*, 4807 ff.; Dante, *Hell*, VII, 61 ff.; Chaucer, *Troilus and Criseyde*, IV, 1 ff. There is a fine thirteenth-century painting of the Wheel of Fortune in the choir of Rochester Cathedral. Cf. A. B. Cook, *Zeus, Jupiter and the Oak, The Classical Review*, XVII, 1903, p. 421; D. M. Robinson, *The Wheel of Fortune, Classical Philology*, XLI, 1946, pp. 207 ff. For the Middle Ages: Italo Siciliano, *François Villon et thèmes poétiques du moyen âge*, Paris, 1934, pp. 291 ff.; Emile Mâle, *The Gothic Image* translated by Dora Hussey, Fontana Library ed., pp. 94 ff.; H. R. Patch, *The Goddess Fortuna in Medieval Literature*, Cambridge, Mass., 1927.
2. Herodotus, I, 75 ff.
3. Livy, XLV, 7 ff.
4. *Iliad*, 24, 527 ff. Penguin translation, p. 451.

ANNA COMNENA

Byzantium Meets the Crusaders

Anna Comnena (1083–1153) was the highly educated and ambitious daughter of a successful Byzantine emperor, Alexius Comnenus (who ruled from 1081–1118). Raised at the court, she studied literature and philosophy and developed a real understanding of military matters. When she was very young, she was engaged to the son of a former emperor who was next in line for the throne. When Alexius had a son, however, Anna's hopes were replaced by bitterness. After her husband's early death, Anna married an aristocrat, Nicephorus Bryennius, who wrote a history of his own times. When Nicephorus was also named Caesar, second only to the emperor, it seemed that Anna might after all become an empress, but her hated brother John Comnenus (who ruled from 1118–1143) succeeded. After Anna was involved in two plots to murder him, she was exiled to a monastery, where she spent the last decades of her life, much of it devoted to writing a history in praise of her father. Her work stresses the campaigns of Alexius and reveals the highly negative Byzantine view of the Crusaders who passed through his empire.

This selection gives the Byzantines' first impressions of the unwelcome arrival of the crusading forces.

He had no time to relax before he heard a rumour that countless Frankish armies were approaching. He dreaded their arrival, knowing as he did their uncontrollable passion, their erratic character and their irresolution, not to mention the other peculiar traits of the Kelt, with their inevitable consequences: their greed for money, for example, which always led them, it seemed, to break their own agreements without scruple for any chance reason. He had consistently heard this said of them and it was abundantly justified. So far from despairing, however, he made every effort to prepare for war if need arose. What actually happened was more far-reaching and terrible than rumour suggested, for the whole of the west and all the barbarians who lived between the Adriatic

and the Straits of Gibraltar migrated in a body to Asia, marching across Europe country by country with all their households. The reason for this mass-movement is to be found more or less in the following events. A certain Kelt, called Peter, with the surname Koukoupetros,[1] left to worship at the Holy Sepulchre and after suffering much ill-treatment at the hands of the Turks and Saracens who were plundering the whole of Asia, he returned home with difficulty. Unable to admit defeat, he wanted to make a second attempt by the same route, but realizing the folly of trying to do this alone (worse things might happen to him) he worked out a clever scheme. He decided to preach in all the Latin countries. A divine voice, he said, commanded him to proclaim to all the counts in France that all should depart from their homes, set out to worship at the Holy Shrine and with all their soul and might strive to liberate Jerusalem from the Agarenes.[2] Surprisingly, he was successful. It was as if he had inspired every heart with some divine oracle. Kelts assembled from all parts, one after another, with arms and horses and all the other equipment for war. Full of enthusiasm and ardour they thronged every highway, and with these warriors came a host of civilians, outnumbering the sand of the sea shore or the stars of heaven, carrying palms and bearing crosses on their shoulders. There were women and children, too, who had left their own countries. Like tributaries joining a river from all directions they streamed towards us in full force, mostly through Dacia. The arrival of this mighty host was preceded by locusts, which abstained from the wheat but made frightful inroads on the vines. The prophets of those days interpreted this as a sign that the Keltic army would refrain from interfering in the affairs of Christians but bring dreadful affliction on the barbarian Ishmaelites, who were the slaves of drunkenness and wine and Dionysos. The Ishmaelites are indeed dominated by Dionysos and Eros; they indulge readily in every kind of sexual licence, and if they are circumcised in the flesh they are certainly not so in their passions. In fact, the Ishmaelites are nothing more than slaves—trebly slaves—of the vices of Aphrodite[3]. Hence they reverence and worship Astarte and Ashtaroth, and in their land the figure of the moon and the golden image of Chobar[4] are considered of major importance. Corn, because it is not heady and at the same time is most nourishing, has been accepted as the symbol of Christianity. In the light of this the diviners interpreted the references to vines and wheat. So much for the prophecies. The incidents of the barbarians' advance followed in the order I have given and there was something strange about it, which intelligent people at least would notice. The multitudes did not arrive at the same moment, nor even by the same route—how could they cross the Adriatic *en masse* after setting

out from different countries in such great numbers?—but they made the voyage in separate groups, some first, some in a second party and others after them in order, until all had arrived, and then they began their march across Epirus. Each army as I have said, was preceded by a plague of locusts, so that everyone, having observed the phenomenon several times, came to recognize locusts as the forerunners of Frankish battalions. They had already begun to cross the Straits of Lombardy in small groups when the emperor summoned certain leaders of the Roman forces and sent them to the area round Dyrrachium and Avlona, with instructions to receive the voyagers kindly and export from all countries abundant supplies for them along their route; then to watch them carefully and follow, so that if they saw them making raids or running off to plunder the neighbouring districts, they could check them by light skirmishes. These officers were accompanied by interpreters who understood the Latin language; their duty was to quell any incipient trouble between natives and pilgrims.

EXPLANATORY NOTES

1. Steven Runciman suggests that *chtou* or *kiokio* (Picard words) meaning 'little' may be the origin of this name. He was known to his contemporaries as Peter the Little but we know him as Peter the Hermit.
2. Another name (like Ishmaelites) for the Turks, i.e. descendants of Hagar.
3. Anna is unfair to the Mohammedans, but other authors accuse them of excessive wine-bibbing. She seems to be unaware that Aphrodite, Astarte and Ashtaroth are identical goddesses of love.
4. Chobar (or Chabar), meaning 'The Great', was the name given by the Saracens to the goddess of love. 'Moon' should perhaps be supplanted by 'star' (the Greek *astron* may refer to Lucifer). . . .

Theodora's Scandalous Origins

*Procopius (c. 500–565 C.E.) was born at Caesarea, in Palestine, and was
educated as a lawyer and rhetorician. In 527 C.E., he joined the staff of
Belisarius, the general who reconquered North Africa and Italy for the
emperor Justinian. Procopius accompanied Belisarius on his campaigns and
continued to move in the highest circles of government, becoming prefect
(mayor) of Constantinople in 562 C.E. His major work,* The Histories, *a
long and detailed narrative of the wars of Justinian, is the most important
work of history of the period. He used his own experience, eyewitnesses,
and documents to produce a wide-ranging account of events, peoples, and
places. In about 550 C.E., he produced a totally different work,* The Secret
History, *a scurrilous attack on Justinian, his wife Theodora, and the entire
administration. This reflects the attitude of the aristocracy toward the low-
born rulers and their policies.*

The wealth of detail, objectivity, and classical language of Procopius's
Histories *mark them as the last great representative of the ancient Greek
tradition of writing history. They are the main source for the last period
when the Empire could aspire to supreme power in the Western world. The
scandal and gossip of the* Secret History *provide "behind the scenes"
insights into the workings and corruption of the government and the activ-
ities of the people of Constantinople. The following selection attacks the
empress Theodora, enemy of the established order, by accusing her of start-
ing her career as a prostitute.*

When the children were old enough, they were at once put on the stage
there by their mother, as their appearance was very attractive; not all at
the same time, however, but as each one seemed to her to be mature
enough for this profession. The eldest one, Comito, was already one of
the most popular harlots of the day. Theodora, who came next, clad in a
little tunic with long sleeves, the usual dress of a slave girl, used to assist
her in various ways, following her about and invariably carrying on her

shoulders the bench on which her sister habitually sat at public meetings. For the time being Theodora was still too undeveloped to be capable of sharing a man's bed or having intercourse like a woman; but she acted as a sort of male prostitute to satisfy customers of the lowest type, and slaves at that, who when accompanying their owners to the theatre seized their opportunity to divert themselves in this revolting manner; and for some considerable time she remained in a brothel, given up to this unnatural bodily commerce. But as soon as she was old enough and fully developed, she joined the women on the stage and promptly became a courtesan, of the type our ancestors called 'the dregs of the army'. For she was not a flautist or harpist; she was not even qualified to join the corps of dancers; but she merely sold her attractions to anyone who came along, putting her whole body at his disposal.

Later she joined the actors in all the business of the theatre and played a regular part in their stage performances, making herself the butt of their ribald buffoonery. She was extremely clever and had a biting wit, and quickly became popular as a result. There was not a particle of modesty in the little hussy, and no one ever saw her taken aback: she complied with the most outrageous demands without the slightest hesitation, and she was the sort of girl who if somebody walloped her or boxed her ears would make a jest of it and roar with laughter; and she would throw off her clothes and exhibit naked to all and sundry those regions, both in front and behind, which the rules of decency require to be kept veiled and hidden from masculine eyes.

She used to tease her lovers by keeping them waiting, and by constantly playing about with novel methods of intercourse she could always bring the lascivious to her feet; so far from waiting to be invited by anyone she encountered, she herself by cracking dirty jokes and wiggling her hips suggestively would invite all who came her way, especially if they were still in their teens. Never was anyone so completely given up to unlimited self-indulgence. Often she would go to a bring-your-own-food dinner-party with ten young men or more, all at the peak of their physical powers and with fornication as their chief object in life, and would lie with all her fellow-diners in turn the whole night long: when she had reduced them all to a state of exhaustion she would go to their menials, as many as thirty on occasions, and copulate with every one of them; but not even so could she satisfy her lust.

One night she went into the house of a distinguished citizen during the drinking, and, it is said, before the eyes of all the guests she stood up on the end of the couch near their feet, pulled up her dress in the most disgusting manner as she stood there, and brazenly displayed her

lasciviousness. And though she brought three openings into service, she often found fault with Nature, grumbling because Nature had not made the openings in her nipples wider than is normal, so that she could devise another variety of intercourse in that region. Naturally she was frequently pregnant, but by using pretty well all the tricks of the trade she was able to induce immediate abortion.

Often in the theatre, too, in full view of all the people she would throw off her clothes and stand naked in their midst, having only a girdle about her private parts and her groins—not, however, because she was ashamed to expose these also to the public, but because no one is allowed to appear there absolutely naked: a girdle round the groins is compulsory. With this minimum covering she would spread herself out and lie face upwards on the floor. Servants on whom this task had been imposed would sprinkle barley grains over her private parts, and geese trained for the purpose used to pick them off one by one with their bills and swallow them. Theodora, so far from blushing when she stood up again, actually seemed to be proud of this performance. For she was not only shameless herself, but did more than anyone else to encourage shamelessness.

JUSTINIAN

Sexual Harassment in Ancient Rome

Flavius Justinianus (482–565 C.E.), a Latin speaker from a village in the Balkans, succeeded his uncle as eastern Roman emperor in 527 C.E., at a time when the whole of the Western Roman Empire had been lost to Germanic tribes. He was determined to restore the Roman Empire to its full glory. His armies rapidly reconquered Italy and North Africa, and he embarked on a vast series of reforms and building projects that affected the whole empire. The most enduring among them were the cathedral of St. Sophia in Constantinople and the codification of the Roman law. By Justinian's time, the law, which relied on decrees of emperors and Roman officials, as well as interpretations by famous jurists—some of them going back several hundred years —was in a state of confusion. He appointed a commission to create an organized code, including only what was still relevant. They completed the Digest of Roman Law, *a major part of their work in 533 C.E. Justinian's other projects, however, virtually bankrupted the empire, which was also devastated by the bubonic plague; he lived to see many of his ambitions collapse.*

The present selection, which features the opinions of the Roman jurist Labeo (early first century C.E.), defines the kinds of harassment of women that would be punishable by law.

If anyone accosts young girls who are dressed as slaves he would seem to have committed only a minor offence—and less still if they are got up as prostitutes and not dressed like respectable mothers of families. Therefore if a woman was not (soberly) dressed in matronly clothes, anyone who calls out to her or who entices away her female companion is not guilty of *iniuria*. We must accept the term 'companion' to mean someone who accompanies and follows anyone, and, as Labeo says, they may be slave or free, male or female. Labeo defines 'companion' in this context as one who is appointed to follow someone around for the purpose of keeping him or her company, and it is the abduction of such a person

either privately or in a public place which is *iniuria*; and teachers are included amongst companions. Labeo says further that the abduction is committed not at its outset but only when someone has actually removed the companion from the company of his or her master or mistress. Moreover, not only someone who employs force to do this, but he who simply persuades the companion to leave also seems guilty. And it is not only he who actually abducts the companion who is liable under the Edict, but also anyone who calls out to one of them or follows them around. To 'call out' for this purpose is to make improper suggestions or alluring proposals—this is not like raising a clamour, but it is contrary to good morals. He who simply uses foul language is not making an assault on anyone's virtue but he is liable to an action for the affront.

It is one thing to call out or accost someone, and another thing to follow them about; for he who accosts a woman attacks her virtue by his speech, whereas he who follows her constantly, even silently, dogs her steps. Such assiduous pursuit can be productive of a certain degree of dishonour. It must be remembered however that not everyone who accosts someone or follows her about can be guilty under this Edict (nor will he who does it as a merry prank or by way of rendering some honourable service come within the terms of this Edict), but only someone who acts contrary to good morals.

I think that a betrothed man should be able to bring the action for outrage, for any insult inflicted upon his intended wife is deemed to be an insult to him too.

THE KORAN

The Believer's Duties

The Koran, *according to Muslims, was not written by any human being, but is an eternal creation of God, revealed by him to the prophet Mohammed through the angel Gabriel. For them, it is the direct word of God, an unchangeable holy scripture. It consists of 114 chapters, or* surahs, *revealed over a long period beginning in 610 C.E., memorized and copied on perishable materials in the prophet's lifetime, and edited by the caliph Othman (644–656 C.E.). The chapters were arranged according to their length, not by subject or date of revelation. Some scholars believe the work actually passed through a long period of oral transmission and that it may have introduced confusion when it was finally written down perhaps a century or more after it was revealed. The prophet Mohammed (570–632 C.E.) was a native of Mecca in Arabia, the member of a poor branch of one of the ruling families. He became a merchant, visited Syria with caravans, and eventually married a rich widow. His travels acquainted him with Judaism and Christianity. In 610 C.E., he received his first revelation and began to preach a new religion, Islam. His success in his native city stirred the hostility of the ruling establishment and in 622 C.E. he was forced to take refuge in the city of Medina. Muslims count their era from the date of Mohammed's flight, or* hegira. *At Medina, he became both prophet and head of state, completely reorganizing society according to the revelations he constantly received, and expelling the Jews who refused to hearken to his call. Finally in 630 C.E., he gained control of his native Mecca, whose sacred shrine became, and has remained, the center of the new religion. Mohammed, who made no claims to miracle-working or immortality, died in Medina in 632 C.E.*

Reflecting the prophet's dual civil and religious role, The Koran *bears a mixed message of religious texts, including revelations of God's will, references to prophets of the past (including many familiar from the Old Testament), descriptions of heaven and hell, as well as prescriptions, some quite precise, for running an entire society. The present selection deals with prime obligations of every Moslem regarding diet, retaliation, fasting, and pilgrimage, among others.*

"The Believer's Duties," from Book 2 in *The Koran,* translated by N. J. Dawood, copyright © 1959, 1965, 1966, 1968, 1974, 1990, 1993, 1997 by N. J. Dawood, 26–30. Reprinted by permission of Penguin Books Ltd.

You people! Eat of what is lawful and wholesome on the earth and do not walk in Satan's footsteps, for he is your inveterate foe. He enjoins on you evil and lewdness, and bids you assert about God what you know not. 2:168

When they are told: 'Follow what God has revealed,' they reply: 'We will follow what our fathers practised,' even though their fathers understood nothing and had no guidance.

The unbelievers are like beasts which, call out to them as one may, can hear nothing but a shout and a cry. Deaf, dumb, and blind, they understand nothing.

Believers, eat of the wholesome things with which We have provided you and give thanks to God, if it is Him you worship.

He has forbidden you carrion, blood, and the flesh of swine; also any flesh that is consecrated other than in the name of God. But whoever is driven by necessity, intending neither to sin nor to transgress, shall incur no guilt. God is forgiving and merciful. 2:173

Those that suppress any part of the Scriptures which God has revealed in order to gain some paltry end shall swallow nothing but fire into their bellies. On the Day of Resurrection God will neither speak to them nor purify them. Woeful punishment awaits them. 2:174

Such are those that barter guidance for error and forgiveness for punishment. How steadfastly they seek the Fire! That is because God has revealed the Book with the truth; those that disagree about it are in extreme schism.

Righteousness does not consist in whether you face towards the East or the West. The righteous man is he who believes in God and the Last Day, in the angels and the Book and the prophets; who, though he loves it dearly, gives away his wealth to kinsfolk, to orphans, to the destitute, to the traveller in need and to beggars, and for the redemption of captives; who attends to his prayers and renders the alms levy; who is true to his promises and steadfast in trial and adversity and in times of war. Such are the true believers; such are the God-fearing.

Believers, retaliation is decreed for you in bloodshed: a free man for a free man, a slave for a slave, and a female for a female. He who is pardoned by his aggrieved brother shall be prosecuted according to usage and shall pay him a liberal fine. This is a merciful dispensation from your Lord. He that transgresses thereafter shall be sternly punished. 2:178

Men of understanding! In retaliation you have a safeguard for your lives; perchance you will guard yourselves against evil.

It is decreed that when death approaches, those of you that leave property shall bequeath it equitably to parents and kindred. This is a duty incumbent on the righteous. He that alters a will after hearing it shall be accountable for his crime. God hears all and knows all.

He that suspects an error or an injustice on the part of a testa- 2:182 tor and brings about a settlement among the parties incurs no guilt. God is forgiving and merciful.

Believers, fasting is decreed for you as it was decreed for 2:183 those before you; perchance you will guard yourselves against evil. Fast a certain number of days, but if any one among you is ill or on a journey, let him fast a similar number of days later; and for those that cannot[1] endure it there is a penance ordained: the feeding of a poor man. He that does good of his own accord shall be well rewarded; but to fast is better for you, if you but knew it.

In the month of Ramadān the Koran was revealed, a book of guidance for mankind with proofs of guidance distinguishing right from wrong.[2] Therefore whoever of you is present in that month let him fast. But he who is ill or on a journey shall fast a similar number of days later on.

God desires your well-being, not your discomfort. He desires you to fast the whole month so that you may magnify God and render thanks to Him for giving you His guidance.

If My servants question you about Me, tell them that I am 2:186 near. I answer the prayer of the suppliant when he calls to Me; therefore let them answer My call and put their trust in Me, that they may be rightly guided.

It is now lawful for you to lie with your wives on the night of the fast; they are a comfort to you as you are to them. God knew that you were deceiving yourselves. He has relented towards you and pardoned you. Therefore you may now lie with them and seek what God has ordained for you. Eat and drink until you can tell a white thread from a black one in the light of the coming dawn. Then resume the fast till nightfall and do not approach them, but stay at your prayers in the mosques.

These are the bounds set by God: do not approach them. Thus He makes known His revelations to mankind that they may guard themselves against evil.

Do not devour one another's property by unjust means, nor 2:188
bribe the judges with it in order that you may wrongfully and
knowingly usurp the possessions of other men.

They question you about the phases of the moon. Say: 'They 2:189
are seasons fixed for mankind and for the pilgrimage.'

Righteousness does not consist in entering your dwellings
from the back.[3] The righteous man is he that fears God. Enter
your dwellings by their doors and fear God, so that you may
prosper.

Fight for the sake of God those that fight against you, but do
not attack them first. God does not love aggressors.

Slay them wherever you find them. Drive them out of the
places from which they drove you. Idolatry is more grievous
than bloodshed. But do not fight them within the precincts of
the Holy Mosque unless they attack you there; if they attack
you put them to the sword. Thus shall the unbelievers be
rewarded: but if they mend their ways, know that God is for-
giving and merciful.

Fight against them until idolatry is no more and God's reli- 2:193
gion reigns supreme. But if they desist, fight none except the
evil-doers.

A sacred month for a sacred month: sacred things too are
subject to retaliation. If anyone attacks you, attack him as he
attacked you. Have fear of God, and know that God is with the
righteous.

Give generously for the cause of God and do not with your
own hands cast yourselves into destruction. Be charitable; God
loves the charitable.

Make the pilgrimage and visit the Sacred House for His sake. 2:196
If you cannot, send such offerings as you can afford and do not
shave your heads until the offerings have reached their destina-
tion. But if any of you is ill or suffers from an ailment of the
head, he must do penance either by fasting or by almsgiving or
by offering a sacrifice.

If in peacetime anyone among you combines the visit
with the pilgrimage, he must offer such gifts as he can afford;
but if he lacks the means let him fast three days during the pil-
grimage and seven when he has returned; that is, ten days in
all. That is incumbent on him whose family are not present at
the Holy Mosque. Have fear of God: know that God is stern in
retribution.

Make the pilgrimage in the appointed months. He that intends 2:197
to perform it in those months must abstain from sexual inter-
course, obscene language, and acrimonious disputes while on pil-
grimage. God is aware of whatever good you do. Provide well for
yourselves: the best provision is piety. Fear Me, then, you that
are endowed with understanding.

It shall be no offence for you to seek the bounty of your
Lord. When you come running from 'Arafāt[4] remember God as
you approach the sacred monument. Remember Him that gave
you guidance when you were in error. Then go out from the
place whence the pilgrims will go out and implore the forgive-
ness of God. God is forgiving and merciful. And when you have
fulfilled your sacred duties, remember God as you remember
your forefathers or with deeper reverence.

There are some who say: 'Lord, give us abundance in this 2:201
world.' These shall have no share in the world to come. But
there are others who say: 'Lord, give us what is good both in
this world and in the world to come, and keep us from the tor-
ment of the Fire.' These shall have a share, according to what
they did. Swift is God's reckoning.

Give glory to God on the appointed days. He that departs on
the second day incurs no sin, nor does he who stays on longer, if
he truly fears God. Have fear of God, then, and know that you
shall all be gathered before Him.

EXPLANATORY NOTES

1. Thus Al-Jalālayn; the negative being understood. Alternatively: '. . . and for
 those well able to fast there is a penance ordained.'
2. Alternatively: '. . . with proofs of guidance and *salvation.*'
3. It was the custom of pagan Arabs, on returning from pilgrimage, to enter
 their homes from the back.
4. Near Mecca.

THE KORAN

Women

The Koran, *according to Muslims, was not written by any human being, but is an eternal creation of God, revealed by him to the prophet Mohammed through the angel Gabriel. For them, it is the direct word of God, an unchangeable holy scripture. It consists of 114 chapters, or* surahs, *revealed over a long period beginning in 610 C.E., memorized and copied on perishable materials in the prophet's lifetime, and edited by the caliph Othman (644–656 C.E.). The chapters were arranged according to their length, not by subject or date of revelation. Some scholars believe the work actually passed through a long period of oral transmission and that it may have introduced confusion when it was finally written down perhaps a century or more after it was revealed. The prophet Mohammed (570–632 C.E.) was a native of Mecca in Arabia, the member of a poor branch of one of the ruling families. He became a merchant, visited Syria with caravans, and eventually married a rich widow. His travels acquainted him with Judaism and Christianity. In 610 C.E., he received his first revelation and began to preach a new religion, Islam. His success in his native city stirred the hostility of the ruling establishment and in 622 C.E. he was forced to take refuge in the city of Medina. Muslims count their era from the date of Mohammed's flight, or* hegira. *At Medina, he became both prophet and head of state, completely reorganizing society according to the revelations he constantly received, and expelling the Jews who refused to hearken to his call. Finally in 630 C.E., he gained control of his native Mecca, whose sacred shrine became, and has remained, the center of the new religion. Mohammed, who made no claims to miracle-working or immortality, died in Medina in 632 C.E.*

Reflecting the prophet's dual civil and religious role, The Koran *bears a mixed message of religious texts, including revelations of God's will, reports of prophets of the past (including many familiar from the Old Testament), descriptions of heaven and hell, as well as prescriptions, some quite precise, for running an entire society. This selection tells the male believer how to relate to women, over whom he is said to have natural authority.*

Believers, it is unlawful for you to inherit the women of your 4:19
deceased kinsmen against their will, or to bar them from re-
marrying, in order that you may force them to give up a part of
what you have given them, unless they be guilty of a proven
lewd act. Treat them with kindness; for even if you dislike them,
it may well be that you dislike a thing which God has meant for
your own abundant good.

If you wish to replace one wife with another, do not take 4:20
from her the dowry you have given her even if it be a talent of
gold. That would be improper and grossly unjust; for how can
you take it back when you have lain with each other and entered
into a firm contract?

You shall not marry the women whom your fathers married:
all previous such marriages excepted. That was an evil practice,
indecent and abominable.

Forbidden to you are your mothers, your daughters, your
sisters, your paternal and maternal aunts, the daughters of your
brothers and sisters, your foster-mothers, your foster-sisters,
the mothers of your wives, your step-daughters who are in your
charge, born of the wives with whom you have lain (it is no
offence for you to marry your step-daughters if you have not
consummated your marriage with their mothers), and the wives
of your own begotten sons. You are also forbidden to take in
marriage two sisters at one and the same time: all previous such
marriages excepted. Surely God is forgiving and merciful. Also 4:24
married women, except those whom you own as slaves. Such
is the decree of God. All women other than these are lawful
for you, provided you court them with your wealth in modest
conduct, not in fornication. Give them their dowry for the
enjoyment you have had of them as a duty; but it shall be no
offence for you to make any other agreement among yourselves
after you have fulfilled your duty. Surely God is all-knowing
and wise.

If any one of you cannot afford to marry a free believing 4:25
woman, let him marry a slave-girl who is a believer (God best
knows your faith: you are born one of another). Marry them
with the permission of their masters and give them their dowry
in all justice, provided they are honourable and chaste and have
not entertained other men. If after marriage they commit adul-
tery, they shall suffer half the penalty inflicted upon free adul-
teresses. Such is the law for those of you who fear to commit

sin: but if you abstain, it will be better for you. God is forgiving and merciful.

God desires to make this known to you and to guide you along the paths of those who have gone before you, and to turn to you with mercy. God is all-knowing and wise.

God wishes to forgive you, but those who follow their own appetites wish to see you stray grievously into error. God wishes to lighten your burdens, for man was created weak.

Believers, do not consume your wealth among yourselves in vanity, but rather trade with it by mutual consent.

Do not kill yourselves. God is merciful to you, but he that does that through wickedness and injustice shall be burned in fire. That is easy enough for God.

If you avoid the enormities you are forbidden, We shall pardon your misdeeds and usher you in with all honour. Do not covet the favours by which God has exalted some among you above others. Men shall be rewarded according to their deeds, and women shall be rewarded according to their deeds. Rather implore God to bestow on you His gifts. Surely God has knowledge of all things.

To every parent and kinsman We have appointed heirs who will inherit from them. As for those with whom you have entered into agreements, let them, too, have their share. Surely God bears witness to all things.

Men have authority over women because God has made the one superior to the other, and because they spend their wealth to maintain them. Good women are obedient. They guard their unseen parts because God has guarded them. As for those from whom you fear disobedience, admonish them and send them to beds apart and beat them. Then if they obey you, take no further action against them. Surely God is high, supreme.

If you fear a breach between a man and his wife, appoint an arbiter from his people and another from hers. If they wish to be reconciled, God will bring them together again. Surely God is all-knowing and wise.

THE KORAN

Jews and Christians

The Koran, *according to Muslims, was not written by any human being, but is an eternal creation of God, revealed by him to the prophet Mohammed through the angel Gabriel. For them, it is the direct word of God, an unchangeable holy scripture. It consists of 114 chapters, or surahs, revealed over a long period beginning in 610 C.E., memorized and copied on perishable materials in the prophet's lifetime, and edited by the caliph Othman (644–656 C.E.). The chapters were arranged according to their length, not by subject or date of revelation. Some scholars believe the work actually passed through a long period of oral transmission and that it may have introduced confusion when it was finally written down perhaps a century or more after it was revealed. The prophet Mohammed (570–632 C.E.) was a native of Mecca in Arabia, the member of a poor branch of one of the ruling families. He became a merchant, visited Syria with caravans, and eventually married a rich widow. His travels acquainted him with Judaism and Christianity. In 610 C.E., he received his first revelation and began to preach a new religion, Islam. His success in his native city stirred the hostility of the ruling establishment and in 622 C.E. he was forced to take refuge in the city of Medina. Muslims count their era from the date of Mohammed's flight, or hegira. At Medina, he became both prophet and head of state, completely reorganizing society according to the revelations he constantly received, and expelling the Jews who refused to hearken to his call. Finally in 630 C.E., he gained control of his native Mecca, whose sacred shrine became, and has remained, the center of the new religion. Mohammed, who made no claims to miracle-working or immortality, died in Medina in 632 C.E.*

Reflecting the prophet's dual civil and religious role, The Koran bears a mixed message of religious texts, including revelations of God's will, reports of prophets of the past (including many familiar from the Old Testament), descriptions of heaven and hell, as well as prescriptions, some quite precise, for running an entire society. The present selection explains to Muslims the correct attitude to adopt to Jews and Christians, holding out hopes to those who choose Islam.

"Jews and Christians," from Book 5 in *The Koran*, translated by N. J. Dawood, copyright © 1959, 1965, 1966, 1968, 1974, 1990, 1993, 1997 by N. J. Dawood, 84–88. Reprinted by permission of Penguin Books Ltd.

Apostle, do not grieve for those who plunge headlong into 5:41
unbelief; those who say with their tongues: 'We believe,' but
have no faith in their hearts, and those Jews who listen to lies
and listen to others who have not come to you. They tamper
with words out of their context and say: 'If this be given you,
accept it; if not, then beware!'

You cannot help a man if God intends to try him. Those
whose hearts God does not intend to purify shall be held up to
shame in this world, and in the world to come grievous punish-
ment awaits them.

They listen to falsehoods and practise what is unlawful. If
they come to you, give them your judgement or avoid them. If
you avoid them, they can in no way harm you; but if you do act
as their judge, judge them with fairness. God loves those that
deal justly.

But how will they come to you for judgement when they
already have the Torah which enshrines God's own judgement?
Soon after, they will turn their backs: they are no true believers.

We have revealed the Torah, in which there is guidance and 5:44
light. By it the prophets who surrendered themselves judged the
Jews, and so did the rabbis and the divines, according to God's
Book which had been committed to their keeping and to which
they themselves were witnesses.

Have no fear of man; fear Me, and do not sell My revelations
for a paltry sum. Unbelievers are those who do not judge
according to God's revelations.

We decreed for them a life for a life, an eye for an eye, a nose for
a nose, an ear for an ear, a tooth for a tooth, and a wound for a
wound. But if a man charitably forbears from retaliation, his
remission shall atone for him. Transgressors are those that do not
judge according to God's revelations.

After them We sent forth Jesus son of Mary, confirming the
Torah already revealed, and gave him the Gospel, in which there
is guidance and light, corroborating what was revealed before it
in the Torah: a guide and an admonition to the righteous. There-
fore let those who follow the Gospel judge according to what 5:47
God has revealed therein. Evil-doers are those that do not judge
according to God's revelations.

And to you We have revealed the Book with the truth. It 5:48
confirms the Scriptures which came before it and stands as a
guardian over them. Therefore give judgement among men

according to God's revelations, and do not yield to their whims or swerve from the truth made known to you.

We have ordained a law and assigned a path for each of you. Had God pleased, He could have made of you one community: but it is His wish to prove you by that which He has bestowed upon you. Vie with each other in good works, for to God shall you all return and He will resolve your differences for you.

Pronounce judgement among them according to God's revelations and do not be led by their desires. Take heed lest they turn you away from a part of that which God has revealed to you. If they reject your judgement, know that it is God's wish to scourge them for their sins. A great many of mankind are evil-doers.

Is it pagan laws that they wish to be judged by? Who is a better judge than God for men whose faith is firm?

Believers, take neither the Jews nor the Christians for your friends. They are friends with one another. Whoever of you seeks their friendship shall become one of their number. God does not guide the wrongdoers. 5:51

You see the faint-hearted hastening to woo them. They say: 'We fear lest a change of fortune should befall us.' But it may well be that when God grants you victory or makes known His will, they will regret their secret plans. Then will the faithful say: 'Are these the men who solemnly swore by God that they would stand by you?' Their works will come to nothing and they will lose all.

Believers, if any among you renounce the Faith, God will replace them by others who love Him and are loved by Him, who are humble towards the faithful and stern towards the unbelievers, zealous for God's cause and fearless of man's censure. Such is the grace of God: He bestows it on whom He will. God is munificent and all-knowing. 5:54

Your only protectors are God, His apostle, and the faithful: those who attend to their prayers, render the alms levy, and kneel down in worship. Those who seek the protection of God, His apostle, and the faithful must know that God's followers are sure to triumph. 5:55

Believers, do not seek the friendship of the infidels and those who were given the Book before you, who have made of your religion a jest and a diversion. Have fear of God, if you are true believers. When you call them to pray, they treat their

prayers as a jest and a diversion. This is because they are devoid of understanding.

Say: 'People of the Book, is it not that you hate us only because we believe in God and in what has been revealed to us and to others before, and because most of you are evil-doers?'

Say: 'Shall I tell you who will receive a worse reward from God? Those whom God has cursed and with whom He has been angry, transforming them into apes and swine, and those who serve the devil. Worse is the plight of these, and they have strayed farther from the right path.'

When they came to you they said: 'We are believers.' Indeed, infidels they came and infidels they departed. God knew best what they concealed. 5:61

You see many among them vie with one another in sin and wickedness and practise what is unlawful. Evil is what they do.

Why do their rabbis and divines not forbid them to blaspheme or to practise what is unlawful? Evil indeed are their doings.

The Jews say: 'God's hand is chained.' May their own hands be chained! May they be cursed for what they say! By no means. His hands are both outstretched: He bestows as He will. 5:64

That which is revealed to you from your Lord will surely increase the wickedness and unbelief of many of them. We have stirred among them enmity and hatred, which will endure till the Day of Resurrection. Whenever they kindle the fire of war, God puts it out. They spread evil in the land, but God does not love the evil-doers.

If the People of the Book accept the true faith and keep from evil, We will pardon them their sins and admit them to the gardens of delight. If they observe the Torah and the Gospel and what has been revealed to them from their Lord, they shall enjoy abundance from above and from beneath. 5:65

There are some among them who are righteous men; but there are many among them who do nothing but evil.

Apostle, proclaim what has been revealed to you from your Lord; if you do not, you will surely fail to convey His message. God will protect you from all men. God does not guide the unbelievers.

Say: 'People of the Book, you will attain nothing until you observe the Torah and the Gospel and that which has been revealed to you from your Lord.'

That which has been revealed to you from your Lord will surely increase the wickedness and unbelief of many of them. But do not grieve for the unbelievers.

Believers, Jews, Sabaeans and Christians—whoever believes in God and the Last Day and does what is right—shall have nothing to fear or to regret.

We made a covenant with the Israelites and sent forth apos- 5:70
tles among them. But whenever an apostle came to them with a message that did not suit their inclinations, some they accused of lying and others they put to death. They thought no punish-ment would follow: they were blind and deaf. Then God turned to them in mercy, but many again were blind and deaf. God is ever watching their actions.

Unbelievers are those that say: 'God is the Messiah, the son of Mary.' For the Messiah himself said: 'Children of Israel, serve God, my Lord and your Lord.' He that worships other deities besides God, God will deny him Paradise, and the Fire shall be his home. None shall help the evil-doers.

Unbelievers are those that say: 'God is one of three.' There is but one God. If they do not desist from so saying, those of them that disbelieve shall be sternly punished.

Will they not turn to God in penitence and seek forgiveness 5:74
of Him? God is forgiving and merciful.

The Messiah, the son of Mary, was no more than an apostle: 5:75
other apostles passed away before him. His mother was a saintly woman. They both ate earthly food.

See how We make plain to them Our revelations. See how they ignore the truth.

Say: 'Will you serve instead of God that which can neither harm nor help you? God is He who hears all and knows all.'

Say: 'People of the Book! Do not transgress the bounds of truth in your religion. Do not yield to the desires of those who have erred before; who have led many astray and have them-selves strayed from the even path.'

Those of the Israelites who disbelieved were cursed by David and Jesus son of Mary, because they rebelled and committed evil. Nor did they censure themselves for any wrong they did. Evil were their deeds.

You see many among them making friends with unbelievers. Evil is that to which their souls prompt them. They have incurred the wrath of God and shall endure eternal torment.

Had they believed in God and the Prophet and that which has been revealed to him, they would not have befriended them. But many of them are evil-doers.

You will find that the most implacable of men in their enmity to the faithful are the Jews and the pagans, and that the nearest in affection to them are those who say: 'We are Christians.' That is because there are priests and monks among them; and because they are free from pride. 5:82

When they listen to that which was revealed to the Apostle, you see their eyes fill with tears as they recognize its truth. They say: 'Lord, we believe. Count us among the witnesses. Why should we not believe in God and in the truth that has come down to us? Why should we not hope our Lord will admit us among the righteous?' And for their words God has rewarded them with gardens watered by running streams, where they shall dwell for ever. Such is the recompense of the righteous. But those that disbelieve and deny Our revelations shall become the inmates of Hell.

GREGORY OF TOURS

The Life of Clovis

Gregory of Tours was an important bishop and one of the best-known his-
torians of the early Middle Ages. Born around 539 in the Auvergne region
of what is now France, Gregory came from a distinguished, aristocratic
family whose members included wealthy landowners and Roman senators
on both his mother's and father's side. The rise of Christianity added eccle-
siastical prestige to the family's political and economic status, and Gregory
could claim all but five of his eighteen predecessors as bishop of Tours as
blood relatives. Attaining the rank of bishop in 573, Gregory spent the
remaining twenty-one years of his life presiding over the ecclesiastical wel-
fare of Tours and surrounding cities. Although he probably never left his
native Gaul, Gregory traveled widely within its limits, while his office and
family connections ensured his place in the tangled web of contemporary
Merovingian politics. But Gregory is best known today as the author of
The History of the Franks, *the longest and most important of his written*
works; beyond history, these include saints' lives, miracle stories, a biblical
commentary, and a treatise on church offices.

Gregory began to write his History *soon after he became bishop. Its ten*
books remain one of the most important sources for the history of the
Frankish kingdom, and Gregory's detailed narrative of events in his own
era (Books 5–10) is an unparalleled source for sixth century Merovingian
Gaul. Earlier books in the History *rely on disparate sources for their infor-*
mation, yet all parts of the work reveal the author's concern for historical
accuracy, narrative flair, and a direct, even plain, literary style. The violent
and shifting world of contemporary politics permeates the History's *last six*
books, though Gregory included numerous holy men and their miracles
along with his kings, queens, and warriors. And if he frequently con-
demned the anarchic brutality he found around him, Gregory seems to
have expected some violence as a matter of course from those who wielded
secular power. The present selection, taken from Gregory's account of Clo-
vis I, founder of the Frankish kingdom, describes the great king's momen-
tous conversion from paganism to Christianity at the urging of his wife,
Clotild. The importance of Clovis's conversion is difficult to overestimate,
especially since he became a Catholic, rather than an Arian, Christian and

thus helped ensure Rome's eventual triumph in the Germanic kingdoms of the West.

27. The next thing which happened was that Childeric died. His son Clovis replaced him on the throne. In the fifth year of his reign Syagrius, the King of the Romans[1] and the son of Aegidius, was living in the city of Soissons, where Aegidius himself used to have his residence. Clovis marched against him with his blood-relation Ragnachar, who also had high authority, and challenged him to come out to fight. Syagrius did not hesitate to do so, for he was not afraid of Clovis. They fought each other and the army of Syagrius was annihilated. He fled and made his way as quickly as he could to King Alaric II in Toulouse. Clovis summoned Alaric to surrender the fugitive, informing him that he would attack him in his turn for having given Syagrius refuge. Alaric was afraid to incur the wrath of the Franks for the sake of Syagrius and handed him over bound to the envoys, for the Goths are a timorous race. When Clovis had Syagrius in his power he ordered him to be imprisoned. As soon as he had seized the kingdom of Syagrius he had him killed in secret.

At that time many churches were plundered by the troops of Clovis, for he still held fast to his pagan idolatries. The soldiers had stolen an ewer of great size and wondrous workmanship, together with many other precious objects used in the church service. The bishop of the church in question sent messengers to the King to beg that, even if he would not hand back any of the other sacred vessels, this ewer at least might be restored to the church. The King listened to them and replied: 'Follow me to Soissons, where all the objects which we have seized are to be distributed. If this vessel for which your bishop is asking falls to my share, I will meet his wishes.' They came to Soissons and all the booty was placed in a heap before them. King Clovis addressed his men as follows, pointing to the vessel in question: 'I put it to you, my lusty freebooters, that you should agree here and now to grant me that ewer over and above my normal share.' They listened to what he said and the more rational among them answered: 'Everything in front of us is yours, noble King, for our very persons are yours to command. Do exactly as you wish, for there is none among us who has the power to say you nay.' As they spoke one of their number, a feckless fellow, greedy and prompt to anger, raised his battle-axe and struck the ewer. 'You shall have none of this booty,' he shouted, 'except your fair share.' All present were astounded at his words. The King hid his chagrin under a pretence of

long-suffering patience. He took the vessel and handed it over to the envoy of the church; but in his heart he resented what had happened. At the end of that year he ordered the entire army to assemble on the parade-ground, so that he could examine the state of their equipment. The King went round inspecting them all and came finally to the man who had struck the ewer. 'No other man has equipment in such a bad state as yours,' said he. 'Your javelin is in a shocking condition, and so are your sword and your axe!' He seized the man's axe and threw it on the ground. As the soldier bent forward to pick up his weapon, King Clovis raised his own battle-axe in the air and split his skull with it. 'That is what you did to my ewer in Soissons,' he shouted. The man fell dead. Clovis ordered the others to dismiss. They were filled with mighty dread at what he had done. Clovis waged many wars and won many victories. In the tenth year of his reign he invaded the Thuringians and subjected them to his rule.

28. The King of the Burgundes was called Gundioc: he was of the family of that King Athanaric who persecuted the Christians and about whom I have told you. He had four sons: Gundobad, Godigisel, Chilperic and Gundomar. Gundobad killed his brother Chilperic and drowned Chilperic's wife after tying a stone round her neck. He drove Chilperic's two daughters into exile: the elder, whose name was Chroma, became a religious, and the younger was called Clotild. Clovis often sent envoys to Burgundy and they saw the girl Clotild. They observed that she was an elegant young woman and clever for her years, and they discovered that she was of the blood royal. They reported all this to Clovis and he immediately sent more messengers to Gundobad to ask for her hand in marriage. Gundobad was afraid to refuse and he handed Clotild over to them. They took her back with them, and presented her to their King. Clovis already had a son called Theuderic by one of his mistresses, but he was delighted when he saw Clotild and made her his wife.

29. The first child which Clotild bore for Clovis was a son. She wanted to have her baby baptized, and she kept on urging her husband to agree to this. 'The gods whom you worship are no good,' she would say. 'They haven't even been able to help themselves, let alone others. They are carved out of stone or wood or some old piece of metal. The very names which you have given them were the names of men, not of gods. Take your Saturn, for example, who ran away from his own son to avoid being exiled from his kingdom, or so they say; and Jupiter, that obscene perpetrator of all sorts of mucky deeds, who couldn't keep his hands off

other men, who had his fun with all his female relatives and couldn't
even refrain from intercourse with his own sister,

'. . . Jovisque
Et soror et coniunx,'[2]

to quote her own words. What have Mars and Mercury ever done for any-
one? They may have been endowed with magic arts, but they were cer-
tainly not worthy of being called divine. You ought instead to worship
Him who created at a word and out of nothing heaven, and earth, the sea
and all that therein is,[3] who made the sun to shine, who lit the sky with
stars, who peopled the water with fish, the earth with beasts, the sky with
flying creatures, at whose nod the fields became fair with fruits, the trees
with apples, the vines with grapes, by whose hand the race of man was
made, by whose gift all creation is constrained to serve in deference and
devotion the man He made.' However often the Queen said this, the King
came no nearer to belief. 'All these things have been created and produced
at the command of *our* gods,' he would answer. 'It is obvious that *your* God
can do nothing, and, what is more, there is no proof that he is a God at all.'

The Queen, who was true to her faith, brought her son to be baptized.
She ordered the church to be decorated with hangings and curtains, in the
hope that the King, who remained stubborn in the face of argument, might
be brought to the faith by ceremony. The child was baptized; he was given
the name Ingomer; but no sooner had he received baptism than he died in
his white robes. Clovis was extremely angry. He began immediately to
reproach his Queen. 'If he had been dedicated in the name of my gods,' he
said, 'he would have lived without question; but now that he has been bap-
tized in the name of your God he has not been able to live a single day!' 'I
give thanks to Almighty God,' replied Clotild, 'the Creator of all things,
who has not found me completely unworthy, for He has deigned to wel-
come to His kingdom a child conceived in my womb. I am not at all cast
down in my mind because of what has happened, for I know that my
child, who was called away from this world in his white baptismal robes,
will be nurtured in the sight of God.'

Some time later Clotild bore a second son. He was baptized Chlo-
domer. He began to ail and Clovis said: 'What else do you expect? It will
happen to him as it happened to his brother: no sooner is he baptized in
the name of your Christ than he will die!' Clotild prayed to the Lord and
at His command the baby recovered.

30. Queen Clotild continued to pray that her husband might recognize
the true God and give up his idol-worship. Nothing could persuade him

to accept Christianity. Finally war broke out against the Alamanni and in this conflict he was forced by necessity to accept what he had refused of his own free will. It so turned out that when the two armies met on the battlefield there was great slaughter and the troops of Clovis were rapidly being annihilated. He raised his eyes to heaven when he saw this, felt compunction in his heart and was moved to tears. 'Jesus Christ,' he said, 'you who Clotild maintains to be the Son of the living God, you who deign to give help to those in travail and victory to those who trust in you, in faith I beg the glory of your help. If you will give me victory over my enemies, and if I may have evidence of that miraculous power which the people dedicated to your name say that they have experienced, then I will believe in you and I will be baptized in your name. I have called upon my own gods, but, as I see only too clearly, they have no intention of helping me. I therefore cannot believe that they possess any power, for they do not come to the assistance of those who trust in them. I now call upon you. I want to believe in you, but I must first be saved from my enemies.' Even as he said this the Alamanni turned their backs and began to run away. As soon as they saw that their King was killed, they submitted to Clovis. 'We beg you,' they said, 'to put an end to this slaughter. We are prepared to obey you.' Clovis stopped the war. He made a speech in which he called for peace. Then he went home. He told the Queen how he had won a victory by calling on the name of Christ. This happened in the fifteenth year of his reign.

31. The Queen then ordered Saint Remigius, Bishop of the town of Rheims, to be summoned in secret. She begged him to impart the word of salvation to the King. The Bishop asked Clovis to meet him in private and began to urge him to believe in the true God, Maker of heaven and earth, and to forsake his idols, which were powerless to help him or anyone else. The King replied: 'I have listened to you willingly, holy father. There remains one obstacle. The people under my command will not agree to forsake their gods. I will go and put to them what you have just said to me.' He arranged a meeting with his people, but God in his power had preceded him, and before he could say a word all those present shouted in unison: 'We will give up worshipping our mortal gods, pious King, and we are prepared to follow the immortal God about whom Remigius preaches.' This news was reported to the Bishop. He was greatly pleased and he ordered the baptismal pool to be made ready. The public squares were draped with coloured cloths, the churches were adorned with white hangings, the baptistry was prepared, sticks of incense gave off clouds of perfume, sweet-smelling candles gleamed bright and the

holy place of baptism was filled with divine fragrance. God filled the hearts of all present with such grace that they imagined themselves to have been transported to some perfumed paradise. King Clovis asked that he might be baptized first by the Bishop.[4] Like some new Constantine he stepped forward to the baptismal pool, ready to wash away the sores of his old leprosy and to be cleansed in flowing water from the sordid stains which he had borne so long. As he advanced for his baptism, the holy man of God addressed him in these pregnant words: 'Bow your head in meekness, Sicamber.[5] Worship what you have burnt, burn what you have been wont to worship.'

Saint Remigius was a bishop of immense learning and a great scholar more than anything else, but he was also famous for his holiness and he was the equal of Saint Silvester for the miracles which he performed. We still have an account of his life, which tells how he raised a man from the dead. King Clovis confessed his belief in God Almighty, three in one. He was baptized in the name of the Father, the Son and the Holy Ghost, and marked in holy chrism with the sign of the Cross of Christ. More than three thousand of his army were baptized at the same time. His sister Albofled was baptized, but she soon after died and was gathered to the Lord. The King grieved over her death, but Saint Remigius sent him a consoling letter which began with these words:

> I am greatly distressed and I share your grief at the loss of your sister of pious memory. We can take consolation in this, that she has met her death in such a way that we can look up to her instead of mourning for her.[6]

Another sister of Clovis, called Lanthechild, was converted at the same time. She had accepted the Arian heresy, but she confessed the triune majesty of the Father, the Son and the Holy Ghost, and received the holy chrism.

EXPLANATORY NOTES

1. Syagrius was not King; he was probably Master of the Soldiers.
2. *Aeneid*, 1, 46–7: 'at once sister and wife of Jupiter'.
3. 43. Psalms 146, 6.
4. A.D. 496.
5. The Merovingians claimed to be descended from the Sicambri.
6. The text of this letter still exists.

EINHARD

The Emperor Charlemagne

Einhard (c. 770–840), was born in East Franconia, in the Main valley and was educated at the monastery of Fulda. Soon after 791 he was sent to the court of Charlemagne and was educated at the palace school by the famous Anglo-Saxon scholar Alcuin. He became a close associate of Charlemagne and of his son and successor, Louis the Pious. His most famous work, which is indeed the most famous biography of the Middle Ages, was his Life of Charlemagne *(829–36). Modeled on the* Life of Augustus *by the Roman biographer Suetonius, it is among the most impressive fruits of the Carolingian Renaissance.*

The present selection contains Einhard's description of Charlemagne's character and habits, as well as his piety and devotion to learning, and tells the story of his crowning as emperor in Rome on Christmas Day, 800 C.E., by Pope Leo III.

BOOK III

THE EMPEROR'S PRIVATE LIFE

§18. What has gone before is a fair picture of Charlemagne and all that he did to protect and enlarge his kingdom, and indeed to embellish it. I shall now speak of his intellectual qualities, his extraordinary strength of character, whether in prosperity or adversity, and all the other details of his personal and domestic life.

After the death of his father, at the time when he was sharing the kingship with Carloman, Charlemagne bore with such patience this latter's hatred and jealousy that everyone was surprised that he never lost his temper with his brother.

Then, at the bidding of his mother, he married the daughter of Desiderius, the King of the Longobards. Nobody knows why, but he dismissed this wife after one year. Next he married Hildigard, a woman

of most noble family, from the Swabian race. By her he had three sons, Charles, Pepin and Lewis, and the same number of daughters, Rotrude, Bertha and Gisela. He had three more daughters, Theoderada, Hiltrude and Rothaide, two of these by his third wife, Fastrada, who was from the race of Eastern Franks or Germans, and the last by a concubine whose name I cannot remember. Fastrada died and he married Liutgard, from the Alamanni, but she bore him no children. After Liutgard's death, he took four concubines: Madelgard, who bore him a daughter Ruothilde; Gersvinda, of the Saxon race, by whom he had a daughter Adaltrude; Regina, who bore him Drogo and Hugo; and Adallinda, who became the mother of Theodoric.

Charlemagne's own mother, Bertrada, lived with him in high honour to a very great age. He treated her with every respect and never had a cross word with her, except over the divorce of King Desiderius' daughter, whom he had married on her advice. Bertrada died soon after Hildigard, living long enough to see three grandsons and as many granddaughters in her son's house. Charlemagne buried her with great honour in the church of Saint Denis, where his father lay.

He had a single sister, Gisela by name, who from her childhood onwards had been dedicated to the religious life. He treated her with the same respect which he showed his mother. She died a few years before Charlemagne himself, in the nunnery where she had spent her life.

§19. Charlemagne was determined to give his children, his daughters just as much as his sons, a proper training in the liberal arts which had formed the subject of his own studies. As soon as they were old enough he had his sons taught to ride in the Frankish fashion, to use arms and to hunt. He made his daughters learn to spin and weave wool, use the distaff and spindle, and acquire every womanly accomplishment, rather than fritter away their time in sheer idleness.

Of all his children he lost only two sons and one daughter prior to his own death. These were his eldest son Charles, Pepin whom he had made King of Italy, and Rotrude, the eldest of his daughters, who had been engaged to Constantine, the Emperor of the Greeks. Pepin left one son, called Bernard, and five daughters, Adelhaid, Atula, Gundrada, Berthaid and Theoderada. Charlemagne gave clear proof of the affection which he bore them all, for after the death of Pepin he ordered his grandson Bernard to succeed and he had his granddaughters brought up with his own girls. He bore the death of his two sons and his daughter with less fortitude than one would have expected, considering the strength of his character; for his emotions as a father, which were very deeply rooted, made him burst into tears.

When the death of Hadrian, the Pope of Rome and his close friend, was announced to him, he wept as if he had lost a brother or a dearly loved son. He was firm and steady in his human relationships, developing friendship easily, keeping it up with care and doing everything he possibly could for anyone whom he had admitted to this degree of intimacy.

He paid such attention to the upbringing of his sons and daughters that he never sat down to table without them when he was at home, and never set out on a journey without taking them with him. His sons rode at his side and his daughters followed along behind. Hand-picked guards watched over them as they closed the line of march. These girls were extraordinarily beautiful and greatly loved by their father. It is a remarkable fact that, as a result of this, he kept them with him in his household until the very day of his death, instead of giving them in marriage to his own men or to foreigners, maintaining that he could not live without them. The consequence was that he had a number of unfortunate experiences, he who had been so lucky in all else that he undertook. However, he shut his eyes to all that happened, as if no suspicion of any immoral conduct had ever reached him, or as if the rumour was without foundation.

§20. I did not mention with the others a son called Pepin who was born to Charlemagne by a concubine. He was handsome enough, but a hunchback. At a moment when his father was wintering in Bavaria, soon after the beginning of his campaign against the Huns, this Pepin pretended to be ill and conspired with certain of the Frankish leaders who had won him over to their cause by pretending to offer him the kingship. The plot was discovered and the conspirators were duly punished. Pepin was tonsured and permitted to take up, in the monastery of Prüm, the life of a religious for which he had already expressed a vocation.

Earlier on there had been another dangerous conspiracy against Charlemagne in Germany. All the plotters were exiled, some having their eyes put out first, but the others were not maltreated physically. Only three of them were killed. These resisted arrest, drew their swords and started to defend themselves. They slaughtered a few men and had to be destroyed themselves, as there was no other way of dealing with them.

The cruelty of Queen Fastrada is thought to have been the cause of both these conspiracies, since it was under her influence that Charlemagne seemed to have taken actions which were fundamentally opposed to his normal kindliness and good nature. Throughout the remainder of his life he so won the love and favour of all his fellow human beings, both at home and abroad, that no one ever levelled against him the slightest charge of cruelty or injustice.

§21. He loved foreigners and took great pains to make them welcome. So many visited him as a result that they were rightly held to be a burden not only to the palace, but to the entire realm. In his magnanimity he took no notice at all of this criticism, for he considered that his reputation for hospitality and the advantage of the good name which he acquired more than compensated for the great nuisance of their being there.

§22. The Emperor was strong and well built. He was tall in stature, but not excessively so, for his height was just seven times the length of his own feet. The top of his head was round, and his eyes were piercing and unusually large. His nose was slightly longer than normal, he had a fine head of white hair and his expression was gay and good-humoured. As a result, whether he was seated or standing, he always appeared masterful and dignified. His neck was short and rather thick, and his stomach a trifle too heavy, but the proportions of the rest of his body prevented one from noticing these blemishes. His step was firm and he was manly in all his movements. He spoke distinctly, but his voice was thin for a man of his physique. His health was good, except that he suffered from frequent attacks of fever during the last four years of his life, and towards the end he was lame in one foot. Even then he continued to do exactly as he wished, instead of following the advice of his doctors, whom he came positively to dislike after they advised him to stop eating the roast meat to which he was accustomed and to live on stewed dishes.

He spent much of his time on horseback and out hunting, which came naturally to him, for it would be difficult to find another race on earth who could equal the Franks in this activity. He took delight in steam-baths at the thermal springs, and loved to exercise himself in the water whenever he could. He was an extremely strong swimmer and in this sport no one could surpass him. It was for this reason that he built his palace at Aachen and remained continuously in residence there during the last years of his life and indeed until the moment of his death. He would invite not only his sons to bathe with him, but his nobles and friends as well, and occasionally even a crowd of his attendants and bodyguards, so that sometimes a hundred men or more would be in the water together.

§23. He wore the national dress of the Franks. Next to his skin he had a linen shirt and linen drawers; and then long hose and a tunic edged with silk. He wore shoes on his feet and bands of cloth wound round his legs. In winter he protected his chest and shoulders with a jerkin made of otter skins or ermine. He wrapped himself in a blue cloak and always had a sword strapped to his side, with a hilt and belt of gold or silver. Sometimes

he would use a jewelled sword, but this was only on great feast days or when ambassadors came from foreign peoples. He hated the clothes of other countries, no matter how becoming they might be, and he would never consent to wear them. The only exception to this was one day in Rome when Pope Hadrian entreated him to put on a long tunic and a Greek mantle, and to wear shoes made in the Roman fashion; and then a second time, when Leo, Hadrian's successor, persuaded him to do the same thing. On feast days he walked in procession in a suit of cloth of gold, with jewelled shoes, his cloak fastened with a golden brooch and with a crown of gold and precious stones on his head. On ordinary days his dress differed hardly at all from that of the common people.

§24. He was moderate in his eating and drinking, and especially so in drinking; for he hated to see drunkenness in any man, and even more so in himself and his friends. All the same, he could not go long without food, and he often used to complain that fasting made him feel ill. He rarely gave banquets and these only on high feast days, but then he would invite a great number of guests. His main meal of the day was served in four courses, in addition to the roast meat which his hunters used to bring in on spits and which he enjoyed more than any other food. During his meal he would listen to a public reading or some other entertainment. Stories would be recited for him, or the doings of the ancients told again. He took great pleasure in the books of Saint Augustine and especially in those which are called *The City of God*.

He was so sparing in his use of wine and every other beverage that he rarely drank more than three times in the course of his dinner. In summer, after his midday meal, he would eat some fruit and take another drink; then he would remove his shoes and undress completely, just as he did at night, and rest for two or three hours. During the night he slept so lightly that he would wake four or five times and rise from his bed. When he was dressing and putting on his shoes he would invite his friends to come in. Moreover, if the Count of the Palace told him that there was some dispute which could not be settled without the Emperor's personal decision, he would order the disputants to be brought in there and then, hear the case as if he were sitting in tribunal and pronounce a judgement. If there was any official business to be transacted on that day, or any order to be given to one of his ministers, he would settle it at the same time.

§25. He spoke easily and fluently, and could express with great clarity whatever he had to say. He was not content with his own mother tongue, but took the trouble to learn foreign languages. He learnt Latin so well that he spoke it as fluently as his own tongue; but he understood

Greek better than he could speak it. He was eloquent to the point of sometimes seeming almost garrulous.

He paid the greatest attention to the liberal arts; and he had great respect for men who taught them, bestowing high honours upon them. When he was learning the rules of grammar he received tuition from Peter the Deacon of Pisa, who by then was an old man, but for all other subjects he was taught by Alcuin, surnamed Albinus, another Deacon, a man of the Saxon race who came from Britain and was the most learned man anywhere to be found. Under him the Emperor spent much time and effort in studying rhetoric, dialectic and especially astrology. He applied himself to mathematics and traced the course of the stars with great attention and care. He also tried to learn to write. With this object in view he used to keep writing-tablets and notebooks under the pillows on his bed, so that he could try his hand at forming letters during his leisure moments; but, although he tried very hard, he had begun too late in life and he made little progress.

§26. Charlemagne practised the Christian religion with great devotion and piety, for he had been brought up in this faith since earliest childhood. This explains why he built a cathedral of such great beauty at Aachen, decorating it with gold and silver, with lamps, and with lattices and doors of solid bronze. He was unable to find marble columns for his construction anywhere else, and so he had them brought from Rome and Ravenna.

As long as his health lasted he went to church morning and evening with great regularity and also for early-morning Mass, and the late-night hours. He took the greatest pains to ensure that all church ceremonies were performed with the utmost dignity, and he was always warning the sacristans to see that nothing sordid or dirty was brought into the building or left there. He donated so many sacred vessels made of gold and silver, and so many priestly vestments, that when service time came even those who opened and closed the doors, surely the humblest of all church dignitaries, had no need to perform their duties in their everyday clothes.

He made careful reforms in the way in which the psalms were chanted and the lessons read. He was himself quite an expert at both of these exercises, but he never read the lesson in public and he would sing only with the rest of the congregation and then in a low voice.

§27. He was most active in relieving the poor and in that form of really disinterested charity which the Greeks call *eleemosyna*. He gave alms not only in his own country and in the kingdom over which he reigned, but also across the sea in Syria, Egypt, Africa, Jerusalem, Alexandria and

Carthage. Wherever he heard that Christians were living in want, he look pity on their poverty and sent them money regularly. It was, indeed, precisely for this reason that he sought the friendship of kings beyond the sea, for he hoped that some relief and alleviation might result for the Christians living under their domination.

Charlemagne cared more for the church of the holy Apostle Peter in Rome than for any other sacred and venerable place. He poured into its treasury a vast fortune in gold and silver coinage and in precious stones. He sent so many gifts to the Pope that it was impossible to keep count of them. Throughout the whole period of his reign nothing was ever nearer to his heart than that, by his own efforts and exertion, the city of Rome should regain its former proud position. His ambition was not merely that the church of Saint Peter should remain safe and protected thanks to him, but that by means of his wealth it should be more richly adorned and endowed than any other church. However much he thought of Rome, it still remains true that throughout his whole reign of forty-seven years he went there only four times to fulfil his vows and to offer up his prayers.

§28. These were not the sole reasons for Charlemagne's last visit to Rome. The truth is that the inhabitants of Rome had violently attacked Pope Leo, putting out his eyes and cutting off his tongue, and had forced him to flee to the King for help. Charlemagne really came to Rome to restore the Church, which was in a very bad state indeed, but in the end he spent the whole winter there. It was on this occasion that he received the title of Emperor and Augustus. At first he was far from wanting this. He made it clear that he would not have entered the cathedral that day at all, although it was the greatest of all the festivals of the Church, if he had known in advance what the Pope was planning to do. Once he had accepted the title, he endured with great patience the jealousy of the so-called Roman Emperors, who were most indignant at what had happened. He overcame their hostility only by the sheer strength of his personality, which was much more powerful than theirs. He was for ever sending messengers to them, and in his dispatches he called them his brothers.

§29. Now that he was Emperor, he discovered that there were many defects in the legal system of his own people, for the Franks have two separate codes of law which differ from each other in many points. He gave much thought to how he could best fill the gaps, reconcile the discrepancies, correct the errors and rewrite the laws which were ill-expressed. None of this was ever finished; he added a few sections, but even these remained incomplete. What he did do was to have collected

222

together and committed to writing the laws of all the nations under his jurisdiction which still remained unrecorded.

At the same time he directed that the age-old narrative poems, barbarous enough, it is true, in which were celebrated the warlike deeds of the kings of ancient times, should be written out and so preserved. He also began a grammar of his native tongue.

He gave the months of the year suitable titles in his own tongue. Before his time the Franks had known some of these by Latin names and others by barbarian ones. He gave titles to the twelve winds, not more than four of which, if as many as that, had been distinguished before. To take the months first, he called January *wintarmanoth,* February *hornung,* March *lentzinmanoth,* April *ostarmanoth,* May *winnemanoth,* June *brachmanoth,* July *heuuimanoth,* August *aranmanoth,* September *witumanoth,* October *windumemanoth,* November *herbistmanoth* and December *heilagmanoth.* He gave the following names to the winds: the east wind he called *ostroniwint,* the south-east wind *ostsundroni,* the south-south-east wind *sundostroni* and the south wind *sundroni;* he called the south-south-west wind *sundwestroni,* the south-west wind *westsundroni,* the west wind *westroni,* the north-west wind *westnordroni,* the north-north-west wind *nordwestroni,* the north wind *nordroni,* the north-north-east wind *nordostroni* and the north-east wind *ostnordroni.*

ANONYMOUS

The Death of Roland

The Song of Roland *is probably the oldest French epic poem to survive from the Middle Ages, and the greatest of the genre known as chansons de geste. The date of the poem has long been a matter of dispute, but the* Song's *language, style, and content strongly suggest that it was written around the time of the First Crusade (1095–1099), or shortly thereafter. In solemn and formulaic ten-syllable lines, the poet (perhaps called "Turoldus," but whose identity is otherwise unknown) offers a grand version of the Battle of Roncesvalles (778), turning the minor battle of history into a heroic and horrifically bloody struggle between Christians and Saracens. The poem's plot centers around the treachery of Roland's stepfather, who betrays Charlemagne and Franks when he is sent to negotiate peace with the Saracens. As Charlemagne and the main part of the Frankish army cross the Pyrenees back into France, their rearguard, led by Roland and the "greatest knights of France," is ambushed by an enormous enemy force. The hopeless but glorious cause affords Roland and his mighty comrades a host of opportunities to demonstrate heroic valor, but the poet also draws a careful portrait of conflicting characters and loyalties among the poem's central figures.*

The Song of Roland *and similar epic poems became enormously popular in the twelfth century and the later Middle Ages. Although the work's early date makes it of central importance for the history of Old French literature, its literary merits and complexities extend well beyond its antiquity. It is certain that patterns of oral poetry and performance were central to the form in which it exists today, but it also demonstrates a unity of theme and style that reflects great care on the part of the poet. The passage selected here, one of the most memorable scenes of Western literature, describes the final hours and the death of Roland, beginning with his own "tender grief" at the death of his friend Oliver.*

151

Now Roland sees that his friend is dead,
2025 Lying face down, his head on the ground.
He began to mourn him in tender fashion:
'Lord companion, how sad that you were so bold;
We have been together for days and years.
You have caused me no harm and I have not wronged you.
2030 Now that you are dead, it grieves me to remain alive.'
With these words the marquis faints
Upon his horse named Veillantif.
He is secure in his stirrups of pure gold;
Whichever way he leans, he cannot fall.
...

156

Count Roland fights on nobly;
2100 But his body is very hot and bathed in sweat.
In his head he feels pain and a great ache;
His temples are burst from the blowing of the horn.
But he wants to know if Charles will come;
He draws forth the oliphant and gave a feeble blow.
2105 The emperor halted and listened to him:
'Lords,' he said, 'things are going very badly for us;
Roland, my nephew, will be lost to us this day.
From the sound of the horn I can tell he has not long;
Let those who want to reach him ride fast!
2110 Blow your bugles, as many as there are in this army.'
Sixty thousand men blow so loudly
That the mountains ring out and the valleys respond.
The pagans hear them and they did not take it lightly.
They say to each other: 'We shall soon have Charles here.'

157

2115 The pagans say: 'The emperor is returning. AOI.
Hear how the men of France sound their bugles;
If Charles comes, we shall have great losses.
Our war will begin afresh, if Roland is alive;
We have lost Spain, our land.'
2120 Some four hundred assemble, their helmets laced,
And they think themselves to be the finest on the field.
They attack Roland violently and savagely;
Now the count is under great pressure. AOI.

158

When Count Roland sees them approach,
2125 He becomes so strong, so fierce, so alert.
As long as he remains alive, he will not yield to them;
He sits astride his horse named Veillantif
And urges it on well with his spurs of pure gold.
In the great throng he carries the attack to them
2130 And Archbishop Turpin joins with him.
One pagan said to the next: 'Come on now, friend!
We have heard the bugles of the men of France;
Charles, the mighty king, is on his way back.'
. . .

160

The pagans say: 'How sad that we were ever born!
What a fateful day has dawned for us today!
We have lost our lords and our peers;
Charles, the brave, is returning with his great army.
2150 We can hear the clear bugles of the men of France;
The noise from the call of "Monjoie" is great.
Count Roland is a man of such great ferocity
That he will never be vanquished by mortal man.
Let us cast our spears at him and then leave him be.'
2155 And this they did with darts and wigars in abundance,
Spears and lances and feathered javelins.
Roland's shield was broken and pierced
And the mail in his hauberk smashed and torn.
They failed to get through to his body;
2160 But Veillantif was wounded in thirty places.
It was left for dead beneath the count's body.
The pagans take flight, leaving him be;
Count Roland remains there on foot. AOI.
. . .

163

2200 Roland sets off to scour the field.
He found his companion Oliver
And, clasping him tightly to his breast,
Comes, as best he can, to the archbishop.
He laid him on a shield with the others
2205 And the archbishop absolved them with the cross;

Then his grief and pity grows more intense.
Roland says: 'Fair companion Oliver,
You were the son of Duke Renier,
Who held the march of the Vale of Runers.
2210 For breaking shafts and shattering shields,
For vanquishing and dismaying the arrogant,
For sustaining and counselling worthy men,
And vanquishing and dismaying miscreants,
In no land is there a finer knight.'

164

2215 When Count Roland sees his peers dead
And Oliver, whom he loved so dearly,
He was filled with emotion and begins to weep;
The colour drained completely from his face.
So great was his grief that he could not remain standing;
2220 Like it or no, he falls to the ground in a faint.
The archbishop said: 'What an unhappy fate, baron!'
. . .

166

Count Roland recovers from his faint;
He rises to his feet, but his agony is great.
2235 He looks uphill and he looks downhill;
On the green grass beyond his companions
He perceives the noble baron lying there;
It is the archbishop, sent by God to be his servant;
He confesses his sins and looks upwards;
2240 He joined both his hands and raised them heavenwards,
Beseeching God to grant him paradise.
Turpin, Charles's warrior, is dead;
In great battles and with very fine sermons
Against the pagans he was a constant champion.
2245 May God grant him his holy blessing. AOI.
. . .

168

Roland feels that his death is near;
2260 Through his ears his brains are seeping.

He beseeches God to summon all his peers
And then prays on his own behalf to the angel Gabriel.
To prevent any reproach he took the oliphant
And seized Durendal in his other hand.
2265 Further than a crossbow can fire an arrow
He goes over towards Spain, into a fallow field;
He climbs on to a mound, beneath a beautiful tree.
Four great marble blocks are there
And on the green grass he fell upon his back.
2270 There he fainted, for death is close to him.

169

High are the hills and the trees tower up;
There are four great blocks of shining marble.
Count Roland faints on the green grass;
A Saracen watches him all the while,
2275 Feigning death and lying amongst the others.
He has smeared his body and his face with blood;
He gets to his feet and rushes forward.
He was handsome and strong and very brave;
In his arrogance he embarks on an act of mortal folly.
2280 He seized Roland's body and his armour
And spoke thus: 'Charles's nephew is vanquished.
I shall take this sword to Arabia.'
As he drew it out, the count began to come round.

170

Roland senses that he is taking away his sword;
2285 He opened his eyes and spoke these words to him:
'You are not one of our men, it seems to me.'
He grasps the oliphant, which he never wanted to lose,
And strikes him on his golden helmet, studded with gold and gems.
He shatters the steel, his skull and his bones;
2290 He put both his eyes out of their sockets
And cast him down dead at his feet.
Then he says: 'Wretched pagan, how did you dare
Grab hold of me, without thought for right or wrong?
Anyone who hears of this will regard you as mad.
2295 Now my oliphant is split at its broad end;
The crystal and the gold have come away.'

228

171

Roland feels that he has lost his sight;
He rises to his feet, exerting all his strength.
All the colour has drained from his face.
2300 Before him lies a dark-hued stone;
On it he strikes ten blows in sorrow and bitterness.
The steel grates, but does not break or become notched;
'O, Holy Mary,' said the count, 'help me!
O, my good sword Durendal, what a fate you have suffered!
2305 Now that I am dying, I have no more need of you;
With you I have won so many battles in the field
And conquered so many vast lands,
Which Charles with the hoary-white beard now holds.
May you never be owned by a man who flees in battle!
2310 A very fine vassal has held you for so long;
There will never be such a man in blessed France.'
 . . .

174

2355 Roland feels that death is upon him;
It is moving down from his head to his heart.
He ran over to a pine and beneath it
And lay face down on the green grass.
He places his sword and the oliphant beneath him;
2360 Towards the pagan host he turned his head,
Because it was his earnest wish that
Charles and all his men should say
That he, the noble count, had died victoriously.
He confesses his sins over and over again;
2365 For his sins he proffered his glove to God. AOI.

175

Roland feels that his time has come;
He is on a steep hill facing Spain.
With one hand he beat his breast:
'O God, the Almighty, I confess
2370 My sins, both great and small,
Which I have committed since the time I was born,
Until this day on which I have been overtaken.'
He held out his right glove to God;
Angels come down to him from Heaven. AOI.

2375 Count Roland lay down beneath a pine tree;
 He has turned his face towards Spain.
 Many things began to pass through his mind:
 All the lands which he conquered as a warrior,
 The fair land of France, the men of his lineage,
2380 Charlemagne, his lord, who raised him.
 He cannot help weeping and heaving great sighs;
 But he does not wish to be unmindful of himself.
 He confesses his sins and prays for the grace of God:
 'True Father, who has never lied,
2385 You who brought back Lazarus from the dead
 And rescued Daniel from the lions,
 Protect my soul from every peril
 And from the sins which I have committed in my life.'
 He proffered his right glove to God;
2390 Saint Gabriel took it from his hand.
 Roland laid his head down over his arm;
 With his hands joined he went to his end.
 God sent down his angel Cherubin
 And with him Saint Michael of the Peril.
2395 With them both came Saint Gabriel.
 They bear the count's soul to paradise.
 . . .

Augustine of Canterbury

The Venerable Bede (672–735) was an Anglo-Saxon monk, scholar, and theologian who achieved his most lasting fame as the author of the Ecclesiastical History of the English People. *The scope and success of this pioneering work, completed in 731, have earned him the epithet "Father of English History." Throughout the Middle Ages, however, Bede was better known for his many scriptural commentaries, covering nearly every book in the Bible. Dedicated to the monastic life at the age of seven, Bede spent virtually all of his life at the Northumbrian monasteries of Wearmouth and Jarrow. He devoted himself to a wide range of scholarship, encompassing not just scripture and theology but also grammar, chronology, and computation. A lifelong champion of the Roman method for calculating the date of Easter, Bede's* Ecclesiastical History *and chronological treatises also made the system of reckoning dates according to "the year of our Lord," or* A.D., *widely popular. His command of language and literature, along with his skills as a historian, made him the greatest scholar of his day in the Latin West.*

Bede's modern reputation rests chiefly on the Ecclesiastical History, *though his other works have begun to receive more attention. Covering English history from Roman times to his own day, the work's five books are an indispensable source for the conversion of the Anglo-Saxons to Christianity, and indeed for early English history in general. Astonishing miracles and incredible biographies of holy men and women coexist peacefully with more conventional historical narrative, for Bede's purpose was a moral one, tracing the hand of God in unifying the disparate peoples of Britain under the banner of Catholic (i.e., Roman) Christianity. Like other scholars of his age Bede wrote in Latin, but he hailed vernacular poets like Caedmon (d. 680) who helped spread Christianity among the illiterate. Key events and themes in the* Ecclesiastical History *include the arrival of Christianity in England, the mission of St. Augustine of Canterbury (the "Apostle of England"), the Synod of Whitby in 664 (at which the Roman dating of Easter prevailed over Celtic custom), and the celebration of local miracles and saints. The present selection describes Augustine of Canterbury's missionary and organizational*

"Augustine of Canterbury," from *Ecclesiastical History of the English People*, by Bede, translated by Leo Sherley-Price, revised by R. E. Latham, edited by D. H. Farmer, translation copyright © 1955, 1968 by Leo Sherley-Price; introduction and notes copyright © 1990 by D. H. Farmer, 72, 74–77, 90–91. Reprinted by permission of Penguin Books Ltd.

activities, from his commissioning by Pope Gregory the Great, to his death in the first decade of the seventh century.

BOOK 1
CHAPTER 23: [A.D. 596]

In the year of our Lord 582, Maurice, fifty-fourth in succession from Augustus, became Emperor, and ruled for twenty-one years. In the tenth year of his reign, Gregory, an eminent scholar and administrator, was elected Pontiff of the apostolic Roman see, and ruled it for thirteen years, six months, and ten days. In the fourteenth year of this Emperor, and about the one hundred and fiftieth year after the coming of the English to Britain, Gregory was inspired by God to send his servant Augustine with several other God-fearing monks to preach the word of God to the English nation. . . .

CHAPTER 25: [A.D. 597]

Reassured by the encouragement of the blessed father Gregory, Augustine and his fellow-servants of Christ resumed their work in the word of God, and arrived in Britain. At this time the most powerful king there was Ethelbert, who reigned in Kent and whose domains extended northwards to the river Humber, which forms the boundary between the north and south Angles. . . .

After some days, the king . . . summoned Augustine and his companions to an audience. . . . And when, at the king's command, they had sat down and preached the word of life to the king and his court, the king said: 'Your words and promises are fair indeed; but they are new and uncertain, and I cannot accept them and abandon the age-old beliefs that I have held together with the whole English nation. But since you have travelled far, and I can see you are sincere in your desire to impart to us what you believe to be true and excellent, we will not harm you. We will receive you hospitably and take care to supply you with all that you need; nor will we forbid you to preach and win any people you can to your religion.' The king then granted them a dwelling in the city of Canterbury, which was the chief city of all his realm. . . .

At length the king himself, among others, edified by the pure lives of these holy men and their gladdening promises, the truth of which they confirmed by many miracles, believed and was baptized. Thenceforward, great numbers gathered each day to hear the word of God, forsaking

their heathen rites and entering the unity of Christ's holy Church as believers. While the king was pleased at their faith and conversion, it is said that he would not compel anyone to accept Christianity; for he had learned from his instructors and guides to salvation that the service of Christ must be accepted freely and not under compulsion. Nevertheless, he showed greater favour to believers, because they were fellow-citizens of the kingdom of heaven. And it was not long before he granted his teachers in his capital of Canterbury a place of residence appropriate to their station, and gave them possessions of various kinds to supply their wants.

. . .

CHAPTER 29: [A.D. 601]

Hearing from Bishop Augustine that he had a rich harvest but few to help him gather it, Pope Gregory sent with his envoys several colleagues and clergy, of whom the principal and most outstanding were Mellitus, Justus, Paulinus, and Rufinianus. They brought with them everything necessary for the worship and service of the Church, including sacred vessels, altar coverings, church ornaments, vestments for priests and clergy, relics of the holy Apostles and martyrs, and many books. Gregory also sent a letter to Augustine, telling him that he had dispatched the *pallium* to him, and giving him directions on the appointment of bishops in Britain. This letter runs as follows:

'To our most reverend and holy brother and fellow-bishop Augustine: Gregory, servant of the servants of God.

'While Almighty God alone can grant His servants the ineffable joys of the kingdom of heaven, it is proper that we should reward them with earthly honours, and encourage them by such recognition to devote themselves to their spiritual labours with redoubled zeal. And since the new Church of the English has now, through the goodness of God and your own efforts, been brought to the grace of God, we grant you the privilege of wearing the *pallium* in that Church whenever you perform the solemnities of the Mass. . . .

'You, my brother, are to exercise authority in the Name of our Lord and God Jesus Christ both over those bishops whom you shall consecrate, and any who shall be consecrated by the Bishop of York, and also over all the British bishops. Let Your Grace's words and example show them a pattern of right belief and holy life, so that they may execute their office in right belief and practice and, when God wills, attain the kingdom of heaven. God keep you safe, most reverend brother.

GEOFFREY OF MONMOUTH

King Arthur

———

Geoffrey of Monmouth, author of The History of the Kings of Britain, *told us nothing about himself except his name. It is probable, however, that he was Welsh, born in or around Monmouth, near the border of England. From (at least) 1129 to 1151 he seems to have lived in Oxford, where he may have been a teacher, although the university had not yet been founded. It was during this period that he wrote his* History, *along with* "The Prophecies of Merlin" (now included in the History) and The Life of Merlin. *In 1151 Geoffrey became Bishop-Elect of St. Asaph, in North Wales, though he probably never visited his see. He died in 1155, according to the Welsh chronicles.*

The History of the Kings of Britain *boldly attempts to cover some nineteen hundred years of British history, from its Trojan founder, Brutus (grandson of Aeneas), to the death of Cadwallader in 689. Geoffrey claimed to have gotten his information from an ancient Welsh book, which he translated into Latin as the* History. *Even in his own day, however, Geoffrey was accused of lying and wholesale fabrication, and modern scholars continue to debate the nature of his sources. Perfectly comfortable with miracles and magic spells, Geoffrey also included a host of circumstantial details in his accounts to aid in the appearance of accuracy, and he delighted in harmonizing his chronology with events in biblical and classical history. Sorting fact from fiction in the* History, *therefore, is often difficult or fruitless, but the influence of Geoffrey's work has been profound. Many figures made familiar by later literature make their first appearance here, from King Leir and King Cole to Arthur himself, son of Utherpendragon. In any case, Geoffrey's motive was patriotic: to showcase the glory of Britain and her people. The present selection is taken from his life of King Arthur, and suggests something of the work's epic quality. Arthur's military prowess is clearly in evidence, as well as the wondrous harmony and courtesy of Arthur's Britain.*

———

[*ix.1*] After the death of Utherpendragon, the leaders of the Britons assembled from their various provinces in the town of Silchester and there suggested to Dubricius, the Archbishop of the City of the Legions, that as their King he should crown Arthur, the son of Uther. Necessity urged them on, for as soon as the Saxons heard of the death of King Uther, they invited their own countrymen over from Germany, appointed Colgrin as their leader and began to do their utmost to exterminate the Britons. They had already over-run all that section of the island which stretches from the River Humber to the sea named Caithness.

Dubricius lamented the sad state of his country. He called the other bishops to him and bestowed the crown of the kingdom upon Arthur. Arthur was a young man only fifteen years old; but he was of outstanding courage and generosity, and his inborn goodness gave him such grace that he was loved by almost all the people. Once he had been invested with the royal insignia, he observed the normal custom of giving gifts freely to everyone. Such a great crowd of soldiers flocked to him that he came to an end of what he had to distribute. However, the man to whom open-handedness and bravery both come naturally may indeed find himself momentarily in need, but poverty will never harass him for long. In Arthur courage was closely linked with generosity, and he made up his mind to harry the Saxons, so that with their wealth he might reward the retainers who served his own household. The justness of his cause encouraged him, for he had a claim by rightful inheritance to the kingship of the whole island. He therefore called together all the young men whom I have just mentioned and marched on York.

. . .

Finally, when he had restored the whole country to its earlier dignity, he himself married a woman called Guinevere. She was descended from a noble Roman family and had been brought up in the household of Duke Cador. She was the most beautiful woman in the entire island.

[*ix.10*] As soon as the next summer came round, Arthur fitted out a fleet and sailed off to the island of Ireland, which he was determined to subject to his own authority. The moment he landed, King Gilmaurius, about whom I have told you before, came to meet him with a numberless horde of his peoples ready to fight against him. However, when Arthur began the battle, Gilmaurius' army, which was naked and unarmed, was miserably cut to pieces where it stood, and ran away to any place where it could find refuge. Gilmaurius himself was captured immediately and forced to submit. The remaining princes of the country, thunderstruck by what had happened, followed their King's example and surrendered. The whole of Ireland was thus conquered.

Arthur then steered his fleet to Iceland, defeated the people there and subdued the island. A rumour spread through all the other islands that no country could resist Arthur. Doldavius, King of Gotland, and Gunhpar, King of the Orkneys, came of their own free will to promise tribute and to do homage.

The winter passed and Arthur returned to Britain. He established the whole of his kingdom in a state of lasting peace and then remained there for the next twelve years.

[*ix.11*] Arthur then began to increase his personal entourage by inviting very distinguished men from far-distant kingdoms to join it. In this way he developed such a code of courtliness in his household that he inspired peoples living far away to imitate him. The result was that even the man of noblest birth, once he was roused to rivalry, thought nothing at all of himself unless he wore his arms and dressed in the same way as Arthur's knights. At last the fame of Arthur's generosity and bravery spread to the very ends of the earth; and the kings of countries far across the sea trembled at the thought that they might be attacked and invaded by him, and so lose control of the lands under their dominion. They were so harassed by these tormenting anxieties that they re-built their towns and the towers in their towns, and then went so far as to construct castles on carefully-chosen sites, so that, if invasion should bring Arthur against them, they might have a refuge in their time of need.

All this was reported to Arthur. The fact that he was dreaded by all encouraged him to conceive the idea of conquering the whole of Europe. He fitted out his fleets and sailed first of all to Norway, for he wished to give the kingship of that country to Loth, who was his brother-in-law.[1] Loth was the nephew of Sichelm the King of Norway, who had just died and left him the kingship in his will. However, the Norwegians had refused to accept Loth and had raised a certain Riculf to the royal power, for they considered that they could resist Arthur now that their towns were garrisoned. The son of this Loth, called Gawain, was at that time a boy twelve years old. He had been sent by Arthur's brother-in-law to serve in the household of Pope Sulpicius, who had dubbed him a knight. As soon as Arthur landed on the coast of Norway, as I had begun to explain to you, King Riculf marched to meet him with the entire population of the country and then joined battle with him. Much blood was shed on either side, but in the end the Britons were victorious. They surged forward and killed Riculf and a number of his men. Once they were sure of victory, they invested the cities of Norway and set fire to them everywhere. They scattered the rural population and continued to give full licence to their savagery until they had forced all Norway and all Denmark, too, to accept Arthur's rule.

EXPLANATORY NOTE

1. Geoffrey is in his usual confused state about Loth and Gawain. In the text Loth is called Arthur's 'uncle by marriage'.

SIR THOMAS MALORY

Arthur Becomes King

It is not entirely certain which Thomas Malory composed Le Morte
d'Arthur. *Prevailing opinion, however, attributes it to Thomas Malory of
Warwickshire. This Malory was born in the early fifteenth century and
served as a soldier in Europe under the Earl of Warwick. Little else is
known of Malory, except the unsettling fact that he was jailed for robbery
and rape. He died in 1471. If this Malory did indeed write* Le Morte
d'Arthur, *the text may be set against the historical context of the declining
fortunes of England's Lancastrian dynasty.*

Malory's Le Morte d'Arthur *was published after his death, in 1485, by
the great printer William Caxton (1422–1491). The original text (discov-
ered in 1934) was longer and ordered somewhat differently than the
printed version.* Le Morte d'Arthur *is the most famous version of the leg-
end of King Arthur and his Knights of the Round Table. Arthurian legend
was set in Camelot and concerned the chivalric exploits of Arthur, Guen-
ever, and Lancelot. The legend has little basis in fact, but was based on the
history of an actual British warlord named Arthur, who lived in the fifth
century C.E. The embellished exploits of Arthur—including vast European
conquests, a coronation by the Pope, and a tragic decline—were narrated in
both French and English medieval literature. Malory employed both lin-
guistic traditions in his account, which is one of the great masterpieces of
early English prose fiction. The long literary influence of the Arthurian leg-
end hardly requires comment. Malory's version explores the quintessential
medieval themes of courtly love and aristocratic honor. Its account of a
noble monarch touched by fate and of the passing of a chivalric code must
have been rather tragic in the bloody chaos of the fifteenth century. In the
more stable days of the Tudors and early Stuarts, the legend served as fod-
der for dynastic propaganda.*

CHAPTER 1: *First, How Uther Pendragon sent for the Duke of Cornwall and Igraine his wife, and of their departing suddenly again*

It befell in the days of Uther Pendragon, when he was king of all England, and so reigned, that there was a mighty duke in Cornwall that held war against him long time. And the duke was called the Duke of Tintagel. And so by means King Uther sent for this duke, charging him to bring his wife with him, for she was called a fair lady, and a passing[1] wise, and her name was called Igraine.

So when the duke and his wife were comen unto the king, by the means of great lords they were accorded both. The king liked and loved this lady well, and he made them great cheer[2] out of measure, and desired to have lain by her. But she was a passing good woman, and would not assent unto the king. And then she told the duke her husband, and said, 'I suppose that we were sent for that I should be dishonoured, wherefore, husband, I counsel you that we depart from hence suddenly, that we may ride all night unto our own castle.' And in like wise as she said so they departed, that neither the king nor none of his council were ware of their departing.

As soon as King Uther knew of their departing so suddenly, he was wonderly wroth. Then he called to him his privy council, and told them of the sudden departing of the duke and his wife. Then they advised the king to send for the duke and his wife by a great charge: 'And if he will not come at your summons, then may ye do your best, then have ye cause to make mighty war upon him.'

So that was done, and the messengers had their answers, and that was this shortly, that neither he nor his wife would not come at him. Then was the king wonderly wroth. And then the king sent him plain word again, and bad him be ready and stuff him and garnish him,[3] for within forty days he would fetch him out of the biggest castle that he hath.

When the duke had this warning, anon he went and furnished and garnished two strong castles of his, of the which the one hight Tintagel, and the other castle hight Terrabil. So his wife Dame Igraine he put in the Castle of Tintagel, and himself he put in the Castle of Terrabil, the which had many issues and posterns out. Then in all haste came Uther with a great host, and laid a siege about the Castle of Terrabil. And there he pitched many pavilions, and there was great war made on both parties, and much people slain.

Then for pure anger and for great love of fair Igraine the King Uther fell sick. So came to the King Uther Sir Ulfius, a noble knight, and asked the king why he was sick.

'I shall tell thee,' said the king. 'I am sick for anger and for love of fair Igraine that I may not be whole.'

'Well, my lord,' said Sir Ulfius, 'I shall seek Merlin, and he shall do you remedy, that your heart shall be pleased.'

So Ulfius departed, and by adventure he met Merlin in a beggar's array, and there Merlin asked Ulfius whom he sought. And he said he had little ado to tell him.

'Well,' said Merlin, 'I know whom thou seekest, for thou seekest Merlin; therefore seek no farther, for I am he, and if King Uther will well reward me, and be sworn unto me to fulfil my desire, that shall be his honour and profit more than mine, for I shall cause him to have all his desire.'

'All this will I undertake,' said Ulfius, 'that there shall be nothing reasonable but thou shalt have thy desire.'

'Well,' said Merlin, 'he shall have his intent and desire. And therefore,' said Merlin, 'ride on your way, for I will not be long behind.'

CHAPTER 2: *How Uther Pendragon made war on the Duke of Cornwall, and how by the mean of Merlin he lay by the Duchess and gat Arthur*

Then Ulfius was glad, and rode on more than a pace till that he came to King Uther Pendragon, and told him he had met with Merlin.

'Where is he?' said the king.

'Sir,' said Ulfius, 'he will not dwell[4] long.'

Therewithal Ulfius was ware where Merlin stood at the porch of the pavilion's door. And then Merlin was bound to come to the king. When King Uther saw him, he said he was welcome.

'Sir,' said Merlin 'I know all your heart every deal.[5] So ye will be sworn unto me as ye be a true king anointed, to fulfil my desire, ye shall have your desire.'

Then the king was sworn upon the four Evangelists.

'Sir,' said Merlin, 'this is my desire: the first night that ye shall lie by Igraine ye shall get a child on her, and when that is born, that it shall be delivered to me for to nourish there as I will have it; for it shall be your worship,[6] and the child's avail as mickle[7] as the child is worth.'

'I will well,' said the king, 'as thou wilt have it.'

'Now make you ready,' said Merlin, 'this night ye shall lie with Igraine in the Castle of Tintagel, and ye shall be like the duke her husband, Ulfius shall be like Sir Brastias, a knight of the duke's, and I will be like a knight that hight[8] Sir Jordans, a knight of the duke's. But wait[9] ye make not many questions with her nor her men, but say ye are diseased,[10]

and so hie you[11] to bed, and rise not on the morn till I come to you, for the Castle of Tintagel is but ten miles hence.'

So this was done as they devised. But the Duke of Tintagel espied how the king rode from the siege of Terrabil, and therefore that night he issued out of the castle at a postern for to have distressed the king's host. And so, through his own issue, the duke himself was slain or-ever[12] the king came at the Castle of Tintagel.

So after the death of the duke, King Uther lay with Igraine more than three hours after his death, and begat on her that night Arthur; and, or day came, Merlin came to the king, and bad him make him ready, and so he kissed the lady Igraine and departed in all haste. But when the lady heard tell of the duke her husband, and by all record he was dead or-ever King Uther came to her, then she marvelled who that might be that lay with her in likeness of her lord; so she mourned privily and held her peace.

Then all the barons by one assent prayed the king of accord betwixt the lady Igraine and him; the king gave them leave, for fain[13] would he have been accorded with her. So the king put all the trust in Ulfius to entreat[14] between them, so by the entreaty at the last the king and she met together.

'Now will we do well,' said Ulfius. 'Our king is a lusty knight and wifeless, and my lady Igraine is a passing fair lady; it were great joy unto us all, and it might please[15] the king to make her his queen.'

Unto that they all well accorded and moved it to the king. And anon, like a lusty knight, he assented thereto with good will, and so in all haste they were married in a morning with great mirth and joy.

And King Lot of Lothian and of Orkney then wedded Margawse that was Gawain's mother, and King Nentres of the land of Garlot wedded Elaine. All this was done at the request of King Uther. And the third sister Morgan le Fay was put to school in a nunnery, and there she learned so much that she was a great clerk of necromancy, and after she was wedded to King Uriens of the land of Gore, that was Sir Uwain's le Blanchemains father.

CHAPTER 3: *Of the birth of King Arthur and of his nurture*

Then Queen Agraine waxed daily greater and greater, so it befell after within half a year, as King Uther lay by his queen, he asked her, by the faith she ought to him,[16] whose was the child within her body; then was she sore abashed to give answer.

'Dismay you not,' said the king, 'but tell me the truth, and I shall love you the better, by the faith of my body.'

'Sir,' said she, 'I shall tell you the truth. The same night that my lord was dead, the hour of his death, as his knights record, there came into my castle of Tintagel a man like my lord in speech and in countenance, and two knights with him in likeness of his two knights Brastias and Jordans, and so I went unto bed with him as I ought to do with my lord, and the same night, as I shall answer unto God, this child was begotten upon me.'

'That is truth,' said the king, 'as ye say; for it was I myself that came in the likeness, and therefore dismay you not, for I am father to the child;' and there he told her all the cause, how it was by Merlin's counsel. Then the queen made great joy when she knew who was the father of her child.

Soon came Merlin unto the king, and said, 'Sir, ye must purvey[17] you for the nourishing of your child.'

'As thou wilt,' said the king, 'be it.'

'Well,' said Merlin, 'I know a lord of yours in this land, that is a passing true man and a faithful, and he shall have the nourishing of your child; and his name is Sir Ector, and he is a lord of fair livelihood in many parts in England and Wales; and this lord, Sir Ector, let him be sent for, for to come and speak with you, and desire him yourself, as he loveth you, that he will put his own child to nourishing to another woman, and that his wife nourish yours. And when the child is born let it be delivered to me at yonder privy postern unchristened.'

So like as Merlin devised it was done. And when Sir Ector was come he made fiance[18] to the king for to nourish the child like as the king desired; and there the king granted Sir Ector great rewards. Then when the lady was delivered, the king commanded two knights and two ladies to take the child, bound in a cloth of gold, 'and that ye deliver him to what poor man ye meet at the postern gate of the castle.' So the child was delivered unto Merlin, and so he bare it forth unto Sir Ector, and made an holy man to christen him, and named him Arthur; and so Sir Ector's wife nourished him with her own pap.

CHAPTER 4: *Of the death of King Uther Pendragon*

Then within two years King Uther fell sick of a great malady. And in the meanwhile his enemies usurped upon him, and did a great battle upon his men, and slew many of his people.

'Sir,' said Merlin, 'ye may not lie so as ye do, for ye must to the field though ye ride on an horse-litter; for ye shall never have the better of your enemies but if your person be there, and then shall ye have the victory.'

So it was done as Merlin had devised, and they carried the king forth in an horse-litter with a great host toward his enemies. And at St Albans

there met with the king a great host of the north. And that day Sir Ulfius and Sir Brastias did great deeds of arms, and King Uther's men overcame the northern battle[19] and slew many people, and put the remnant to flight. And then the king returned unto London, and made great joy of his victory.

And then he fell passing sore sick, so that three days and three nights he was speechless; wherefore all the barons made great sorrow, and asked Merlin what counsel were best.

'There nis[20] none other remedy,' said Merlin 'but God will have his will. But look ye all, barons, be before King Uther to-morn, and God and I shall make him to speak.'

So on the morn all the barons with Merlin came tofore the king; then Merlin said aloud unto King Uther, 'Sir, shall your son Arthur be king, after your days, of this realm with all the appurtenance?'[21]

Then Uther Pendragon turned him, and said in hearing of them all, 'I give him God's blessing and mine, and bid him pray for my soul, and righteously and worshipfully that he claim the crown upon forfeiture of my blessing.' And therewith he yielded up the ghost, and then was he interred as longed[22] to a king, wherefore the queen, fair Igraine, made great sorrow, and all the barons.

CHAPTER 5: *How Arthur was chosen king, and of wonders and marvels of a sword taken out of a stone by the said Arthur*

Then stood the realm in great jeopardy long while, for every lord that was mighty of men made him strong, and many weened[23] to have been king. Then Merlin went to the Archbishop of Canterbury, and counselled him for to send for all the lords of the realm, and all the gentlemen of arms, that they should to London come by Christmas, upon pain of cursing; and for this cause: that Jehu, that was born on that night, that He would of his great mercy show some miracle, as He was come to be king of mankind, for to show some miracle who should be rightwise king of this realm. So the Archbishop, by the advice of Merlin, sent for all the lords and gentlemen of arms that they should come by Christmas even unto London. And many of them made them clean of their life, that their prayer might be the more acceptable unto God.

So in the greatest church of London (whether it were Paul's or not the French book maketh no mention) all the estates were long or day in the church for to pray. And when matins and the first mass was done, there was seen in the churchyard, against the high altar, a great stone four square, like unto a marble stone, and in midst thereof was like an anvil of

243

steel a foot on high, and therein stuck a fair sword naked by the point, and letters there were written in gold about the sword that saiden thus:—WHOSO PULLETH OUT THIS SWORD OF THIS STONE AND ANVIL, IS RIGHTWISE KING BORN OF ALL ENGLAND. Then the people marvelled, and told it to the Archbishop.

'I command,' said the Archbishop, 'that ye keep you within your church, and pray unto God still; that no man touch the sword till the high mass be all done.'

So when all masses were done all the lords went to behold the stone and the sword. And when they saw the scripture, some assayed, such as would have been king. But none might stir the sword nor move it.

'He is not here,' said the Archbishop, 'that shall achieve the sword, but doubt not God will make him known. But this is my counsel,' said the Archbishop, 'that we let purvey²⁴ ten knights, men of good fame, and they to keep this sword.'

So it was ordained, and then there was made a cry, that every man should assay that would, for to win the sword. And upon New Year's Day the barons let make a jousts and a tournament, that all knights that would joust or tourney there might play. And all this was ordained for to keep the lords together and the commons, for the Archbishop trusted that God would make him known that should win the sword.

So upon New Year's Day, when the service was done, the barons rode unto the field, some to joust and some to tourney, and so it happed that Sir Ector, that had great livelihood about London, rode unto the jousts, and with him rode Sir Kay his son, and young Arthur that was his nourished brother; and Sir Kay was made knight at All Hallowmass afore. So as they rode to the jousts-ward, Sir Kay had lost his sword, for he had left it at his father's lodging, and so he prayed young Arthur for to ride for his sword.

'I will well,' said Arthur, and rode fast after the sword. And when he came home the lady and all were out to see the jousting.

Then was Arthur wroth, and said to himself, 'I will ride to the churchyard, and take the sword with me that sticketh in the stone, for my brother Sir Kay shall not be without a sword this day.' So when he came to the churchyard, Sir Arthur alit and tied his horse to the stile, and so he went to the tent, and found no knights there, for they were at jousting; and so he handled the sword by the handles, and lightly²⁵ and fiercely pulled it out of the stone, and took his horse and rode his way until he came to his brother Sir Kay, and delivered him the sword.

And as soon as Sir Kay saw the sword, he wist²⁶ well it was the sword of the stone, and so he rode to his father Sir Ector, and said; 'Sir, lo here is the sword of the stone, wherefore I must be king of this land.'

When Sir Ector beheld the sword, he returned again and came to the church, and there they alit all three, and went into the church. And anon he made Sir Kay to swear upon a book how he came to that sword.

'Sir,' said Sir Kay, 'by my brother Arthur, for he brought it to me.'

'How gat ye this sword?' said Sir Ector to Arthur.

'Sir, I will tell you. When I came home for my brother's sword, I found nobody at home to deliver me his sword, and so I thought my brother Sir Kay should not be swordless, and so I came hither eagerly and pulled it out of the stone without any pain.'

'Found ye any knights about this sword?' said Sir Ector.

'Nay,' said Arthur.

'Now,' said Sir Ector to Arthur, 'I understand ye must be king of this land.'

'Wherefore I,' said Arthur, 'and for what cause?'

'Sir,' said Ector, 'for God will have it so, for there should never man have drawn out this sword, but he that shall be rightwise king of this land. Now let me see whether ye can put the sword there as it was, and pull it out again.'

'That is no mastery,' said Arthur, and so he put it in the stone; therewithal Sir Ector assayed to pull out the sword and failed.

EXPLANATORY NOTES

1. *passing:* exceedingly.
2. *cheer:* entertainment.
3. *stuff him and garnish him:* make provision against a siege.
4. *dwell:* delay.
5. *deal:* part.
6. *worship:* honour.
7. *mickle:* much.
8. *hight:* is called.
9. *wait:* be careful.
10. *diseased:* weary.
11. *hie you:* hurry.
12. *or-ever:* before.
13. *fain:* gladly.
14. *entreat:* negotiate.
15. *and it might please:* if it might please.
16. *ought to him:* owed him.
17. *purvey:* provide.
18. *fiance:* promise.

19. *northern battle:* northern battalion.
20. *nis:* is not.
21. At this point nobody except Uther and Merlin know who Arthur is.
22. *longed:* belonged.
23. *weened:* thought.
24. *let purvey:* order to be appointed.
25. *lightly:* easily.
26. *wist:* knew.

ANONYMOUS

The Norse Discovery of America

*The Vinland Sagas (c. 1160–1260) are believed by modern scholars to
describe the Norse exploration and establishment of a colony in Greenland
in the tenth century. Archaeological evidence testifies to the existence of the
settlement and the general accuracy of these literary sources, which were
written in the late twelfth and mid-thirteenth centuries.*

*The sagas also recount the further journeys of Bjarni Herjolfsson and
Leif the Lucky to unknown lands to the south, populated by "Red Indi-
ans," a land now called America.*

2
BJARNI SIGHTS LAND TO THE WEST

Herjolf Bardarson[1] had lived for a time at Drepstokk; his wife was called
Thorgerd, and they had a son called Bjarni.

Bjarni was a man of much promise. From early youth he had been
eager to sail to foreign lands; he earned himself both wealth and a good
reputation, and used to spend his winters alternately abroad and in Ice-
land with his father. He soon had a merchant ship of his own.

During the last winter that Bjarni spent in Norway, his father, Her-
jolf, sold up the farm and emigrated to Greenland with Eirik the Red.
On board Herjolf's ship was a Christian from the Hebrides, the poet
who composed the *Hafgerdinga Lay;*[2] this was its refrain:

I beseech the immaculate Master of monks
To steer my journeys;
May the Lord of the lofty heavens
Hold his strong hand over me.

Herjolf made his home at Herjolfsness; he was a man of considerable
stature.

"The Norse Discovery of America," from *The Vinland Sagas,* translated by Magnus Mag-
nusson and Hermann Pálsson, copyright © 1965 by Magnus Magnusson and Hermann
Pálsson, 51–61. Reprinted by permission of Penguin Books Ltd.

Eirik the Red lived at Brattahlid. He commanded great respect, and all the people in Greenland recognized his authority. He had three sons — Leif, Thorvald, and Thorstein. He also had a daughter called Freydis, who was married to a man called Thorvard; they lived at Gardar, where the bishop's residence is now. Freydis was an arrogant, overbearing woman, but her husband was rather feeble; she had been married off to him mainly for his money.

Greenland was still a heathen country at this time.

Bjarni arrived in Iceland at Eyrar in the summer of the year that his father had left for Greenland. The news came as a shock to Bjarni, and he refused to have his ship unloaded. His crew asked him what he had in mind; he replied that he intended to keep his custom of enjoying his father's hospitality over the winter — 'so I want to sail my ship to Greenland, if you are willing to come with me.'

They all replied that they would do what he thought best. Then Bjarni said, 'This voyage of ours will be considered foolhardy, for not one of us has ever sailed the Greenland Sea.'

However, they put to sea as soon as they were ready and sailed for three days until land was lost to sight below the horizon. Then the fair wind failed and northerly winds and fog set in, and for many days[3] they had no idea what their course was. After that they saw the sun again and were able to get their bearings; they hoisted sail and after a day's sailing they sighted land.[4]

They discussed amongst themselves what country this might be. Bjarni said he thought it could not be Greenland. The crew asked him if he wanted to land there or not; Bjarni replied, 'I think we should sail in close.'

They did so, and soon they could see that the country was not mountainous, but was well wooded and with low hills. So they put to sea again, leaving the land on the port quarter; and after sailing for two days they sighted land once more.

Bjarni's men asked him if he thought this was Greenland yet; he said he did not think this was Greenland, any more than the previous one — 'for there are said to be huge glaciers in Greenland.'

They closed the land quickly and saw that it was flat and wooded. Then the wind failed and the crew all said they thought it advisable to land there, but Bjarni refused. They claimed they needed both firewood and water; but Bjarni said, 'You have no shortage of either.' He was criticized for this by his men.

He ordered them to hoist sail, and they did so. They turned the prow out to sea and sailed before a south-west wind for three days before they sighted a third land. This one was high and mountainous, and topped by

a glacier. Again they asked Bjarni if he wished to land there. but he replied, 'No, for this country seems to me to be worthless.'

They did not lower sail this time, but followed the coastline and saw that it was an island. Once again they put the land astern and sailed out to sea before the same fair wind. But now it began to blow a gale, and Bjarni ordered his men to shorten sail and not to go harder than ship and rigging could stand. They sailed now for four days, until they sighted a fourth land.

The men asked Bjarni if he thought this would be Greenland or not.

'This tallies most closely with what I have been told about Greenland,' replied Bjarni. 'And here we shall go in to land.'

They did so, and made land as dusk was falling at a promontory which had a boat hauled up on it. This was where Bjarni's father, Herjolf, lived, and it has been called Herjolfsness for that reason ever since.

Bjarni now gave up trading and stayed with his father, and carried on farming there after his father's death.

<div style="text-align:center">

3

LEIF EXPLORES VINLAND

</div>

Some time later, Bjarni Herjolfsson sailed from Greenland to Norway and visited Earl Eirik,[5] who received him well. Bjarni told the earl about his voyage and the lands he had sighted. People thought he had shown great lack of curiosity, since he could tell them nothing about these countries, and he was criticized for this. Bjarni was made a retainer at the earl's court, and went back to Greenland the following summer.

There was now great talk of discovering new countries. Leif, the son of Eirik the Red of Brattahlid, went to see Bjarni Herjolfsson and bought his ship from him, and engaged a crew of thirty-five.

Leif asked his father Eirik to lead this expedition too, but Eirik was rather reluctant: he said he was getting old and could endure hardships less easily than he used to. Leif replied that Eirik would still command more luck[6] than any of his kinsmen. And in the end, Eirik let Leif have his way.

As soon as they were ready, Eirik rode off to the ship which was only a short distance away. But the horse he was riding stumbled and he was thrown, injuring his leg.

'I am not meant to discover more countries than this one we now live in,' said Eirik. 'This is as far as we go together.'[7]

Eirik returned to Brattahlid, but Leif went aboard the ship with his crew of thirty-five. Among them was a Southerner called Tyrkir.[8]

They made their ship ready and put out to sea. The first landfall they made was the country that Bjarni had sighted last. They sailed right up

to the shore and cast anchor, then lowered a boat and landed. There was no grass to be seen, and the hinterland was covered with great glaciers, and between glaciers and shore the land was like one great slab of rock. It seemed to them a worthless country.

Then Leif said, 'Now we have done better than Bjarni where this country is concerned—we at least have set foot on it. I shall give this country a name and call it *Helluland*.'[9]

They returned to their ship and put to sea, and sighted a second land. Once again they sailed right up to it and cast anchor, lowered a boat and went ashore. This country was flat and wooded, with white sandy beaches wherever they went; and the land sloped gently down to the sea.

Leif said, 'This country shall be named after its natural resources: it shall be called *Markland*.'[10]

They hurried back to their ship as quickly as possible and sailed away to sea in a north-east wind for two days until they sighted land again. They sailed towards it and came to an island which lay to the north of it.

They went ashore and looked about them. The weather was fine. There was dew on the grass, and the first thing they did was to get some of it on their hands and put it to their lips, and to them it seemed the sweetest thing they had ever tasted. Then they went back to their ship and sailed into the sound that lay between the island and the headland jutting out to the north.

They steered a westerly course round the headland. There were extensive shallows there and at low tide their ship was left high and dry, with the sea almost out of sight. But they were so impatient to land that they could not bear to wait for the rising tide to float the ship; they ran ashore to a place where a river flowed out of a lake. As soon as the tide had refloated the ship they took a boat and rowed out to it and brought it up the river into the lake, where they anchored it. They carried their hammocks ashore and put up booths.[11] Then they decided to winter there, and built some large houses.

There was no lack of salmon in the river or the lake, bigger salmon than they had ever seen.[12] The country seemed to them so kind that no winter fodder would be needed for livestock: there was never any frost all winter and the grass hardly withered at all.

In this country, night and day were of more even length than in either Greenland or Iceland: on the shortest day of the year, the sun was already up by 9 a.m., and did not set until after 3 p.m.[13]

When they had finished building their houses, Leif said to his companions, 'Now I want to divide our company into two parties and have the

country explored; half of the company are to remain here at the houses while the other half go exploring—but they must not go so far that they cannot return the same evening, and they are not to become separated.'

They carried out these instructions for a time. Leif himself took turns at going out with the exploring party and staying behind at the base.

Leif was tall and strong and very impressive in appearance. He was a shrewd man and always moderate in his behaviour.

4
LEIF RETURNS TO GREENLAND

One evening news came that someone was missing: it was Tyrkir the Southerner. Leif was very displeased at this, for Tyrkir had been with the family for a long time, and when Leif was a child had been devoted to him. Leif rebuked his men severely, and got ready to make a search with twelve men.

They had gone only a short distance from the houses when Tyrkir came walking towards them, and they gave him a warm welcome. Leif quickly realized that Tyrkir was in excellent humour.

Tyrkir had a prominent forehead and shifty eyes, and not much more of a face besides; he was short and puny-looking but very clever with his hands.

Leif said to him, 'Why are you so late, foster-father? How did you get separated from your companions?'

At first Tyrkir spoke for a long time in German, rolling his eyes in all directions and pulling faces, and no one could understand what he was saying. After a while he spoke in Icelandic.

'I did not go much farther than you,' he said. 'I have some news. I found vines and grapes.'[14]

'Is that true, foster-father?' asked Leif.

'Of course it is true,' he replied. 'Where I was born there were plenty of vines and grapes.'

They slept for the rest of the night, and next morning Leif said to his men, 'Now we have two tasks on our hands. On alternate days we must gather grapes and cut vines, and then fell trees, to make a cargo for my ship.'

This was done. It is said that the tow-boat was filled with grapes. They took on a full cargo of timber; and in the spring they made ready to leave and sailed away. Leif named the country after its natural qualities and called it *Vínland*.[15]

They put out to sea and had favourable winds all the way until they sighted Greenland and its ice-capped mountains. Then one of the crew spoke up and said to Leif, 'Why are you steering the ship so close to the wind?'

'I am keeping an eye on my steering,' replied Leif, 'but I am also keeping an eye on something else. Don't you see anything unusual?'

They said they could see nothing in particular.

'I am not quite sure,' said Leif, 'whether it is a ship or a reef I can see.'

Now they caught sight of it, and said that it was a reef. But Leif's eyesight was so much keener than theirs that he could now make out people on the reef.

'I want to sail close into the wind in order to reach these people,' he said. 'If they need our help, it is our duty to give it; but if they are hostile, then the advantages are all on our side and none on theirs.'

They approached the reef, lowered sail, anchored, and put out another small boat they had brought with them. Tyrkir asked the men who their leader was.

The leader replied that his name was Thorir, and that he was a Norwegian by birth. 'What is your name?' he asked.

Leif named himself in return.

'Are you a son of Eirik the Red of Brattahlid?'

Leif said that he was. 'And now,' he said, 'I want to invite you all aboard my ship, with as much of your belongings as the ship will take.'

They accepted the offer, and they all sailed to Eiriksfjord thus laden. When they reached Brattahlid they unloaded the ship.

Leif invited Thorir and his wife Gudrid and three other men to stay with him and found lodgings for the rest of the ship's company, both Thorir's men and his own crew.

Leif rescued fifteen people in all from the reef. From then on he was called Leif the Lucky. He gained greatly in wealth and reputation.

A serious disease broke out amongst Thorir's crew that winter and Thorir himself and many of his men died of it. Eirik the Red also died that winter.

Now there was much talk about Leif's Vinland voyage, and his brother Thorvald thought that the country had not been explored extensively enough.

Leif said to Thorvald, 'You can have my ship to go to Vinland, if you like; but first I want to send it to fetch the timber that Thorir left on the reef.'

This was done.

5
THORVALD EXPLORES VINLAND

Thorvald prepared his expedition with his brother Leif's guidance and engaged a crew of thirty. When the ship was ready they put out to sea and there are no reports of their voyage until they reached Leif's Houses in Vinland. There they laid up the ship and settled down for the winter, catching fish for their food.

In the spring Thorvald said they should get the ship ready, and that meanwhile a small party of men should take the ship's boat and sail west along the coast and explore that region during the summer.

They found the country there very attractive, with woods stretching almost down to the shore and white sandy beaches. There were numerous islands there, and extensive shallows. They found no traces of human habitation or animals except on one westerly island, where they found a wooden stackcover. That was the only man-made thing they found; and in the autumn they returned to Leif's Houses.

Next summer Thorvald sailed east with his ship and then north along the coast. They ran into a fierce gale off a headland and were driven ashore; the keel was shattered and they had to stay there for a long time while they repaired the ship.

Thorvald said to his companions, 'I want to erect the old keel here on the headland, and call the place *Kjalarness.*'

They did this and then sailed away eastward along the coast. Soon they found themselves at the mouth of two fjords, and sailed up to the promontory that jutted out between them; it was heavily wooded. They moored the ship alongside and put out the gangway, and Thorvald went ashore with all his men.

'It is beautiful here,' he said. 'Here I should like to make my home.'

On their way back to the ship they noticed three humps on the sandy beach just in from the headland. When they went closer they found that these were three skin-boats,[16] with three men under each of them. Thorvald and his men divided forces and captured all of them except one, who escaped in his boat. They killed the other eight and returned to the headland, from which they scanned the surrounding country. They could make out a number of humps farther up the fjord and concluded that these were settlements.

Then they were overwhelmed by such a heavy drowsiness that they could not stay awake, and they all fell asleep—until they were awakened by a voice that shouted. 'Wake up, Thorvald, and all your men, if you

want to stay alive! Get to your ship with all your company and get away as fast as you can!'

A great swarm of skin-boats was then heading towards them down the fjord.

Thorvald said, 'We shall set up breastworks on the gunwales and defend ourselves as best we can, but fight back as little as possible.'

They did this. The Skrælings shot at them for a while, and then turned and fled as fast as they could.

Thorvald asked his men if any of them were wounded; they all replied that they were unhurt.

'I have a wound in the armpit,' said Thorvald. 'An arrow flew up between the gunwale and my shield, under my arm—here it is. This will lead to my death.

'I advise you now to go back as soon as you can. But first I want you to take me to the headland I thought so suitable for a home. I seem to have hit on the truth when I said that I would settle there for a while. Bury me there and put crosses at my head and feet, and let the place be called *Krossaness* for ever afterwards.'

(Greenland had been converted to Christianity by this time, but Eirik the Red had died before the conversion.)

With that Thorvald died, and his men did exactly as he had asked of them. Afterwards they sailed back and joined the rest of the expedition and exchanged all the news they had to tell.

They spent the winter there and gathered grapes and vines as cargo for the ship. In the spring they set off on the voyage to Greenland; they made land at Eiriksfjord, and had plenty of news to tell Leif.

EXPLANATORY NOTES

1. [Author's note] *He was the son of Bard, the son of Herjolf, a kinsman of Ingolf, the first settler of Iceland, who had given the family land between Vog and Reykjaness.*
2. Literally, 'Lay of the Breakers'. Only two more lines of this poem have survived. It seems to have been written in connexion with this voyage to Greenland. The term *hafgerðingar* refers to a gross disturbance of the sea, probably submarine earthquakes, which would account for the losses in the fleet.
3. *dœgr*: this term is ambiguous. Strictly speaking, it means 'day' in the sense of twelve hours, but it is also used in the sense of the astronomical 'day' of twenty-four hours, and there is often doubt about the particular meaning in many early texts.
4. Bjarni's landfall in the west cannot be identified with any certainty.

5. Earl Eirik Hakonarson ruled over Norway from 1000 to 1014.
6. 'Luck' had a greater significance in pagan Iceland than the word implies now. Good luck or ill luck were innate qualities, part of the complex pattern of Fate. Leif inherited the good luck associated with his father (Chapter 4).
7. A fall from a horse was considered a very bad omen for a journey. Such a fall clinched Gunnar of Hlidarend's decision not to leave Iceland when he was outlawed (*Njal's Saga*, Chapter 75).
8. *Southerner* refers to someone from central or southern Europe; Tyrkir appears to have been a German.
9. Literally, 'Slab-land'; probably Baffin Island (see List of Names).
10. Literally, 'Forest-land'; probably Labrador (see List of Names).
11. Booths were stone-and-turf enclosures which could be temporarily roofed with awnings for occupation.
12. On the east coast of the North American continent, salmon are not usually found any farther south than the Hudson River.
13. This statement indicates that the location of Vinland must have been south of latitude fifty and north of latitude forty—anywhere between the Gulf of St Lawrence and New Jersey.
14. Many later explorers of the New England region commented on the wild grapes they found growing there. Grapes have been known to grow wild on the east coast as far north as Passamaquoddy Bay.
15. Literally, 'Wine-land'. With the compound *Vín-land*, compare the Icelandic term *vínber*, 'grapes' (literally, 'wine-berries'). In order to explain away the absence of grapes in certain parts of North America which have been suggested as the site of Vinland, some scholars (including Dr Helge Ingstad, cf. p. 9) have argued that the first element in the name is not *vín* ('wine') but *vin*, meaning 'fertile land', or 'oasis'. On phonological grounds this suggestion is nonsensical, since the name *Vínland* has never been forgotten in Iceland, and the words *vín* and *vin* are never confused. But the main objection is to be found in the sagas themselves, where the name of the country is explicitly associated with its wine.
16. Certain Red Indian tribes of the New England area used canoes made of moose-hide instead of the more usual birch-bark.

BERNARD OF CLAIRVAUX

Monastic Decadence

———————

Bernard of Clairvaux (1090–1153) was one of the most important and influential ecclesiastical figures of the twelfth century. Born near Dijon, in eastern France, into a large aristocratic family, Bernard received a basic grammatical and rhetorical education before deciding to enter the fledgling monastery of Cîteaux in 1112. It took him only three years from this point to establish a new foundation at Clairvaux, where Bernard became abbot in 1115. The ensuing years found Bernard devoted to increasing levels of spiritual and mystical contemplation, as he and his monastic community practiced harsh self-discipline and ascetic deprivations. He also began to write about his spiritual growth and the contemplative life, while the fame of his community and its abbot grew. After 1130, however, Bernard became heavily involved in international affairs, both secular and ecclesiastical. The most important and vocal supporter of Pope Innocent II against the anti-pope Anacletus during the papal schism of the 1130s, Bernard is probably even better known today for his condemnations of Peter Abelard, with whom he clashed not just over what he saw as the excessive rationalism of Abelard's scholastic method, but also as a result of deep differences in personality. Indeed, the same passionate force of personality by which Bernard inspired thousands to join the Second Crusade in 1147 brought him into conflict with a number of his contemporaries. One of the most significant of these disputes involved Bernard's championship of the austere monastic life associated with the Cistercian movement, against what he perceived to be the comfortable complacency of venerable institutions like the nearby monastery of Cluny. In any case, it was not long after the failure of the Second Crusade that Bernard retired once again into relative seclusion at Clairvaux for the last few years of his life.

Bernard wrote voluminously, including several important treatises and a massive correspondence, much of which has survived. Among his best-loved works are his mystical writings, where Bernard describes the soul's spiritual pursuit of God, driven by the inexorable and inexpressible force of love. However, Bernard's equal flair for sharp-edged satire is apparent in works like An Apologia for Abbot William, *written in 1125 as a kind of*

exposé of what he saw as the hypocritical luxury and decadence of older Benedictine institutions. The chief target of Bernard's attack was the great monastery of Cluny, whose "black monks" (so-called from the color of their robes) were the wealthiest and most venerated in all of Christendom. The present selection demonstrates the force and vigor of Bernard's writing even as it presents a picture—albeit a deliberately exaggerated one—of twelfth century monastic life.

AGAINST SUPERFLUITY

VII, 16 It is said, and quite rightly, that the Cluniac way of life was instituted by holy Fathers; anxious that more might find salvation through it, they tempered the Rule to the weak without weakening the Rule. Far be it from me to believe that they recommended or allowed such an array of vanities or superfluities as I see in many religious houses. I wonder indeed how such intemperance in food and drink, in clothing and bedding, in horses and buildings can implant itself among monks. And it is the houses that pursue this course with thoroughgoing zeal, with full-blown lavishness, that are reputed the most pious and the most observant. They go so far as to count frugality avarice, and sobriety austerity, while silence is reputed gloom. Conversely, slackness is called discretion, extravagance liberality, chattering becomes affability, guffawing cheerfulness, soft clothing and rich caparisons are the requirements of simple decency, luxurious bedding is a matter of hygiene, and lavishing these things on one another goes by the name of charity. By such charity is charity destroyed, and this discretion mocks the very word. It is a cruel mercy that kills the soul while cherishing the body. And what sort of charity is it that cares for the flesh and neglects the spirit? What kind of discretion that gives all to the body and nothing to the soul? What kind of mercy that restores the servant and destroys the mistress? Let no one who has shown that sort of mercy hope to obtain the mercy Mt. 5:7 promised in the Gospel by him who is the truth: 'Blessed are the merciful, for they shall receive mercy.' On the contrary, he can expect the sure and certain

punishment which holy Job invoked with the full force of prophecy on those whom I call 'cruelly kind': 'Let him be no longer remembered, but let him be broken like a sterile tree.' The cause—and a sufficient cause for that most proper retribution—follows at once: 'He feeds the barren, childless woman and does no good to the widow.' Job 24:20
Job 24:21

17 Such kindness is obviously disordered and irrational. It is that of the barren and unfruitful flesh, which the Lord tells us profits nothing and Paul says will not inherit the kingdom of God. Intent on satisfying our every whim it pays no heed to the Sage's wise and warning words: 'Have mercy on your own soul and you will please God.' That is indeed true mercy, and must perforce win mercy, since one pleases God by exercising it. Conversely it is, as I said, not kindness but cruelty, not love but malevolence, not discretion but confusion to feed the barren woman and do no good to the widow— in other words, to pander to the desires of the profitless flesh while giving the soul no help in cultivating the virtues. For the soul is indeed bereaved in this life of her heavenly Bridegroom. Yet she never ceases to conceive by the Holy Spirit and bring forth immortal offspring, which, provided they are nurtured with diligent care, will rightfully be heirs to an incorruptible and heavenly inheritance. Jn. 6:64
1 Cor. 15:50

Sir. 30:25

1 Pet. 1:4

18 Nowadays, however, these abuses are so widespread and so generally accepted that almost everyone acquiesces in them without incurring censure or even blame, though motives differ. Some use material things with such detachment as to incur little or no guilt. Others are moved by simple-mindedness, by charity or by constraint. The first, who do as they are bidden in all simplicity, would be ready to act differently if the bidding were different. The second kind, afraid of dissension in the community, are led, not by their own pleasure, but by their desire to keep the peace. Lastly there are those who are unable to stand out against a hostile majority that vociferously defends such practices as pertaining to the Order and moves swiftly and forcibly to block whatever judicious restrictions or changes the former try to bring in.

IX, 19 Who would have dreamed, in the far beginnings of the monastic order, that monks would have slid into such slackness? What a way we have come from the monks who lived in Anthony's day! When one of them paid on occasion a brotherly call on another, both were so avid for the spiritual nourishment they gained from the encounter that they forgot their physical hunger and would commonly pass the whole day with empty stomachs but with minds replete. And this was the right order of precedence—to give priority to what is nobler in man's make-up; this was real discretion—making greater provision for the more important part; this indeed true charity—to tend with loving care the souls for love of whom Christ died.

As for us, when we come together, to use the Apostle's words, it is not to eat the Lord's supper. There is none 1 Cor. 11:20 who asks for heavenly bread and none who offers it. Never a word about Scripture or salvation. Flippancy, laughter and words on the wind are all we hear. At table our ears are as full of gossip as our mouths of festive fare, and all intent on the former we quite forget to restrain our appetite.

ON MEALS

20 Meanwhile course after course is brought in. To offset the lack of meat—the only abstinence—the laden fish dishes are doubled. The first selection may have been more than enough for you, but you have only to start on the second to think you have never tasted fish before. Such are the skill and art with which the cooks prepare it all that one can down four or five courses without the first spoiling one's enjoyment of the last, or fullness blunting the appetite. Tickle the palate with unaccustomed seasonings and the familiar start to pall, but exotic relishes will restore it even to its preprandial sharpness; and since variety takes away the sense of surfeit, one is not aware that one's stomach is overburdened. Foodstuffs in their pure and unadulterated state have no appeal, so we mix ingredients pell-mell, scorning the natural nutriments God gave us,

and use outlandish savours to stimulate our appetite. That way we can eat far more than we need and still enjoy it.

To give but one example: who could itemize all the ways in which eggs are maltreated? Or describe the pains that are taken to toss them and turn them, soften and harden them, botch them and scotch them, and finally serve them up fried, baked and stuffed by turns, in conjunction with other foods or on their own? What is the purpose of all this unless it be to titillate a jaded palate? Attention is also lavished on the outward appearance of a dish, which must please the eye as much as it gratifies the taste buds, for though a belching stomach may announce that it has had enough, curiosity is never sated. Poor stomach! the eyes feast on colour, the palate on flavour, yet the wretched stomach, indifferent to both but forced to accept the lot, is more often oppressed than refreshed as a result.

ON DRINK

21 What can I say about the drinking of water when even watering one's wine is inadmissible? Naturally all of us, 1 Tim. 5:23 as monks, suffer from a weak stomach, which is why we pay good heed to Paul's advice to use a little wine. It is just that the word *little* gets overlooked, I can't think why. And if only we were content with drinking it plain, albeit undiluted. There are things it is embarrassing to say, though it should be more embarrassing still to do them. If hearing about them brings a blush, it will cost you none to put them right. The fact is that three or four times during the same meal you might see a half-filled cup brought in, so that different wines may be not drunk or drained so much as carried to the nose and lips. The expert palate is quick to discriminate between them and pick out the most potent. And what of the monasteries—and there are said to be some—which regularly serve spiced and honeyed wine in the refectory on major feasts? We are surely not going to say that this is done to nurse weak stomachs? The only reason for it that I can see is to allow deeper drinking, or keener pleasure. But once the wine is flowing through the veins and the

whole head is throbbing with it, what else can they do when they get up from table but go and sleep it off? And if you force a monk to get up for vigils before he has digested, you will set him groaning rather than intoning. Having got to bed, it's not the sin of drunkenness they regret if questioned, but not being able to face their food.

ON THOSE WHO TAKE THEIR EASE IN THE INFIRMARY WITHOUT BEING ILL

22 I have heard a laughable story—laughable, that is, if it is true—from a number of people who claim to be certain of the facts, and I see no reason not to repeat it here. I am told that healthy and strong young men are opting out of the common life and taking up quarters in the infirmary without being in any way infirm; and this to enjoy the meat that the Rule in its wisdom allows to the genuinely weak and ailing in order to build up their strength.[1] In this case, of course, the purpose is not to restore a body weakened by illness but to satisfy the wanton whims of the flesh.

I ask you, is it a sensible strategy, when the flashing spears of a furious enemy are all about you and their darts are flying on every side, to throw down your arms as though the war were already over and won, and either embark on a protracted lunch or snuggle down unarmed in a soft bed? Is this not cowardice, my brave warriors? While your comrades mill around in gore and carnage, you are enjoying the finest fare or catching up on your morning sleep. Others keep watch round the clock, anxious to redeem the time because the days are evil, while **Eph. 5:16** you sleep the long nights through and pass your days in idle chatter. Are you perhaps crying 'Peace', when there is no peace? How can you feel no shame at the fierce **Ez. 13:10** reproach in the Apostle's words: 'You have not yet resisted to the point of shedding your blood'? Can you not even **Heb. 12:4** rouse yourselves at the thunder of his fearful threat: 'When people say, "There is peace and security", then sudden destruction will come upon them as travail comes upon a woman with child, and there will be no escape.' **1 Thess. 5:3**

What a comfortable therapy! You bandage yourselves before receiving a wound, bewail the sound limb, ward off the undealt blow, rub ointment into the unbruised skin and stick a plaster where there is no cut.

The final touch is this: in order to distinguish between the hale and the sick, the latter are made to carry a walking-stick. Since they are neither pale nor drawn, the stick is needed to support the Pretence of illness. Ought we to laugh or cry at such absurdities? Did Macarius live like that? Is that what Basil taught or Anthony began? Is that the life the Fathers lived in Egypt? And lastly, what of their own founding fathers and teachers—Odo, Majolus, Odilo and Hugh,[2] the glory of their Order—did they take that course or hold with its taking? No, these were holy men, and being holy were of one mind with the Apostle in his affirmation: 'If we have food and clothing, with these we shall be content.' But as for us, we must have food to glut us, and are content with nothing less than finery. — 1 Tim. 6:8

ON COSTLY AND OSTENTATIOUS CLOTHING

X, 24 As regards clothing, today's religious is less concerned with keeping out the cold than with cutting a good figure; so he is after refinement rather than service-ability, and seeks, not the cheapest article, as the Rule prescribes,[3] but the one that can be displayed to the best advantage. Alas, poor wretched monk that I am, why have I lived to see the monastic order come to this?—the order that preceded every other in the Church; indeed the Church grew out of it.[4] Nothing on earth was liker to the angelic orders, nothing closer to the heavenly Jerusalem, our mother, whether it were for the grace of chastity or for the fervour of charity. It was founded by the apostles, and those whom Paul so often calls the saints were its first members. And because none among them kept anything back for his own use, distribution was made to each as he had need, not to gratify individual childish whims. And it is obvious that, where need was the one criterion, there was no room for the useless, the exotic or the showy. 'As he had need' are the words; — Gal. 4:26 Acts 4:32, 35

as regards clothing, the need was the dual one of staying covered and keeping warm. You don't suppose that anyone there was furnished with silks and satins[5] to wear, or mules to ride worth two hundred pieces of gold? Do you imagine that, where distribution was according to need, the beds were spread with catskin coverlets or multicoloured quilts?[6] I do not think myself that they would have bothered overmuch with the quality, colour and style of their clothes: they were too intent on living in harmony, achieving unity and progressing in virtue, Acts 4:32 which is why the company of believers is described as being of one heart and soul.

25 Where is this zeal for unanimity nowadays? Our ener- Lk. 17:21 gies are directed outward and, turning our backs on the true and lasting values of God's kingdom, which is within us, we look abroad for the hollow comfort afforded by trifles and fancies, losing thereby not only the inward vigour of the old religious life but even its outward semblance. Take the habit itself, which used to betoken humility: it grieves me to say that on the backs of our contemporaries it has become a sign of pride. They have trouble finding anything locally that is good enough to wear. Knight and monk today cut cloak and cowl from the one bolt. There isn't a secular dignitary— no, not the king, nor the emperor himself—who would turn up his nose at our clothing, provided cut and style were adapted to his use.

26 Religion is in the heart and not the habit, I hear you say. Quite so. Consider this, then: when you want to buy a cowl, you traipse from town to town and trail round the markets, visiting every booth. You turn the merchant's premises upside down, unrolling the huge bolts of cloth, fingering, peering, holding the lengths up to the light and rejecting anything coarse or faded. But if something takes your eye with its quality or sheen, you will pay any price to ensure you get it. Tell me, do you act thus quite unthinking, or is this the heart speaking? When, instead of buying, as the Rule enjoins, the cheapest you can find, you seek out with infinite pains the most distinctive and therefore costliest article, do you do this in all ignorance or by design? There are no surface

vices that do not spring from our hidden depths. The heart's frivolity is worn without, and extravagant attire mirrors the vanity within. Soft clothing is a sign of moral flabbiness: the body would not be decked out with such care had not neglect first left the soul unkempt and bare of virtues.

. . .

ON MOUNTING ONE'S HIGH HORSE

Leaving the rest aside, what evidence is there of humility when one solitary abbot travels with a parade of horseflesh and a retinue of lay-servants that would do honour to two bishops? I swear I have seen an abbot with sixty horses and more in his train. If you saw them passing, you would take them for lords with dominion over castles and counties, not for fathers of monks and shepherds of souls. Moreover, napery, cups, dishes and candlesticks have to be taken along, together with packs stuffed full, not with ordinary bedding, but with ornate quilts. A man cannot go a dozen miles from home without transporting all his household goods, as though he were going on campaign or crossing the desert where the basic necessities were unobtainable. Surely water for washing one's hands and wine for drinking can be Jn. 5:35 poured from the same jug? Do you think that your lamp will fail to burn and shine unless it stands in your very own candlestick, and a gold or silver one at that? Can you really not sleep except on a chequered blanket and under an imported coverlet? And is a single servant not capable of loading the packhorse, serving the food and making up the bed? And lastly, if we must travel with these retinues of men and beasts, can we not mitigate the evil by taking the necessary provisions instead of battening on our hosts?

ON THE PLACE OF PICTURES, SCULPTURE, GOLD AND SILVER IN MONASTERIES

XII, 28 But these are minor points. I am coming to the major abuses, so common nowadays as to seem of

lesser moment. I pass over the vertiginous height of churches, their extravagant length, their inordinate width and costly finishings. As for the elaborate images that catch the eye and check the devotion of those at prayer within, they put me more in mind of the Jewish rite of old. But let this be: it is all done for the glory of God. But as a monk I ask my fellow monks the question a pagan poet put to pagans: 'Tell me, O priests, why is there gold in the holy place?' 'Tell me, O poor men,' say I—for it is the meaning, not the measure that concerns me—'tell me, O poor men, if poor you are, what is gold doing in the holy place?' It is one thing for bishops but quite another for monks. Bishops are under an obligation both to the wise and the foolish. Where people remain impervious to a purely spiritual stimulus, they use material ornamentation to inspire devotion. But we who have separated ourselves from the mass, who have relinquished for Christ's sake all the world's beauty and all that it holds precious, we who, to win Christ, count as dung every delight of sight and sound, of smell and taste and touch, whose devotion do we seek to excite with this appeal to the senses? What are we angling for, I should like to know: the admiration of fools, or the offerings of the simple? Or have we perhaps, through mixing with the Gentiles, learned their ways and taken to worshipping their idols? *Rom. 1:14* *Phil. 3:8* *Ps. 105:35–6*

To put it plainly: suppose that all this is the work of cupidity, which is a form of idol-worship; suppose that the real objective is not yield but takings. You want me to explain? It's an amazing process: the art of scattering money about that it may breed. You spend to gain, and what you pour out returns as a flood-tide. A costly and dazzling show of vanities disposes to giving rather than to praying. Thus riches elicit riches, and money brings money in its train, because for some unknown reason the richer a place is seen to be the more freely the offerings pour in. When eyes open wide at gold-cased relics, purses do the same. A beautiful image of a saint is on show: the brighter the colours the holier he or she will be considered. Those who hasten to kiss the image are

invited to leave a gift, and wonder more at the beauty than at the holiness they should be venerating.

Instead of crowns one sees in churches nowadays great jewelled wheels bearing a circle of lamps, themselves as good as outshone by the inset gems. Massive tree-like structures, exquisitely wrought, replace the simple candlestick. Here too the precious stones glimmer as brightly as the flames above.

. . .

30 This is a rich vein, and there is plenty more to be quarried, but I am prevented from carrying on by my own demanding duties and your imminent departure, Brother Oger. Since I cannot persuade you to stay, and you do not want to leave without this latest little book, I am falling in with your wishes: I am letting you go and shortening my discourse, particularly since a few words spoken in a spirit of conciliation do more good than many that are a cause of scandal. And would to heaven that these few lines do not occasion scandal! I am well aware that in rooting out vices I shall have offended those involved. However, God willing, those I fear I may have exasperated may end up grateful for my strictures if they desist from their evil ways—that is to say, if the rigorists stop carping and the lax prune back their excesses, and if both sides act in conscience according to their own beliefs, without judging the others who hold different views. Those who are able to live austerer lives should neither despise nor copy those who cannot. As for the latter, they should not be led by admiration for their stricter brethren to imitate them injudiciously: just as there is a danger of apostasy when those who have taken a more exacting vow slip into easier ways, not everyone can safely scale the heights.

EXPLANATORY NOTES

1. *Rule*, ch. 36.
2. The four great abbots who governed Cluny, with the briefest of interregnums, from its early years until the death of the last in 1109, a span of nearly two centuries. Their reforming zeal extended itself further and further afield at the behest of princes and popes. Very many monasteries placed themselves

under the authority of Cluny and more were founded. The total of large and small houses reached 1,184 under St Hugh, of which over two thirds were in France. This compares with the 694 Cistercian houses achieved by the end of the thirteenth century, scattered over a wider geographical area.

3. *Rule*, ch. 55.
4. Monks commonly saw themselves as the heirs and continuators of the apostolic community. Cf. William of St Thierry's *Life of St Bernard*, p. 31.
5. Lit. 'galabrunum aut isembrunum'. I am indebted to Michael Casey for the rendering. The Latin words refer to fabrics with no exact modern equivalent, the essential being that they were luxury articles. For further elucidation see *Apologia*, trans. M. Casey, p. 60, n. 149.
6. Lit. 'discolor barricanus'. Cf. as above. Catskins (ibid. p. 60, n. 149) were also in the luxury class. The Cluniacs defended their use of sheepskins on the reasonable grounds that the climate in Burgundy was much colder than in Italy, where the Rule was drawn up.

FRANCIS OF ASSISI

In Praise of God's Creation

St. Francis of Assisi (1181/82–1226) was the founder of the Franciscan Order and one of the most beloved of medieval saints. Born in central France into a wealthy merchant family, Francis was educated locally and worked in his father's business until about the age of twenty. By all accounts he was a popular and worldly young man, at least until he had a vision in 1204, while on his way to war. Seeking God's will back in Assisi, Francis experienced other visions and miracles that caused him to abandon his old career and pursue a life of poverty. In several famous incidents, Francis was disowned by his father, overcame his repugnance of leprosy by embracing a leper, and eventually (around 1208) received a call to leave his home and preach repentance as a penniless wanderer. His audience was made up chiefly of townspeople, and he soon gained a small throng of disciples. In 1209 and 1210, Francis wrote up a simple Rule *for his followers and also managed to gain the all-important approval of Pope Innocent III for his foundation. The new order of Lesser Brothers—later known as the Franciscans—had as yet little official organization, but nevertheless expanded rapidly in the following years. By 1217 it was already necessary to establish provinces and ministers to organize its growth and administration. Meanwhile Francis helped establish a similar order for women in 1212, called the "Poor Clares" after their noble founder St. Clare. Francis's distaste for official organization and the inevitable conflicts and compromises necessitated by expansion led to some dissension and confusion in the early 1220s, although a new rule known as the "Regula Bullata" received formal papal approval in 1223. Francis was canonized by Pope Gregory IX in 1228, only two years after his death.*

St. Francis's written output was not large. Beyond the short rules for his order, his most famous work is probably a hymn known as the "Canticle of the Sun." Presented here in its entirety, the hymn praises God and his revelation through the natural world. Its deep admiration for nature and the Creator has long been seen as an attractive and accurate reflection of the humility and simple faith for which St. Francis was renowned in his own lifetime and beyond.

"In Praise of God's Creation," from the *Canticle of the Sun*, by Francis of Assisi, translated by P. Robinson, in *The Viking Medieval Reader*, copyright © 1977 by James Bruce Ross and Mary Martin McLaughlin, 517–518.

*Here begin the praises of the creatures which the Blessed Francis made
to the praise and honour of God while he was ill at St. Damian's:*

Most high, omnipotent, good Lord,
Praise, glory, and honour and benediction all, are Thine.
To Thee alone do they belong, most High,
And there is no man fit to mention Thee.

Praise be to Thee, my Lord, with all Thy creatures,
Especially to my worshipful brother sun,
The which lights up the day, and through him dost Thou brightness give;
And beautiful is he and radiant with splendour great;
Of Thee, most High, signification gives.

Praised be my Lord, for sister moon and for the stars,
In heaven Thou hast formed them clear and precious and fair.

Praised be my Lord for brother wind
And for the air and clouds and fair and every kind of weather,
By the which Thou givest to Thy creatures nourishment.

Praised be my Lord for sister water,
The which is greatly helpful and humble and precious and pure.

Praised be my Lord for brother fire,
By the which Thou lightest up the dark.
And fair is he and gay and mighty and strong.

Praised be my Lord for our sister, mother earth,
The which sustains and keeps us
And brings forth diverse fruits with grass and flowers bright.

Praised be my Lord for those who for Thy love forgive
And weakness bear and tribulation.
Blessed those who shall in peace endure,
And by Thee, most High, shall they be crowned.

Praised be my Lord for our sister, the bodily death,
From the which no living man can flee.
Woe to them who die in mortal sin;
Blessed those who shall find themselves in Thy most holy will,
For the second death shall do them no ill.

Praise ye and bless ye my Lord, and give Him thanks,
And be subject unto Him with great humility.

HELOISE

Woman Is More Bitter than Death

———

Heloise, most famous as the beautiful teenaged lover of the great medieval philosopher Abelard, was born around 1098. Her parentage is unknown, but she was the niece (possibly the illegitimate daughter) of Fulbert, a canon of the cathedral of Notre Dame in Paris. She was already a highly educated young woman when Abelard began to tutor her while living as a lodger in Fulbert's house. Eventually the two fell in love and, according to Abelard, "With our books open before us, more words of love than of our reading passed between us, and more kissing than teaching. My hands strayed oftener to her bosom than to the pages; love drew our eyes to look on each other more than reading kept them on our texts." When Fulbert discovered their affair, the couple fled to Brittany where they secretly married. Abelard was castrated in revenge by Fulbert's enraged relatives, and afterward, Abelard persuaded Heloise to take the veil in the abbey of Argenteuil. Later Abelard gave her the Benedictine convent of the Paraclete that he had founded, and she became a famous abbess, corresponding with leading figures of the day such as Peter the Venerable. She died in 1164.

Heloise was one of the most daring and original minds of the Middle Ages, as is revealed in her correspondence with Abelard, which also displays her literary skill and philosophical acumen. The present letter was written after Heloise became a nun. It contains a bitter protest against the hypocrisy of contemporary religion, and a passionate complaint against God for his treatment of her and the female sex in general. The letter is also a radical critique of the concept of "living by rule," fundamental to medieval monasticism, and of the notion that outward conformity to a religious life can make one holy inside.

———

LETTER 3. HELOISE TO ABELARD

To her only one after Christ, she who is his alone in Christ.

I am surprised, my only love, that contrary to custom in letter-writing and, indeed, to the natural order, you have thought fit to put my name

before yours in the greeting which heads your letter, so that we have woman before man, wife before husband, handmaid before master, nun before monk, deaconess[1] before priest and abbess before abbot. Surely the right and proper order is for those who write to their superiors or equals to put their names before their own, but in letters to inferiors, precedence in order of address follows precedence in rank.[2]

We were also greatly surprised when instead of bringing us the healing balm of comfort you increased our desolation and made the tears to flow which you should have dried. For which of us could remain dry-eyed on hearing the words you wrote towards the end of your letter: 'But if the Lord shall deliver me into the hands of my enemies so that they overcome and kill me . . .'? My dearest, how could you think such a thought? How could you give voice to it? Never may God be so forgetful of his humble handmaids as to let them outlive you; never may he grant us a life which would be harder to bear than any form of death. The proper course would be for you to perform our funeral rites, for you to commend our souls to God, and to send ahead of you those whom you assembled for God's service—so that you need no longer be troubled by worries for us, and follow after us the more gladly because freed from concern for our salvation. Spare us, I implore you, master, spare us words such as these which can only intensify our existing unhappiness; do not deny us, before death, the one thing by which we live. 'Each day has trouble enough of its own,'[3] and that day, shrouded in bitterness, will bring with it distress enough to all it comes upon. 'Why is it necessary,' says Seneca, 'to summon evil'[4] and to destroy life before death comes?

You ask us, my love, if you chance to die when absent from us, to have your body brought to our burial-ground so that you may reap a fuller harvest from the prayers we shall offer in constant memory of you. But how could you suppose that our memory of you could ever fade? Besides, what time will there be then which will be fitting for prayer, when extreme distress will allow us no peace, when the soul will lose its power of reason and the tongue its use of speech? Or when the frantic mind, far from being resigned, may even (if I may say so) rage against God himself, and provoke him with complaints instead of placating him with prayers? In our misery then we shall have time only for tears and no power to pray; we shall be hurrying to follow, not to bury you, so that we may share your grave instead of laying you in it. If we lose our life in you, we shall not be able to go on living when you leave us. I would not even have us live to see that day, for if the mere mention of your death is death for us, what will the reality be if it finds us still alive?

God grant we may never live on to perform this duty, to render you the service which we look for from you alone; in this may we go before, not after you!

And so, I beg you, spare us—spare her at least, who is yours alone, by refraining from words like these. They pierce our hearts with swords of death, so that what comes before is more painful than death itself. A heart which is exhausted with grief cannot find peace, nor can a mind preoccupied with anxieties genuinely devote itself to God. I beseech you not to hinder God's service to which you specially committed us. Whatever has to come to us bringing with it total grief we must hope will come suddenly, without torturing us far in advance with useless apprehension which no foresight can relieve. This is what the poet has in mind when he prays to God:

> May it be sudden, whatever you plan for us; may man's mind
> Be blind to the future. Let him hope on in his fears.[5]

But if I lose you, what is left for me to hope for? What reason for continuing on life's pilgrimage, for which I have no support but you, and none in you save the knowledge that you are alive, now that I am forbidden all other pleasures in you and denied even the joy of your presence which from time to time could restore me to myself? O God—if I dare say it—cruel to me in everything! O merciless mercy! O Fortune who is only ill-fortune, who has already spent on me so many of the shafts she uses in her battle against mankind that she has none left with which to vent her anger on others. She has emptied a full quiver on me, so that henceforth no one else need fear her onslaughts, and if she still had a single arrow she could find no place in me to take a wound. Her only dread is that through my many wounds death may end my sufferings; and though she does not cease to destroy me, she still fears the destruction which she hurries on.

Of all wretched women I am the most wretched, and amongst the unhappy I am unhappiest. The higher I was exalted when you preferred me to all other women, the greater my suffering over my own fall and yours, when I was flung down; for the higher the ascent, the heavier the fall. Has Fortune ever set any great or noble woman above me or made her my equal, only to be similarly cast down and crushed with grief? What glory she gave me in you, what ruin she brought upon me through you! Violent in either extreme, she showed no moderation in good or evil. To make me the saddest of all women she first made me blessed above all, so that when I thought how much I had lost, my consuming grief would match my crushing loss, and my sorrow for what was taken

from me would be the greater for the fuller joy of possession which had gone before; and so that the happiness of supreme ecstasy would end in the supreme bitterness of sorrow.

Moreover, to add to my indignation at the outrage you suffered, all the laws of equity in our case were reversed. For while we enjoyed the pleasures of an uneasy love and abandoned ourselves to fornication (if I may use an ugly but expressive word) we were spared God's severity. But when we amended our unlawful conduct by what was lawful, and atoned for the shame of fornication by an honourable marriage, then the Lord in his anger laid his hand heavily upon us, and would not permit a chaste union though he had long tolerated one which was unchaste. The punishment you suffered would have been proper vengeance for men caught in open adultery. But what others deserve for adultery came upon you through a marriage which you believed had made amends for all previous wrong doing; what adulterous women have brought upon their lovers, your own wife brought on you. Nor was this at the time when we abandoned ourselves to our former delights, but when we had already parted and were leading chaste lives, you presiding over the school in Paris and I at your command living with the nuns at Argenteuil. Thus we were separated, to give you more time to devote yourself to your pupils, and me more freedom for prayer and meditation on the Scriptures, both of us leading a life which was holy as well as chaste. It was then that you alone paid the penalty in your body for a sin we had both committed. You alone were punished though we were both to blame, and you paid all, though you had deserved less, for you had made more than necessary reparation by humbling yourself on my account and had raised me and all my kind to your own level—so much less then, in the eyes of God and of your betrayers, should you have been thought deserving of such punishment.

What misery for me—born as I was to be the cause of such a crime! Is it the general lot of women to bring total ruin on great men? Hence the warning about women in Proverbs:[6] 'But now, my son, listen to me, attend to what I say: do not let your heart entice you into her ways, do not stray down her paths; she has wounded and laid low so many, and the strongest have all been her victims. Her house is the way to hell and leads down to the halls of death.' And in Ecclesiastes:[7] 'I put all to the test . . . I find woman more bitter than death; she is a snare, her heart a net, her arms are chains. He who is pleasing to God eludes her, but the sinner is her captive.'

It was the first woman in the beginning who lured man from Paradise, and she who had been created by the Lord as his helpmate became the

instrument of his total downfall. And that mighty man of God, the Nazarite whose conception was announced by an angel,[8] Delilah alone overcame; betrayed to his enemies and robbed of his sight, he was driven by his suffering to destroy himself along with his enemies. Only the woman he had slept with could reduce to folly Solomon, wisest of all men; she drove him to such a pitch of madness that although he was the man whom the Lord had chosen to build the temple in preference to his father David, who was a righteous man, she plunged him into idolatry until the end of his life, so that he abandoned the worship of God which he had preached and taught in word and writing.[9] Job, holiest of men, fought his last and hardest battle against his wife, who urged him to curse God.[10] The cunning arch-tempter well knew from repeated experience that men are most easily brought to ruin through their wives, and so he directed his usual malice against us too, and attacked you by means of marriage when he could not destroy you through fornication. Denied the power to do evil through evil, he effected evil through good.

At least I can thank God for this: the tempter did not prevail on me to do wrong of my own consent, like the women I have mentioned, though in the outcome he made me the instrument of his malice. But even if my conscience is clear through innocence, and no consent of mine makes me guilty of this crime, too many earlier sins were committed to allow me to be wholly free from guilt. I yielded long before to the pleasures of carnal desires, and merited then what I weep for now. The sequel is a fitting punishment for my former sins, and an evil beginning must be expected to come to a bad end. For this offence, above all, may I have strength to do proper penance, so that at least by long contrition I can make some amends for your pain from the wound inflicted on you; and what you suffered in the body for a time, I may suffer, as is right, throughout my life in contrition of mind, and thus make reparation to you at least, if not to God.

For if I truthfully admit to the weakness of my unhappy soul, I can find no penitence whereby to appease God, whom I always accuse of the greatest cruelty in regard to this outrage. By rebelling against his ordinance, I offend him more by my indignation than I placate him by making amends through penitence. How can it be called repentance for sins, however great the mortification of the flesh, if the mind still retains the will to sin and is on fire with its old desires?[11] It is easy enough for anyone to confess his sins, to accuse himself, or even to mortify his body in outward show of penance, but it is very difficult to tear the heart away from hankering after its dearest pleasures. Quite rightly then, when the saintly Job said 'I will speak out against myself,' that is, 'I will loose my

tongue and open my mouth in confession to accuse myself of my sins,' he added at once 'I will speak out in bitterness of soul.'[12] St Gregory comments on this: 'There are some who confess their faults aloud but in doing so do not know how to groan over them—they speak cheerfully of what should be lamented. And so whoever hates his faults and confesses them must still confess them in bitterness of spirit, so that this bitterness may punish him for what his tongue, at his mind's bidding, accuses him.'[13] But this bitterness of true repentance is very rare, as St Ambrose observes, when he says: 'I have more easily found men who have preserved their innocence than men who have known repentance.'[14]

In my case, the pleasures of lovers which we shared have been too sweet—they can never displease me, and can scarcely be banished from my thoughts. Wherever I turn they are always there before my eyes, bringing with them awakened longings and fantasies which will not even let me sleep. Even during the celebration of the Mass, when our prayers should be purer, lewd visions of those pleasures take such a hold upon my unhappy soul that my thoughts are on their wantonness instead of on prayers. I should be groaning over the sins I have committed, but I can only sigh for what I have lost. Everything we did and also the times and places are stamped on my heart along with your image, so that I live through it all again with you. Even in sleep I know no respite. Sometimes my thoughts are betrayed in a movement of my body, or they break out in an unguarded word. In my utter wretchedness, that cry from a suffering soul could well be mine: 'Miserable creature that I am, who is there to rescue me out of the body doomed to this death?'[15] Would that in truth I could go on: 'The grace of God through Jesus Christ our Lord.' This grace, my dearest, came upon you unsought—a single wound of the body by freeing you from these torments has healed many wounds in your soul. Where God may seem to you an adversary he has in fact proved himself kind: like an honest doctor who does not shrink from giving pain if it will bring about a cure. But for me, youth and passion and experience of pleasures which were so delightful intensify the torments of the flesh and longings of desire, and the assault is the more overwhelming as the nature they attack is the weaker.

Men call me chaste; they do not know the hypocrite I am. They consider purity of the flesh a virtue, though virtue belongs not to the body but to the soul. I can win praise in the eyes of men but deserve none before God, who searches our hearts and loins[16] and sees in our darkness. I am judged religious at a time when there is little in religion which is not hypocrisy, when whoever does not offend the opinions of men receives the highest praise. And yet perhaps there is some merit and it is

somehow acceptable to God, if a person whatever his intention gives no offence to the Church in his outward behaviour, does not blaspheme the name of the Lord in the hearing of unbelievers nor disgrace the Order of his profession amongst the worldly. And this too is a gift of God's grace and comes through his bounty—not only to do good but to abstain from evil—though the latter is vain if the former does not follow from it, as it is written: 'Turn from evil and do good.'[17] Both are vain if not done for love of God.

At every stage of my life up to now, as God knows, I have feared to offend you rather than God, and tried to please you more than him. It was your command, not love of God which made me take the veil. Look at the unhappy life I lead, pitiable beyond any other, if in this world I must endure so much in vain, with no hope of future reward. For a long time my pretence deceived you, as it did many, so that you mistook hypocrisy for piety; and therefore you commend yourself to my prayers and ask me for what I expect from you. I beg you, do not feel so sure of me that you cease to help me by your own prayers. Do not suppose me healthy and so withdraw the grace of your healing. Do not believe I want for nothing and delay helping me in my hour of need. Do not think me strong, lest I fall before you can sustain me. False praise has harmed many and taken from them the support they needed. The Lord cries out through Isaiah: 'O my people! Those who call you happy lead you astray and confuse the path you should take.'[18] And through Ezekiel he says: 'Woe upon you women who hunt men's lives by sewing magic bands upon the wrists and putting veils over the heads of persons of every age.'[19] On the other hand, through Solomon it is said that 'The sayings of the wise are sharp as goads, like nails driven home.'[20] That is to say, nails which cannot touch wounds gently, but only pierce through them.

Cease praising me, I beg you, lest you acquire the base stigma of being a flatterer or the charge of telling lies, or the breath of my vanity blows away any merit you saw in me to praise. No one with medical knowledge diagnoses an internal ailment by examining only outward appearance. What is common to the damned and the elect can win no favour in the eyes of God: of such a kind are the outward actions which are performed more eagerly by hypocrites than by saints. 'The heart of man is deceitful and inscrutable; who can fathom it?'[21] And: 'A road may seem straightforward to a man, yet may end as the way to death.'[22] It is rash for man to pass judgement on what is reserved for God's scrutiny, and so it is also written: 'Do not praise a man in his lifetime.'[23] By this is meant, do not praise a man while in doing so you can make him no longer praiseworthy.

To me your praise is the more dangerous because I welcome it. The more anxious I am to please you in everything, the more I am won over and delighted by it. I beg you, be fearful for me always, instead of feeling confidence in me, so that I may always find help in your solicitude. Now particularly you should fear, now when I no longer have in you an outlet for my incontinence. I do not want you to exhort me to virtue and summon me to the fight, saying 'Power comes to its full strength in weakness'[24] and 'He cannot win a crown unless he has kept the rules.'[25] I do not seek a crown of victory; it is sufficient for me to avoid danger, and this is safer than engaging in war. In whatever corner of heaven God shall place me, I shall be satisfied. No one will envy another there, and what each one has will suffice. Let the weight of authority reinforce what I say—let us hear St Jerome: 'I confess my weakness, I do not wish to fight in hope of victory, lest the day comes when I lose the battle. What need is there to forsake what is certain and pursue uncertainty?'[26]

EXPLANATORY NOTES

1. It is not clear what Heloise means here by 'deaconess', though subservience is implied from its use in the early Church. In Letter 7 Abelard uses the term for an abbess.
2. Heloise shows her knowledge of the rules for composing formal letters (*Dictamen* or *Ars dictandi*) which are found in several treatises from the eleventh century onwards, notably in that by Alberic (later Cardinal), theologian and monk of Monte Cassino, born in 1008. The rule of precedence is generally observed; it is a tribute to Heloise's status and reputation when Peter the Venerable, abbot of Cluny, in writing to her as abbess of the Paraclete, puts her name before his own.
3. Matthew vi, 34.
4. Seneca, *Epistulae ad Lucilium,* 24. 1.
5. Lucan, *Pharsalia* 2, 14–15.
6. Proverbs vii, 24–7.
7. Ecclesiastes vii, 26.
8. Samson, in Judges xiii, 3.
9. 1 Kings xi, 1–8.
10. Job ii, 9–10.
11. Heloise's concern for true repentance is closely linked with her belief in the ethic of intention. Inner contrition for sin is all-important.
12. Cf. Job x, 1.
13. *Moralia,* 9. 43.
14. *De paenitentia,* 2.10.
15. Romans vii, 24.

16. Psalm viii, 10.
17. Psalm xxxvii, 27.
18. Isaiah iii, 12 (Vulgate version).
19. Ezekiel xiii, 18, a much disputed verse. This is the N.E.B. translation; the Knox translation of the Vulgate says 'stitching an elbow cushion for every comer, making a soft pillow for the heads of young and old' and suggests that these are stuffed with magical herbs. Heloise appears to understand it as an attack on those who raise false hopes by superstitious practices.
20. Ecclesiastes xii, 11.
21. Jeremiah xvii, 9.
22. Proverbs xiv, 12; xvi, 25.
23. Ecclesiasticus xi, 28: the Vulgate (verse 30) reads *Ante mortem ne laudes hominem quemquam,* which cannot bear the explanation Heloise gives it. The N.E.B. translates the Hebrew 'Call no man happy before his death'. It continues 'for it is by his end that a man is known for what he is.' The similar classical tag means of course that death is the only guarantee against a reversal of fortune.
24. 2 Corinthians xii, 9.
25. 2 Timothy ii, 5.
26. *Adversus Vigilantium,* 16.

ABELARD

Forbidden Love and Its Punishment

Peter Abelard (1079–1142) was the greatest philosopher of the twelfth cen-
tury and the true founder of the method of comparing and questioning
texts, known as the "scholastic method." He was born in Le Pallet in Brit-
tany, the son of a minor noble, studied logic under Roscelin of Compiègne
and William of Champeaux, and briefly, divinity under Anselm of Laon.
Most of his career as a student and teacher was spent in the cathedral
schools of northern France, particularly in Paris, which was just then
emerging as the chief scholastic center of France. While teaching in Paris,
Abelard became the tutor of the beautiful and brilliant Heloise, the seventeen-
year-old daughter of his landlord Fulbert, and the two fell passionately in
love. When their relationship was discovered, Fulbert threw them out of
the house, and the couple fled to Brittany, where Heloise gave birth to a
son, Astrolabe ("Slipped-from-a-Star"). The couple returned to Paris and
secretly married, but were discovered by Fulbert's relatives, who broke into
their house one night and castrated Abelard. He fled in shame to the abbey
of St. Denis and became a monk, while Heloise took the veil as a nun at
Argenteuil. Abelard was hounded by his enemies for the rest of his life. He
was accused several times of heresy and was actually condemned by the
Council of Sens in 1140. He died as a monk in the priory of Saint-Michel
near Chalon-sur-Saone.

Abelard's teaching method, which became the standard approach to
reading texts in the medieval university, was outlined in his Sic et Non (Yes
and No). Abelard also composed a treatise, Nosce te ipsum (Know Thy-
self), *in which he defended an ethics that makes the intention of the agent*
the prime criterion of the right or wrong of an action. His most influential
works were his various logic textbooks, and his most controversial were his
works on theology. Thanks to his extraordinarily vivid autobiography, The
Story of My Misfortunes, *Abelard has also become one of the best-known*
personalities of the Middle Ages. The autobiography takes the form of a
consolatory epistle to an unnamed friend. The passage excerpted here is
from this text, which tells the most famous love story of the Middle Ages,
and its unhappy outcome.

But success always puffs up fools with pride, and worldly security weakens the spirit's resolution and easily destroys it through carnal temptations. I began to think myself the only philosopher in the world, with nothing to fear from anyone, and so I yielded to the lusts of the flesh. Hitherto I had been entirely continent, but now the further I advanced in philosophy and theology, the further I fell behind the philosophers and holy Fathers in the impurity of my life. It is well known that the philosophers, and still more the Fathers, by which is meant those who have devoted themselves to the teachings of Holy Scripture, were especially glorified by their chastity. Since therefore I was wholly enslaved to pride and lechery, God's grace provided a remedy for both these evils, though not one of my choosing: first for my lechery by depriving me of those organs with which I practised it, and then for the pride which had grown in me through my learning—for in the words of the Apostle, 'Knowledge breeds conceit'[1]—when I was humiliated by the burning of the book of which I was so proud.[2]

The true story of both these episodes I now want you to know from the facts, in their proper order, instead of from hearsay. I had always held myself aloof from unclean association with prostitutes, and constant application to my studies had prevented me from frequenting the society of gentle-women: indeed, I knew little of the secular way of life. Perverse Fortune flattered me, as the saying goes, and found an easy way to bring me toppling down from my pedestal, or rather, despite my overbearing pride and heedlessness of the grace granted me, God's compassion claimed me humbled for Himself.

There was in Paris at the time a young girl named Heloise,[3] the niece of Fulbert, one of the canons, and so much loved by him that he had done everything in his power to advance her education in letters. In looks she did not rank lowest, while in the extent of her learning she stood supreme. A gift for letters is so rare in women that it added greatly to her charm and had won her renown throughout the realm. I considered all the usual attractions for a lover and decided she was the one to bring to my bed, confident that I should have an easy success; for at that time I had youth and exceptional good looks as well as my great reputation to recommend me, and feared no rebuff from any woman I might choose to honour with my love. Knowing the girl's knowledge and love of letters I thought she would be all the more ready to consent, and that even when separated we could enjoy each other's presence by exchange of written messages in which we could speak more openly than in person, and so need never lack the pleasures of conversation.

All on fire with desire for this girl I sought an opportunity of getting to know her through private daily meetings and so more easily winning

her over; and with this end in view I came to an arrangement with her uncle, with the help of some of his friends, whereby he should take me into his house, which was very near my school, for whatever sum he liked to ask. As a pretext I said that my household cares were hindering my studies and the expense was more than I could afford. Fulbert dearly loved money, and was moreover always ambitious to further his niece's education in letters, two weaknesses which made it easy for me to gain his consent and obtain my desire: he was all eagerness for my money and confident that his niece would profit from my teaching. This led him to make an urgent request which furthered my love and fell in with my wishes more than I had dared to hope; he gave me complete charge over the girl, so that I could devote all the leisure time left me by my school to teaching her by day and night, and if I found her idle I was to punish her severely. I was amazed by his simplicity—if he had entrusted a tender lamb to a ravening wolf it would not have surprised me more. In hand-ing her over to me to punish as well as to teach, what else was he doing but giving me complete freedom to realize my desires, and providing an opportunity, even if I did not make use of it, for me to bend her to my will by threats and blows if persuasion failed? But there were two special reasons for his freedom from base suspicion: his love for his niece and my previous reputation for continence.

Need I say more? We were united, first under one roof, then in heart; and so with our lessons as a pretext we abandoned ourselves entirely to love. Her studies allowed us to withdraw in private, as love desired, and then with our books open before us, more words of love than of our reading passed between us, and more kissing than teaching. My hands strayed oftener to her bosom than to the pages; love drew our eyes to look on each other more than reading kept them on our texts. To avert suspicion I sometimes struck her, but these blows were prompted by love and tender feeling rather than anger and irritation, and were sweeter than any balm could be. In short, our desires left no stage of love-making untried, and if love could devise something new, we welcomed it. We entered on each joy the more eagerly for our previous inexperience, and were the less easily sated.

Now the more I was taken up with these pleasures, the less time I could give to philosophy and the less attention I paid to my school. It was utterly boring for me to have to go to the school, and equally weari-some to remain there and to spend my days on study when my nights were sleepless with love-making. As my interest and concentration flagged, my lectures lacked all inspiration and were merely repetitive; I could do no more than repeat what had been said long ago, and when

inspiration did come to me, it was for writing love-songs, not the secrets of philosophy. A lot of these songs, as you know, are still popular and sung in many places,[4] particularly by those who enjoy the kind of life I led. But the grief and sorrow and laments of my students when they realized my preoccupation, or rather, distraction of mind are hard to realize. Few could have failed to notice something so obvious, in fact no one, I fancy, except the man whose honour was most involved—Heloise's uncle. Several people tried on more than one occasion to draw his attention to it, but he would not believe them; because, as I said, of his boundless love for his niece and my well-known reputation for chastity in my previous life. We do not easily think ill of those whom we love most, and the taint of suspicion cannot exist along with warm affection. Hence the remark of St Jerome in his letter to Sabinian:[5] 'We are always the last to learn of evil in our own home, and the faults of our wife and children may be the talk of the town but do not reach our ears.'

But what is last to be learned is somehow learned eventually, and common knowledge cannot easily be hidden from one individual. Several months passed and then this happened in our case. Imagine the uncle's grief at the discovery, and the lovers' grief too at being separated! How I blushed with shame and contrition for the girl's plight, and what sorrow she suffered at the thought of my disgrace! All our laments were for one another's troubles, and our distress was for each other, not for ourselves. Separation drew our hearts still closer while frustration inflamed our passion even more; then we became more abandoned as we lost all sense of shame and, indeed, shame diminished as we found more opportunities for love-making. And so we were caught in the act as the poet says happened to Mars and Venus.[6] Soon afterwards the girl found that she was pregnant, and immediately wrote me a letter full of rejoicing to ask what I thought she should do. One night then, when her uncle was away from home, I removed her secretly from his house, as we had planned, and sent her straight to my own country. There she stayed with my sister until she gave birth to a boy, whom she called Astrolabe.[7]

On his return her uncle went almost out of his mind—one could appreciate only by experience his transports of grief and mortification. What action could he take against me? What traps could he set? He did not know. If he killed me or did me personal injury, there was the danger that his beloved niece might suffer for it in my country. It was useless to try to seize me or confine me anywhere against my will, especially as I was very much on guard against this very thing, knowing that he would not hesitate to assault me if he had the courage or the means.

In the end I took pity on his boundless misery and went to him, accusing myself of the deceit love had made me commit as if it were the basest treachery. I begged his forgiveness and promised to make any amends he might think fit. I protested that I had done nothing unusual in the eyes of anyone who had known the power of love, and recalled how since the beginning of the human race women had brought the noblest men to ruin. Moreover, to conciliate him further, I offered him satisfaction in a form he could never have hoped for: I would marry the girl I had wronged. All I stipulated was that the marriage should be kept secret so as not to damage my reputation.[8] He agreed, pledged his word and that of his supporters, and sealed the reconciliation I desired with a kiss. But his intention was to make it easier to betray me.

I set off at once for Brittany and brought back my mistress to make her my wife. But she was strongly opposed to the proposal, and argued hotly against it for two reasons: the risk involved and the disgrace to myself. She swore that no satisfaction could ever appease her uncle, as we subsequently found out. What honour could she win, she protested, from a marriage which would dishonour me and humiliate us both? The world would justly exact punishment from her if she removed such a light from its midst. Think of the curses, the loss to the Church and grief of philosophers which would greet such a marriage! Nature had created me for all mankind—it would be a sorry scandal if I should bind myself to a single woman and submit to such base servitude. She absolutely rejected this marriage; it would be nothing but a disgrace and a burden to me. Along with the loss to my reputation she put before me the difficulties of marriage, which the apostle Paul exhorts us to avoid when he says:[9] 'Has your marriage been dissolved? Do not seek a wife. If, however, you do marry, there is nothing wrong in it; and if a virgin marries, she has done no wrong. But those who marry will have pain and grief in this bodily life, and my aim is to spare you.' And again: 'I want you to be free from anxious care.'

But if I would accept neither the advice of the Apostle nor the exhortations of the Fathers on the heavy yoke of marriage, at least, she argued, I could listen to the philosophers, and pay regard to what had been written by them or concerning them on this subject—as for the most part the Fathers too have carefully done when they wish to rebuke us. For example, St Jerome in the first book of his *Against Jovinian*[10] recalls how Theophrastus sets out in considerable detail the unbearable annoyances of marriage and its endless anxieties, in order to prove by the clearest possible arguments that a man should not take a wife; and he brings his reasoning from the exhortations of the philosophers to this conclusion:

'Can any Christian hear Theophrastus argue in this way without a blush?' In the same book Jerome goes on to say that 'After Cicero had divorced Terentia and was asked by Hirtius to marry his sister he firmly refused to do so, on the grounds that he could not devote his attention to a wife and philosophy alike. He does not simply say "devote attention", but adds "alike", not wishing to do anything which would be a rival to his study of philosophy.'

But apart from the hindrances to such philosophic study, consider, she said, the true conditions for a dignified way of life. What harmony can there be between pupils and nursemaids, desks and cradles, books or tablets and distaffs, pen or stylus and spindles? Who can concentrate on thoughts of Scripture or philosophy and be able to endure babies crying, nurses soothing them with lullabies, and all the noisy coming and going of men and women about the house? Will he put up with the constant muddle and squalor which small children bring into the home? The wealthy can do so, you will say, for their mansions and large houses can provide privacy and, being rich, they do not have to count the cost nor be tormented by daily cares. But philosophers lead a very different life from rich men, and those who are concerned with wealth or are involved in mundane matters will not have time for the claims of Scripture or philosophy. Consequently, the great philosophers of the past have despised the world, not renouncing it so much as escaping from it, and have denied themselves every pleasure so as to find peace in the arms of philosophy alone. The greatest of them, Seneca, gives this advice to Lucilius:[11] 'Philosophy is not a subject for idle moments. We must neglect everything else and concentrate on this, for no time is long enough for it. Put it aside for a moment, and you might as well give it up, for once interrupted it will not remain. We must resist all other occupations, not merely dispose of them but reject them.'

This is the practice today through love of God of those among us who truly deserve the name of monks,[12] as it was of distinguished philosophers amongst the pagans in their pursuit of philosophy. For in every people, pagan, Jew or Christian, some men have always stood out for their faith or upright way of life, and have cut themselves off from their fellows because of their singular chastity or austerity. Amongst the Jews in times past there were the Nazirites,[13] who dedicated themselves to the Lord according to the Law, and the sons of the prophets, followers of Elijah or Elisha, whom the Old Testament calls monks, as St Jerome bears witness;[14] and in more recent times the three sects of philosophers described by Josephus in the eighteenth book of his *Antiquities*,[15] the Pharisees, Sadducees and Essenes. Today we have the monks who imitate

either the communal life of the apostles or the earlier, solitary life of John. Among the pagans, as I said, are the philosophers: for the name of wisdom or philosophy used to be applied not so much to acquisition of learning as to a religious way of life, as we learn from the first use of the word itself and from the testimony of the saints themselves. And so St Augustine, in the eighth book of his *City of God,* distinguishes between types of philosopher:[16]

> The Italian school was founded by Pythagoras of Samos, who is said to have been the first to use the term philosophy; before him men were called 'sages' if they seemed outstanding for some praiseworthy manner of life. But when Pythagoras was asked his profession, he replied that he was a philosopher, meaning a devotee or lover of wisdom, for he thought it too presumptuous to call himself a sage.

So the phrase 'if they seemed outstanding for some praiseworthy manner of life' clearly proves that the sages of the pagans, that is, the philosophers, were so called as a tribute to their way of life, not to their learning. There is no need for me to give examples of their chaste and sober lives—I should seem to be teaching Minerva herself. But if pagans and laymen could live in this way, though bound by no profession of faith, is there not a greater obligation on you, as clerk and canon, not to put base pleasures before your sacred duties, and to guard against being sucked down headlong into this Charybdis, there to lose all sense of shame and be plunged forever into a whirlpool of impurity? If you take no thought for the privilege of a clerk, you can at least uphold the dignity of a philosopher, and let a love of propriety curb your shamelessness if the reverence due to God means nothing to you. Remember Socrates' marriage and the sordid episode whereby he did at least remove the slur it cast on philosophy by providing an example to be a warning to his successors. This too was noted by Jerome, when he tells this tale of Socrates in the first book of his *Against Jovinian:*[17] 'One day after he had withstood an endless stream of invective which Xanthippe poured out from a window above his head, he felt himself soaked with dirty water. All he did was to wipe his head and say: "I knew that thunderstorm would lead to rain."'

Heloise then went on to the risks I should run in bringing her back, and argued that the name of mistress instead of wife would be dearer to her and more honourable for me—only love freely given should keep me for her, not the constriction of a marriage tie, and if we had to be parted for a time, we should find the joy of being together all the sweeter the rarer our meetings were. But at last she saw that her attempts to persuade or dissuade me were making no impression on my foolish obstinacy, and

she could not bear to offend me; so amidst deep sighs and tears she ended in these words: 'We shall both be destroyed. All that is left us is suffering as great as our love has been.' In this, as the whole world knows, she showed herself a true prophet.

And so when our baby son was born we entrusted him to my sister's care and returned secretly to Paris. A few days later, after a night's private vigil of prayer in a certain church, at dawn we were joined in matrimony in the presence of Fulbert and some of his, and our, friends. Afterwards we parted secretly and went our ways unobserved. Subsequently our meetings were few and furtive, in order to conceal as far as possible what we had done. But Fulbert and his servants, seeking satisfaction for the dishonour done to him, began to spread the news of the marriage and break the promise of secrecy they had given me. Heloise cursed them and swore that there was no truth in this, and in his exasperation Fulbert heaped abuse on her on several occasions. As soon as I discovered this I removed her to a convent of nuns in the town near Paris called Argenteuil, where she had been brought up and educated as a small girl, and I also had made for her a religious habit of the type worn by novices, with the exception of the veil, and made her put it on.[18]

At this news her uncle and his friends and relatives imagined that I had tricked them, and had found an easy way of ridding myself of Heloise by making her a nun. Wild with indignation they plotted against me, and one night as I slept peacefully in an inner room in my lodgings, they bribed one of my servants to admit them and there took cruel vengeance on me of such appalling barbarity as to shock the whole world; they cut off the parts of my body whereby I had committed the wrong of which they complained. Then they fled, but the two who could be caught were blinded and mutilated as I had been, one of them being the servant who had been led by greed while in my service to betray his master.

Next morning the whole city gathered before my house, and the scene of horror and amazement, mingled with lamentations, cries and groans which exasperated and distressed me, is difficult, no, impossible, to describe. In particular, the clerks and, most of all, my pupils tormented me with their unbearable weeping and wailing until I suffered more from their sympathy than from the pain of my wound, and felt the misery of my mutilation less than my shame and humiliation.[19] All sorts of thoughts filled my mind—how brightly my reputation had shone, and now how easily in an evil moment it had been dimmed or rather completely blotted out; how just a judgement of God had struck me in the parts of the body with which I had sinned, and how just a reprisal had

been taken by the very man I had myself betrayed. I thought how my rivals would exult over my fitting punishment, how this bitter blow would bring lasting grief and misery to my friends and parents, and how fast the news of this unheard-of disgrace would spread over the whole world. What road could I take now? How could I show my face in public, to be pointed at by every finger, derided by every tongue, a monstrous spectacle to all I met? I was also appalled to remember that according to the cruel letter of the Law, a eunuch is such an abomination to the Lord that men made eunuchs by the amputation or mutilation of their members are forbidden to enter a church as if they were stinking and unclean, and even animals in that state are rejected for sacrifice. 'Ye shall not present to the Lord any animal if its testicles have been bruised or crushed, torn or cut.' 'No man whose testicles have been crushed or whose organ has been severed shall become a member of the assembly of the Lord.'[20]

I admit that it was shame and confusion in my remorse and misery rather than any devout wish for conversion which brought me to seek shelter in a monastery cloister. Heloise had already agreed to take the veil in obedience to my wishes and entered a convent. So we both put on the religious habit, I in the Abbey of St Denis,[21] and she in the Convent of Argenteuil which I spoke of before. There were many people, I remember, who in pity for her youth tried to dissuade her from submitting to the yoke of monastic rule as a penance too hard to bear, but all in vain; she broke out as best she could through her tears and sobs into Cornelia's famous lament:[22]

> O noble husband,
> Too great for me to wed, was it my fate
> To bend that lofty head? What prompted me
> To marry you and bring about your fall?
> Now claim your due, and see me gladly pay . . .

So saying she hurried to the altar, quickly took up the veil blessed by the bishop, and publicly bound herself to the religious life.

. . .

EXPLANATORY NOTES

1. 1 Corinthians viii, 1. Abelard and Heloise both quote from the Bible very freely. Their own words have been translated when they are only approximate to the Latin of the Vulgate; otherwise the N.E.B., Knox or Jerusalem Bible has been used.
2. His treatise *On the Unity and Trinity of God*, burnt by order of the Council of Soissons.

3. None of the conjectures about Heloise's birth and parentage can be proved, and as she was a young girl *(adolescentula)*, it can only be assumed that she was about seventeen at this time, and born in 1100 or 1101. Her mother's name appears in the necrology of the Paraclete as Hersinde; her father is unknown. It is possible that she was illegitimate, and twice in her letters she implies that her social status was lower than Abelard's. Fulbert presumably lived in the cathedral close, north-east of Notre Dame, traditionally in a house on the Quai aux Fleurs.
4. None of these love-lyrics survives, and there are no love-poems in north France as early as this.
5. *Epistulae* cxlvii, 10. The MSS. read 'to Castrician'.
6. They were found in bed together by Venus' husband, Vulcan. The story we now associate with Homer (*Odyssey*, Book 8) was well known to Abelard through the versions by Ovid in *Ars amatoria*, 2. 561 ff. and *Metamorphoses*, 4. 169 ff.
7. In Letter 4, Abelard adds the detail that she was disguised as a nun. The sister was probably the Denise or Dionisia who appears in the necrology of the Paraclete, as does Peter Astralabe or Astrolabe. We can only assume that Heloise stayed at Le Pallet, and there is no historical basis for associating her with the more romantic scenery of Clisson. The child's strange name, which Abelard says she chose, remains unexplained.
8. Opinion is divided on whether Abelard was in Orders at this time but, even if he were, the Church was only just beginning to forbid marriage to priests and the higher orders of clergy. It would have been thought unworthy of anyone in Abelard's position not to remain celibate, and would have been a bar to his advancement in the Church, where alone he could find scope for his ambitions. One of Heloise's arguments is that his marriage would mean a loss to the Church, her main one that it would be a betrayal of the philosophic ideal. But obviously a secret marriage would not satisfy Fulbert's demand for public satisfaction for the wrong done to his niece. Abelard's true motive for wanting a marriage is revealed in his second letter.
9. 1 Corinthians vii, 27, 28, 32.
10. *Contra Jovinianum*, 47.
11. *Epistulae ad Lucilium*, 72. 3.
12. *Monachus* (monk) originally denotes one who chooses a solitary life.
13. Cf. Numbers vi, 21 and Judges xvi, 17 (Samson).
14. Kings vi, 1; Jerome, *Epistulae* cxxv, 7.
15. *Antiquities*, 18.1.11.
16. *De civitate Dei*, 8.2.
17. 1.48. Muckle points out that all these quotations (apart from the one from Seneca) appear in other works by Abelard, and in particular in Book II of his *Theologia Christiana* written ten years previously (*Mediaeval Studies*, Vol. XII, pp. 173–4). This suggests that before circulating the *Historia calamitatum* Abelard had expanded Heloise's arguments and supplied precise quotations.

18. Heloise took the veil later when she became a nun, but she could have stayed at the convent without wearing a habit at all. The Convent of Ste Marie of Argenteuil was founded as a monastery in the late seventh century by a nobleman Hermenricus and his wife Numma, who presented it to the Abbey of St Denis. In the early ninth century Charlemagne removed it from St Denis and made it independent, with his daughter Theodrada as abbess. She intended it to revert to St Denis at her death, but in the civil wars and the Norman invasions it was destroyed and abandoned for about 150 years. At the end of the tenth century it was restored by Queen Adelaide, wife of Hugh Capet, richly endowed and filled with nuns of the order of St Benedict.

19. A letter of consolation exists, written by Fulk, prior of the Benedictine house of St Eugène at Deuil, near Montmorency.

20. Leviticus xxii, 24; Deuteronomy xxiii, 1.

21. The Benedictine Abbey of St Denis, built to enshrine the tomb of the first bishop of Paris, had close royal connections (many of the kings of France were crowned and buried there), and at this date (c. 1119) was still 'unreformed' and often used as a centre for transacting state business. It was to be splendidly embellished and monastic discipline restored in accordance with St Benedict's Rule by Abbot Suger under the guidance of St Bernard of Clairvaux. See *The Letters of St Bernard*, trans. B. S. James, no. 80.

22. Lucan, *Pharsalia*, 8. 94.

THOMAS AQUINAS

Thomas Aquinas on Natural Law

Thomas Aquinas (c. 1225–1274) was the greatest theologian of the medieval Catholic Church and an outstanding representative of scholasticism, the intellectual tradition associated with medieval universities. Aquinas was born in Roccasecca near Aquino, a town in Campania south of Rome. The son of a nobleman, he was educated at the abbey of Montecassino and at the University of Naples, where he became a member of the Dominican Order of Preachers. Aquinas later studied the newly revived philosophy of Aristotle at Cologne under Albert the Great and took the degree of Master of Theology at Paris in 1256. He spent the rest of his life teaching at Dominican study houses and universities in France and Italy, and died in 1274. He was canonized in 1323.

Aquinas's thought, known as Thomism, has historically constituted the most important theological tradition within Roman Catholicism. Broadly speaking, it attempts to reconcile the teachings of the best pagan philosophers, particularly Aristotle, with Christian doctrine, or (as Aquinas would have said) Reason with Faith. The present selection, written in 1271, is one of the most famous parts of the Summa Theologiae, *in which Thomas discusses his conception of natural law and its relationship to eternal law, divine law, and human law.*

Article 2: Is there some natural law in us?

It seems that there is not.

1. A man is sufficiently governed by eternal law, for Augustine says in *On Free Will* 1.6 that the eternal law is that by which it is just that all things are perfectly ordered. But nature does not abound in superfluities, just as it is not deficient in what is necessary. Therefore there is no natural law in man.

2. Moreover, by law a man's acts are ordered to the end, as was said above, but the ordering of human acts to the end is not by nature, as

happens in irrational creatures, which by natural appetite alone act for the sake of the end; man acts for the sake of the end through reason and will. Therefore, there is no natural law in man.

3. To the degree that one is free he is less subject to the law. But man is freer than the other animals, thanks to free will, which he has beyond the other animals. Therefore since other animals are not subject to natural law, neither should man be subject to any natural law.

ON THE CONTRARY:

On Romans 2.14, 'These having no law are a law unto themselves,' the Gloss says that although they do not have the written law, they have the natural law which each understands and is thereby conscious of what is good and what is evil.

RESPONSE:

It should be said that, as has been urged, law, since it is a rule and measure, can be in something in two ways: in one way, as in the one ruling and measuring, in another way, as in the ruled and measured, since insofar as they participate in something of the rule or measure, they are ruled and measured. Since all things subject to divine providence are ruled and measured by the eternal law, as is clear from what has been said, it is manifest that all things participate in some way in eternal law, insofar as by its impression they have inclinations to their proper acts and ends. Among others, however, the rational creature is subject to divine providence in a more excellent manner, insofar as he comes to be a participant in providence, providing for himself and others. Hence in him the eternal reason is participated in in such a way that he has a natural inclination to the fitting act and end. Such a participation in eternal law in the rational creature is called natural law. Hence when the Psalmist says in Psalm 4.6, 'Offer sacrifices of righteousness, and hope in the Lord,' he adds as if in response to someone asking what the works of justice are, 'Many say: "Who will show us good things?"' Replying to that question, he says, 'Lift up the light of thy countenance upon us, O Lord,' as if the natural light of reason, whereby we discern good and evil, which pertains to natural law, is nothing else than the impression of the divine light in us. Hence it is evident that natural law is nothing other than the participation in eternal law on the part of the rational creature.

Ad 1. It should be said that that argument would work if natural law were something different from eternal law. But it is nothing but a participation in it, as has been said.

Ad 2. It should be said that every act of reason and will in us is derived from that which is according to nature, as was said above, for all reasoning derives from principles naturally known, and every desire for the things which are for the sake of the end derives from the natural desire for the ultimate end. Thus it is necessary that the first direction of our acts to the end should come about through natural law.

Ad 3. It should be said that even the irrational animals participate in the eternal law in their fashion, as does the rational creature. But because the rational creature participates in it intellectually and rationally, the participation in eternal law by the rational creature is properly called law, for law is something of reason, as has been said. But in the irrational creature it is not participated in rationally, hence it can only be called law by way of similitude.

MARIE DE FRANCE

Lanval and Les Deus Amanz

Marie de France is the name conventionally assigned to the earliest female French poet known to literary history. Beyond her first name, however, virtually nothing else about Marie's life can be established with certainty. She was active in the second half of the twelfth century, a period that witnessed an extraordinary flourishing of French vernacular literature. A number of textual indications suggests that Marie was at least known in English courtly circles, and she may in fact have written in England. Marie is best known for her lais, *relatively brief poems that recount Breton tales of love and adventure. She is also thought to be the author of a collection of fables, known as* ysopets, *translated from English into Old French.*

In contrast to contemporary epic poetry, Marie's lais *are much more concerned with the relationships between their characters than with the heroic and gory clatter of battle. Indeed, the poems usually include the resolution of a dramatic crisis in a love affair, leading eventually to happiness for the lovers (although further tests may be required, or trials endured). In contrast to contemporary courtly romances, the* lais *spend much less time on rhetorically polished descriptions of idealized love, and more on its sometimes spontaneous development and immediate practical effects. Moreover, Marie's protagonists are not restricted to the adulterous courtly women of Arthurian romance, although a number of her poems incorporate situations and characters familiar to other types of courtly love literature. The lays presented here are two of the collection's more celebrated poems, and they both include complex approaches to themes as familiar as the court of Camelot and the tragic death of two young lovers.*

LANVAL

Just as it happened, I shall relate to you the story of another lay, which tells of a very noble young man whose name in Breton is Lanval.

Arthur, the worthy and courtly king, was at Carlisle on account of the Scots and the Picts who were ravaging the country, penetrating into the land of Logres and frequently laying it waste.

The king was there during the summer, at Pentecost, and he gave many rich gifts to counts and barons and to those of the Round Table: there was no such company in the whole world. He apportioned wives and lands to all, save to one who had served him: this was Lanval, whom he did not remember, and for whom no one put in a good word. Because of his valour, generosity, beauty and prowess, many were envious of him. There were those who pretended to hold him in esteem, but who would not have uttered a single regret if misfortune had befallen him. He was the son of a king of noble birth, but far from his inheritance, and although he belonged to Arthur's household he had spent all his wealth, for the king gave him nothing and Lanval asked for nothing. Now he was in a plight, very sad and forlorn. Lords, do not be surprised: a stranger bereft of advice can be very downcast in another land when he does not know where to seek help.

This knight whose tale I am telling you had served the king well. One day he mounted his horse and went to take his ease. He left the town and came alone to a meadow, dismounting by a stream; but there his horse trembled violently, so he loosened its saddlegirth and left it, allowing it to enter the meadow to roll over on its back. He folded his cloak, which he placed beneath his head, very disconsolate because of his troubles, and nothing could please him. Lying thus, he looked downriver and saw two damsels coming, more beautiful than any he had ever seen: they were richly dressed in closely fitting tunics of dark purple and their faces were very beautiful. The older one carried dishes of gold, well and finely made—I will not fail to tell you the truth—and the other carried a towel. They went straight to where the knight lay and Lanval, who was very well-mannered, stood up to meet them. They first greeted him and then delivered their message: 'Sir Lanval, my damsel, who is very worthy, wise and fair, has sent us for you. Come with us, for we will conduct you safely. Look, her tent is near.' The knight went with them, disregarding his horse which was grazing before him in the meadow. They led him to the tent, which was so beautiful and well-appointed that neither Queen Semiramis at the height of her wealth, power and knowledge, nor the Emperor Octavian, could have afforded even the right-hand side of it. There was a golden eagle placed on the top, the value of which I cannot tell, nor of the ropes or the poles which supported the walls of the tent. There is no king under the sun who could afford it, however much he might give. Inside this tent was the maiden who surpassed in beauty the

lily and the new rose when it appears in summer. She lay on a very beautiful bed—the coverlets cost as much as a castle—clad only in her shift. Her body was well formed and handsome, and in order to protect herself from the heat of the sun, she had cast about her a costly mantle of white ermine covered with Alexandrian purple. Her side, though, was uncovered, as well as her face, neck and breast; she was whiter than the hawthorn blossom.

The maiden called the knight, who came forward and sat before the bed. 'Lanval,' she said, 'fair friend, for you I came from my country. I have come far in search of you and if you are worthy and courtly, no emperor, count or king will have felt as much joy or happiness as you, for I love you above all else.' He looked at her and saw that she was beautiful. Love's spark pricked him so that his heart was set alight, and he replied to her in seemly manner: 'Fair lady, if it were to please you to grant me the joy of wanting to love me, you could ask nothing that I would not do as best I could, be it foolish or wise. I shall do as you bid and abandon all others for you. I never want to leave you and this is what I most desire.' When the girl heard these words from the man who loved her so, she granted him her love and her body. Now Lanval was on the right path! She gave him a boon, that henceforth he could wish for nothing which he would not have, and however generously he gave or spent, she would still find enough for him. Lanval was very well lodged, for the more he spent, the more gold and silver he would have. 'Beloved,' she said, 'I admonish, order, and beg you not to reveal this secret to anyone! I shall tell you the long and the short of it: you would lose me forever if this love were to become known. You would never be able to see me or possess me.' He replied that he would do what she commanded. He lay down beside her on the bed: now Lanval was well lodged. That afternoon he remained with her until evening and would have done so longer had he been able and had his love allowed him. 'Beloved,' she said, 'arise! You can stay no longer. Go from here and I shall remain, but I shall tell you one thing: whenever you wish to speak with me, you will not be able to think of a place where a man may enjoy his love without reproach or wickedness, that I shall not be there with you to do your bidding. No man save you will see me or hear my voice.' When he heard this, Lanval was well pleased and, kissing her, he arose. The damsels who had led him to the tent dressed him in rich garments, and in his new clothes there was no more handsome young man on earth. He was neither foolish nor ill-mannered. The damsels gave him water to wash his hands and a towel to dry them and then brought him food. He took his supper, which was not to be disdained, with his beloved. He was very

courteously served and dined joyfully. There was one dish in abundance that pleased the knight particularly, for he often kissed his beloved and embraced her closely.

When they had risen from table, his horse was brought to him, well saddled. Lanval was richly served there. He took his leave, mounted, and went towards the city, often looking behind him, for he was greatly disturbed, thinking of his adventure and uneasy in his heart. He was at a loss to know what to think, for he could not believe it was true. When he came to his lodgings, he found his men finely dressed. That night he offered lavish hospitality but no one knew how this came to be. There was no knight in the town in sore need of shelter whom he did not summon and serve richly and well. Lanval gave costly gifts, Lanval freed prisoners, Lanval clothed the jongleurs, Lanval performed many honourable acts. There was no one, stranger or friend, to whom he would not have given gifts. He experienced great joy and pleasure, for day or night he could see his beloved often and she was entirely at his command.

In the same year, I believe, after St John's day, as many as thirty knights had gone to relax in a garden beneath the tower where the queen was staying. Gawain was with them and his cousin, the fair Ywain. Gawain, the noble and the worthy, who endeared himself to all, said: 'In God's name, lords, we treat our companion Lanval ill, for he is so generous and courtly, and his father is a rich king, yet we have not brought him with us.' So they returned, went to his lodgings and persuaded him to come with them.

The queen, in the company of three ladies, was reclining by a window cut out of the stone when she caught sight of the king's household and recognized Lanval. She called one of her ladies to summon her most elegant and beautiful damsels to relax with her in the garden where the others were. She took more than thirty with her, and they went down the steps where the knights, glad of their coming, came to meet them. They took the girls by the hand and the conversation was not uncourtly. Lanval withdrew to one side, far from the others, for he was impatient to hold his beloved, to kiss, embrace and touch her. He cared little for other people's joy when he could not have his own pleasure. When the queen saw the knight alone, she approached him straightaway. Sitting down beside him, she spoke to him and opened her heart. 'Lanval, I have honoured, cherished and loved you much. You may have all my love: just tell me what you desire! I grant you my love and you should be glad to have me.' 'Lady,' he said, 'leave me be! I have no desire to love you, for I have long served the king and do not want to betray my faith. Neither

you nor your love will ever lead me to wrong my lord!' The queen became angry and distressed, and spoke unwisely: 'Lanval,' she said, 'I well believe that you do not like this kind of pleasure. I have been told often enough that you have no desire for women. You have well-trained young men and enjoy yourself with them. Base coward, wicked recreant, my lord is extremely unfortunate to have suffered you near him. I think he may have lost his salvation because of it!'

When he heard her, he was distressed, but not slow to reply. He said something in spite that he was often to regret. 'Lady, I am not skilled in the profession you mention, but I love and am loved by a lady who should be prized above all others I know. And I will tell you one thing: you can be sure that one of her servants, even the very poorest girl, is worth more than you, my lady the Queen, in body, face and beauty, wisdom and goodness.' Thereupon the queen left and went in tears to her chamber, very distressed and angry that he had humiliated her in this way. She took to her bed ill and said that she would never again get up, unless the king saw that justice was done her in respect of her complaint.

The king had returned from the woods after an extremely happy day. He entered the queen's apartments and when she saw him, she complained aloud, fell at his feet, cried for mercy and said that Lanval had shamed her. He had requested her love and because she had refused him, had insulted and deeply humiliated her. He had boasted of a beloved who was so well-bred, noble and proud that her chambermaid, the poorest servant she had, was worthier than the queen. The king grew very angry and swore on oath that, if Lanval could not defend himself in court, he would have him burned or hanged. The king left the room, summoned three of his barons and sent them for Lanval, who was suffering great pain. He had returned to his lodgings, well aware of having lost his beloved by revealing their love. Alone in his chamber, distraught and anguished, he called his beloved repeatedly, but to no avail. He lamented and sighed, fainting from time to time; a hundred times he cried to her to have mercy, to come and speak with her beloved. He cursed his heart and his mouth and it was a wonder he did not kill himself. His cries and moans were not loud enough nor his agitation and torment such that she would have mercy on him, or even permit him to see her. Alas, what will he do?

The king's men arrived and told Lanval to go to court without delay: the king had summoned him through them, for the queen had accused him. Lanval went sorrowfully and would have been happy for them to kill him. He came before the king, sad, subdued and silent, betraying his great sorrow. The king said to him angrily: 'Vassal, you have wronged

me greatly! You were extremely ill-advised to shame and vilify me, and to slander the queen. You boasted out of folly, for your beloved must be very noble for her handmaiden to be more beautiful and more worthy than the queen.'

Lanval denied point by point having offended and shamed his lord, and maintained that he had not sought the queen's love, but he acknowledged the truth of his words about the love of which he had boasted. He now regretted this, for as a result he had lost her. He told them he would do whatever the court decreed in this matter, but the king was very angry and sent for all his men to tell him exactly what he should do, so that his action would not be unfavourably interpreted. Whether they liked it or not, they obeyed his command and assembled to make a judgement, deciding that a day should be fixed for the trial, but that Lanval should provide his lord with pledges that he would await his judgement and return later to his presence. Then the court would be larger, for at that moment only the king's household itself was present. The barons returned to the king and explained their reasoning. The king asked for pledges, but Lanval was alone and forlorn, having no relation or friend there. Then Gawain approached and offered to stand bail, and all his companions did likewise. The king said to them: 'I entrust him to you on surety of all that you hold from me, lands and fiefs, each man separately.' When this had been pledged, there was no more to be done, and Lanval returned to his lodging with the knights escorting him. They chastised him and urged him strongly not to be so sorrowful, and cursed such foolish love. They went to see him every day, as they wished to know whether he was drinking and eating properly, being very much afraid that he might harm himself.

On the appointed day the barons assembled. The king and queen were there and the guarantors brought Lanval to court. They were all very sad on his account and I think there were a hundred who would have done all in their power to have him released without a trial because he had been wrongly accused. The king demanded the verdict according to the charge and the rebuttal, and now everything lay in the hands of the barons. They considered their judgement, very troubled and concerned on account of this noble man from abroad, who was in such a plight in their midst. Some of them wanted to harm him in conformity with their lord's will. Thus spoke the Count of Cornwall: 'There shall be no default on our part. Like it or not, right must prevail. The king accused his vassal, whom I heard you call Lanval, of a felony and charged him with a crime, about a love he boasted of which angered my lady. Only the king is accusing him, so by the faith I owe you, there

ought, to tell the truth, to be no case to answer, were it not that one should honour one's lord in all things. An oath will bind Lanval and the king will put the matter in our hands. If he can provide proof and his beloved comes forward, and if what he said to incur the queen's displeasure is true, then he will be pardoned, since he did not say it to spite her. And if he cannot furnish proof, then we must inform him that he will lose the king's service and that the king must banish him.' They sent word to the knight and informed him that he should send for his beloved to defend and protect him. He told them that this was not possible and that he would receive no help from her. The messengers returned to the judges, expecting no help to be forthcoming for Lanval. The king pressed them hard because the queen was waiting for them.

When they were about to give their verdict, they saw two maidens approaching on two fine ambling palfreys. They were extremely comely and dressed only in purple taffeta, next to their bare skin; the knights were pleased to see them. Gawain and three other knights went to Lanval, told him about this, and pointed the two maidens out to him. Gawain was very glad and strongly urged Lanval to tell him if this was his beloved, but he told them that he did not know who they were, whence they came or where they were going. The maidens continued to approach, still on horseback, and then dismounted before the dais where King Arthur was seated. They were of great beauty and spoke in courtly fashion: 'King, make your chambers available and hang them with silken curtains so that my lady may stay here, for she wishes to lodge with you.' This he granted them willingly and summoned two knights who led them to the upper chambers. For the moment they said no more.

The king asked his barons for the judgement and the responses, and said that they had greatly angered him by the long delay. 'Lord,' they said, 'we are deliberating, but because of the ladies we saw, we have not reached a verdict. Let us continue with the trial.' So they assembled in some anxiety, and there was a good deal of commotion and contention.

While they were in this troubled state, they saw two finely accoutred maidens coming along the street, dressed in garments of Phrygian silk and riding on Spanish mules. The vassals were glad of this and they said to each other that Lanval, the worthy and brave, was now saved. Ywain went up to him with his companions, and said: 'Lord, rejoice! For the love of God, speak to us! Two damsels are approaching, very comely and beautiful. It is surely your beloved.' Lanval quickly replied that he did not recognize them, nor did he know or love them. When they had arrived, they dismounted before the king and many praised them highly for their bodies, faces, and complexions. They were both more worthy

than the queen had ever been. The older of the two, who was courtly and wise, delivered her message fittingly: 'King, place your chambers at our disposal for the purpose of lodging my lady. She is coming here to speak with you.' He ordered them to be taken to the others who had arrived earlier. They paid no heed to their mules, and, as soon as they had left the king, he summoned all his barons so that they might deliver their verdict. This had taken up too much of the day and the queen, who had been waiting for them for such a long time, was getting angry.

Just as they were about to give their verdict, a maiden on horseback entered the town. There was none more beautiful in the whole world. She was riding a white palfrey which carried her well and gently; its neck and head were well-formed and there was no finer animal on earth. The palfrey was richly equipped, for no count or king on earth could have paid for it, save by selling or pledging his lands. The lady was dressed in a white tunic and shift, laced left and right so as to reveal her sides. Her body was comely, her hips low, her neck whiter than snow on a branch; her eyes were bright and her face white, her mouth fair and her nose well-placed; her eyebrows were brown and her brow fair, and her hair curly and rather blond. A golden thread does not shine as brightly as the rays reflected in the light from her hair. Her cloak was of dark silk and she had wrapped its skirts about her. She held a sparrowhawk on her wrist and behind her there followed a dog. There was no one in the town, humble or powerful, old or young, who did not watch her arrival, and no one jested about her beauty. She approached slowly and the judges who saw her thought it was a great wonder. No one who had looked at her could have failed to be inspired with real joy. Those who loved the knight went and told him about the maiden who was coming and who, please God, would deliver him. 'Lord and friend, here comes a lady whose hair is neither tawny nor brown. She is the most beautiful of all women in the world.' Lanval heard this and raised his head, for he knew her well, and sighed. His blood rushed to his face and he was quick to speak: 'In faith,' he said, 'it is my beloved! If she shows me no mercy, I hardly care if anyone should kill me, for my cure is in seeing her.' The lady entered the palace, where no one so beautiful had ever before been seen. She dismounted before the king, and in the sight of all, let her cloak fall so that they could see her better. The king, who was well-mannered, rose to meet her, and all the others honoured her and offered themselves as her servants. When they had looked at her and praised her beauty greatly, she spoke thus, for she had no wish to remain: 'King, I have loved one of your vassals, Lanval, whom you see there. Because of what he said, he was accused in your court, and I do not wish him to come to

any harm. You should know that the queen was wrong, as he never sought her love. As regards the boast he made, if he can be acquitted by me, let your barons release him!' The king granted that it should be as the judges recommended, in accordance with justice. There was not one who did not consider that Lanval had successfully defended himself, and so he was freed by their decision. The maiden, who had many servants, then left, for the king could not retain her. Outside the hall there was a large block of dark marble on to which heavily armed men climbed when they left the king's court. Lanval mounted it and when the maiden came through the door, he leapt in a single bound on to the palfrey behind her. He went with her to Avalon, so the Bretons tell us, to a very beautiful island. Thither the young man was borne and no one has heard any more about him, nor can I relate any more.

LES DEUS AMANZ

There once took place in Normandy a now celebrated adventure of two young people who loved each other and who both met their end because of love. The Bretons made a lay about them which was given the title *The Two Lovers*.

The truth is that in Neustria, which we call Normandy, there is a marvellously high mountain where the two young people lie. Near this mountain, on one side, a king, who was lord of the Pistrians, wisely and carefully had a city built which he named after the inhabitants and called Pitres. The name has survived to this day and there is still a town and houses there. We know the area well, for it is called the Valley of Pitres. The king had a beautiful daughter, a most courtly damsel who had been a comfort to him ever since he had lost the queen. Many people reproached him for this, and even his own people blamed him. When he heard that people were talking thus, he was very sad and disturbed, and began to consider how he could prevent anyone seeking his daughter's hand. Far and near he had it proclaimed that whoever wanted to win his daughter ought to know one thing for certain: that it was decreed and destined that he should carry her in his arms, without resting, up the mountain outside the town. When the news was known and had spread throughout the region, many made the attempt, but without success. There were some who made such an effort that they carried the girl halfway up the mountain, but could go no further and had to abandon the attempt. She remained unmarried for a long time, as no one wanted to seek her hand.

There was in the country a young man, noble and fair, the son of a count. He strove to perform well so as to be esteemed above all others and he frequented the king's court and often stayed there. He fell in love with the king's daughter and many times urged her to grant him her love and to love him truly. Because he was worthy and courtly, and because the king held him in high esteem, she granted him her love for which he humbly thanked her. They often spoke together and loved each other loyally, concealing their love as best they could so that no one would notice them. This suffering caused them much grief, but the young man considered it better to suffer these misfortunes than to make too much haste and thus fail. Love was a great affliction to him. Then once it happened that the young man, so wise, worthy and fair, came to his beloved and addressed his complaint to her, begging her in his anguish to elope with him, for he could no longer bear the pain. He knew full well that her father loved her so much that, if he asked for her, she would not be given to him unless he could carry her in his arms to the top of the mountain. The damsel answered him: 'Beloved, I know it is impossible for you to carry me, for you are not strong enough. But if I went away with you, my father would be sad and distressed and his life would be an endless torment. Truly, I love him so much and hold him so dear that I would not wish to grieve him. You must decide upon something else, for I will not hear of this. I have a relative in Salerno, a rich woman with a large income, who has been there for more than thirty years and who has practised the art of physic so much that she is well-versed in medicines. She knows so much about herbs and roots that if you go to her, taking with you a letter from me, and tell her your story, she will give thought and consideration to the matter. She will give you such electuaries and such potions as will revive you and increase your strength. When you come back to this country, ask my father for me. He will consider you a child and tell you about the agreement whereby he will give me to no one, however hard he tries, unless he can carry me up the mountain in his arms without resting.' The young man listened to the maiden's words and advice which brought him great joy and he thanked his beloved, asking her for leave to depart.

He went back to his homeland and quickly equipped himself with rich clothes and money, palfreys and pack-horses. Taking his most trusted men with him, the young man went to stay at Salerno and speak with his beloved's aunt. He gave her a letter from the girl and, when she had read it from start to finish, she retained him with her until she knew all about him. She fortified him with medicines and gave him a potion such that, however weary, afflicted, or burdened he might be, it would

refresh his whole body, even his veins and his bones, and restore all his strength to him as soon as he had drunk it. Then he put the potion in a vessel and took it back to his land.

On his return the young man, joyful and happy, did not stay long in his own region. He went and asked the king for his daughter, saying that if he would give her to him, he would take her and carry her up to the top of the mountain. The king did not refuse him, but still considered it great folly as he was so young, and as so many valiant, wise, and worthy men had made the attempt unsuccessfully. He named the day, summoning his vassals, his friends, and all those available to him, letting no one remain behind. People came from far and wide because of the young girl and the young man who would attempt to carry her up to the top of the mountain. The damsel made ready, fasting and refraining from eating in order to lose weight, for she wished to help her beloved. On the day everyone assembled, the young man, who had not forgotten his potion, arrived first. The king led his daughter into the meadow towards the Seine, where a great crowd gathered. She wore nothing but her shift, and the young man took her in his arms. The little phial containing the potion (he well knew that she had no wish to let him down) was given to her to carry, but I fear it will be of little avail to him, because he knew no moderation. He set off with her at a good pace and climbed the mountain halfway. She brought him such great happiness that he did not remember his potion, and when she realized he was tiring, she said: 'My love, please drink. I know you are tiring, so recover your strength.' The young man replied: 'Fair one, I feel my heart to be strong. Providing I can still walk three paces, on no account shall I stop, not even long enough to take a drink. These people would shout at us and deafen me with their noise, and they could easily distract me. I shall not stop here.' When he had climbed two thirds of the way, he nearly collapsed. The girl repeatedly begged him: 'My love, drink your potion.' Yet he would take no heed of her, and carried her onward in great pain. He reached the top, in such distress that he fell down and never rose again, for his heart left his body. The maiden saw her beloved and, thinking he had fainted, knelt down beside him and tried to make him drink. But he could not speak to her. Thus he died, just as I am telling you. She lamented him loudly and then threw away the vessel containing the potion, scattering its contents so that the mountain was well sprinkled with it, and the land and surrounding area much improved. Many good plants were found there which took root because of the potion.

Now I shall tell you about the girl: because she had lost her beloved, she was more distressed than ever before. She lay down beside him, took

him in her arms and embraced him, kissing his eyes and his mouth repeatedly. Sorrow for him touched her heart and there this damsel died, who was so worthy, wise and fair. When the king and those who were waiting saw that they were not coming, they went after them and found them. The king fell to the ground in a swoon, and when he could speak, he lamented loudly, as did all the strangers. They left them there on the ground for three days, and then had a marble coffin brought and the two young people placed in it. On the advice of those present they buried them on top of the mountain and then departed.

Because of what happened to these two young people, the mountain is called The Mountain of the Two Lovers. The events took place just as I have told you, and the Bretons composed a lay about them.

THE KORAN

Heaven and Hell

The Koran, *according to Muslims, was not written by any human being, but is an eternal creation of God, revealed by him to the prophet Mohammed through the angel Gabriel. For them, it is the direct word of God, an unchangeable holy scripture. It consists of 114 chapters, or* surahs, *revealed over a long period beginning in 610 C.E., memorized and copied on perishable materials in the prophet's lifetime, and edited by the caliph Othman (644–656 C.E.). The chapters were arranged according to their length, not by subject or date of revelation. Some scholars believe the work actually passed through a long period of oral transmission and that it may have introduced confusion when it was finally written down perhaps a century or more after it was revealed. The prophet Mohammed (570–632 C.E.) was a native of Mecca in Arabia, the member of a poor branch of one of the ruling families. He became a merchant, visited Syria with caravans, and eventually married a rich widow. His travels acquainted him with Judaism and Christianity. In 610 C.E., he received his first revelation and began to preach a new religion, Islam. His success in his native city stirred the hostility of the ruling establishment and in 622 C.E. he was forced to take refuge in the city of Medina. Muslims count their era from the date of Mohammed's flight, or* hegira. *At Medina, he became both prophet and head of state, completely reorganizing society according to the revelations he constantly received, and expelling the Jews who refused to hearken to his call. Finally in 630 C.E., he gained control of his native Mecca, whose sacred shrine became and has remained the center of the new religion. Mohammed, who made no claims to miracle-working or immortality, died in Medina in 632 C.E.*

Reflecting the prophet's dual civil and religious role, The Koran *bears a mixed message of religious texts, including revelations of God's will, reports of prophets of the past (including many familiar from the Old Testament), descriptions of heaven and hell, as well as prescriptions, some quite precise, for running an entire society. These two chapters present the Islamic vision of a fiery hell and a cool, shady paradise, where the faithful are attended by beautiful virgins.*

"Heaven and Hell," from Book 55 in *The Koran*, translated by N. J. Dawood, copyright © 1959, 1965, 1966, 1968, 1974, 1990, 1993, 1997 by N. J. Dawood, 376–380. Reprinted by permission of Penguin Books Ltd.

THE MERCIFUL[1]
In the Name of God, the Compassionate, the Merciful

It is the Merciful who has taught Koran.

He created man and taught him articulate speech. The sun 55:1
and the moon pursue their ordered course. The plants and the
trees bow down in adoration.

He raised the heaven on high and set the balance of all things,
that you might not transgress that balance. Give just weight and
full measure.

He laid the earth for His creatures, with all its fruits and
blossom-bearing palm, chaff-covered grain and scented herbs.
Which of your Lord's blessings would you[2] deny?

He created man from potter's clay, and the jinn from smoke-
less fire. Which of your Lord's blessings would you deny?

The Lord of the two easts[3] is He, He, and the Lord of the
two wests. Which of your Lord's blessings would you deny?

He has let loose the two oceans:[4] they meet one another. Yet 55:19
between them stands a barrier which they cannot overrun. 55:20
Which of your Lord's blessing would you deny?

Pearls and corals come from both. Which of your Lord's
blessings would you deny?

His are the ships that sail like mountains upon the ocean.
Which of your Lord's blessings would you deny?

All that lives on earth is doomed to die. But the face of your
Lord will abide for ever, in all its majesty and glory. Which of
your Lord's blessings would you deny?

All who dwell in heaven and earth entreat him. Each day
some mighty task engages Him. Which of your Lord's blessings
would you deny?

Mankind and jinn, We shall surely find the time to judge you!
Which of your Lord's blessings would you deny?

Mankind and jinn, if you have power to penetrate the confines
of heaven and earth, then penetrate them! But this you shall not
do except with Our own authority. Which of your Lord's bless-
ings would you deny?

Flames of fire shall be lashed at you, and molten brass. There 55:35
shall be none to help you. Which of your Lord's blessings
would you deny?

When the sky splits asunder, and reddens like a rose or
stained leather (which of your Lord's blessings would you

deny?), on that day neither man nor jinnee will be asked about his sins. Which of your Lord's blessings would you deny?

The wrongdoers will be known by their looks; they shall be seized by their forelocks and their feet. Which of your Lord's blessings would you deny?

That is the Hell which the sinners deny. They shall wander between fire and water fiercely seething. Which of your Lord's blessings would you deny?

But for those that fear the majesty of their Lord there are two gardens (which of your Lord's blessings would you deny?) planted with shady trees. Which of your Lord's blessings would you deny?

Each is watered by a flowing spring. Which of your Lord's blessings would you deny? 55:51

Each bears every kind of fruit in pairs. Which of your Lord's blessings would you deny? 55:52

They shall recline on couches lined with thick brocade, and within reach will hang the fruits of both gardens. Which of your Lord's blessings would you deny?

Therein are bashful virgins whom neither man nor jinnee will have touched before. Which of your Lord's blessings would you deny?

Virgins as fair as corals and rubies. Which of your Lord's blessings would you deny?

Shall the reward of goodness be anything but good? Which of your Lord's blessings would you deny?

And beside these there shall be two other gardens (which of your Lord's blessings would you deny?) of darkest green. Which of your Lord's blessings would you deny?

A gushing fountain shall flow in each. Which of your Lord's blessings would you deny? 55:66

Each planted with fruit-trees, the palm and the pomegranate. Which of your Lord's blessings would you deny?

In each there shall be virgins chaste and fair. Which of your Lord's blessings would you deny?

Dark-eyed virgins, sheltered in their tents (which of your Lord's blessings would you deny?), whom neither man nor jinnee will have touched before. Which of your Lord's blessings would you deny?

They shall recline on green cushions and fine carpets. Which of your Lord's blessings would you deny?

Blessed be the name of your Lord, the Lord of majesty and glory! 55:78

THAT WHICH IS COMING
In the Name of God, the Compassionate, the Merciful

When that which is coming comes—and no soul shall then deny its coming—some shall be abased and others exalted. 56:1

When the earth shakes and quivers, and the mountains crumble away and scatter abroad into fine dust, you shall be divided into three multitudes: those on the right (blessed shall be those on the right); those on the left (damned shall be those on the left); and those to the fore (foremost shall be those). Such are they that shall be brought near to their Lord in the gardens of delight: a whole multitude from the men of old, but only a few from the latter generations. 56:6

They shall recline on jewelled couches face to face, and there shall wait on them immortal youths with bowls and ewers and a cup of purest wine (that will neither pain their heads nor take away their reason); with fruits of their own choice and flesh of fowls that they relish. And theirs shall be the dark-eyed houris, chaste as virgin pearls: a guerdon for their deeds.

There they shall hear no idle talk, no sinful speech, but only the greeting, 'Peace! Peace!'

Those on the right hand—happy shall be those on the right hand! They shall recline on couches raised on high in the shade of thornless sidrs and clusters of talh;[5] amidst gushing waters and abundant fruits, unforbidden, never-ending. 56:27

We created the houris and made them virgins, loving companions for those on the right hand: a multitude from the men of old, and a multitude from the latter generations.

As for those on the left hand (wretched shall be those on the left hand!) they shall dwell amidst scorching winds and seething water: in the shade of pitch-black smoke, neither cool nor refreshing. For they have lived in comfort and persisted in the heinous sin,[6] saying: 'When we are once dead and turned to dust and bones, shall we be raised to life? And our forefathers, too?'

Say: 'Those of old, and those of the present age, shall be 56:55

brought together on an appointed day. As for you sinners who deny the truth, you shall eat the fruit of the Zaqqūm tree and fill your bellies with it. You shall drink scalding water: yet you shall drink it as the thirsty camel drinks.'

Such shall be their fare on the Day of Reckoning. 56:56

We created you: will you not believe then in Our power?

Behold the semen you discharge: did you create it, or We?

It was We that ordained death among you. Nothing can hinder Us from replacing you by others like yourselves or transforming you into beings you know nothing of.

You surely know of the First Creation. Why, then, do you not reflect? Consider the seeds you grow. Is it you that give them growth, or We? If We pleased, We could turn your harvest into chaff, so that, filled with wonder, you would exclaim: 'We are laden with debts! Surely we have been robbed!'

Consider the water which you drink. Was it you that poured it from the cloud, or We? If We pleased, We could turn it bitter. Why, then, do you not give thanks?

Observe the fire which you light. Is it you that create its wood, or We? A reminder for man We made it, and for the traveller a comfort.

Praise, then, the name of your Lord, the Supreme One. 56:74

I swear by the shelter of the stars (a mighty oath, if you but knew it) that this is a glorious Koran, safeguarded in a book which none may touch except the purified; a revelation from the Lord of the Universe.

Would you scorn a scripture such as this, and earn your daily bread denying it?

When under your very eyes a man's soul is about to leave him (We are nearer to him than you, although you cannot see Us), why do you not restore it, if you will not be judged hereafter? Answer this, if what you say be true!

Thus, if he is favoured, his lot will be repose and plenty, and a garden of delight. If he is one of those on the right hand, he will be greeted with, 'Peace be with you!' by those on the right hand.

But if he is an erring disbeliever, his welcome will be scalding water, and he will burn in Hell.

This is surely the indubitable truth. Praise, then, the name of 56:96 your Lord, the Supreme One.

EXPLANATORY NOTES

1. Compare this chapter with Psalm cxxxvi of the Old Testament.
2. The pronoun is in the dual number, the words being addressed to mankind and the jinn. This refrain is repeated no fewer than 31 times.
3. The points at which the sun rises in summer and in winter.
4. Salt water and fresh water.
5. Probably the banana fruit.
6. Idolatry.

Dante Begins His Journey through Hell

———————

Dante Alighieri is widely considered the greatest and most characteristic poet of the Middle Ages, but little is known about his life. Born in Florence in 1265, his early life coincided with the emergence of Florence as the major economic and military power in Tuscany. Dante played a minor role in Florence's great victory of Campaldino in 1289, which established her dominance in Tuscany. After a brief but disastrous career in politics, Dante was falsely accused of corruption and in 1302 he was banished from Florence. As an exile, he became progressively more alienated from the Florentine traditions of republicanism, pro-papalism, and commercialism and aligned himself with the forces of Florence's enemy, the German emperor Henry VII of Luxembourg. After the latter's death, Dante continued to live in exile and attached himself to the courts of petty lords in northern Italy. He died in Ravenna in 1321 without ever returning to Florence.

Before his exile Dante was the youngest member in a group of Florentine poets whose aim was to turn Tuscan into a literary language, to create a "sweet new style" (dolce stil novo) suitable for writing courtly poetry. Dante took this development one step further and during his exile developed a poetic language capable of treating with sustained elevation the most sublime and difficult subjects: the nature of God; the universe and human destiny; divine justice and forgiveness. Drawing on traditions of courtly love poetry and religious poetry as well as the example of Virgil and other ancient Latin poets, Dante created a new kind of poetry that is learned and mysterious, but also extremely vivid and sensuous. It is didactic poetry that also tells an absorbing story.

The Divine Comedy tells the story of Dante's journey to the center of the Earth, through lowest Hell to Purgatory, located on the opposite side of the globe. At the top of the mountain of Purgatory is the Earthly Paradise, where the human race began, and from there Dante ascends to the height of Heaven and has a vision of the Blessed Virgin Mary and the Trinity. Indeed, the whole poem is a vision, an experience that Dante undergoes while in an elevated state of divine inspiration during the Easter Triduum,

"Dante Begins His Journey through Hell," from canto 1 in *The Divine Comedy*, vol. I: *The Inferno*, by Dante Alighieri, translated by Mark Musa, copyright © 1971 by Indiana University Press, 67–71. Reprinted by permission of Penguin Books, a division of Penguin Putnam Inc.

the three days before Easter in the church calendar. His vision brings Dante to an understanding of the workings of Divine Providence in history and in the lives of Christians and non-Christians. The purpose of the Comedy *is thus prophetic: It aims to rouse Dante's fellow Christians from spiritual tepidity by showing them the ultimate consequences of their acts. But it is also a supreme work of literary skill that, like most medieval poetry, can be read on many levels at once, symbolically and allegorically as well as literally. In the present selection Dante describes the circumstances that started him on his visionary journey, and he meets a guide in the person of Virgil, the great Roman epic poet.*

CANTO I

HALFWAY through his life, DANTE THE PILGRIM wakes to find himself lost in a dark wood. Terrified at being alone in so dismal a valley, he wanders until he comes to a hill bathed in sunlight, and his fear begins to leave him. But when he starts to climb the hill his path is blocked by three fierce beasts: first a LEOPARD, then a LION, and finally a SHE-WOLF. They fill him with fear and drive him back down to the sunless wood. At that moment the figure of a man appears before him; it is the shade of VIRGIL, and the Pilgrim begs for help. Virgil tells him that he cannot overcome the beasts which obstruct his path; they must remain until a "GREYHOUND" comes who will drive them back to Hell. Rather by another path will the Pilgrim reach the sunlight, and Virgil promises to guide him on that path through Hell and Purgatory, after which another spirit, more fit than Virgil, will lead him to Paradise. The Pilgrim begs Virgil to lead on, and the Guide starts ahead. The Pilgrim follows.

> Midway along the journey of our life
> I woke to find myself in a dark wood,
> for I had wandered off from the straight path. 3
>
> How hard it is to tell what it was like,
> this wood of wilderness, savage and stubborn
> (the thought of it brings back all my old fears), 6
>
> a bitter place! Death could scarce be bitterer.
> But if I would show the good that came of it
> I must talk about things other than the good. 9
>
> How I entered there I cannot truly say,
> I had become so sleepy at the moment
> when I first strayed, leaving the path of truth; 12

but when I found myself at the foot of a hill,
 at the edge of the wood's beginning, deep in the valley,
 where I first felt my heart plunged deep in fear, 15

I raised my head and saw the hilltop shawled
 in morning rays of light sent from the planet
 that leads men straight ahead on every road. 18

And then only did terror start subsiding
 in my heart's lake, which rose to heights of fear
 that night I spent in deepest desperation. 21

Just as a swimmer, still with panting breath,
 now safe upon the shore, out of the deep,
 might turn for one last look at the dangerous waters, 24

so I, although my mind was turned to flee,
 turned round to gaze once more upon the pass
 that never let a living soul escape. 27

I rested my tired body there awhile
 and then began to climb the barren slope
 (I dragged my stronger foot and limped along). 30

Beyond the point the slope begins to rise
 sprang up a leopard, trim and very swift!
 It was covered by a pelt of many spots. 33

And, everywhere I looked, the beast was there
 blocking my way, so time and time again
 I was about to turn and go back down. 36

The hour was early in the morning then,
 the sun was climbing up with those same stars
 that had accompanied it on the world's first day, 39

the day Divine Love set their beauty turning;
 so the hour and sweet season of creation
 encouraged me to think I could get past 42

that gaudy beast, wild in its spotted pelt,
 but then good hope gave way and fear returned
 when the figure of a lion loomed up before me, 45

and he was coming straight toward me, it seemed,
 with head raised high, and furious with hunger—
 the air around him seemed to fear his presence. 48

And now a she-wolf came, that in her leanness
 seemed racked with every kind of greediness
 (how many people she has brought to grief!). 51

This last beast brought my spirit down so low
 with fear that seized me at the sight of her,
 I lost all hope of going up the hill. 54

As a man who, rejoicing in his gains,
 suddenly seeing his gain turn into loss,
 will grieve as he compares his then and now, 57

so she made me do, that relentless beast;
 coming toward me, slowly, step by step,
 she forced me back to where the sun is mute. 60

While I was rushing down to that low place,
 my eyes made out a figure coming toward me
 of one grown faint, perhaps from too much silence. 63

And when I saw him standing in this wasteland,
 "Have pity on my soul," I cried to him,
 "whichever you are, shade or living man!" 66

"No longer living man, though once I was,"
 he said, "and my parents were from Lombardy,
 both of them were Mantuans by birth. 69

I was born, though somewhat late, *sub Julio,*
 and lived in Rome when good Augustus reigned,
 when still the false and lying gods were worshipped. 72

I was a poet and sang of that just man,
 son of Anchises, who sailed off from Troy
 after the burning of proud Ilium. 75

But why retreat to so much misery?
 Why not climb up this blissful mountain here,
 the beginning and the source of all man's joy?" 78

"Are you then Virgil, are you then that fount
 from which pours forth so rich a stream of words?"
 I said to him, bowing my head modestly. 81

"O light and honor of the other poets,
 may my long years of study, and that deep love
 that made me search your verses, help me now! 84

You are my teacher, the first of all my authors,
 and you alone the one from whom I took
 the noble style that was to bring me honor. 87

You see the beast that forced me to retreat;
 save me from her, I beg you, famous sage,
 she makes me tremble, the blood throbs in my veins." 90

"But you must journey down another road,"
 he answered, when he saw me lost in tears,
 "if ever you hope to leave this wilderness; 93

this beast, the one you cry about in fear,
 allows no soul to succeed along her path,
 she blocks his way and puts an end to him. 96

She is by nature so perverse and vicious,
 her craving belly is never satisfied,
 still hungering for food the more she eats. 99

She mates with many creatures, and will go on
 mating with more until the greyhound comes
 and tracks her down to make her die in anguish. 102

He will not feed on either land or money:
 his wisdom, love, and virtue shall sustain him;
 he will be born between Feltro and Feltro. 105

He comes to save that fallen Italy
 for which the maid Camilla gave her life
 and Turnus, Nisus, Euryalus died of wounds. 108

And he will hunt for her through every city
 until he drives her back to Hell once more,
 whence Envy first unleashed her on mankind. 111

And so, I think it best you follow me
 for your own good, and I shall be your guide
 and lead you out through an eternal place 114

where you will hear desperate cries, and see
 tormented shades, some old as Hell itself,
 and know what second death is, from their screams. 117

And later you will see those who rejoice
 while they are burning, for they have hope of coming,
 whenever it may be, to join the blessèd— 120

DANTE BEGINS HIS JOURNEY THROUGH HELL

to whom, if you too wish to make the climb,
 a spirit, worthier than I, must take you;
 I shall go back, leaving you in her care, 123

because that Emperor dwelling on high
 will not let me lead any to His city,
 since I in life rebelled against His law. 126

Everywhere He reigns, and there He rules;
 there is His city, that is His high throne.
 Oh, happy the one He makes His citizen!" 129

And I to him: "Poet, I beg of you,
 in the name of God, that God you never knew,
 save me from this evil place and worse, 132

lead me there to the place you spoke about
 that I may see the gate Saint Peter guards
 and those whose anguish you have told me of." 135

Then he moved on, and I moved close behind him.

316

DANTE ALIGHIERI

The Gates of Hell

Dante Alighieri is widely considered the greatest and most characteristic poet of the Middle Ages, but little is known about his life. Born in Florence in 1265, his early life coincided with the emergence of Florence as the major economic and military power in Tuscany. Dante played a minor role in Florence's great victory of Campaldino in 1289, which established her dominance in Tuscany. After a brief but disastrous career in politics, Dante was falsely accused of corruption and in 1302 he was banished from Florence. As an exile, he became progressively more alienated from the Florentine traditions of republicanism, pro-papalism, and commercialism and aligned himself with the forces of Florence's enemy, the German emperor Henry VII of Luxembourg. After the latter's death, Dante continued to live in exile and attached himself to the courts of petty lords in northern Italy. He died in Ravenna in 1321 without ever returning to Florence.

Before his exile Dante was the youngest member in a group of Florentine poets whose aim was to turn Tuscan into a literary language, to create a "sweet new style" (dolce stil novo) suitable for writing courtly poetry. Dante took this development one step further and during his exile developed a poetic language capable of treating with sustained elevation the most sublime and difficult subjects: the nature of God; the universe and human destiny; divine justice and forgiveness. Drawing on traditions of courtly love poetry and religious poetry as well as the example of Virgil and other ancient Latin poets, Dante created a new kind of poetry that is learned and mysterious, but also extremely vivid and sensuous. It is didactic poetry that also tells an absorbing story.

The Divine Comedy tells the story of Dante's journey to the center of the Earth, through lowest Hell to Purgatory, located on the opposite side of the globe. At the top of the mountain of Purgatory is the Earthly Paradise, where the human race began, and from there Dante ascends to the height of Heaven and has a vision of the Blessed Virgin Mary and the Trinity. Indeed, the whole poem is a vision, an experience that Dante undergoes while in an elevated state of divine inspiration during the Easter Triduum, the three days before Easter in the church calendar. His vision brings Dante to an understanding of the workings of Divine Providence in history and in

"The Gates of Hell," from canto 3 in *The Divine Comedy,* vol. I: *The Inferno,* by Dante Alighieri, translated by Mark Musa, copyright © 1971 by Indiana University Press, 89–93. Reprinted by permission of Penguin Books, a division of Penguin Putnam Inc.

the lives of Christians and non-Christians. The purpose of the Comedy *is thus prophetic: It aims to rouse Dante's fellow Christians from spiritual tepidity by showing them the ultimate consequences of their acts. But it is also a supreme work of literary skill that, like most medieval poetry, can be read on many levels at once, symbolically and allegorically as well as literally. In the present selection Dante describes the terrifying legend of the Gates of Hell and sees the fate of those who have failed to make a choice in life and are scorned even by Hell.*

CANTO III

AS THE TWO POETS enter the vestibule that leads to Hell itself, Dante sees the inscription above the gate, and he hears the screams of anguish from the damned souls. Rejected by God and not accepted by the powers of Hell, the first group of souls are "nowhere," because of their cowardly refusal to make a choice in life. Their punishment is to follow a banner at a furious pace forever, and to be tormented by flies and hornets. The Pilgrim recognizes several of these shades but mentions none by name. Next they come to the River Acheron, where they are greeted by the infernal boatman, CHARON. Among those doomed souls who are to be ferried across the river, Charon sees the living man and challenges him, but Virgil lets it be known that his companion must pass. Then across the landscapes rushes a howling wind, which blasts the Pilgrim out of his senses, and he falls to the ground.

I AM THE WAY INTO THE DOLEFUL CITY.
 I AM THE WAY INTO ETERNAL GRIEF,
 I AM THE WAY TO A FORSAKEN RACE 3

JUSTICE IT WAS THAT MOVED MY GREAT CREATOR;
 DIVINE OMNIPOTENCE CREATED ME,
 AND HIGHEST WISDOM JOINED WITH PRIMAL LOVE. 6

BEFORE ME NOTHING BUT ETERNAL THINGS
 WERE MADE, AND I SHALL LAST ETERNALLY.
 ABANDON EVERY HOPE, ALL YOU WHO ENTER. 9

I saw these words spelled out in somber colors
 inscribed along the ledge above a gate;
 "Master," I said, "these words I see are cruel." 12

He answered me, speaking with experience:
 "Now here you must leave all distrust behind;
 let all your cowardice die on this spot. 15

We are at the place where earlier I said
 you could expect to see the suffering race
 of souls who lost the good of intellect." 18

Placing his hand on mine, smiling at me
 in such a way that I was reassured,
 he led me in, into those mysteries. 21

Here sighs and cries and shrieks of lamentation
 echoed throughout the starless air of Hell;
 at first these sounds resounding made me weep: 24

tongues confused, a language strained in anguish
 with cadences of anger, shrill outcries
 and raucous groans that joined with sounds of hands, 27

raising a whirling storm that turns itself
 forever through that air of endless black,
 like grains of sand swirling when a whirlwind blows. 30

And I, in the midst of all this circling horror,
 began, "Teacher, what are these sounds I hear?
 What souls are these so overwhelmed by grief?" 33

And he to me: "This wretched state of being
 is the fate of those sad souls who lived a life
 but lived it with no blame and with no praise. 36

They are mixed with that repulsive choir of angels
 neither faithful nor unfaithful to their God,
 who undecided stood but for themselves. 39

Heaven, to keep its beauty, cast them out,
 but even Hell itself would not receive them,
 for fear the damned might glory over them." 42

And I. "Master, what torments do they suffer
 that force them to lament so bitterly?"
 He answered: "I will tell you in few words: 45

these wretches have no hope of truly dying,
 and this blind life they lead is so abject
 it makes them envy every other fate. 48

The world will not record their having been there;
 Heaven's mercy and its justice turn from them.
 Let's not discuss them; look and pass them by." 51

And so I looked and saw a kind of banner
 rushing ahead, whirling with aimless speed
 as though it would not ever take a stand; 54

behind it an interminable train
 of souls pressed on, so many that I wondered
 how death could have undone so great a number. 57

When I had recognized a few of them,
 I saw the shade of the one who must have been
 the coward who had made the great refusal. 60

At once I understood, and I was sure
 this was that sect of evil souls who were
 hateful to God and to His enemies. 63

These wretches, who had never truly lived,
 went naked, and were stung and stung again
 by the hornets and the wasps that circled them 66

and made their faces run with blood in streaks;
 their blood, mixed with their tears, dripped to their feet,
 and disgusting maggots collected in the pus. 69

And when I looked beyond this crowd I saw
 a throng upon the shore of a wide river,
 which made me ask, "Master, I would like to know: 72

who are these people, and what law is this
 that makes those souls so eager for the crossing—
 as I can see, even in this dim light?" 75

And he: "All this will be made plain to you
 as soon as we shall come to stop awhile
 upon the sorrowful shore of Acheron." 78

And I, with eyes cast down in shame, for fear
 that I perhaps had spoken out of turn,
 said nothing more until we reached the river. 81

And suddenly, coming toward us in a boat,
 a man of years whose ancient hair was white
 shouted at us, "Woe to you, perverted souls! 84

Give up all hope of ever seeing Heaven:
 I come to lead you to the other shore,
 into eternal darkness, ice, and fire. 87

And you, the living soul, you over there,
 get away from all these people who are dead."
But when he saw I did not move aside, 90

he said, "Another way, by other ports,
 not here, shall you pass to reach the other shore;
a lighter skiff than this must carry you." 93

And my guide, "Charon, this is no time for anger!
 It is so willed, there where the power is
for what is willed; that's all you need to know." 96

These words brought silence to the woolly cheeks
 of the ancient steersman of the livid marsh,
whose eyes were set in glowing wheels of fire. 99

But all those souls there, naked, in despair,
 changed color and their teeth began to chatter
at the sound of his announcement of their doom. 102

They were cursing God, cursing their own parents,
 the human race, the time, the place, the seed
of their beginning, and their day of birth. 105

Then all together, weeping bitterly,
 they packed themselves along the wicked shore
that waits for every man who fears not God. 108

The devil, Charon, with eyes of glowing coals,
 summons them all together with a signal,
and with an oar he strikes the laggard sinner. 111

As in autumn when the leaves begin to fall,
 one after the other (until the branch
is witness to the spoils spread on the ground), 114

so did the evil seed of Adam's Fall
 drop from that shore to the boat, one at a time,
at the signal, like the falcon to its lure. 117

Away they go across the darkened waters,
 and before they reach the other side to land,
a new throng starts collecting on this side. 120

"My son," the gentle master said to me,
 "all those who perish in the wrath of God
assemble here from all parts of the earth; 123

they want to cross the river, they are eager;
 it is Divine Justice that spurs them on,
 turning the fear they have into desire. 126

A good soul never comes to make this crossing,
 so, if Charon grumbles at the sight of you,
 you see now what his words are really saying." 129

He finished speaking, and the grim terrain
 shook violently; and the fright it gave me
 even now in recollection makes me sweat. 132

Out of the tear-drenched land a wind arose
 which blasted forth into a reddish light,
 knocking my senses out of me completely, 135

and I fell as one falls tired into sleep.

DANTE ALIGHIERI

Paolo and Francesca

———————

Dante Alighieri is widely considered the greatest and most characteristic poet of the Middle Ages, but little is known about his life. Born in Florence in 1265, his early life coincided with the emergence of Florence as the major economic and military power in Tuscany. Dante played a minor role in Florence's great victory of Campaldino in 1289, which established her dominance in Tuscany. After a brief but disastrous career in politics, Dante was falsely accused of corruption and in 1302 he was banished from Florence. As an exile, he became progressively more alienated from the Florentine traditions of republicanism, pro-papalism, and commercialism and aligned himself with the forces of Florence's enemy, the German emperor Henry VII of Luxembourg. After the latter's death Dante continued to live in exile and attached himself to the courts of petty lords in northern Italy. He died in Ravenna in 1321 without ever returning to Florence.

Before his exile Dante was the youngest member in a group of Florentine poets whose aim was to turn Tuscan into a literary language, to create a "sweet new style" (dolce stil novo) suitable for writing courtly poetry. Dante took this development one step further and during his exile developed a poetic language capable of treating with sustained elevation the most sublime and difficult subjects: the nature of God; the universe and human destiny; divine justice and forgiveness. Drawing on traditions of courtly love poetry and religious poetry as well as the example of Virgil and other ancient Latin poets, Dante created a new kind of poetry that is learned and mysterious, but also extremely vivid and sensuous. It is didactic poetry that also tells an absorbing story.

The Divine Comedy *tells the story of Dante's journey to the center of the Earth, through lowest Hell to Purgatory, located on the opposite side of the globe. At the top of the mountain of Purgatory is the Earthly Paradise, where the human race began, and from there Dante ascends to the height of Heaven and has a vision of the Blessed Virgin Mary and the Trinity. Indeed, the whole poem is a vision, an experience that Dante undergoes while in an elevated state of divine inspiration during the Easter Triduum, the three days before Easter in the church calendar. His vision brings Dante*

"Paolo and Francesca," from canto 5 in *The Divine Comedy*, vol. I: *The Inferno*, by Dante Alighieri, translated by Mark Musa, copyright © 1971 by Indiana University Press, 109–113. Reprinted by permission of Penguin Books, a division of Penguin Putnam Inc.

to an understanding of the workings of Divine Providence in history and in the lives of Christians and non-Christians. The purpose of the Comedy *is thus prophetic: it aims to rouse Dante's fellow Christians from spiritual tepidity by show them the ultimate consequences of their acts. But it is also a supreme work of literary skill that, like most medieval poetry, can be read on many levels at once, symbolically and allegorically as well as literally. In the present selection, probably the most famous canto in* The Divine Comedy, *Dante hears the piteous tale of two lovers who are being punished for their adulterous love, along with other famously lustful men and women in history including Helen of Troy.*

CANTO V

FROM LIMBO Virgil leads his ward down to the threshold of the Second Circle of Hell, where for the first time he will see the damned in Hell being punished for their sins. There, barring their way, is the hideous figure of MINÒS, the bestial judge of Dante's underworld; but after strong words from Virgil, the poets are allowed to pass into the dark space of this circle, where can be heard the wailing voices of the LUSTFUL, whose punishment consists in being forever whirled about in a dark, stormy wind. After seeing a thousand or more famous lovers—including SEMIRAMIS, DIDO, HELEN, ACHILLES, and PARIS—the Pilgrim asks to speak to two figures he sees together. They are FRANCESCA DA RIMINI and her lover, PAOLO, and the scene in which they appear is probably the most famous episode of the Inferno. *At the end of the scene, the Pilgrim, who has been overcome by pity for the lovers, faints to the ground.*

This way I went, descending from the first
　　into the second round, that holds less space
　　but much more pain—stinging the soul to wailing.　　　3

There stands Minòs grotesquely, and he snarls,
　　examining the guilty at the entrance;
　　he judges and dispatches, tail in coils.　　　6

By this I mean that when the evil soul
　　appears before him, it confesses all,
　　and he, who is the expert judge of sins,　　　9

knows to what place in Hell the soul belongs;
　　the times he wraps his tail around himself
　　tell just how far the sinner must go down.　　　12

The damned keep crowding up in front of him:
 they pass along to judgment one by one;
 they speak, they hear, and then are hurled below. 15

"O you who come to the place where pain is host,"
 Minòs spoke out when he caught sight of me,
 putting aside the duties of his office, 18

"be careful how you enter and whom you trust
 it's easy to get in, but don't be fooled!"
 And my guide said to him: "Why keep on shouting? 21

Do not attempt to stop his fated journey;
 it is so willed there where the power is
 for what is willed; that's all you need to know." 24

And now the notes of anguish start to play
 upon my ears; and now I find myself
 where sounds on sounds of weeping pound at me. 27

I came to a place where no light shone at all,
 bellowing like the sea racked by a tempest,
 when warring winds attack it from both sides. 30

The infernal storm, eternal in its rage,
 sweeps and drives the spirits with its blast:
 it whirls them, lashing them with punishment. 33

When they are swept back past their place of judgment,
 then come the shrieks, laments, and anguished cries;
 there they blaspheme God's almighty power. 36

I learned that to this place of punishment
 all those who sin in lust have been condemned,
 those who make reason slave to appetite; 39

and as the wings of starlings in the winter
 bear them along in wide-spread, crowded flocks,
 so does that wind propel the evil spirits: 42

now here, then there, and up and down, it drives them
 with never any hope to comfort them—
 hope not of rest but even of suffering less. 45

And just like cranes in flight, chanting their lays,
 stretching an endless line in their formation,
 I saw approaching, crying their laments, 48

spirits carried along by the battling winds.
 And so I asked, "Teacher, tell me, what souls
 are these punished in the sweep of the black wind?" 51

"The first of those whose story you should know,"
 my master wasted no time answering,
 "was empress over lands of many tongues; 54

her vicious tastes had so corrupted her
 she licensed every form of lust with laws
 to cleanse the stain of scandal she had spread; 57

she is Semiramis, who, legend says,
 was Ninus' wife as well as his successor;
 she governed all the land the Sultan rules. 60

The next is she who killed herself for love
 and broke faith with the ashes of Sichaeus;
 and there is Cleopatra, who loved men's lusting. 63

See Helen there, the root of evil woe
 lasting long years, and see the great Achilles,
 who lost his life to love, in final combat; 66

see Paris, Tristan"—then, more than a thousand
 he pointed out to me, and named them all,
 those shades whom love cut off from life on earth. 69

After I heard my teacher call the names
 of all these knights and ladies of ancient times,
 pity confused my senses, and I was dazed. 72

I began: "Poet, I would like, with all my heart,
 to speak to those two there who move together
 and seem to be so light upon the winds." 75

And he: "You'll see when they are closer to us;
 if you entreat them by that love of theirs
 that carries them along, they'll come to you." 78

When the winds bent their course in our direction
 I raised my voice to them, "O wearied souls,
 come speak with us if it be not forbidden." 81

As doves, called by desire to return
 to their sweet nest, with wings raised high and poised,
 float downward through the air, guided by will, 84

so these two left the flock where Dido is
 and came toward us through the malignant air,
 such was the tender power of my call. 87

"O living creature, gracious and so kind,
 who makes your way here through this dingy air
 to visit us who stained the world with blood, 90

if we could claim as friend the King of Kings,
 we would beseech him that he grant you peace,
 you who show pity for our atrocious plight. 93

Whatever pleases you to hear or speak
 we will hear and we will speak about with you
 as long as the wind, here where we are, is silent. 96

The place where I was born lies on the shore
 where the river Po with its attendant streams
 descends to seek its final resting place. 99

Love, quick to kindle in the gentle heart,
 seized this one for the beauty of my body,
 torn from me, (How it happened still offends me!) 102

Love, that excuses no one loved from loving,
 seized me so strongly with delight in him
 that, as you see, he never leaves my side. 105

Love led us straight to sudden death together.
 Caïna awaits the one who quenched our lives."
 These were the words that came from them to us. 108

When those offended souls had told their story,
 I bowed my head and kept it bowed until
 the poet said, "What are you thinking of?" 111

When finally I spoke, I sighed, "Alas,
 all those sweet thoughts, and oh, how much desiring
 brought these two down into this agony." 114

And then I turned to them and tried to speak;
 I said, "Francesca, the torment that you suffer
 brings painful tears of pity to my eyes. 117

But tell me, in that time of your sweet sighing
 how, and by what signs, did love allow you
 to recognize your dubious desires?" 120

And she to me: "There is no greater pain
 than to remember, in our present grief,
 past happiness (as well your teacher knows)! 123

But if your great desire is to learn
 the very root of such a love as ours,
 I shall tell you, but in words of flowing tears. 126

One day we read, to pass the time away,
 of Lancelot, of how he fell in love;
 we were alone, innocent of suspicion. 129

Time and again our eyes were brought together
 by the book we read; our faces flushed and paled.
 To the moment of one line alone we yielded: 132

it was when we read about those longed-for lips
 now being kissed by such a famous lover,
 that this one (who shall never leave my side) 135

then kissed my mouth, and trembled as he did.
 Our Galehot was that book and he who wrote it.
 That day we read no further." And all the while 138

the one of the two spirits spoke these words,
 the other wept, in such a way that pity
 blurred my senses; I swooned as though to die, 141

and fell to Hell's floor as a body, dead, falls.

GEOFFREY CHAUCER

A Group of Medieval Pilgrims

Geoffrey Chaucer was born in London around 1342. His father was a wine seller, and had once served as Butler to the King. He managed to place Geoffrey at court, as a page to King Edward III. Other than a brief stint as a soldier, Chaucer remained a courtier throughout his life. He served Edward as a valet, and later as a minor diplomat. In 1366 Chaucer married a woman named Philippa, who served in the queen's court. During his travels as a diplomat, Chaucer encountered the literary culture of Europe, and particularly that of Italy. Dante, Petrarch, and Boccaccio all influenced his themes and style. Chaucer's skills as a poet and translator seemed to have served him well at court, but he was not paid for his writing. In 1374 Chaucer became Comptroller of the Customs; in 1385 he became Justice of the Peace in Kent, and in 1386 he sat in Parliament. Chaucer was a man of many talents. He mastered several languages, was deeply versed in European literature, and had some skill as a mathematician and astronomer. He also executed an esteemed translation of Boethius's Consolation of Philosophy. *He died in 1400.*

Chaucer's twin masterpieces were The Canterbury Tales *(c. 1390) and* Troilus and Criseyde *(mid-1380s).* The Canterbury Tales *tells the story of a group of English pilgrims on their way to Canterbury. On their pilgrimage the diverse travelers tell a series of tales, and these tales provide the material for Chaucer's poem.* The Canterbury Tales *survives in a series of fragments. The "First Fragment" is the most polished. It contains Chaucer's prologue and four of his most famous tales (those of the Knight, the Miller, the Reeve, and the Cook). Many of the stories in* The Canterbury Tales *are comic, and all provide glimpses into the social world of medieval England.*

An asterisk, placed at the nearest point in the glosses, indicates a note immediately helpful to the reader.

his his, its *shoures soote* sweet showers
droghte dryness* *perced* pierced
veyne vein (of sap) *swich licour* liquid such (that)
Of which vertu by its power *flour* flower
5 *Zephirus* god of the west wind; breeze *eek* also
Inspired breathed life into *holt* grove *heeth* field
croppes shoots, new leaves *yonge* young*
Has run (the second) half of his course in Aries*
smale foweles little birds
10 *ye* eye
So much does Nature prick them in their hearts*
longen folk to goon people long to go
palmeres pilgrims* *straunge strondes* foreign shores
To distant shrines known in various lands
15 *every shires ende* the corner of every county
wende make their way
blisful martir blessed martyr (St Thomas à Becket)* *seke* seek
hem hath holpen helped them* *seeke* sick
Bifil it happened *seson* season
20 *Southwerk* Southwark *Tabard* Tabard Inn* *lay* stayed

corage spirit

25 Of various sorts of people fallen by chance
felaweship fellowship
wolden wished to
chambres bedrooms *wyde* spacious
And we were made very comfortable in the best way
30 *to reste* setting
hem everichon every one of them
That I became part of their company
made forward (we) made agreement
ther as as *devyse* shall tell
35 *natheless* nonetheless
Er before *pace* proceed
Me thynketh it it seems to me *resoun* proper order
condicioun state, circumstances
ech of hem each one of them
40 And of what occupation and rank they were
eek also *array* dress
than wol then will

GENERAL PROLOGUE

Here bygynneth the Book of the Tales of Caunterbury.

Whan that Aprill with his shoures soote
The droghte of March hath perced to the roote,
And bathed every veyne in swich licour
of which vertu engendred is the flour;
5 Whan Zephirus eek with his sweete breeth
Inspired hath in every holt and heeth
The tendre croppes, and the yonge sonne
Hath in the Ram his half cours yronne,
and smale foweles maken melodye,
10 That slepen al the nyght with open ye
(So priketh hem nature in hir corages),
Thanne longen folk to goon on pilgrimages,
And palmeres for to seken straunge strondes,
To ferne halwes, kowthe in sondry londes;
15 And specially from every shires ende
Of Engelond to Caunterbury they wende,
The hooly blisful martir for to seke,
That hem hath holpen whan that they were seeke.
 Bifil that in that seson on a day,
20 In Southwerk at the Tabard as I lay
Redy to wenden on my pilgrymage
To Caunterbury with ful devout corage,
At nyght was come into that hostelrye
Wel nyne and twenty in a compaignye
25 Of sondry folk, by aventure yfalle
In felaweshipe, and pilgrimes were they alle,
That toward Caunterbury wolden ryde.
The chambres and the stables weren wyde,
And wel we weren esed atte beste.
30 And shortly, whan the sonne was to reste,
So hadde I spoken with hem everichon
That I was of hir felaweshipe anon,
And made forward erly for to ryse,
To take oure wey ther as I yow devyse.
35 But nathelees, whil I have tyme and space,
Er that I ferther in this tale pace,
Me thynketh it acordaunt to resoun
To telle yow al the condicioun
Of ech of hem, so as it semed me,
40 And which they weren, and of what degree,
And eek in what array that they were inne;
And at a knyght than wol I first bigynne.

KNYGHT knight* *worthy* respected, brave

45 *riden out* go on campaign *chivalrie* prowess
Trouthe integrity *fredom* magnanimity
lordes werre the war of his feudal superior
ferre further
In Christendom as well as in heathen lands*
50 . . .

SQUIER (e)squire, beginner in knighthood*
80 *lovyere* lover *lusty* zestful *bacheler* aspirant to knighthood*
crulle curly *presse* curler

of even lengthe well-proportioned
delyvere agile
85 *somtyme* for a time *chyvachie* cavalry expedition
Flaundres Flanders*
born hym conducted himself *space* space of time
his lady grace his lady's favour
Embrouded embroidered *meede* meadow
90 *reede* red
floytynge playing the flute

koude knew how to
95 *endite* write (the words for a song)
Juste joust *purtreye* draw
hoote passionately *nyghtertale* night-time
sleep slept
lowely humble *servysable* willing to serve
100 *carf* carved
YEMAN yeoman, free-born servant* *he* the Knight *namo* no more
hym liste it pleased him
he the Yeoman
pecok with flights made from peacock feathers
105 *bar ful thriftily* bore very properly
He knew well how to care for his equipment like a true yeoman
His arrows did not fall short with sagging feathers

not heed close-cropped head *broun* dark brown
110

bracer archer's arm-guard
bokeler buckler, shield
gay bright
Harneised ornamented

A Knyght ther was, and that a worthy man,
That fro the tyme that he first bigan
45 To riden out, he loved chivalrie,
Trouthe and honour, fredom and curteisie.
Ful worthy was he in his lordes werre,
And therto hadde he riden, no man ferre,
As well in cristendom as in hethenesse,
50 And evere honoured for his worthynesse;
. . .
 With hym ther was his sone, a young Squier,
80 A lovyere and a lusty bacheler,
With lokkes crulle as they were leyd in presse.
Of twenty yeer of age he was, I gesse.
Of his stature he was of evene lengthe,
And wonderly delyvere, and of greet strengthe.
85 And he hadde been somtyme in chyvachie
In Flaundres, in Artoys, and Pycardie,
And born hym weel, as of so litel space,
In hope to stonden in his lady grace.
Embrouded was he, as it were a meede
90 Al ful of fresshe floures, whyte and reede.
Syngynge he was, or floytynge, al the day;
He was as fressh as is the month of May.
Short was his gowne, with sleves longe and wyde.
Wel koude he sitte on hors and faire ryde.
95 He koude songes make and wel endite,
Juste and eek daunce, and weel purtreye and write.
So hoote he lovede that by nyghtertale
He sleep namoore than dooth a nyghtyngale.
Curteis he was, lowely, and servysable,
100 And carf biforn his fader at the table.
 A Yeman hadde he and servantz namo
At that tyme, for hym liste ride so,
And he was clad in cote and hood of grene.
A sheef of pecok arwes, bright and kene,
105 Under his belt he bar ful thriftily
(Wel koude he dresse his takel yemanly;
His arwes drouped noght with fetheres lowe),
and in his hand he baar a myghty bowe.
A not heed hadde he, with a broun visage.
110 Of wodecraft wel koude he al the usage.
Upon his arm he baar a gay bracer,
And by his syde a swerd and a bokeler,
And on that oother syde a gay daggere
Harneised wel and sharp as point of spere;

115 *Cristopher* image of St Christopher* *sheene* bright
bar bore *bawdryk* baldrick, shoulder strap
forster forester, gamekeeper *soothly* truly
PRIORESSE head of a priory of nuns*
symple unaffected *coy* shyly reserved
120 *ooth* oath *but* only *Seinte Loy* St Eloi, St Eligius*
cleped called
soong the service dyvyne sang the liturgy*
Entuned intoned *ful semely* in a most seemly manner
fetisly gracefully
125 In the manner of Stratford at Bow*
unknowe unknown
At mete at table* *with alle* indeed
leet allowed

130 *koude* know how to *kepe* take care
fille fell
She took great delight in courtly manners
over upper
hir coppe her cup *ferthyng* spot the size of a farthing
135

after hir mete she raughte she reached for her food
sikerly certainly *greet desport* fine deportment
port bearing, manner
And took pains to represent the manners
140 *estatlich* dignified*
And to be held worthy of respect
conscience moral sense
pitous compassionate
saugh saw

chapeleyne assistant *preestes thre**
. . .

165 MONK* *a fair for the maistrie* a surpassingly fine one
outridere a rider-out, supervisor *venerie* hunting*
A fine figure of a man, good enough to make an abbot
deyntee fine
rood was riding *heere* hear
. . .

270 MARCHANT merchant*
mottelee cloth woven with a parti-coloured design *hye* in a high saddle
Flaundryssh Flemish *bever* beaver
fetisly neatly
resons opinions *solempnely* impressively

115 A Cristopher on his brest of silver sheene.
 An horn he bar, the bawdryk was of grene;
 A forster was he, soothly, as I gesse.
 Ther was also a Nonne, a PRIORESSE,
 That of hir smylyng was ful symple and coy;
120 Hire gretteste ooth was but by Seinte Loy;
 And she was cleped madame Eglentyne.
 Ful weel she soong the service dyvyne,
 Entuned in hir nose ful semely;
 And Frenssh she spak ful faire and fetisly,
125 After the scole of Stratford atte Bowe,
 For Frenssh of Parys was to hire unknowe.
 At mete wel ytaught was she with alle;
 She leet no morsel from hir lippes falle,
 Ne wette hir fyngres in hir sauce depe;
130 Wel koude she carie a morsel and wel kepe
 That no drope ne fille upon hire brest.
 In curteisie was set ful muchel hir lest.
 Hir over-lippe wyped she so clene
 That in hir coppe ther was no ferthyng sene
135 Of grece, whan she dronken hadde hir draughte.
 Ful semely after hir mete she raughte.
 And sikerly she was of greet desport,
 And ful plesaunt, and amyable of port,
 And peyned hire to countrefete cheere
140 Of court, and to been estatlich of manere,
 And to ben holden digne of reverence.
 But for to speken of hire conscience,
 She was so charitable and so pitous
 She wolde wepe, if that she saugh a mous
 · · ·

 Another NONNE with hire hadde she,
 That was hir chapeleyne, and preestes thre.
165 A MONK ther was, a fair for the maistrie,
 An outridere, that lovede venerie,
 A manly man, to been an abbot able.
 Ful many a deyntee hors hadde he in stable,
 And whan he rood, men myghte his brydel heere
 · · ·

270 A MARCHANT was ther with a forked berd,
 In mottelee, and hye on horse he sat;
 Upon his heed a Flaundryssh bever hat,
 His bootes clasped faire and fetisly.
 His resons he spak ful solempnely,

275 *Sownynge in* tending to *wynning* profit
He wanted the sea to be guarded at any price
Middleburgh Dutch port *Orewelle* Orwell, nr Ipswich*
koude knew how to *sheeldes* écus, units of exchange*
bisette employed
280 *wight* creature* *dette* debt*
estatly dignified *governaunce* conduct
bargaynes lending and borrowing *chevyssaunce* dealing*
For sothe truly *with alle* indeed
noot (ne woot) do not know

SERGEANT OF THE LAWE lawyer for the Crown* *war* shrewd
310 *Parvys* the porch of St Paul's Cathedral*

swich so
Justice judge *assise* (county) court of assizes
315 By open (royal) letter and with full jurisdiction
science knowledge *renoun* reputation
fees and robes yearly grants* *many oon* many a one
purchasour buyer of land *noon* not one
fee symple unrestricted ownership* *in effect* in the upshot
320 *been infect* be invalidated
nas was not
. . .

540 *propre swynk* own labour *catel* posessions*
tabard short sleeveless outer garment *mere* mare
REVE steward
SOMNOUR summoner (to the church court)
MAUNCIPLE buyer of provisions *namo* no more
. . .
715 *clause* short compass
estaat condition

highte was called *faste* close *Belle* Bell, an inn
720

baren us behaved *ilke* same
alyght arrived
wol will *viage* journey
remenaunt remainder

275 Sownynge alwey th'encrees of his wynnyng.
He wolde the see were kept for any thyng
Bitwixe Middelburgh and Orewelle.
Wel koude he in eschaunge sheeldes selle.
This worthy man ful wel his wit bisette:
280 Ther wiste no wight that he was in dette,
So estatly was he of his governaunce
With his bargaynes and with his chevyssaunce.
For sothe he was a worthy man with alle,
But, sooth to seyn, I noot how men hym calle.

 . . .

 A SERGEANT OF THE LAWE, war and wys,
310 That often hadde been at the Parvys,
Ther was also, ful riche of excellence.
Discreet he was and of greet reverence
He semed swich, his wordes weren so wise.
Justice he was ful often in assise,
315 By patente and by pleyn commissioun.
For his science and for his heigh renoun,
Of fees and robes hadde he many oon.
So greet a purchasour was nowher noon:
Al was fee symple to hym in effect;
320 His purchasyng myghte nat been infect.
Nowher so bisy a man as he ther nas,
And yet he semed bisier than he was.

 . . .

540 Bothe of his propre swynk and his catel.
In a tabard he rood upon a mere.
 Ther was also a REVE, and a MILLERE,
A SOMNOUR, and a PARDONER also,
A MAUNCIPLE, and myself—ther were namo.

 . . .

715 Now have I toold you soothly, in a clause,
Th'estaat, th'array, the nombre, and eek the cause
Why that assembled was this compaignye
In Southwerk at this gentil hostelrye
That highte the Tabard, faste by the Belle.
720 But now is tyme to yow for to telle
How that we baren us that ilke nyght,
Whan we were in that hostelrie alyght;
And after wol I telle of our viage
and al the remenaunt of oure pilgrimage.

337

CHRISTINE DE PIZAN

In Defense of Women

Christine de Pizan (1364– c. 1430) was one of the first explicitly feminist writers in European history. She was born in Italy but was raised at the court of Charles V of France where her father was a physician and astrologer. Her father insisted that Christine be given the same education received by young men and she was taught languages, music, and moral and natural philosophy and spent much time reading classical literature. She married early but was widowed by the age of twenty-four and spent the rest of her life in literary pursuits. She wrote poetry, political tracts, a flattering biography of Charles V, and several works on moral philosophy, of which the most famous was The Book of the City of Ladies *(1405). Despite her avowed feminism, Christine enjoyed the financial support of noble male patrons until she entered a convent in 1418. She died there around 1430.*

The Book of the City of Ladies reflects Christine's wide reading in classical authors as well as her deep commitment to Christianity. The work takes the form of a dialogue between Christine and Reason in the first part and Christine and Rectitude in the second. In the following selection Reason refutes prevalent ancient myths about female inferiority and shows Christine the central role played by women in Christianity.

CHRISTINE EXPLAINS HOW REASON INSTRUCTED HER AND HELPED HER TO BEGIN DIGGING UP THE GROUND IN ORDER TO LAY THE FOUNDATIONS.

Lady Reason replied to my words, saying: 'Stand up now, daughter, and without further delay let us make our way to the Field of Letters. There we will build the City of Ladies on flat, fertile ground, where fruits of all kinds flourish and fresh streams flow, a place where every good thing grows in abundance. Take the spade of your intelligence and dig deep to make a great trench all around where you see the line I have traced. I'll help to carry away the hods of earth on my shoulders.'

Obeying her instructions, I jumped to my feet: thanks to the three ladies, my body felt much stronger and lighter than before. She took the lead and I followed on behind. When we came to the spot she had described, I began to excavate and dig out the earth with the spade of my intelligence, just as she had directed me to do. The first fruit of my labours was this: 'My lady, I'm remembering that image of gold being refined in the furnace that you used before to symbolize the way many male writers have launched a full-scale attack on the ways of women. I take this image to mean that the more women are criticized, the more it redounds to their glory. But please tell me exactly what it is that makes so many different authors slander women in their writings because, if I understand you correctly, they are wrong to do so. Is it Nature that makes them do this? Or, if it is out of hatred, how can you explain it?'

Reason answered my questions, saying: 'My dear daughter, in order to help you see more clearly how things stand, let me carry away this first load of earth. I can tell you that, far from making them slander women, Nature does the complete opposite. There is no stronger or closer bond in the world than that which Nature, in accordance with God's wishes, creates between man and woman. Rather, there are many other different reasons which explain why men have attacked women in the past and continue to do so, including those authors whose works you have already mentioned. Some of those who criticized women did so with good intentions: they wanted to rescue men who had already fallen into the clutches of depraved and corrupt women or to prevent others from suffering the same fate, and to encourage men generally to avoid leading a lustful and sinful existence. They therefore attacked all women in order to persuade men to regard the entire sex as an abomination.'

'My lady,' I said, 'forgive me for interrupting you. Were they right to do so, since they were acting with good intentions? Isn't it true that one's actions are judged by one's intentions?'

'You're wrong, my dear girl,' she replied, 'because there is no excuse for plain ignorance. If I killed you with good intentions and out of stupidity, would I be in the right? Those who have acted in this way, whoever they may be, have abused their power. Attacking one party in the belief that you are benefiting a third party is unfair. So is criticizing the nature of all women, which is completely unjustified, as I will prove to you by analogy. Condemning all women in order to help some misguided men get over their foolish behaviour is tantamount to denouncing fire, which is a vital and beneficial element, just because some people are burnt by it, or to cursing water just because some people are

drowned in it. You could apply the same reasoning to all manner of things which can be put to either good or bad use. In none of these cases should you blame the thing in itself if foolish people use it unwisely. You yourself have made these points elsewhere in your writings. Those who subscribe to these opinions, whether in good or bad faith, have over-stepped the mark in order to make their point. It's like somebody cutting up the whole piece of cloth in order to make himself a huge coat simply because it's not going to cost him anything and no one is going to object. It thus stops anyone else from using the material. If instead, as you your-self have rightly remarked, these writers had tried to find ways to save men from indulging in vice and from frequenting debauched women by attacking only the morals and the habits of those who were evidently guilty of such behaviour, I freely admit that they would have produced texts which were extremely useful. It's true that there's nothing worse than a woman who is dissolute and depraved: she's like a monster, a crea-ture going against its own nature, which is to be timid, meek and pure. I can assure you that those writers who condemn the entire female sex for being sinful, when in fact there are so many women who are extremely virtuous, are not acting with my approval. They've committed a grave error, as do all those who subscribe to their views. So let us throw out these horrible, ugly, misshapen stones from your work as they have no place in your beautiful city.

'Other men have criticized women for different reasons: some because they are themselves steeped in sin, some because of a bodily impediment, some out of sheer envy, and some quite simply because they naturally take delight in slandering others. There are also some who do so because they like to flaunt their erudition: they have come across these views in books and so like to quote the authors whom they have read.

'Those who criticize the female sex because they are inherently sinful are men who have wasted their youth on dissolute behaviour and who have had affairs with many different women. These men have therefore acquired cunning through their many experiences and have grown old without repenting of their sins. Indeed, they look back with nostalgia on the appalling way they used to carry on when they were younger. Now that old age has finally caught up with them and the spirit is still willing but the flesh has grown weak, they are full of regret when they see that, for them, the "good old days" are over and they can merely watch as younger men take over from where they have had to leave off. The only way they can release their frustration is to attack women and to try to stop others from enjoying the pleasures that they themselves used to

take. You very often see old men such as these going around saying vile and disgusting things, as in the case of your Matheolus, who freely admits that he is just an impotent old man who would still like to satisfy his desires. He's an excellent example to illustrate my point as he's typical of many other similar cases.

'Yet, thank goodness, not all old men are full of depravity and rotten to the core like a leper. There are many other fine, decent ones whose wisdom and virtue have been nourished by me and whose words reflect their good character, since they speak in an honourable and sober fashion. Such men detest all kinds of wrongdoing and slander. Thus, rather than attacking and defaming individual sinners, male or female, they condemn all sins in general. Their advice to others is to avoid vice, pursue virtue and stick to the straight and narrow.

'Those men who have attacked women because of their own bodily impediments, such as impotence or a deformed limb, are all bitter and twisted in the mind. The only pleasure they have to compensate for their incapacity is to slander the female sex since it is women who bring such joy to other men. That way they are convinced that they can put others off enjoying what they themselves have never had.

'Those men who have slandered the opposite sex out of envy have usually known women who were cleverer and more virtuous than they are. Out of bitterness and spite, envious men such as these are driven to attack all women, thinking that they can thereby undermine these individuals' good reputation and excellent character, as in the case of the author of *On Philosophy* whose name I've forgotten. In this book, he goes to great lengths to argue that men should on no account praise women and that those who do so are betraying the title of his book: their doctrine is no longer "philosophy" but "philofolly". However, I can assure you that it is definitely he who is the arch-exponent of "philofolly" because of all the false reasoning and erroneous conclusions he comes out with in his book.

'As for those men who are slanderous by nature, it's not surprising if they criticize women, given that they attack everyone indiscriminately. You can take it from me that any man who wilfully slanders the female sex does so because he has an evil mind, since he's going against both reason and nature. Against reason, because he is lacking in gratitude and failing to acknowledge all the good and indispensable things that woman has done for him both in the past and still today, much more then he can ever repay her for. Against nature, in that even the birds and the beasts naturally love their mate, the female of the species. So man acts in a most unnatural way when he, a rational being, fails to love woman.

'Finally, there are those who dabble in literature and delight in mimicking even the very finest works written by authors who are greatly superior to them. They think themselves to be beyond reproach since they are merely repeating what others have already said. Believe me, this is how they set about making their defamatory remarks. Some of them scribble down any old nonsense, verse without rhyme or reason, in which they discuss the ways of women, or princes, or whoever it might be, when it is they themselves, whose habits leave much to be desired, who are most in need of moral self-improvement. Yet the common folk, who are as ignorant as they are, think that it's the best thing they've ever read.'

HOW CHRISTINE DUG OVER THE EARTH: IN OTHER WORDS, THE QUESTIONS WHICH SHE PUT TO REASON AND THE ANSWERS SHE RECEIVED FROM HER.

'Now that I have prepared and set out this great task for you, you should carry on the task of digging up the ground, following the line which I have laid down.'

In obedience to Reason's wishes, I set to with all my might, saying, 'My lady, why is it that Ovid, who is considered to be the greatest of poets (though others, myself included, think that Virgil is more worthy of that accolade, if you don't mind my saying so), made so many derogatory remarks about women in his writings, such as the *Art of Love*, the *Remedies of Love* and other works?'

Reason replied: 'Ovid was a man very well versed in the theory and practice of writing poetry and his fine mind allowed him to excel in everything he wrote. However, his body was given over to all kinds of worldliness and vices of the flesh: he had affairs with many women, since he had no sense of moderation and showed no loyalty to any particular one. Throughout his youth, he behaved like this only to end up with the reward he richly deserved: he lost not just his good name and his possessions, but even some parts of his body! Because he was so licentious, both in the way he carried on and in the encouragement he gave to others to do the same, he was finally sent into exile. Even when he was brought back from banishment by some of his followers, who were influential young men of Rome, he couldn't help himself from falling into exactly the same pattern as before. So finally he was castrated and deprived of his organs because of his immortality. He's another good example of what I was telling you about just now: once he realized that he could no longer indulge in the same kind of pleasures as before, he

342

began to attack women with his sly remarks in an attempt to make others despise them too.'

'My lady, your words certainly ring true. However, I've seen another book by an Italian writer called Cecco d'Ascoli who, if I remember correctly, comes from the Marches of Tuscany. In this work, he says some extraordinarily unpleasant things which are worse than anything else I've ever read and which shouldn't be repeated by anybody with any sense.'

Reason's response was: 'My dear girl, don't be surprised if Cecco d'Ascoli slandered the whole of womankind since he hated and despised them all. Being unspeakably wicked, he tried to make all other men share his nasty opinion about women. He too got what he deserved: thanks to his heretical views, he suffered a shameful death at the stake.'

'My lady, I've also come across another little book in Latin, called *On the Secrets of Women*, which states that the female body is inherently flawed and defective in many of its functions.'[1]

Reason replied, 'You shouldn't need any other evidence than that of your own body to realize that this book is a complete fabrication and stuffed with lies. Though some may attribute the book to Aristotle, it is unthinkable that a philosopher as great as he would have produced such outrageous nonsense. Any woman who reads it can see that, since certain things it says are the complete opposite of her own experience, she can safely assume that the rest of the book is equally unreliable. Incidentally, do you remember the part at the beginning where he claims that one of the popes excommunicated any man found either reading the book out loud to a woman or giving it to her to read for herself?'

'Yes, my lady, I do remember that passage.'

'Do your know what evil motive drove him to put such vile words at the front of his book for gullible, foolish men to read?'

'No, my lady, you'll have to tell me.'

'It was because he didn't want women to get hold of his book and read it or have someone else read it to them for fear that if they did, they would pour scorn on it and would recognize it for the utter rubbish that it is. By this ruse, he thought he could trick the men who wanted to read his text.'

'My lady, amongst the other things he said, I seem to remember that, after going on at great length about female children being the result of some weakness or deficiency in the mother's womb, he claimed that Nature herself is ashamed when she sees that she has created such an imperfect being.'

'Well, my dear Christine, surely it's obvious that those who come out with this opinion are totally misguided and irrational? How can

Nature, who is God's handmaiden, be more powerful than her own master from whom she derives her authority in the first place? It is God almighty who, at the very core of His being, nurtured the idea of creating man and woman. When He put His divine wish into action and made Adam from the clay of the fields of Damascus, He took him to dwell in the earthly paradise, which has always been the noblest place on this lowly earth. There He put Adam to sleep and created the body of woman from one of his ribs. This was a sign that she was meant to be his companion standing at his side, whom he would love as if they were one flesh, and not his servant lying at his feet. If the Divine Craftsman Himself wasn't ashamed to create the female form, why should Nature be? It really is the height of stupidity to claim otherwise. Moreover, how was she created? I'm not sure if you realize this, but it was in God's image.[2] How can anybody dare to speak ill of something which bears such a noble imprint? There are, however, some who are foolish enough to maintain that when God made man in His image, this means His physical body. Yet this is not the case, for at that time God had not yet adopted a human form, so it has to be understood to mean the soul, which is immaterial intellect and which will resemble God until the end of time. He endowed both male and female with this soul, which He made equally noble and virtuous in the two sexes. Whilst we're still on the subject of how the human body was formed, woman was created by the very finest of craftsmen. And where exactly was she made? Why, in the earthly paradise. What from? Was it from coarse matter? No, it was from the finest material that had yet been invented by God: from the body of man himself.'

'My lady, from what you've told me, I can see that woman is a very noble creature. Yet, all the same, wasn't it Cicero who said that man should not be subject to woman and that he who did so abased himself because it is wrong to be subject to one who is your inferior?'

Reason answered, 'It is he or she who is the more virtuous who is the superior being: human superiority or inferiority is not determined by sexual difference but by the degree to which one has perfected one's nature and morals. Thus, happy is he who serves the Virgin Mary, for she is exalted even above the angels.'

'My lady, it was one of the Catos, the one who was a great orator, who declared that if woman hadn't been created, man would converse with the gods.'

Reason's reply was: 'Now you see an example of someone who was supposed to be very wise coming out with something very foolish. It is because of woman that man sits side by side with God. As for those who

state that it is thanks to a woman, the lady Eve, that man was expelled from paradise, my answer to them would be that man has gained far more through Mary than he ever lost through Eve. Humankind has now become one with God, which never would have happened if Eve hadn't sinned. Both men and women should praise this fault of Eve's since it is because of her that such an honour has been bestowed on them. If human nature is fallen, due to the actions of one of God's creatures, it has been redeemed by the Creator himself. As for conversing with the gods if womankind hadn't been invented, as this Cato claims, his words were truer than he knew. Being a pagan, he and those of his faith believed that both heaven and hell were ruled by the gods. But the ones in hell are what we call devils. So it's definitely true to say that men would be conversing with the gods of hell if Mary had not come into the world!

MORE QUESTIONS AND ANSWERS ON THIS SUBJECT.

'It was also this Cato Uticensis who said that a woman who is attractive to a man is like a rose which is lovely to look at but hides its sharp thorns underneath.'[3]

Reason replied: 'Once again, he was wiser than he knew, this Cato, because every decent, upright woman who leads a virtuous life is, and should be, one of the loveliest things to behold. Yet the thorn represents both her fear of doing wrong and her contrition, which are lodged deep in the heart of such a woman and make her reserved, cautious and prudent in order to protect herself.'

'My lady, is it true what certain authors have said about women being by nature gluttonous and prone to overindulgence?'

'My dear girl, you must have often heard the saying, "What is in our nature cannot be taken away." It would be very surprising if they *were* naturally so inclined when in fact so few of them every actually frequent taverns and other such establishments which sell rich and intoxicating fare. It is extremely rare to find women in these places: not from shame, as some might suggest, but rather, in my opinion, because they are naturally disposed to avoid them altogether. Even if women *were* given over to gluttony and yet managed to restrain their appetites out of a sense of shame, they should be praised for showing such virtue and strength of character. As we're on this subject, don't you remember that on a feast day a little while ago you were talking outside your house with your neighbour, a respectable young lady. You saw a man coming out of a tavern who said to his friend: "I've just spent so much in the inn that my wife won't have any wine to drink today." You called him over and

asked him why she wouldn't do so. He replied: "My lady, it's because every time I come home from the tavern she asks me how much I've spent. If it's more than twelve deniers,[4] she makes up for this cost by refraining from drinking herself. Her view is that we don't earn enough for the two of us to be able to indulge ourselves so heavily."'

'My lady,' I replied, 'I remember this incident very well.'

Reason then said to me: 'With many examples such as these, you can see that women are inherently sober creatures and that those who aren't go against their own nature. There is no worse vice in women than gluttony, because whoever is gluttonous is susceptible to all kinds of other vices too. Instead, it's well known that women flock to churches in great numbers to listen to sermons, to make their confessions and to say their daily prayers.'

'My lady, you're quite right,' I said, 'but some writers make out that, in fact, women go to church all dressed and made up in order to show themselves off to men and find themselves lovers.'

Her reply was: 'That might be true, my dear friend, if it was only pretty young girls who went to church. But, if you notice, for every young woman that you see, there are twenty or thirty old women attending services and dressed in plain, modest clothes. Moreover, women are not just pious but also charitable. After all, who is it that visits the sick and attends to their needs? Who gives aid to the poor? Who goes to the hospitals? Who helps bury the dead? To my mind, these are the tasks that women perform and which are like milestones on the road that leads to God.'

'My lady, you've put it very clearly. Yet, there is another author who has said that women are by nature weak-minded and childish, which explains why they get on so well with children and why children like being with them.'

She replied, 'My dear daughter, if you look carefully at the nature of a child, you will see that it is instinctively attracted to kindness and gentleness. And what could be kinder or gentler than a respectable woman? It's truly wicked of people to try to turn something which is good and praiseworthy in a woman—her tenderness—into something bad and blameworthy. Women love children because they're acting not out of ignorance but rather a natural instinct to be gentle. And if being gentle therefore means that they are childlike, so much the better for them. Remember the story the gospels tell about what Jesus Christ said to his apostles when they were arguing amongst themselves as to who would be the greatest of them all? He called a child to him and laid his hand on its head saying, "I tell you that he who is humble and meek like a child

will be the greatest among you, for he who abases himself will be exalted whereas he who exalts himself will be abased." '[5]

'My lady, men have made a great deal of mileage out of mocking women because of a Latin proverb which says that "God made woman to weep, talk and spin".'[6]

Reason's reply was: 'My dear Christine, this is absolutely true, though it's not meant to be a criticism, despite what some might claim. It's a fine thing that God endowed women with such qualities because many have been saved thanks to their tears, words and distaffs. In answer to those who have attacked women for weeping, I would say that if Jesus Christ, who could read directly into human hearts and minds, had thought that women only wept because they were weak or simple-minded, he would never have lowered himself in his majesty to let fall tears from his own saintly eyes out of compassion at the sight of Martha and Mary Magdalene weeping for their dead brother, the leper,[7] whom he brought back to life. Indeed, God has showered women with so many favours precisely because He has been moved by their weeping. Far from despising Mary Magdalene's tears, He appreciated them so much that He forgave her all her sins. It is thanks to her weeping that she is now living in heavenly glory.

'Nor did God scorn the tears of the widow who wept for her only son as he was being laid in the ground. When Christ saw her weeping, his compassion gushed forth like a fountain of mercy at the sight of her tears. Asking her, "Woman, why are you crying?", he straightaway brought back her child from the dead.[8] The Holy Scriptures tell of so many other miracles which God has performed in the past and still does perform for the sake of a woman's tears. Indeed, the tears shed by a pious woman have often been the cause of her own salvation or that of those for whom she has been praying. Take the example of Saint Augustine, the holy Father of the Church, who was converted to Christianity by his mother's weeping. The good lady never stopped crying and praying to God to shine the light of faith into the unbelieving heart of her heathen son. Because of her persistence, Saint Ambrose, whom she used to implore to pray to God to save her son, was moved to say: "Woman, I believe that your tears will surely not be shed in vain." Blessed Ambrose, you didn't dismiss a woman's tears as trivial. What one should say to anybody coming out with this opinion is that it was thanks to the tears of a woman that Saint Augustine, this holy luminary, now shines his light down from the altar and illuminates the whole of Christendom. So men really should have nothing more to say on this point.

'God similarly endowed women with speech, thank the Lord, for if He hadn't done so, they would all have remained dumb. But let's go back

to that proverb, which somebody has obviously just cobbled together to get at women. If women's speech had been as unreliable and worthless as some maintain, Our Lord Jesus Christ would never have allowed news of such a glorious miracle as his resurrection to be announced first by a woman, as he told the blessed Magdalene to do when he appeared to her first on Easter day and sent her to inform Peter and the other apostles. Praise be to God for having bestowed so many gifts and favours on women by wishing them to become the bearers of such great glad tidings.'

I said to Reason, 'My lady, these envious men would all be reduced to silence if they could see the truth of the matter. I've just remembered something that makes me smile, something silly which I've heard men and even foolish preachers say about Christ appearing first to a woman because he knew she couldn't keep her mouth shut and so the news of his resurrection would spread all the faster.'

Reason replied, 'My dear daughter, you're quite right to say that it's only fools who have come out with this view. They're not just criticizing women but also going so far as to suggest that Jesus Christ blasphemed when he said that such a perfect and holy mystery could be revealed by a vice. I don't know how men can dare say such a thing. Even if they're only joking, they shouldn't do so at the Lord's expense.

'To get back to your first point: it was a fine thing that the woman from Canaan should have been such a talker since she never stopped shrieking and shouting out to Christ as he went through the streets of Jerusalem, begging him to have pity on her and cure her sick daughter.[9] And what did Our Lord do, He who has always been an endless fountain of mercy and who shows compassion at the least little word spoken truly from the heart? He seemed to take delight in the unending flow of words and prayers pouring out of this woman's mouth. Why? Because he wanted to test her constancy. When he used harsh words to compare her to a dog for not being of the Christian faith, she did not flinch but rather replied most intelligently, saying: "Lord, that is absolutely true, but little dogs feed off the crumbs which fall from the master's table." What a wise woman! Who taught you to speak like that? You won your case thanks to the modest words which you spoke from a pure heart. This was made clear when Christ turned to his apostles, declaring that nowhere in the whole of Israel had he ever come across such faith as in this woman, and then granted her request. One cannot praise highly enough this honour shown to women which the envious seek to denigrate, when one sees that Jesus Christ found greater faith in the heart of a poor little heathen woman than in all the bishops, princes and priests,

not to mention the whole of the Jewish race who claimed to be God's chosen people.

'The Samaritan woman is another example of one whose persuasive words redounded to her glory when she went to the well to draw water and met Christ who was sitting there all dejected.[10] Blessed was this noble body in which God chose to manifest Himself, deigning to pour forth such words of comfort from His holy mouth into this little female sinner who was not even a Christian. That was clear proof that He does not despise the female sex. How many of our great bishops today would condescend to speak to such a humble little woman, even if her salvation was at stake?

'The woman who was listening to one of Jesus's sermons was no less wise in her speech when she was set alight by his holy words.[11] She is a good example of that saying that women can't keep quiet, since she covered herself in glory for jumping up and shouting out, "Blessed be the womb that bore you and the breasts which fed you!"

'My dear, sweet friend, you can now surely see that God gave women the power of speech so that they might serve Him. They shouldn't therefore be criticized for something which has done so much good and so little harm, since women's words rarely hurt anyone.

'As for spinning, God made this into women's natural domain, and it is an activity which is essential for serving Him and for the good of all rational beings. Without it, the world would be in a vile state. So it's the height of wickedness to reproach women for something for which they should be thanked, honoured and praised.'

EXPLANATORY NOTES

1. The medieval view of woman as a flawed being, a kind of deformed male, *was* largely derived from Aristotle. In his view, menstruation in particular was a sign that the female sex did not match up to the physiological perfection of the male sex. However, *On the Secrets of Women,* which Christine quite rightly says was not written by Aristotle, takes these arguments about female physiology to extremes by claiming, amongst other things, that menstrual blood can seep out of the eyes, poison children and induce madness in dogs. . . .

2. Christine here refers to the medieval theological dispute on the interpretation of Genesis 1: 27, 'So God created man in his own image, in the image of God created he him; male and female created he them', and I Corinthians 11: 7, man 'is the image and glory of God: but the woman is the glory of the man'.

3. Christine here wrongly refers to Cato the Elder by the name of his great-grandson.
4. The denier, or silver penny, was introduced by the Carolingians in the eighth century and became the main unit of currency in medieval western Europe.
5. See Matthew 18: 2–4, Mark 9: 33–7 and Luke 9: 46–8.
6. The Latin proverb is *'fallere, flere, nere, statuit deus in muliere'*.
7. Martha and Mary's brother was called Lazarus. See John 11: 1–44.
8. See Luke 7: 12–15.
9. See Matthew 15: 22–8.
10. See John 4: 7–29.
11. See Luke 11: 27.

FRANCESCO PETRARCH

The Scholar-Poet and His Love

———————

Petrarch (1304–1374), Italy's greatest humanist and most influential lyric poet, was born in Arezzo, a provincial town in Tuscany. He spent much of his youth in the city of Avignon in Provence, where his father, a political exile from Florence, worked as a notary. After an unsuccessful career as a law student, Petrarch returned to Avignon and entered the service of the powerful Colonna family. It was on Good Friday of 1327 in a church in Avignon that Petrarch claimed to have seen for the first time his beloved Laura, the inspiration for his famous Canzoniere, *a collection of lyric poems in various metrical forms. This* Songbook *(as translates* Canzoniere*) was the model for romantic and other lyric poetry in various European vernacular languages for the next three hundred years. Petrarch is also famous as the first major Renaissance humanist, the man who more than any other inspired the Renaissance movement to revive classical literature. Petrarch tried to revive both the language of classical Latin and the genres of ancient literature including the epic, bucolic poetry, and the biography. He also compiled several large collections of his Latin correspondence, and worked to rediscover and restore lost, fragmentary, or corrupt copies of ancient literary works. All these activities were to become typical of the humanist movement during the Renaissance.*

Not only was Petrarch a brilliant and inspiring writer, but he also displayed a quite extraordinary self-awareness as an individual who struggled with the desire for love and fame while trying to respond to the claims of religion. The poems from the Canzoniere *excerpted here set the fashion for introspective love poetry that focused more on the emotions of the poet than upon the beloved.*

———————

SELECTED POEMS FROM THE CANZONIERE

264

 I'm always thinking, and I'm caught in thought
by such abundant pity for myself
that often I am led
to weeping for a different kind of grief:
for seeing every day the end come closer,
a thousand times I begged God for those wings
with which our intellect
can soar to Heaven from this mortal jail.[1]

 But until now I have received no help,
no matter how I plead or sigh or weep,
and it is only just that it be so—
if he who can walk straight chooses to fall,
then he deserves to lie upon the ground.
Those arms stretched out in mercy[2]
in which I trust are open to me still,
but I still fear to think
how others ended, and I dread my state
and am spurred on, and it could be too late.

 A thought speaks to the mind and it declares:
"You're longing still? What help do you expect?
You poor thing, don't you see
with what dishonor time is passing by?
Make up your mind now, wisely, and decide
to pull out of your heart every last root
of pleasure that can never
bring happiness, nor will it let you breathe.

 Since you have long been tired and disgusted
by that false sweetness of a fleeting good,
a gift the treacherous world bestows on some,
why do you still place hope in such a thing
devoid of all peace and stability?
While life is in your body
you have the rein of all thoughts in your hands.
Hold tight now while you can,
for, as you know, delay is dangerous,
and now is not too early to begin.

 How well you know the great amount of sweetness
your eyes have taken from the sight of her,
the one I wish now were

still to be born, that we may have more peace.
You certainly remember, as you must,
the image of her rushing down into
your heart, there where, perhaps,
the flame of other torches could not enter.

 She set it burning, and if the false flame
has lasted many years waiting the day
that for our own salvation never comes,
now raise yourself to a more blessed hope,
by gazing on the heavens whirling round you,
beautiful and immortal:
if here desire, happy in its ills,
achieves its satisfaction
by a mere glance, a word or two, a song,
what will that joy be like, if this is great?"

 There is another thought that's bittersweet
with difficult and yet delightful weight
sitting within my soul
which fills my heart with need and feeds it hope;
only for love of glorious, kindly fame
it does not feel the times I freeze or burn
or if I'm pale or thin;
and killing it makes it grow back the stronger.

 This,[3] from the day I slept in baby clothes,
has been growing with me all of my days,
and I fear both of us will share one grave;
for when my soul is naked of its body,
glory's desire cannot accompany it.
If Latin or Greek tongues[4]
praise me when I am dead, it is all wind;
and since I fear to be
always hoarding what in a moment scatters,
I would embrace the truth,[5] and leave the lies.

 But then that other passion filling me
seems to block out all others born around it;
meanwhile time flies while I
with no concern for self write for another;
the radiance of those lovely eyes melting me
mellifluously in warmth of clarity
has hold of me with reins
against which neither wit nor might avails.

 So then what good is it for me to oil
my boat when it is caught upon a reef
and still tied up so tight by those two knots?[6]

You,[7] who from other knots that bind the world
in different ways have liberated me,
my Lord, why do you not,
once and for all, wipe from my face this shame?
For like a man who dreams
I seem to see Death standing there before me,
and I would fight for life, and have no weapons.

 I know myself, and I am not deceived
by a mistaken truth; I'm forced by Love
who blocks the path of honor
for anyone who trusts too much in him;
I feel enter my heart from time to time
a virtuous disdain, harsh and severe,
which pulls all hidden thoughts
up to my brow for everyone to see.
 To love a mortal thing with such great faith,
the kind that should be placed in God alone,
is less becoming the more one looks for honor.
And this[8] in a loud voice also calls back
my reason which went wandering with the senses;
but though it hears and means
to come back home, bad habit drives it further
and paints before my eyes
the one born only so that I may die
because she pleased me, and herself, too much.

 Nor do I know how much space Heaven gave me
when I was newly brought upon the earth
to suffer that harsh war
that I managed to start against myself;
nor can I through my body's veil foresee
the day that must arrive to close my life;
but I see my hair changing
and within me all of my desires aging.
 Now that I feel the time for my departure
approaches—it cannot be far away—
as he whose loss makes him wary and wise,
I think back to the point it was I left
the right road leading to the port of good:
on one side[9] I am pierced
by shame and sorrow, and they turn me back:
the other[10] will not free me
from pleasure which through time has grown so strong
that it dares bargain now with Death itself.

Song, this is how I live and my heart is
colder with fear than snow that's turned to ice,
feeling for certain that I am perishing;
in trying to decide I've wound the spool
by now with a good length of my short thread;[11]
never was there a weight
heavier than the one I carry now,
for with Death at my side
I seek new rules by which to lead my life,
and see the best, but still cling to the worst.

EXPLANATORY NOTES

1. Although this poem was probably written in 1348 while Laura was still alive, Petrarch places it at the beginning of the poems on Laura's death.
2. The arms of Christ upon the cross.
3. "This" refers to the thought described in the preceding stanza.
4. Latin and Greek were considered the most noble languages by Renaissance humanists. Although the study of Latin was widespread, Greek was hardly known in Petrarch's day.
5. A reference to God.
6. The "two knots" are Petrarch's love for Laura and his desire for worldly fame, which keep him from devoting his entire life to God. He debates his "two chains" with St. Augustine in the *Secretum.*
7. The poet addresses God directly until the end of the stanza.
8. "This" refers back to "virtuous disdain" in line 96.
9. The side of reason is afflicted.
10. This "other" is the side of the appetite or passion.
11. Metaphors for a man's life.

GIOVANNI BOCCACCIO

The Inquisition Ridiculed

————

Giovanni Boccaccio (1313–1375), poet, scholar, and writer of short stories, was one of the greatest writers of the Italian Renaissance. He was born in Tuscany, a bastard child of the general manager of the Bardi Bank of Florence, one of the greatest European banks of the day. When his father became director of the Naples branch of the bank in 1327, young Giovanni went along and there received an education in law, a subject for which he proved unsuited. Turning to literature and scholarship instead, the young Boccaccio established a reputation in the court of the Angevin Kings of Naples as an innovative poet, specializing in the transfer of popular poetic genres from French to Italian. In 1341 he was compelled to return to Florence where in 1348–9 he witnessed firsthand the effects of the Black Death, the most devastating plague in European history. In later life Boccaccio came under the influence of Francesco Petrarca, the first great humanist of the Renaissance, and spent the final decades of his life writing various learned compendia in Latin, including biographical collections of famous men and women, and erudite studies of classical mythology.

It was in the decade after the Black Death that Boccaccio composed what is by far his most famous work, The Decameron. *This work is a collection of one hundred short tales, purporting to be told by young noblemen and noblewomen to each other while in the country, seeking refuge from the plague. By turns witty, satirical, ribald, and moralizing, the tales reveal the attitudes of laymen of the Renaissance to the world of religious and social conformity that surrounded them. In the tale excerpted here Boccaccio tells a story mocking the venality and hypocrisy of the Inquisition.*

————

With a clever remark, an honest man exposes the wicked hypocrisy of the religious.

All the ladies applauded the courage of the Marchioness and the eloquent rebuff she had given to the King of France. Then in deference to

the wishes of the queen, Emilia, who was seated next to Fiammetta, started boldly to speak:

I likewise will describe a stinging rebuke, but one which was administered by an honest layman to a grasping friar, with a gibe no less amusing than it was laudable.

Not long ago then, dear young ladies, there was in our city a Franciscan, an inquisitor on the look-out for filthy heretics, who whilst trying very hard, as they all do, to preserve an appearance of saintly and tender devotion to the Christian faith, was no less expert at tracking down people with bulging purses than at seeking out those whom he deemed to be lacking in faith. His diligence chanced to put him on the trail of a certain law-abiding citizen, endowed with far more money than common sense, who one day, not from any lack of faith but simply in the course of an innocent conversation with his friends, came out with the remark that he had a wine of such a quality that Christ himself would have drunk it.

The worthy soul had been drinking too much perhaps, or possibly he was over-excited, but unfortunately his words were reported to the inquisitor, who on hearing that the man had large estates and a tidy sum of money, hastily proceeded *cum gladiis et fustibus* to draw up serious charges against him. This, he thought, would have the effect, not so much of lessening his victim's impiety, as of lining his own pockets with florins, which was what in fact happened. Having issued a summons, he asked the man whether the charges against him were correct. The good man admitted that they were, and explained the circumstances, whereupon this devout and venerable inquisitor of Saint John Golden-Mouth said:

'So you turned Christ into a drinker, did you, and a connoisseur of choice wines, as if he were some tosspot or drunken tavern-crawler like one of yourselves? And now you eat humble-pie, and try to pass the whole thing off as something very trifling. But that is where you are mistaken. The fire is what you deserve when we come to take action against you, as indeed we must.'

The friar addressed these words to him, and a great many more, with a menacing look all over his features, as though the fellow were an Epicurean denying the immortality of the soul. In brief, he struck such terror into him, that the poor man arranged for certain go-betweens to grease the friar's palm with a goodly amount of Saint John Golden-Mouth's ointment (a highly effective remedy against the disease of galloping greed common among the clergy, and especially among Franciscans, who look upon money with distaste), so that the inquisitor would deal leniently with him.

The ointment he used is highly efficacious (though it is not mentioned by Galen in any of his treatises on medicine), and he applied it so liberally and effectively that the fire which he had been threatened was graciously commuted to the wearing of a cross, which made him look as if he were about to set off on a Crusade. In order to make his badge more attractive, the friar stipulated that the cross should be yellow on a black ground. And apart from this, having pocketed the money, he kept him for several days under open arrest, ordering him by way of penance to attend mass every morning in Santa Croce and report to him every day at the hour of breakfast, after which he was free to do as he pleased for the rest of the day.

The man carried out his instructions to the letter, and one morning at mass he happened to be listening to the Gospel when he heard these words being sung: 'For every one you shall receive an hundredfold, and shall inherit everlasting life.' He committed the words firmly to memory, and at the usual hour he presented himself as instructed before the inquisitor, whom he found already at table. The inquisitor asked him whether he had listened to mass that morning, and he promptly replied that he had. Whereupon the inquisitor said:

'Do you have any doubts, or questions you wish to ask, about anything you heard during the service?'

'To be sure,' the good man replied, 'I have no doubts about any of the things I heard, indeed I firmly believe them all to be true. But one of the things I heard made me feel very sorry for you and your fellow friars, and I still feel very sorry when I think what an awful time you are all going to have in the life to come.'

'And what was it,' asked the inquisitor, 'which caused you to feel so sorry for us?'

'Sir,' the good man replied, 'it was that passage from the Gospel which says that for every one you shall receive an hundred-fold.'

'That is true,' said the inquisitor. 'But why should this have perturbed you so?'

'Sir,' replied the good man, 'I will tell you. Every day since I started coming here, I have seen a crowd of poor people standing outside and being given one and sometimes two huge cauldrons of vegetable-water which, being surplus to your needs, is taken away from you and the other friars here in the convent. So if you are going to receive a hundred in the next world for every one you have given, you will have so much of the stuff that you will all drown in it.'

The other friars sitting at the inquisitor's table all burst out laughing, but the inquisitor himself, on hearing their guzzling hypocrisy exposed

in this fashion, flew into a towering rage. And but for the fact that the affair had already brought him discredit, he would have laid further charges against the man for the way his amusing remark had held both him and the other lazy rogues up to ridicule. So he angrily told him to go about his business, and not to show his face there again.

GIOVANNI BOCCACCIO

Nuns in Heat

Giovanni Boccaccio (1313–1375), poet, scholar, and writer of short stories, was one of the greatest writers of the Italian Renaissance. He was born in Tuscany, a bastard child of the general manager of the Bardi Bank of Florence, one of the greatest European banks of the day. When his father became director of the Naples branch of the bank in 1327, young Giovanni went along and there received an education in law, a subject for which he proved unsuited. Turning to literature and scholarship instead, the young Boccaccio established a reputation in the court of the Angevin Kings of Naples as an innovative poet, specializing in the transfer of popular poetic genres from French to Italian. In 1341 he was compelled to return to Florence where in 1348-9 he witnessed firsthand the effects of the Black Death, the most devastating plague in European history. In later life Boccaccio came under the influence of Francesco Petrarca, the first great humanist of the Renaissance, and spent the final decades of his life writing various learned compendia in Latin, including biographical collections of famous men and women, and erudite studies of classical mythology.

It was in the decade after the Black Death that Boccaccio composed what is by far his most famous work, The Decameron. *This work is a collection of one hundred short tales, purporting to be told by young noblemen and noblewomen to each other while in the country, seeking refuge from the plague. By turns witty, satirical, ribald, and moralizing, the tales reveal the attitudes of laymen of the Renaissance to the world of religious and social conformity that surrounded them. In the tale excerpted here Boccaccio shows the practical consequences of forcing healthy young women into convents against their will.*

"Nuns in Heat," from "Third Day, First Story" in *The Decameron*, by Giovanni Boccaccio, second edition, translated by G. H. McWilliam, copyright © 1972, 1995 by G. H. McWilliam, 192–199. Reprinted by permission of Penguin Books Ltd.

Masetto of Lamporecchio pretends to be dumb, and becomes a gardener at a convent, where all the nuns combine forces to take him off to bed with them.

Fairest ladies, there are a great many men and women who are so dense as to be firmly convinced that when a girl takes the white veil and dons the black cowl, she ceases to be a woman or to experience feminine longings, as though the very act of making her a nun had caused her to turn into stone. And if they should happen to hear of anything to suggest that their conviction is ill-founded, they become quite distressed, as though some enormous and diabolical evil had been perpetrated against Nature. It never enters their heads for a moment, possibly because they have no wish to face facts, that they themselves are continually dissatisfied even though they enjoy full liberty to do as they please, or that idleness and solitude are such powerful stimulants. Again, there are likewise many people who are firmly convinced that digging and hoeing and coarse food and hardy living remove all lustful desires from those who work on the land, and greatly impair their intelligence and powers of perception. But, since the queen has bidden me to speak, I would like to tell you a little tale, relevant to the topic she has prescribed, which will show you quite clearly that all these people are sadly mistaken in their convictions.

In this rural region of ours, there was and still is a nunnery, greatly renowned for its holiness, which I shall refrain from naming for fear of doing the slightest harm to its reputation. At this convent, not long ago, at a time when it housed no more than eight nuns and an abbess, all of them young, there was a worthy little man whose job it was to look after a very beautiful garden of theirs. And one day, being dissatisfied with his remuneration, he settled up with the nuns' steward and returned to his native village of Lamporecchio.

On his return, he was warmly welcomed by several of the villagers, among them a young labourer, a big, strong fellow called Masetto, who, considering that he was of peasant stock, possessed a remarkably handsome physique and agreeable features. Since the good man, whose name was Nuto, had been away from the village for some little time, Masetto wanted to know where he had been, and when he learned that Nuto had been living at a convent, he questioned him about his duties there.

'I tended a fine, big garden of theirs,' Nuto replied, 'in addition to which, I sometimes used to go and collect firewood, or I would fetch water and do various other little jobs of that sort. But the nuns gave me

such a paltry wage that it was barely sufficient to pay for my shoe-
leather. Besides, they are all young and they seem to me to have the devil
in them, because whatever you do, it is impossible to please them. Some-
times, in fact, I would be working in the garden when one of them would
order me to do one thing, another would tell me to do something else,
and yet another would snatch the very hoe from my hands, and tell me I
was doing things the wrong way. They used to pester me to such an extent
that occasionally I would down tools and march straight out of the gar-
den. So that eventually, what with one thing and another, I decided I'd had
enough of the place and came away altogether. Just as I was leaving, their
steward asked me whether I knew of anyone who could take the job on,
and I promised to send somebody along, provided I could find the right
man, but you won't catch me sending him anybody, not unless God has
provided the fellow with the strength and patience of an ox.'

As he listened, Masetto experienced such a longing to go and stay
with these nuns that his whole body tingled with excitement, for it was
clear from what he had heard that he should be able to achieve what he
had in mind. Realizing, however, that he would get nowhere by reveal-
ing his intentions to Nuto, he replied:

'How right you were to come away from the place! What sort of a life
can any man lead when he's surrounded by a lot of women? He might as
well be living with a pack of devils. Why, six times out of seven they
don't even know their own minds.'

But when they had finished talking, Masetto began to consider what
steps he ought to take so that he could go and stay with them. Knowing
himself to be perfectly capable of carrying out the duties mentioned by
Nuto, he had no worries about losing the job on that particular score,
but he was afraid lest he should be turned down because of his youth and
his unusually attractive appearance. And so, having rejected a number of
other possible expedients, he eventually thought to himself: 'The con-
vent is a long way off, and there's nobody there who knows me. If I can
pretend to be dumb, they'll take me on for sure.' Clinging firmly to this
conjecture, he therefore dressed himself in pauper's rags and slung an axe
over his shoulder, and without telling anyone where he was going, he set
out for the convent. On his arrival, he wandered into the courtyard,
where as luck would have it he came across the steward, and with the aid
of gestures such as dumb people use, he conveyed the impression that he
was begging for something to eat, in return for which he would attend to
any wood-chopping that needed to be done.

The steward gladly provided him with something to eat, after which
he presented him with a pile of logs that Nuto had been unable to chop.

Being very powerful, Masetto made short work of the whole consignment, and then the steward, who was on his way to the wood, took Masetto with him and got him to fell some timber. He then provided Masetto with an ass, and gave him to understand by the use of sign-language that he was to take the timber back to the convent.

The fellow carried out his instructions so efficiently that the steward retained his services for a few more days, getting him to tackle various jobs that needed to be done about the place. One day, the Abbess herself happened to catch sight of him, and she asked the steward who he was.

'The man is a poor deaf-mute, ma'am, who came here one day begging for alms,' said the steward. 'I saw to it that he was well fed, and set him to work on various tasks that needed to be done. If he turns out to be good at gardening, and wants to stay, I reckon we would do well out of it, because we certainly need a gardener, and this is a strong fellow who will always do as he's told. Besides, you wouldn't need to worry about his giving any check to these young ladies of yours.'

'I do believe you're right,' said the Abbess. 'Find out whether he knows what to do, and make every effort to hold on to him. Provide him with a pair of shoes and an old hood, wheedle him, pay him a few compliments, and give him plenty to eat.'

The steward agreed to carry out her instructions, but Masetto was not far away, pretending to sweep the courtyard, and he had overheard their whole conversation. 'Once you put me inside that garden of yours,' he said to himself, gleefully, 'I'll tend it better than it's ever been tended before.'

Now, when the steward had discovered what an excellent gardener he was, he gestured to Masetto, asking him whether he would like to stay there, and the latter made signs to indicate that he was willing to do whatever the steward wanted. The steward therefore took him on to the staff, ordered him to look after the garden, and showed him what he was to do, after which he went away in order to attend to the other affairs of the convent, leaving him there by himself. Gradually, as the days passed and Masetto worked steadily away, the nuns started teasing and annoying him, which is the way people frequently behave with deaf-mutes, and they came out with the foulest language imaginable, thinking that he was unable to hear them. Moreover, the Abbess, who was possibly under the impression that he had lost his tail as well as his tongue, took little or no notice of all this.

Now one day, when Masetto happened to be taking a rest after a spell of strenuous work, he was approached by two very young nuns who were out walking in the garden. Since he gave them the impression that

he was asleep, they began to stare at him, and the bolder of the two said to her companion:

'If I could be sure that you would keep it a secret, I would tell you about an idea that has often crossed my mind, and one that might well work out to our mutual benefit.'

'Do tell me,' replied the other. 'You can be quite certain that I shan't talk about it to anyone.'

The bold one began to speak more plainly.

'I wonder,' she said, 'whether you have ever considered what a strict life we have to lead, and how the only men who ever dare set foot in this place are the steward, who is elderly, and this dumb gardener of ours. Yet I have often heard it said, by several of the ladies who have come to visit us, that all other pleasures in the world are mere trifles by comparison with the one experienced by a woman when she goes with a man. I have thus been thinking, since I have nobody else to hand, that I would like to discover with the aid of this dumb fellow whether they are telling the truth. As it happens, there couldn't be a better man for the purpose, because even if he wanted to let the cat out of the bag, he wouldn't be able to. He wouldn't even know how to explain, for you can see for yourself what a mentally retarded, dim-witted hulk of a youth the fellow is. I would be glad to know what you think of the idea.'

'Dear me!' said the other. 'Don't you realize that we have promised God to preserve our virginity?'

'Pah!' she said. 'We are constantly making Him promises that we never keep! What does it matter if we fail to keep this one? He can always find other girls to preserve their virginity for Him.'

'But what if we become pregnant?' said her companion. 'What's going to happen then?'

'You're beginning to worry about things before they've even happened. We can cross that bridge if and when we come to it. There'll be scores of different ways to keep it a secret, provided we control our own tongues.'

'Very well, then,' said the other, who was already more eager than the first to discover what sort of stuff a man was made of. 'How do we set about it?'

'As you see,' she replied, 'it is getting on for nones, and I expect all our companions are asleep. Let's make sure there's nobody else in the garden. And then, if the coast is clear, all we have to do is to take him by the hand and steer him across to that hut over there, where he shelters from the rain. Then one of us can go inside with him while the other keeps watch. He's such a born idiot that he'll do whatever we suggest.'

Masetto heard the whole of this conversation, and since he was quite willing to obey, the only thing he was waiting for now was for one of them to come and fetch him. The two nuns had a good look round, and having made certain that they could not be observed, the one who had done all the talking went over to Masetto and woke him up, whereupon he sprang instantly to his feet. She then took him by the hand, making alluring gestures to which he responded with big broad, imbecilic grins, and led him into the hut, where Masetto needed very little coaxing to do her bidding. Having got what she wanted, she loyally made way for her companion, and Masetto, continuing to act the simpleton, did as he was asked. Before the time came for them to leave, they had each made repeated trials of the dumb fellow's riding ability, and later on, when they were busily swapping tales about it all, they agreed that it was every bit as pleasant an experience as they had been led to believe, indeed more so. And from then on, whenever the opportunity arose, they whiled away many a pleasant hour in the dumb fellow's arms.

One day, however, a companion of theirs happened to look out from the window of her cell, saw the goings-on, and drew the attention of two others to what was afoot. Having talked the matter over between themselves, they at first decided to report the pair to the Abbess. But then they changed their minds, and by common agreement with the other two, they took up shares in Masetto's holding. And because of various indiscretions, these five were subsequently joined by the remaining three, one after the other.

Finally, the Abbess, who was still unaware of all this, was taking a stroll one very hot day in the garden, all by herself, when she came across Masetto stretched out fast asleep in the shade of an almond-tree. Too much riding by night had left him with very little strength for the day's labours, and so there he lay, with his clothes ruffled up in front by the wind, leaving him all exposed. Finding herself alone, the lady stood with her eyes riveted to this spectacle, and she was seized by the same craving to which her young charges had already succumbed. So, having roused Masetto, she led him away to her room, where she kept him for several days, thus provoking bitter complaints from the nuns over the fact that the handyman had suspended work in the garden. Before sending him back to his own quarters, she repeatedly savoured the one pleasure for which she had always reserved her most fierce disapproval, and from then on she demanded regular supplementary allocations, amounting to considerably more than her fair share.

Eventually, Masetto, being unable to cope with all their demands, decided that by continuing to be dumb any longer he might do himself

some serious injury. And so one night, when he was with the Abbess, he untied his tongue and began to talk.

'I have always been given to understand, ma'am,' he said, 'that whereas a single cock is quite sufficient for ten hens, ten men are hard put to satisfy one woman, and yet here am I with nine of them on my plate. I can't endure it any longer, not at any price, and as a matter of fact I've been on the go so much that I'm no longer capable of delivering the goods. So you'll either have to bid me farewell or come to some sort of an arrangement.'

When she heard him speak, the lady was utterly amazed, for she had always believed him to be dumb.

'What is all this?' she said. 'I thought you were supposed to be dumb.'

'That's right, ma'am, I was,' said Masetto, 'but I wasn't born dumb. It was owing to an illness that I lost the power of speech, and, praise be to God, I've recovered it this very night.'

The lady believed him implicitly, and asked him what he had meant when he had talked about having nine on his plate. Masetto explained how things stood, and when the Abbess heard, she realized that every single one of the nuns possessed sharper wits than her own. Being of a tactful disposition, she decided there and then that rather than allow Masetto to go away and spread tales concerning the convent, she would come to some arrangement with her nuns in regard to the matter.

Their old steward had died a few days previously. And so, with Masetto's consent, they unanimously decided, now that they all knew what the others had been doing, to persuade the people living in the neighbourhood that after a prolonged period of speechlessness, his ability to talk had been miraculously restored by the nuns' prayers and the virtues of the saint after whom the convent was named, and they appointed him their new steward. They divided up his various functions among themselves in such a way that he was able to do them all justice. And although he fathered quite a number of nunlets and monklets, it was all arranged so discreetly that nothing leaked out until after the death of the Abbess, by which time Masetto was getting on in years and simply wanted to retire to his village on a fat pension. Once his wishes became known, they were readily granted.

Thus it was that Masetto, now an elderly and prosperous father who was spared the bother of feeding his children and the expense of their upbringing, returned to the place from which he had set out with an axe on his shoulder, having had the sense to employ his youth to good advantage. And this, he maintained, was the way that Christ treated anyone who set a pair of horns on His crown.

COLUCCIO SALUTATI

In Defense of Liberal Studies

Coluccio Salutati (1331–1406) was chancellor of Florence and an important humanist. Born in Tuscany, Salutati began studying law at Bologna but soon gave it up. Although the early death of his father obliged him to become a notary against his natural inclinations, Salutati's professional career was a brilliant one. He was chancellor of two Italian communes and the papal curia at Viterbo in the 1360s and '70s, and in 1371 he became the chancellor of Florence. This powerful office he held until his death, in the midst of the turbulent conflicts of Florentine and Italian politics. Salutati was also one of the major humanists of the fourteenth century. Claiming the great Petrarch as a model as well as his friend, Salutati was an active supporter of and participant in Florentine intellectual life. Along with collecting manuscripts, Salutati was a keen philologist and textual critic. He also wrote numerous treatises and letters on humanist and philosophical themes, as well as on politics and religion. Moreover, he saw a close connection between his literary and political career, and his skills in both spheres were equally feared. Salutati even began studying Greek late in his life, in the midst of the general enthusiasm for the language sparked by the arrival of the Byzantine scholar Manuel Chrysoloras in 1397.

Of Salutati's letters a political enemy once claimed that they were more damaging than a thousand Florentine horsemen. Despite this flair for satire and invective, Salutati could write eloquently and gracefully on any number of humanist themes, as demonstrated by the present selection. Salutati's defense of Latin literature and Virgil offers a classic example of a humanist response to those who would expunge the pagan classics from Christian reading.

And now, my dear colleague, I will come to a matter in which you have stirred me up in no slight degree. I wrote to you asking you to buy for me a copy of Virgil, and you reply reproving me for not occupying myself with quite different matters and calling Virgil—to quote your

own words—a "lying soothsayer." You say that, since it is forbidden in the canon law to concern oneself with books of that sort, I ought not to burden you with such an errand, and you generously offer me a number of volumes of pious literature. I beg you, my dearest Giuliano, to pardon me if, in order that due supremacy of honour be maintained for the prince of Roman eloquence, the divinest of all poets, our own countryman, Virgil, and also that I may set you free from the error in which you seem to be involved, I address you in language rather more severe than is my wont.

I seem to feel a deep obligation to defend Virgil, of whom Horace says that earth never bore a purer spirit, lest he be shut out from the sanctuaries of Christians. I am bound also to clear up that error of yours which gives you such a horror of Virgil that you fear to be polluted by the mere purchase of the book.

How do you happen, my dear colleague, to have this dread of Virgil? You say that he records the monstrous doings of the gods and the vicious practices of men, and that, because he did not, as you say, walk in the way of the Lord, he leads his readers away from the straight path of the faith. But, if you think Virgil ought not to be touched because he was a heathen, why do you read Donatus, or Priscian, who was something far worse, an apostate? Or Job, to whom you yourself call attention, was he a Christian or was he of the circumcision? Or shall we give up Seneca and his writings because he was not renewed with the water of regeneration? If we throw aside the heritage of the Gentiles, whence shall we draw the rules of literary composition? Cicero is the fountain of eloquence, and everyone who since his day has handed on the art of rhetoric has drawn from that source. Read Augustine on Christian doctrine where he seems to touch [the heights of] eloquence, and certainly you will find the Ciceronian tradition renewed in the style of that great man. Not to read the inventions of the heathen out of devotion to the faith is a very weak foundation, especially when with their assistance you can the more easily combat the futilities of the Gentiles. Don't imagine that I have ever so read Virgil as to be led to accept his fables about the heathen gods! What I enjoy is his style, hitherto unequalled in verse, and I do not believe it is possible that human talent can ever attain to its loftiness and its charm.

I admire the majesty of his language, the appropriateness of his words, the harmony of his verses, the smoothness of his speech, the elegance of his composition, and the sweetly flowing structure of his sentences. I admire the profundity of his thought and his ideas drawn from the depths of ancient learning and from the loftiest heights of philosophy.

In these days there is no mixture of heathenism among Christians throughout the civilized world; . . . [those gods] whom that accursed blind superstition worshipped have vanished from their altars and their shrines and have abandoned their glory to the true God, to Christ our Lord. It may have been worth while to warn Christians against the study of the poets at a time when heathens still lingered among them, but since that pest has been exterminated, what harm can it be for consecrated men to have read the poets who, even if they are of [no] profit for the moral conduct of life, nevertheless cannot spread such poison for the destruction of our faith that we shall cease humbly to adore our Creator. . . .

But you will say, that when we are reading these vain things we are wandering away from the study of sacred literature, since—to continue the Psalm which I began elsewhere—that man is blessed, "whose delight is in the law of the Lord and in his law doth he meditate day and night." I grant you, it is a more holy thing to apply oneself without ceasing to the reading of the sacred page; but these devices of the heathen, even the songs of the poets of which you have such a horror, if one reads them in a lofty spirit are of no little profit and incline us toward those writings which pertain to the faith and the reading of which you urge in your letters. . . .

I have dwelt upon this at such length that you may not suppose the reading of Virgil to be a mere idle occupation if one is willing to take the right view of it and to separate the wheat from the tares. Not, indeed, that I believe one should look there for the teachings of our faith or for the Truth; but, as Seneca says of himself, I go over into the enemy's camp, not as a guest or as a deserter, but as a spy. I, as a Christian, do not read my Virgil as if I were to rest in it forever or for any considerable time; but as I read I examine diligently to see if I can find anything that tends toward virtuous and honourable conduct, and as I run through the foreshadowings of his poetry, often with the aid of allegory and not without enjoyment, if I find something not compatible with the truth, or obscurely stated, I try to make it clear by the use of reason. But, when it is my good fortune to find something in harmony with our faith, even though it be wrapped up in fiction, I admire it and rejoice in it, and, since our poet himself thought it well to learn even from an enemy, I joyfully accept it and make a note of it. . . .

As to Jerome, on whose authority the sacred canons forbid the reading of Virgil and other poets, I would maintain without hesitation that if he had been ignorant of the poetry and rhetoric against which he inveighs so beautifully he would never have handed down to us the volumes of Holy Writ translated in his sweetly flowing style from both Greek and Hebrew into the Latin tongue. Never could he have spoken against his

critics with such brilliancy of ideas and such charm of language. Nor, in his criticism of rhetoric—which I should regard as a fault in another man—would he have made use of the forces of rhetoric.

Furthermore, Aurelius Augustine, exponent and champion of the Christian faith, displayed such knowledge of the poets in all his writings that there is scarcely a single letter or treatise of his which is not crowded with poetic ornament. Not to speak of others, his *City of God* could never have been so strongly and so elaborately fortified against the vanity of the heathen if he had not been familiar with the poets and especially with Virgil. . . .

Now, if you, through the power of your intellect, without a knowledge of the poets can understand grammar or most of the writings of the holy fathers, filled as they are with poetical allusions, do not forbid the reading of Virgil to me and to others, who delight in such studies, but who have not attained to the lofty heights of your genius. If you enjoy reading your books as by a most brilliant illumination, allow me, whose eyes do not admit so much light, in the midst of my darkness to gaze upon the stars of poetry, whereby the darkness of my night is brightened, and to search out a something for the upbuilding of truth and of our faith from amidst those fables whose bitter rind conceals a savour of exceeding sweetness. If you neither can nor will do this, then, with all good will on my part, leave the poets alone! . . .

So, good-bye! And, according to that verse of Cato—for that apocryphal book has by usage come to be thus known—go right on reading your Virgil, secure, since you are not a priest, against any prohibition by your law. You will find in him delight for your eyes, food for your mind, refreshment for your thought, and you will gain from him no little instruction in the art of eloquence.

Fare you well again and again, my dearest friend and colleague! Don't forget me and do give me not only your approval, but your love!

The Dignity of Man

Giovanni Pico della Mirandola (1463–1494), a child prodigy, was the most famous philosopher of the Renaissance. The scion of wealthy, noble, and famous heirs to the tiny principality of Mirandola, Pico studied at the universities of Ferrara, Bologna, Padua, and Paris and was taught informally by Marsilio Ficino, the Platonist philosopher, in Florence. He mastered Hebrew, Greek, Arabic, and Latin in addition to his native Italian and gathered a large collection of esoteric writings in Asian languages. While the Christian Latin tradition provided the frame of reference for all his work, Pico came to believe that all religious and philosophical traditions spread across time and geography participated in a single universal theology, and that pagan and Hebrew occult traditions such as Hermetism and Kabbalah gave unique access to that theology. Pico spent most of his short life trying to work out a concord of all theologies, though only a short section of this planned work was ever finished, a treatise On Being and the One *(1491), which attempted to reconcile Plato and Aristotle on a fundamental metaphysical issue.*

Pico's first attempt at concord was launched in 1486, when he published nine hundred theses and offered, after the manner of university exercises of the day, to defend them at a grand disputation to be held in Rome; Pico even offered to pay the traveling expenses of the scholars invited to attend. It was for the opening of this debate that he wrote the Oration on the Dignity of Man, *from which the opening pages are excerpted here. But the actual debate never took place, for when Pope Innocent VIII had a commission investigate Pico's theses, they condemned thirteen propositions as heretical. Pico then became involved in a controversy with Church authorities and was obliged to flee to France, where he was arrested. He was returned to Italy on parole in the custody of Lorenzo de' Medici, and he remained in Florence until his death.*

The brief section of Pico's Oration *excerpted here has become famous in modern accounts of the Renaissance as the finest expression of the optimism believed to be characteristic of Italian humanism. More recent research emphasizes the traditional elements in Pico's celebration of human free*

will, and sees the work rather as an example of the new Renaissance inter-
est in Christianizing the Kabbalah.

I have read in the ancient annals of the Arabians, most reverend Fathers,
that when asked what on the world's stage could be considered most
admirable, Abdala the Saracen answered that there is nothing more
admirable to be seen than man. In agreement with this opinion is the
saying of Hermes Trismegistus: "What a great miracle, O Asclepius, is
man!"

When I had thought over the meaning of these maxims, the many rea-
sons for the excellence of man advanced by many men failed to satisfy
me—that man is the intermediary between the creatures, the intimate of
the higher beings and the lord of those below him; the interpreter of
nature by the sharpness of his senses, by the discernment of his reason,
and by the light of his intellect; the intermediate point between fixed
eternity and fleeting time; and, as the Persians say, the bond or rather the
marriage song of the world, but little lower than the angels according to
David's testimony. These are weighty reasons, indeed, but they are not
the principal reasons, that is, those which should be accorded boundless
admiration. For why should we not admire more the angels themselves
and the most blessed choirs of heaven?

At last, it seems to me that I have understood why man is the most
fortunate living thing worthy of all admiration and precisely what rank
is his lot in the universal chain of being, a rank to be envied not only by
the brutes but even by the stars and by minds beyond this world. It is a
matter past faith and extraordinary! Why should it not be so? For it is
upon this account that man is justly considered and called a great miracle
and a truly admirable being. But hear, Fathers, exactly what man's rank
is, and as friendly listeners by virtue of your humanity, forgive any defi-
ciencies in this, my work.

God the Father, the supreme Architect, had already built this cosmic
home which we behold, this most majestic temple of divinity, in accor-
dance with the laws of a mysterious wisdom. He had adorned the region
above the heavens with intelligences, had quickened the celestial spheres
with eternal souls and had filled the vile and filthy parts of the lower
world with a multitude of animals of every kind. But when the work was
completed, the Maker kept wishing that there were someone who could
examine the plan of so great an enterprise, who could love its beauty,
who could admire its vastness. On that account, when everything was

completed, as Moses and Timaeus both testify, He finally took thought
of creating man. However, not a single archetype remained from which
he might fashion this new creature, not a single treasure remained which
he might bestow upon this new son, and not a single seat remained in the
whole world in which the contemplator of the universe might sit. All
was now complete; all things had been assigned to the highest, the middle,
and the lowest orders. But it was not in the nature of the Father's power
to fail in this final creative effort, as though exhausted; nor was it in the
nature of His wisdom to waver in such a crucial matter through lack of
counsel; and it was not in the nature of His Beneficent Love that he who
was destined to praise God's divine generosity in regard to others should
be forced to condemn it in regard to himself. At last, the Supreme Arti-
san ordained that the creature to whom He could give nothing properly
his own should share in whatever He had assigned individually to the
other creatures. He therefore accepted man as a work of indeterminate
nature, and placing him in the center of the world, addressed him thus:

"O Adam, we have given you neither a place nor a form nor any abil-
ity exclusively your own, so that according to your wishes and your
judgment, you may have and possess whatever place, form, or abilities
you desire. The nature of all other beings is limited and constrained in
accordance with the laws prescribed by us. Constrained by no limits, in
accordance with your own free will, in whose hands we have placed you,
you shall independently determine the bounds of your own nature. We
have placed you at the world's center, from where you may more easily
observe whatever is in the world. We have made you neither celestial nor
terrestrial, neither mortal nor immortal, so that with honor and freedom
of choice, as though the maker and molder of yourself, you may fashion
yourself in whatever form you prefer. You shall have the power to
degenerate into the inferior forms of life which are brutish; you shall
have the power, through your soul's judgment, to rise to the superior
orders which are divine."

O supreme generosity of God the Father! O highest and most
admirable felicity of man to whom it is granted to have whatever he
chooses, to be whatever he wills! From the moment of their birth, or as
Lucilius says, from their mother's womb, the beasts bring with them all
that they will ever possess. The highest spirits, either from the beginning
of time or soon thereafter, become what they are to be throughout eter-
nity. In man alone, at the moment of his creation, the Father placed the
seeds of all kinds and the germs of every way of life. Whatever seeds
each man cultivates will mature and bear their own fruit in him; if vege-
tative, he will be like a plant; if sensitive, he will become a brute; if

rational, he will become a celestial being; if intellectual, he will be an angel and the son of God. And if content with the lot of no creature he withdraws into the center of his own unity, his spirit, made one with God, in the solitary darkness of the Father who is placed above all things, will surpass them all.

Who would not admire this our chameleon? Or who could admire any other being more greatly than man? Asclepius the Athenian justly says that man was symbolized in the mysteries by the figure of Proteus, because of his ability to change his character and transform his nature. This is the origin of those metamorphoses or transformations celebrated among the Hebrews and the Pythagoreans. For the occult theology of the Hebrews sometimes transforms the holy Enoch into an angel of divinity and sometimes transforms other people into other divinities. The Pythagoreans transform impious men into beasts and, if Empedocles is to be believed, even into plants. Echoing this, Mohammed often had this saying on his lips: "He who deviates from divine law becomes a beast," and he was right in saying so. For it is not the bark that makes the plant but its dumb and insentient nature; neither is it the hide that makes the beast of burden but its irrational and sensitive soul; neither is it the spherical form which makes the heavens, but their undeviating order; nor is it the freedom from a body which makes the angel but its spiritual intelligence.

If you see one abandoned to his appetites crawling along the earth on his belly, it is a plant, not a man, which you see; if you see one enchanted by the vain illusions of fancy, as if by the spells of Calypso, and seduced by these tempting wiles, a slave to his own senses, it is a beast and not a man you see. However, if you see a philosopher who discerns all things by means of right reason, you will venerate him: he is a celestial, not an earthly being. If you see a pure contemplator, unmindful of the body and wholly withdrawn into the inner reaches of the mind, he is neither a terrestrial nor a celestial being; he is a higher spirit clothed in mortal flesh and most worthy of respect.

Are there any who will not admire man? In the sacred Mosaic and Christian writings, man, not without reason, is sometimes described by the name of "all flesh" and sometimes by that of "every creature," since man molds, fashions, and transforms himself according to the form of all flesh and the character of every creature. For this reason, the Persian Evantes, in describing Chaldean theology, writes that man does not have an inborn and fixed image of himself but many which are external and foreign to him; whence comes the Chaldean saying: "Man is a being of varied, manifold, and inconstant nature."

But why do we reiterate all these things? To the end that from the moment we are born into the condition of being able to become whatever we choose, we should be particularly certain that it may never be said of us that, although born to a privileged position, we failed to realize it and became like brutes and mindless beasts of burden, but that the saying of Asaph the prophet might be repeated: "You are all gods and the sons of the Most High." Otherwise, abusing the most indulgent generosity of the Father, we shall make that freedom of choice which He has given to us into something harmful rather than something beneficial.

Let some holy ambition invade our souls, so that, dissatisfied with mediocrity, we shall eagerly desire the highest things and shall toil with all our strength to obtain them, since we may if we wish. Let us disdain earthly things, despise heavenly things, and finally, esteeming less all the things of this world, hasten to that court beyond the world which is nearest to the Godhead. There, as the sacred mysteries relate, Seraphim, Cherubim, and Thrones occupy the first places. Let us emulate their dignity and glory, intolerate of a secondary position for ourselves and incapable of yielding to them the first. If we have willed it, we shall be inferior to them in nothing.

But how shall we proceed and what in the end shall we do? Let us observe what they do, what sort of lives they live. For if we also come to live like them, and we are able to do so, we shall then equal their destiny.

LEONARDO DA VINCI

Portrait of a Renaissance Artist

Artist, scientist, and engineer, Leonardo da Vinci (1452–1519) is the very embodiment of the "universal man" of the Renaissance. Best known for his drawings and paintings, Leonardo was also a tireless observer of nature and the human race. His penetrating insights were set down in numerous notebooks, of which only a few survive. These preserve the enigma of his strange and mysterious personality, as well as his numerous ingenious and unorthodox ideas.

The Duke of Milan was only one of several patrons for whom Leonardo worked. He began his career as an apprentice to the prominent Florentine artist Andrea del Verrochio, a favorite artist of Lorenzo de'Medici. He then moved to Milan in 1482/83 to work in the court of Lodovico Sforza before returning to Florence after fleeing the French invasion of Milan. Yet in 1506 he became painter and engineer to Francis I, King of France. In the last decade of his life he became more and more absorbed in his scientific studies, though these, as he repeatedly insisted, were always undertaken in the service of his art. That his scientific writings did not have more impact on his era is no doubt due to the fact that they were published (at least in part) only in the 1570s, long after his death. Still, they are a memorial to a unique moment in Western history when art was at the forefront of the move toward a more practical, applied science, and scientific observation was a precondition of the highest artistic achievement.

The brief selection presented here provides the reader with a glimpse of Leonardo and his most characteristic thoughts: his rejection of book learning and his preference for observation and experience; his famous self-description as a man without erudition; his preference for painting over sculpture; his general views on the proper way to approach this craft; his contempt for useless contemporaries who failed to share his devotion to work and study; and his profound unhappiness. The selection ends with a famous draft of a letter he sent to Lodovico Sforza, Duke of Milan, which is the best short text extant on the kind of skills expected of the "artist-engineer" of the High Renaissance in Italy.

3

Let no man who is not a mathematician read the elements of my work.

4

Begun at Florence, in the house of Piero di Braccio Martelli, on the 22nd day of March 1508. And this is to be a collection without order, taken from the many papers which I have copied here, with the hope of arranging them later on each in its own place, according to the subjects of which they treat.[1] But I think that before I come to the end of this work I shall have to do the same things a number of times; for which, O reader! do not blame me, since the subjects are many and memory cannot retain all of them, and say: "I will not write this because I wrote it before." And if I should wish to avoid committing this error, it would be necessary in every case when I wanted to copy [something] that, in order not to repeat myself, I should read over all that had gone before; and all the more since the intervals between writing one time and the next are long.

INTRODUCTION

I am full conscious that, since I am not a literary man, certain presumptuous persons will think it quite proper to blame me, alleging that I am not a man of letters.[2] Foolish people! Do they not realize that I might well answer as Marius did the Roman Patricians by saying that they who deck themselves out in the labors of others will not allow me my own. They will say that since I have no literary ability, I cannot properly express what I wish to deal with, but what they do not know is that my subjects are to be dealt with by experience rather than by words; and experience has always been the mistress of those who wrote well. And so, as mistress in this, I will cite her in all cases.

11

Even though I may not, like them, be able to quote other authors, I shall rely on what is far greater and more worthy: on experience, the mistress of their Masters.[3] They go about puffed up and pompous, dressed and decorated not in their own labors, but in those of others. And they will not allow me my own. They will scorn me as an inventor, but how much more might they—who are not inventors but braggarts and declaimers of the works of others—be blamed.

19
OF THE MISTAKES MADE BY THOSE WHO PRACTICE WITHOUT KNOWLEDGE

Those who love practice without knowledge are like the sailor who gets into a ship that has no rudder or compass and who can never be sure of where he is going. Practice must always be founded on sound theory, and to this perspective is the guide and the gateway; and without this nothing good can be done when it comes to drawing.

483

The young artist should learn about perspective first, then the proportions of objects. Then he may copy from some good master, to accustom himself to find forms, and then from nature, to confirm by practice the rules he has learned; then observe for a while the works of a number of different masters; then get into the habit of putting his art into practice and work.

488
OF PAINTING

It is indispensable to a painter, in order to be thoroughly familiar with the limbs in all the positions and actions of which they are capable in the nude, to know the anatomy of the sinews, bones, muscles, and tendons so that, in their various movements and exertions, he may know which nerve or muscle is the cause of each movement and show only those as prominent and swelled, and not all the others in limb, as many do who, in order to appear as great artists, draw their nude figures looking like wood, and lacking in grace—you would think you were looking at a sack of walnuts rather than the human form, or a bundle of radishes rather than bare muscles.[4]

651

A beautiful object that is mortal passes away, but not so with art.

652
HE WHO DESPISES PAINTING LOVES NEITHER PHILOSOPHY NOR NATURE

If you condemn painting, which is the only imitator of all of nature's visible works, you will certainly despise a subtle invention which brings

philosophy and subtle speculation to the consideration of the nature of all forms—seas and land, trees, animals, plants and flowers—which are surrounded by shade and light. And this is true knowledge and the legitimate offspring of nature; for painting is born of nature—or, to be more correct, we will say it is the grandchild of nature; for all visible things are produced by nature, and these, her children, have given birth to painting. Hence we may justly call it the grandchild of nature and related to God.

<div align="center">653</div>

THAT PAINTING SURPASSES ALL HUMAN WORKS BY THE SUBTLE CONSIDERATIONS BELONGING TO IT

The eye, which is called the window of the soul, is the principal means by which the central sense can most completely and fully appreciate the infinite works of nature; and the ear is the second, which acquires dignity by hearing of the things the eye has seen. If you, historians, or poets, or mathematicians, had not seen things with your eyes, you would have been able to write about them poorly. And if you, O poet, tell a story with your pen, the painter with his brush can tell it more easily, with simpler completeness, and it would be less tedious to understand. And if you call painting dumb poetry, the painter may call poetry blind painting. Now which is the worse defect, to be blind or dumb? Though the poet is as free as the painter in the invention of his stories, they are not so satisfactory to men as paintings, for, though poetry is able to describe forms, actions, and places in words, the painter deals with the actual similitude of the forms in order to represent them. Now tell me which is closer to man himself: the name of man or the image of man. The name of a man may differ from country to country, but a man's form is never changed except by death.

<div align="center">655</div>

THAT SCULPTURE IS LESS INTELLECTUAL THAN PAINTING, AND LACKS MANY CHARACTERISTICS OF NATURE

Since I myself have practiced the art of sculpture no less than that of painting, doing both of them to the same degree, it seems to me that I, without invidiousness, can give my opinion as to which of the two is most worthy, difficult, and perfect. To begin with, sculpture requires a certain light (that is, from above), while a picture carries with it throughout its own light and shade. Thus sculpture owes its importance to light and shade, and the sculptor is assisted in this by nature, by the relief

which is inherent in it, while the painter whose art expresses the acciden-
tal aspects of nature places his effects in the spots where nature would
reasonably have put them. The sculptor cannot change his work by
means of the various natural colors that objects contain, but painting is
not defective in any particular. The perspective used by sculptors never
appears to be true; that of the painter can appear to be a hundred miles
beyond the picture itself. Their sculpted works have no aerial perspec-
tive whatever; they cannot represent luminous bodies, nor reflected
lights, nor lustrous bodies—as mirrors and similar polished surfaces—
nor mists, nor dark skies, nor an infinite number of things which I need
not mention for fear of becoming tedious. As regards the capability to
resist time, though they do have this resistance, a picture painted on
thick copper covered with white enamel on which it is painted with
enamel colors and then put back into the fire and baked will last forever
compared to sculpture. It may be said that if a mistake is made it is not
easy to correct it, but it is a poor argument to try to prove that a piece of
work is nobler because oversights are irremediable; I would say rather
that it is more difficult to improve the mind of the master who makes
such mistakes than to fix the work he has ruined.

660

THAT PAINTING DECLINES AND DETERIORATES FROM AGE TO AGE, WHEN PAINTERS HAVE NO OTHER STANDARD THAN PAINTING ALREADY DONE

The painter will produce pictures of little worth if he takes for his stan-
dard the pictures of others. But if he will learn from the objects of nature
he will bear good fruit; this we have seen in the painters following the
Romans who always imitated both, and their art continued to decline
from age to age. After these came Giotto the Florentine, who was not
content with imitating the works of Cimabue, his master. Born in soli-
tude and in the mountains inhabited only by goats and the like, and
guided by nature to his art, he began by drawing on the rocks the move-
ments of the goats of which he was keeper. And then he began to draw
all types of animals found in the country, and he did so in such a way
that after much study he excelled not only all the masters of his time but
all those of many centuries past. Later this art declined once more,
because everyone imitated the pictures already existing; and so it went
from century to century until Tommaso of Florence, nicknamed Masac-
cio, showed by his perfect works how those who take for their standard
anyone but nature, the mistress of all masters, labor in vain.[5] And I

would say concerning these mathematical studies that those who study only the authorities and not the works of nature are nephews but not sons of nature, the mistress of all good authors. Oh! how great is the folly of those who accuse artists who learn from nature, setting aside those authorities who themselves were the disciples of nature.

661

The first drawing was nothing but a line going around the shadow of a man cast by the sun on a wall.

1162

Now you see how the hope and desire of returning home and to one's former state is like the moth to the light, and that the man who with constant longing awaits with joy the coming of each new springtime, each new summer, each new month and new year—and it seems that the things he longs for are always too late in coming—does not perceive that he is longing for his own destruction. But this desire is the very quintessence, the spirit of the elements, which finding itself imprisoned within the soul always longs to return to its giver. And I want you to know that this same longing is that quintessence, the companion of nature, and that man is the image of the world.

1179

There are some who are nothing more than a passage for food and augmentors of excrement and fillers of privies, because through them no other things in the world, nor any good effects, are produced, since nothing but full privies results from them.

1340
(TO LUDOVICO SFORZA, DUKE OF MILAN)[6]

Having now, most illustrious Lord, sufficiently seen the specimens of all those who consider themselves master craftsmen of instruments of war, and that the invention and operation of such instruments are no different from those in common use, I shall now endeavor, without offending anyone, to explain myself to your Excellency by revealing to your Lordship my secrets, and then offering them for your pleasure and approbation to work with effect at the opportune time as well as all those things which, in part, shall be briefly noted below.

1. I have the kind of bridges that are extremely light and strong, made to be carried with great ease, and with them you may pursue, and, at any time, flee from the enemy; and there are others, that are safe, indestructible by fire and battle, easy and convenient to lift and set up; and also methods of burning and destroying those of the enemy.

2. I know how, when a place is under attack, to eliminate the water from the trenches, and make endless variety of bridges, and covered ways and ladders, and other machines pertaining to such expeditions.

3. If, because of the height of the banks, or the strength of the place and its position, it is impossible, when besieging a place, to follow a plan of bombardment, I have methods for destroying every rock or other fortress, even if it were built on rock, etc.

4. I also have other kinds of mortars that are most convenient and easy to carry; and with these small stones can be thrown creating the effect of a storm; and the smoke produced by this will strike terror into the hearts of the enemy to his great detriment and confusion.

9. And if it should be a sea battle, I have many kinds of machines that are most efficient for offense and defense; I also have vessels which will resist the attack of the largest guns and powder and fumes.

5. I also have means that are noiseless to reach a designated area by secret and tortuous mines and ways, even if they had to pass under a trench or river.

6. I will make covered chariots, safe and unattackable, which can penetrate the enemy with their artillery, and there is no body of men strong enough to prevent them from breaking through. And behind these, infantry could advance unharmed and without any hindrance.

7. In case of need I will make big guns, mortars, and light ordnance of fine and useful forms that are out of the ordinary.

8. If the operation of bombardment shall fail, I would contrive catapults, mangonels, trabocchi, and other machines of marvelous efficacy and unusualness.[7] In short, I can, according to each case in question, contrive various and endless means of offense and defense.

10. In time of peace I believe I can give perfect satisfaction that is equal to any other in the field of architecture and the construction of buildings, public and private, and in directing water from one place to another.

I can execute sculpture in marble, bronze, or clay, and also in painting I do the best that can be done, and as well as any other, whoever he may be.

Again, the bronze horse may be taken up, which is to be to the immortal glory and eternal honor of the happy memory of the prince, your father, and of the illustrious house of Sforza.

And if any of the above-named things appear to anyone to be impossible or not feasible, I am more than ready to test the experiment in your park or in whatever place may please your Excellency, to whom I commend myself with the utmost humility, etc.

EXPLANATORY NOTES

1. Leonardo seems to have planned a general treatise on painting and had a number of possible introductions in mind. Given the state of the extant manuscripts, the disorderly nature of Leonardo's original plan has been intensified by the loss or dispersal of many of his original manuscripts.

2. This passage, one of the possible introductions mentioned above in note 1, contains Leonardo's famous self-description as an unlettered (but not unlearned) man. Leonardo rejected the bookish science of the universities for the practical experience of personal observation.

3. Leonardo anticipates Francesco Guicciardini's attack upon the book learning of Renaissance thought. Whereas Leonardo rejects studying ancient classical scientific texts, since they obscure our perception of the natural world around us (and are often simply incorrect), Guicciardini (see selections in this [original source] anthology) will reject abstract, bookish political schemes (like those of his friend Machiavelli) in favor of practical experience in government.

4. Leonardo's own skill as a painter was due, in large measure, to his incomparable gift of noticing the details of every object or body contained in his paintings or sketches.

5. In this fragment, Leonardo anticipates the theory of the development of Italian art in the Renaissance usually associated with Giorgio Vasari's *Lives of the Artists.* However, he stresses the fact that Giotto and Masaccio imitated nature, not their predecessors.

6. Leonardo left Florence in 1481 and went to Milan, then ruled by the dashing Ludovico Sforza (known as "Il Moro," 1451–1508), who was the virtual ruler of Milan, since his nephew and the heir to the city's rule, Gian Galeazzo Sforza, was only thirteen years old. Ludovico needed an architect and military engineer as much as he required an artist, and Leonardo's letter of presentation to him stresses his many practical talents. The bronze horse mentioned was to be an equestrian monument to commemorate Ludovico's father, Francesco Sforza (1401–66), sixth Duke of Milan. The extant manuscript of this letter is not in Leonardo's hand and may have been only a draft.

7. Mangonels and trabocchi are technical terms for different kinds of military catapults or mortars frequently employed in Leonardo's time in besieging a city or fortress.

NICCOLÒ MACHIAVELLI

The Prince, the Nobility, and the People

Niccolò Machiavelli (1469–1527), the most famous of all Renaissance polit-
ical writers, is also the most controversial. He has been called the founder
of the social sciences, the originator of the theory of "power politics" in
international relations, the greatest Renaissance representative of "civic
humanism," a great theorist of republican liberty, as well as many less com-
plimentary names. He was born into an old but declining Florentine family
and received a standard humanistic education in the Greek and Latin clas-
sics. In his twenties he witnessed the expulsion of the Medici from Florence
and the ascendency of Fra Girolamo Savonarola, who temporarily turned
Florence into a kind of theocracy. From 1498 to 1512 he was employed as
the Second Chancellor (or under-secretary of state) to Florence's republican
regime, and became a close confidant ("lapdog," said his enemies) of Piero
Soderini, the Florentine head of state. In this period Machiavelli also served
as secretary to the emergency war commission, and secretary of the civic
board governing the militia. He was an ambassador and envoy on some
thirty-five diplomatic missions, including several to important leaders such
as King Louis XII of France, Cesare Borgia, Pope Julius II, and the
emperor Maximilian I. He had a much more extensive acquaintance with
men and affairs than most political theorists.

In 1512 the Soderini regime fell and the Medici returned to power.
Machiavelli was removed from office, and briefly imprisoned and tortured.
Yet he was still eager to serve the new regime and wrote The Prince *(1513,*
printed in 1531) in part to give the new Medici rulers proof of his political
acumen. Eventually he was commissioned by Cardinal Giulio de'Medici to
write a history of Florence. After his initial rejection by the Medici, Machi-
avelli sought to curry favor with leading oligarchs of the old republic, spec-
ulating on the possibility of their return to power. With this end in view he
composed The Discourses on the First Ten Books of Titus Livy *(1513–17,*
printed 1531). The dialogues on The Art of War, *written around 1520 and*
printed in 1521, display Machiavelli's credentials as an expert on military
matters. All of Machiavelli's works were on the papal Index of Prohibited
Books from 1557 until 1850.

In this selection from chapter IX of The Prince, *Machiavelli told the prince how he may hold on to power by understanding the different desires characteristic of the nobility and populace, and how they may be manipulated.*

———————

IX. THE CONSTITUTIONAL PRINCIPALITY

But now we come to the other case, where a private citizen becomes the ruler of his country neither by crime nor by any other outrageous act of violence but by the favour of his fellow citizens (and this we can call a constitutional principality, to become the ruler of which one needs neither prowess alone nor fortune, but rather a lucky astuteness). I say that one becomes a prince in this case with the favour of the people or of the nobles.[1] These two different dispositions are found in every city; and the people are everywhere anxious not to be dominated or oppressed by the nobles, and the nobles are out to dominate and oppress the people. These opposed ambitions bring about one of three results: a principality, a free city, or anarchy.

A principality is created either by the people or by the nobles, according to whether the one or the other of these two classes is given the opportunity. What happens is that when the nobles see they cannot withstand the people, they start to increase the standing of one of their own numbers, and they make him prince in order to be able to achieve their own ends under his cloak. The people in the same way, when they see they cannot withstand the nobles increase the standing of one of themselves and make him prince in order to be protected by his authority. A man who becomes prince with the help of the nobles finds it more difficult to maintain his position than one who does so with the help of the people. As prince, he finds himself surrounded by many who believe they are his equals, and because of that he cannot command or manage them the way he wants. A man who becomes prince by favour of the people finds himself standing alone, and he has near him either no one or very few not prepared to take orders. In addition, it is impossible to satisfy the nobles honourably, without doing violence to the interests of others; but this can be done as far as the people are concerned. The people are more honest in their intentions than the nobles are, because the latter want to oppress the people, whereas they want only not to be oppressed. Moreover, a prince can never make himself safe against a hostile people: there are too many of them. He can make himself safe against

385

the nobles, who are few. The worst that can happen to a prince when the people are hostile is for him to be deserted; but from the nobles, if hostile, he has to fear not only desertion but even active opposition. The nobles have more foresight and are more astute, they always act in time to safeguard their interests, and they take sides with the one whom they expect to win. Again, a prince must always live with the same people, but he can well do without the nobles, since he can make and unmake them every day, increasing and lowering their standing at will.

To clarify the discussion further, I say that there are two main considerations to be remembered in regard to the nobles: either they conduct themselves in such a way that they come to depend entirely on your fortunes, or they do not. Those who become dependent, and are not rapacious, must be honoured and loved; those who remain independent of you do so for two different reasons. They may do so because they are pusillanimous and naturally lacking in spirit; if so you should make use of them, especially those who are capable of giving sensible advice, since they will respect you when you are doing well, and you will have nothing to fear from them in times of adversity. But when they deliberately and for reasons of ambition remain independent of you, it is a sign that they are more concerned about themselves than about you. Against nobles such as these, a prince must safeguard himself, fearing them as if they were his declared enemies, because in times of adversity they will always help to ruin him.

A man who is made a prince by the favour of the people must work to retain their friendship; and this is easy for him because the people ask only not to be oppressed. But a man who has become prince against the will of the people and by the favour of the nobles should, before anything else, try to win the people over; this too is easy if he takes them under his protection. When men receive favours from someone they expected to do them ill, they are under a greater obligation to their benefactor; just so the people can in an instant become more amicably disposed towards the prince than if he had seized power by their favour. And there are many ways in which a prince can win them over. These vary according to circumstances, so no definite rule can be given and I shall not deal with them here. I shall only conclude that it is necessary for a prince to have the friendship of the people; otherwise he has no remedy in times of adversity.

Nabis, prince of the Spartans, withstood the whole of Greece and a triumphant Roman army, and successfully defended his country and his own authority against them.[2] All he had to do, when danger threatened, was to take steps against a few of his subjects; but this would not have

been enough had the people been hostile to him. Let no one contradict this opinion of mine with that trite proverb that he who builds on the people builds on mud. That may be so when a private citizen bases his power on the people and takes it for granted that the people will rescue him if he is in danger from enemies or from the magistrates. (In this case, he could often find he had made a mistake, as happened with the Gracchi in Rome and messer Giorgio Scali in Florence.) But if it is a prince who builds his power on the people, one who can command and is a man of courage, who does not despair in adversity, who does not fail to take precautions, and who wins general allegiance by his personal qualities and the institutions he establishes, he will never be let down by the people; and he will be found to have established his power securely.

Principalities usually come to grief when the transition is being made from limited power to absolutism. Princes taking this step rule either directly or through magistrates. In the latter case, their position is weaker and more dangerous, because they rely entirely on the will of those citizens who have been put in office; and these, especially in times of adversity, can very easily depose them either by positive action against them or by not obeying them. And when danger comes, the prince has no time to seize absolute authority, because the citizens and subjects, accustomed to taking orders from the magistrates, will not take them from him in a crisis. In disturbed times, also, men whom the prince can trust will be hard to find. So such a prince cannot rely on what he has experienced in times of tranquillity, when the citizens have need of his government. When things are quiet, everyone dances attendance, everyone makes promises, and everybody would die for him so long as death is far off. But in times of adversity, when the state has need of its citizens, there are few to be found. And this test of loyalty is all the more dangerous since it can be made only once. Therefore a wise prince must devise ways by which his citizens are always and in all circumstances dependent on him and on his authority; and then they will always be faithful to him.

EXPLANATORY NOTES

1. Machiavelli contrasts the *grandi* with the *popolo,* the former being loosely the grandees. In ancient Rome, Machiavelli believed, their mutual hostility had been constructive; in Florence it had proved ruinous. Cf. *Istorie Fiorentine* (History of Florence), Book III.

2. The Achaean league of Greeks and Romans, against which Nabis (207–192 B.C.) fought in alliance with Philip V of Macedon (237–179 B.C.). Machiavelli's references to Nabis are derived from Livy's *History of Rome* (Book XXXIV).

NICCOLÒ MACHIAVELLI

Whether It Is Better to be Loved than Feared

*Niccolò Machiavelli (1469–1527), the most famous of all Renaissance polit-
ical writers, is also the most controversial. He has been called the founder
of the social sciences, the originator of the theory of "power politics" in
international relations, the greatest Renaissance representative of "civic
humanism," a great theorist of republican liberty, as well as many less com-
plimentary names. He was born into an old but declining Florentine family
and received a standard humanistic education in the Greek and Latin clas-
sics. In his twenties he witnessed the expulsion of the Medici from Florence
and the ascendency of Fra Girolamo Savonarola, who temporarily turned
Florence into a kind of theocracy. From 1498 to 1512 he was employed as
the Second Chancellor (or under-secretary of state) to Florence's republican
regime, and became a close confidant ("lapdog," said his enemies) of Piero
Soderini, the Florentine head of state. In this period Machiavelli also served
as secretary to the emergency war commission, secretary of the civic board
governing the militia, and served as an ambassador and envoy on some
thirty-five diplomatic missions, including several to important leaders such
as King Louis XII of France, Cesare Borgia, Pope Julius II, and the
emperor Maximilian I. He had a much more extensive acquaintance with
men and affairs than most political theorists.*

*In 1512 the Soderini regime fell and the Medici returned to power.
Machiavelli was removed from office, and briefly imprisoned and tortured.
Yet he was still eager to serve the new regime and wrote* The Prince *(1513,
printed in 1531) in part to give the new Medici rulers proof of his political
acumen. Eventually he was commissioned by Cardinal Giulio de'Medici to
write a history of Florence. After his initial rejection by the Medici, Machi-
avelli sought to curry favor with leading oligarchs of the old republic, spec-
ulating on the possibility of their return to power. With this end in view he
composed* The Discourses on the First Ten Books of Titus Livy *(1513–17,
printed 1531). The dialogues on* The Art of War, *written around 1520 and
printed in 1521, display Machiavelli's credentials as an expert on military
matters. All of Machiavelli's works were on the papal Index of Prohibited
Books from 1557 until 1850.*

In this selection from chapter XVII of The Prince, *Machiavelli explained that the prince's power and success must always trump lesser considerations such as his reputation for compassion and the love of the people.*

XVII. CRUELTY AND COMPASSION; AND WHETHER IT IS BETTER TO BE LOVED THAN FEARED, OR THE REVERSE

Taking others of the qualities I enumerated above, I say that a prince must want to have a reputation for compassion rather than for cruelty: none the less, he must be careful that he does not make bad use of compassion. Cesare Borgia was accounted cruel; nevertheless, this cruelty of his reformed the Romagna, brought it unity, and restored order and obedience. On reflection, it will be seen that there was more compassion in Cesare than in the Florentine people, who, to escape being called cruel, allowed Pistoia to be devastated.[1] So a prince must not worry if he incurs reproach for his cruelty so long as he keeps his subjects united and loyal. By making an example or two he will prove more compassionate than those who, being too compassionate, allow disorders which lead to murder and rapine. These nearly always harm the whole community, whereas executions ordered by a prince only affect individuals. A new prince, of all rulers, finds it impossible to avoid a reputation for cruelty, because of the abundant dangers inherent in a newly won state. Vergil, through the mouth of Dido, says:

> Res dura, et regni novitas me talia cogunt
> Moliri, et late fines custode tueri.[2]

None the less, a prince must be slow to believe allegations and to take action, and must watch that he does not come to be afraid of his own shadow; his behaviour must be tempered by humanity and prudence so that over-confidence does not make him rash or excessive distrust make him unbearable.

From this arises the following question: whether it is better to be loved than feared, or the reverse. The answer is that one would like to be both the one and the other; but because it is difficult to combine them, it is far better to be feared than loved if you cannot be both. One can make this generalization about men: they are ungrateful, fickle, liars, and deceivers, they shun danger and are greedy for profit; while you treat them well, they are yours. They would shed their blood for you, risk their property, their lives, their sons, so long, as I said above, as danger is

remote; but when you are in danger they turn away. Any prince who has come to depend entirely on promises and has taken no other precautions ensures his own ruin; friendship which is bought with money and not with greatness and nobility of mind is paid for, but it does not last and it yields nothing. Men worry less about doing an injury to one who makes himself loved than to one who makes himself feared. For love is secured by a bond of gratitude which men, wretched creatures that they are, break when it is to their advantage to do so; but fear is strengthened by a dread of punishment which is always effective.

The prince must none the less make himself feared in such a way that, if he is not loved, at least he escapes being hated. For fear is quite compatible with an absence of hatred; and the prince can always avoid hatred if he abstains from the property of his subjects and citizens and from their women. If, even so, it proves necessary to execute someone, this is to be done only when there is proper justification and manifest reason for it. But above all a prince must abstain from the property of others; because men sooner forget the death of their father than the loss of their patrimony. It is always possible to find pretexts for confiscating someone's property; and a prince who starts to live by rapine always finds pretexts for seizing what belongs to others. On the other hand, pretexts for executing someone are harder to find and they are sooner gone.

However, when a prince is campaigning with his soldiers and is in command of a large army then he need not worry about having a reputation for cruelty; because, without such a reputation, no army was ever kept united and disciplined. Among the admirable achievements of Hannibal is included this: that although he led a huge army, made up of countless different races, on foreign campaigns, there was never any dissension, either among the troops themselves or against their leader, whether things were going well or badly. For this, his inhuman cruelty was wholly responsible. It was this, along with his countless other qualities, which made him feared and respected by his soldiers. If it had not been for his cruelty, his other qualities would not have been enough. The historians, having given little thought to this, on the one hand admire what Hannibal achieved, and on the other condemn what made his achievements possible.

That his other qualities would not have been enough by themselves can be proved by looking at Scipio, a man unique in his own time and through all recorded history. His armies mutinied against him in Spain, and the only reason for this was his excessive leniency, which allowed his soldiers more licence than was good for military discipline. Fabius Maximus reproached him for this in the Senate and called him a corrupter of

the Roman legions. Again, when the Locrians were plundered by one of Scipio's officers, he neither gave them satisfaction nor punished his officer's insubordination; and this was all because of his being too lenient by nature.[3] By way of excuse for him some senators argued that many men were better at not making mistakes themselves than at correcting them in others. But in time Scipio's lenient nature would have spoilt his fame and glory had he continued to indulge it during his command; when he lived under orders from the Senate, however, this fatal characteristic of his was not only concealed but even brought him glory.

So, on this question of being loved or feared, I conclude that since some men love as they please but fear when the prince pleases, a wise prince should rely on what he controls, not on what he cannot control. He must only endeavour, as I said, to escape being hated.

EXPLANATORY NOTES

1. Pistoia was a subject-city of Florence, which forcibly restored order there when conflict broke out between two rival factions in 1502–2. Machiavelli was concerned with this business at first hand.
2. 'Harsh necessity, and the newness of my kingdom, force me to do such things and to guard my frontiers everywhere.' *Aeneid* i, 563.
3. Locri Epizephyrii was in Calabria. Machiavelli liked to make comparisons—elaborated in the *Discorsi*—between Hannibal and Publius Cornelius Scipio, called Scipio Africanus Major (326–182 B.C.), who defeated Hannibal during the Punic wars at Zama in 202 B.C.

BALDESAR CASTIGLIONE

The Ideal Courtier and the Ideal Court

The Book of the Courtier *by Baldesar Castiglione ranks as one of the supreme expressions of the Italian Renaissance. First published in 1528 in the full glory of the High Renaissance, the book encapsulates more than a century of humanistic discussions concerning the ways to perfect human nature. Though formally confined to one particular way of life—the life of courtiers at princely courts—the dialogue in fact is a virtual compendium of themes central to Italian Renaissance thought: themes such as virtue and good manners, spiritual and sensual love, religion, the nature of beauty, true nobility, the correct use of language, the active and contemplative lives, the status of women, the ideal form of the polity, and the respective truths of arms, letters, and the arts. These subjects are laid out in the form of imaginary dialogues among the most distinguished Italian noblemen and noblewomen of the day, gathered together at the famous Renaissance court in the Duchy of Urbino.*

The author of the dialogues, Baldesar Castiglione (1478–1529), was a humanist, soldier, and diplomat who spent most of his career in the service of the dukes of Urbino. In 1524 he was appointed papal nuncio to Spain and died in Toledo of the plague in 1529. The Courtier *is his only important work, but it is one of surpassing literary artistry that represents the Urbino of his youth as a model of Renaissance ideals. In this selection from the beginning of Book I, Castiglione told how he came to write the* Courtier, *and described the noblemen and ladies of the court of Urbino.*

I have spent a long time wondering, my dear Alfonso, which of two things was the more difficult for me: either to refuse what you have asked me so often and so insistently, or to do it. On the one hand, it seemed to me to be very hard to refuse anything, and especially something praiseworthy, to one whom I love dearly and by whom I feel I am very dearly loved; yet on the other hand, to embark on a project which I was uncertain of being able to finish seemed wrong to one who respects

adverse criticism as much as it ought to be respected. Eventually, after a great deal of thought, I have made up my mind to find out how diligent I can be when helped by affection and the anxiety to please, which usually act as a sharp spur to all kinds of activity.

Now your request is that I should describe what, in my view, is the form of courtiership most appropriate for a gentleman living at the Courts of princes, by which he will have the knowledge and the ability to serve them in every reasonable thing, winning their favour and the praise of others. In short, you want to know what kind of man must be one who deserves the name of a perfect courtier and has no shortcomings whatsoever. Considering this request, I must say that, if I did not think it a greater fault to be judged wanting in love by you than wanting in prudence by others, I would have rejected the task, for fear of being accused of rashness by all those who know how difficult an undertaking it is to select from all the many and various customs followed at the Courts of Christendom the most perfect model and, as it were, the very flower of courtiership. For familiarity often causes the same things to be liked and disliked: and thus it sometimes happens that the customs, behaviour, ceremonies and ways of life approved of at one period of time grow to be looked down on, and those which were once looked down on come to be approved. So we can see clearly enough that usage is more effective than reason in introducing new things among us and in wiping out the old. And anyone who tries to judge what is perfect in these matters often deceives himself. Being well aware of this, therefore, and of the many other problems connected with the subject proposed to me, I am compelled to say something by way of excuse and to testify that what I am doing wrong (if it can be called so) you are responsible for as well, and that if I am to be blamed for it you must share the blame. After all, you must be judged to be as much at fault in imposing on me a task greater than my resources as I am in having accepted it.

But let us now begin to discuss the subject we have chosen and if it is possible, create a courtier so perfect that the prince who is worthy of his service, even though his dominion is small, can count himself a truly great ruler. In these books we shall not follow any strict order or list a series of precepts, as is the normal practice in teaching. Instead, following many writers of the ancient world, and reviving a pleasant memory, we shall recount some discussions which once took place among men who were singularly qualified in these matters. Even though I did not take part in them in person (being in England when they were held), they were faithfully reported to me soon after my return by someone who was present, and I shall endeavour to reproduce them as accurately as my memory

allows so that you may discover what was held and thought on the subject by eminent men whose judgement can always be trusted completely. Nor will it be beside the purpose, in order to continue the story in logical order, to describe the occasion of the discussions that took place.

On the slopes of the Apennines, almost in the centre of Italy towards the Adriatic, is situated, as everyone knows, the little city of Urbino. Although it is surrounded by hills which are perhaps not as agreeable as those found in many other places, none the less it has been favoured by Nature with a very rich and fertile countryside, so that as well as a salubrious atmosphere it enjoys an abundance of all the necessities of life. Among the blessings and advantages that can be claimed for it, I believe the greatest is that for a long time now it has been governed by outstanding rulers, even though in the turmoils into which Italy was plunged by war it was for a time deprived of them. Without looking any further, we can find a splendid example in Duke Federico of glorious memory, who in his day was the light of Italy. Nor are there lacking today any number of reliable witnesses to his prudence, humanity, justice, generosity and unconquerable spirit, and to his military skill, which was brilliantly attested by his many victories, his ability to capture impregnable places, his swift and decisive expeditions, his having routed many times with few troops great and formidable armies, and his never having lost a single battle. So we can fairly compare him with many famous men of the ancient world. Among his other commendable enterprises, Duke Federico built on the rugged site of Urbino a palace which many believe to be the most beautiful in all Italy; and he furnished it so well and appropriately that it seemed more like a city than a mere palace. For he adorned it not only with the usual objects, such as silver vases, wall-hangings of the richest cloth of gold, silk and other similar material, but also with countless antique statues of marble and bronze, with rare pictures, and with every kind of musical instrument; nor would he tolerate anything that was not most rare and outstanding. Then, at great cost, he collected a large number of the finest and rarest books, in Greek, Latin and Hebrew, all of which he adorned with gold and silver, believing that they were the crowning glory of his great palace.

Following, therefore, the course of Nature, and being already sixty-five years old, Duke Federico died as gloriously as he had lived, leaving as his heir his only son, a little, motherless boy of ten named Guidobaldo. And Guidobaldo seemed to inherit not only his father's

state but all his virtues as well, immediately showing in his marvellous disposition the promise of more than can be expected from a mortal man. In consequence, it was widely said that of all the wonderful things that Duke Federico had done, the greatest was to have fathered such a son. But envious of his great qualities, Fortune set herself with all her might to frustrate what had begun so nobly, with the result that before he was yet twenty years old Duke Guido fell sick with the gout which, inflicting terrible pain, grew steadily worse and within a short space of time crippled him so badly that he could neither stand nor walk. Thus one of the best and most handsome men in the whole world was deformed and ruined while still of tender age. Not satisfied even with this, Fortune so opposed him in all his projects that he rarely succeeded in what he undertook; and although he was a man of mature deliberation and unconquerable spirit, everything he set his hand to, whether in arms or anything else, great or small, always ended unhappily, as we can see from the many diverse calamities which befell him, and which he always bore with such fortitude that his will was never crushed by fate. On the contrary, with great resilience and spirit, he despised the blows of Fortune, living the life of a healthy and happy man, despite sickness and adversity, and achieving true dignity and universal renown. Thus even though he was infirm, he campaigned with a most honourable rank in the service of their Serene Highnesses Kings Alfonso and Ferdinand the Younger of Naples, and subsequently with Pope Alexander VI as well as the Signories of Venice and Florence. Then, after the accession of Pope Julius II, he was made Captain of the Church; and during this time, following his customary style of life, he saw to it that his household was filled with very noble and worthy gentlemen, with whom he lived on the most familiar terms, delighting in their company. In this the pleasure he caused others was no less than what he received, for he was very well versed in both Latin and Greek, and possessed as well as an affable and charming nature, an infinite range of knowledge. Moreover, his indomitable spirit so spurred him on that, even though he himself was unable to take part in chivalrous activities, as he once used to, he loved to see them pursued by others, and he would show his fine judgement when commenting on what they did, correcting or praising each one according to his merits. So in jousts and tournaments, in riding, in handling every kind of weapon, as well as in the festivities, games and musical performances, in short, in all the activities appropriate to a well-born gentleman, everyone at his Court strove to behave in such a way as to deserve to be judged worthy of the Duke's noble company.

So all day and every day at the Court of Urbino was spent on honourable and pleasing activities both of the body and the mind. But since the Duke always retired to his bedroom soon after supper, because of his infirmity, as a rule at that hour everyone went to join the Duchess, Elisabetta Gonzaga, with whom was always to be found signora Emilia Pia, a lady gifted with such a lively wit and judgement, as you know, that she seemed to be in command of all and to endow everyone else with her own discernment and goodness. In their company polite conversations and innocent pleasantries were heard, and everyone's face was so full of laughter and gaiety that the house could truly be called the very inn of happiness. And I am sure that the delight and enjoyment to be had from loving and devoted companionship were never experienced elsewhere as they once were in Urbino. For, apart from the honour it was for each of us to be in the service of a ruler such as I described above, we all felt supremely happy whenever we came into the presence of the Duchess; and this sense of contentment formed between us a bond of affection so strong that even between brothers there could never have been such harmonious agreement and heartfelt love as there was among us all. It was the same with the ladies, whose company we all enjoyed very freely and innocently, since everyone was allowed to talk and sit, make jokes and laugh with whom he pleased, though such was the respect we had for the wishes of the Duchess that the liberty we enjoyed was accompanied by the most careful restraint. And without exception everyone considered that the most pleasurable thing possible was to please her and the most displeasing thing in the world was to earn her displeasure. So for these reasons in her company the most decorous behaviour proved compatible with the greatest freedom, and in her presence our games and laughter were seasoned both with the sharpest witticisms and with a gracious and sober dignity. For the modesty and nobility which informed every act, word and gesture of the Duchess, in jest and laughter, caused even those seeing her for the first time to recognize that she was a very great lady. It seemed, from the way in which she influenced those around her, that she tempered us all to her own character and quality, so that everyone endeavoured to imitate her personal way of behaviour, deriving as it were a model of fine manners from the presence of so great and talented a woman, whose high qualities I do not intend to describe now, since this is not to my purpose and they are well known to all the world, apart from being beyond the reach of whatever I could say or write. But I must add that those qualities in the Duchess which might have remained somewhat hidden, Fortune, as if admiring such rare virtues, chose to reveal through many adversities and harsh

blows, in order to demonstrate that in the tender soul of a woman, and accompanied by singular beauty, there may also dwell prudence and a courageous spirit and all those virtues very rarely found even in the staunchest of men.

To continue, let me say that it was the custom for all the gentlemen of the house to go, immediately after supper, to the rooms of the Duchess; and there, along with pleasant recreations and enjoyments of various kinds, including constant music and dancing, sometimes intriguing questions were asked, and sometimes ingenious games played (now on the suggestion of one person and now of another) in which, using various ways of concealment, those present revealed their thoughts in allegories to this person or that. And occasionally, there would be discussions on various subjects, or there would be a sharp exchange of spontaneous witticisms; and often 'emblems', as we call them nowadays, were devised for the occasion. And everyone enjoyed these exchanges immensely, since, as I have said, the house was full of very noble and talented persons, among whom, as you know, the most famous was signor Ottaviano Fregoso, his brother Federico, the Magnifico Giuliano de' Medici, Pietro Bembo, Cesare Gonzaga, Count Lodovico da Canossa, Gaspare Pallavicino, signor Lodovico Pio, signor Morello da Ortona, Pietro da Napoli, Roberto da Bari and countless other high-born gentlemen. There were also many who, although they did not as a rule stay permanently, yet spent most of their time there: they included Bernardo Bibbiena, the Unico Aretino, Giovan Cristoforo Romano, Pietro Monte, Terpandro and Nicolò Frisio. So gathered together at the Court of Urbino there were always to be found poets, musicians, buffoons of all kinds, and the finest talent of every description anywhere in Italy.

BALDESAR CASTIGLIONE

What Women Want

————————

The Book of the Courtier *by Baldesar Castiglione ranks as one of the supreme expressions of the Italian Renaissance. First published in 1528 in the full glory of the High Renaissance, the book encapsulates more than a century of humanistic discussions concerning the ways to perfect human nature. Though formally confined to one particular way of life—the life of courtiers at princely courts—the dialogue in fact is a virtual compendium of themes central to Italian Renaissance thought: themes such as virtue and good manners, spiritual and sensual love, religion, the nature of beauty, true nobility, the correct use of language, the active and contemplative lives, the status of women, the ideal form of the polity, and the respective truths of arms, letters, and the arts. These subjects are laid out in the form of imaginary dialogues among the most distinguished Italian noblemen and noblewomen of the day, gathered together at the famous Renaissance court in the Duchy of Urbino.*

The author of the dialogues, Baldesar Castiglione (1478–1529), was a humanist, soldier, and diplomat who spent most of his career in the service of the dukes of Urbino. In 1524 he was appointed papal nuncio to Spain and died in Toledo of the plague in 1529. The Courtier *is his only important work, but it is one of surpassing literary artistry that represents the Urbino of his youth as a model of Renaissance ideals. In the present selection from Book III, Castiglione spoke through the brilliant Emilia Pia, faithful companion of the Duchess of Urbino, about what women want from their male lovers.*

————————

'It seems to me,' continued the Unico, 'to be only reasonable that men should win favour from their ladies by serving them and pleasing them; but what they consider serving and pleasing to consist in must, I think, be taught by the ladies themselves, since they often want such strange things that no man can think what they are, and indeed they often don't know themselves. So it would be very fitting, madam, if since you are a

woman and ought to know what pleases women, you undertake the task yourself and put everyone in your debt.'

'But you enjoy such universal favour with women,' replied signora Emilia, 'that you must surely know all the ways in which their favour can be won. So it's fitting that you should teach them to others.'

'Madam,' replied the Unico, 'I could give a lover no more useful advice than that he should ensure that you have no influence on the lady whose favour he seeks; for such good qualities as everyone once thought were mine, together with the sincerest love that ever existed, have not had as much power to make me loved as you have had to make me hated.'

'Signor Unico,' replied Emilia, 'God keep me from thinking, much less doing, anything to make you hated. For not only would this be wrong, but I would be thought very silly if I attempted the impossible in that way. But since you urge me to say something about what is pleasing to women I shall do so; and if what I say displeases you, then you have only yourself to blame. I consider, then, that if a man is to be loved he must himself love and be lovable; and these two things are enough for him to win the favour of women. And to answer your accusation, I declare that everyone knows and sees that you are most lovable; but I am very doubtful as to whether you love as sincerely as you claim, and perhaps the others are too. For by being too lovable you have made yourself loved by many women. But when great rivers divide into several channels they dwindle to small streams; and in the same way when love is given to more than one object it loses much of its force. However, your own constant lamenting and accusations of ingratitude against the women you have served, which do not ring true, considering your great merits, are really designed as a kind of concealment to hide the favours, the joys and the pleasures you have known in love, and to reassure those women who love you and have abandoned themselves to you that you won't give them away. So they too are content that you should openly make a pretence of loving other women in order to conceal your genuine love for them. And so if the women you pretend to love now are not as credulous as you would wish, this is because your technique is beginning to be understood, and not because I cause you to be hated.'

Then the Unico remarked: 'I've no wish to go on disproving what you say, since as far as I can see I am as fated to be disbelieved when I speak the truth as you are to be believed when you tell lies.'

'But admit,' replied signora Emilia, 'that you do not love in the way you say. For if you did, you would desire only to please your lover and

to wish only what she wishes, since this is the law of love. But the way you complain of her so much suggests deceit, as I said before, or indeed proves that your wishes are not the same as hers.'

'On the contrary,' said the Unico, 'I certainly wish whatever she wishes, and this proves that I love her; but I complain because she doesn't wish what I wish, and this, according to the rule you quoted, suggests that she doesn't love me.'

Then signora Emilia replied: 'But a man who begins to love must also begin to please the woman he loves and to be ruled by her in accommodating his every wish to hers. And he must ensure that his desires are all subordinate to hers and that his soul is the slave of hers, or indeed, if possible, that it is transformed into hers; and he should see this as being the greatest happiness he could want. For this is the way of those who are truly in love.'

'The greatest happiness for me,' said the Unico, 'would be precisely if a single will governed both her soul and mine.'

'Then you must bring this about,' replied signora Emilia.

At this point, Bernardo interrupted to say:

'Certainly a man who is truly in love without any prompting by others devotes all his thoughts to serving and pleasing the woman he loves. But sometimes his devotion goes unrecognized, and so I think that as well as loving and serving he must demonstrate his love so clearly in some other way that the woman he loves cannot conceal that she knows she is loved; though he should do this so modestly as to avoid any suggestion of disrespect. And so, madam, since you were saying that a lover's soul should be the slave of the woman he loves, I implore you to teach us this secret too, as it seems to me extremely important.'

At this, Cesare smiled and remarked: 'If the lover is so modest that he is ashamed to declare his love, let him write it in a letter.'

'On the contrary,' said signora Emilia, 'if he is discreet as he ought to be, before he makes any declaration he should make sure that he won't offend her.'

Then signor Gaspare said: 'Well, all women like to be begged for their love, even though they mean to refuse what is asked of them.'

At this, the Magnifico Giuliano remarked: 'You are very much mistaken, and I would advise the courtier never to adopt this strategy, unless he is certain that he won't be repulsed.'